PALADARES

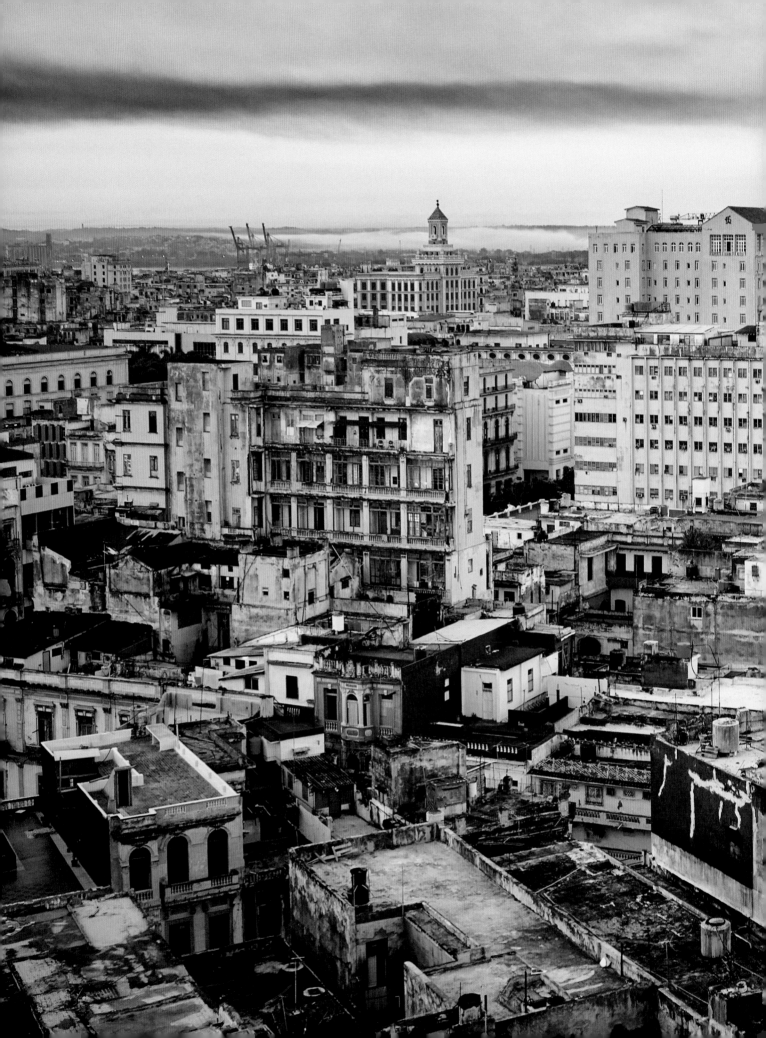

PALADARES

RECIPES INSPIRED BY THE
Private Restaurants of Cuba

ANYA VON BREMZEN

RECIPE DEVELOPMENT AND PHOTOGRAPHY BY
MEGAN FAWN SCHLOW

ABRAMS, NEW YORK

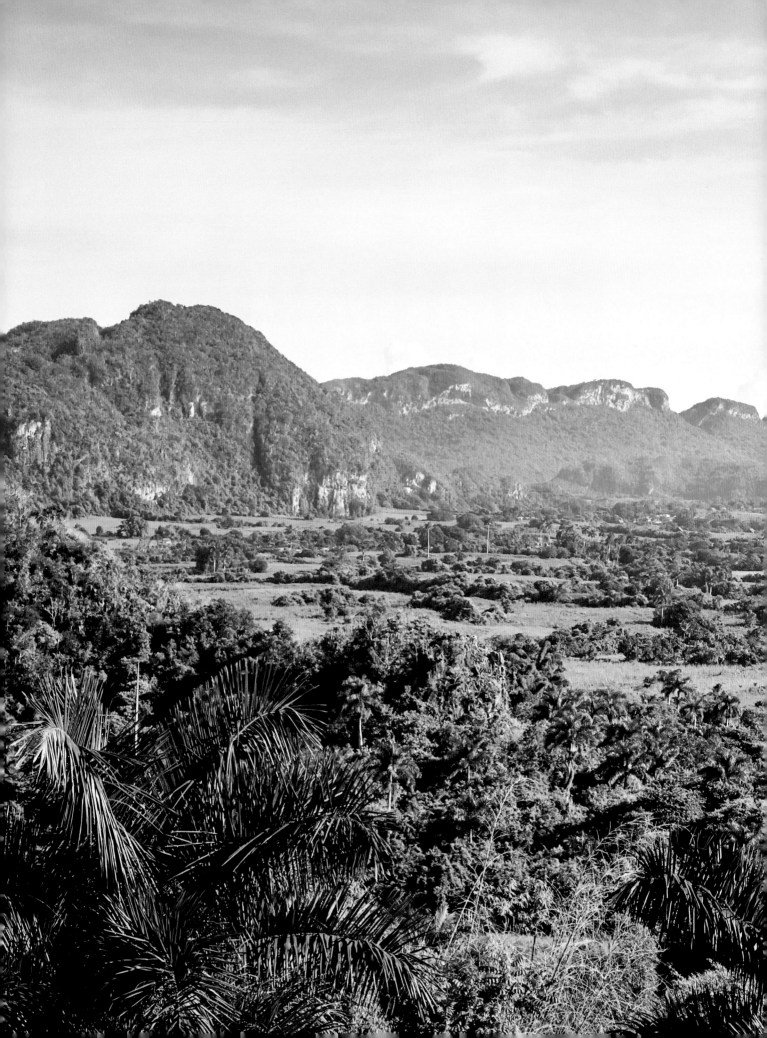

CONTENTS

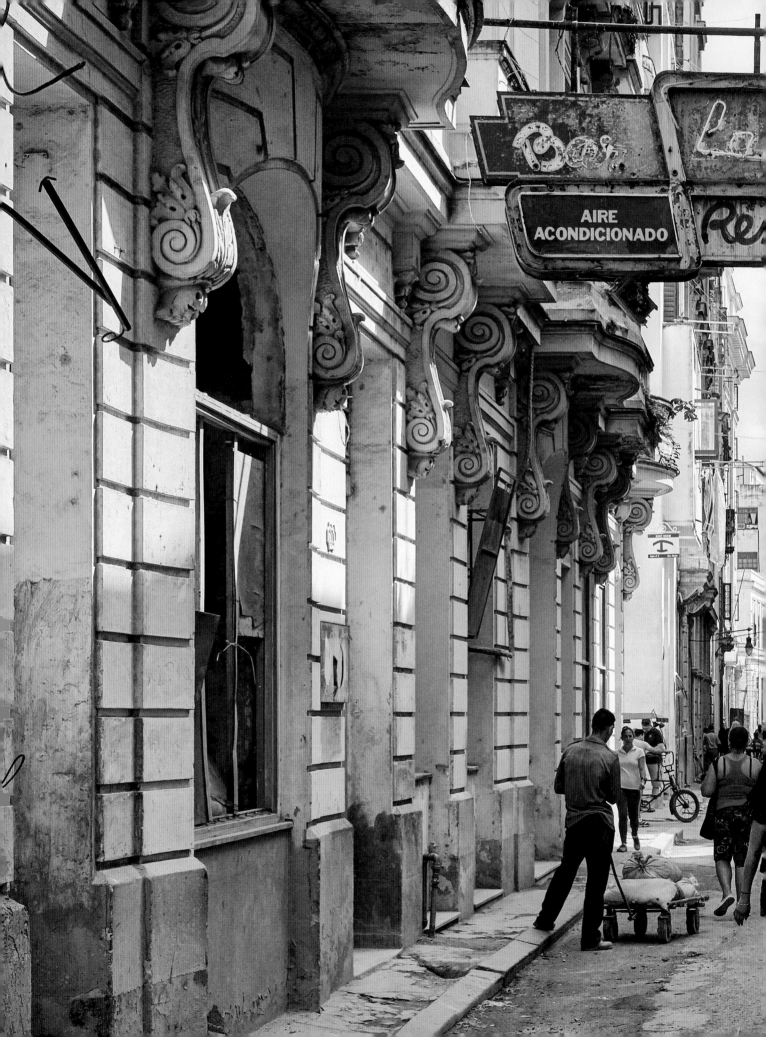

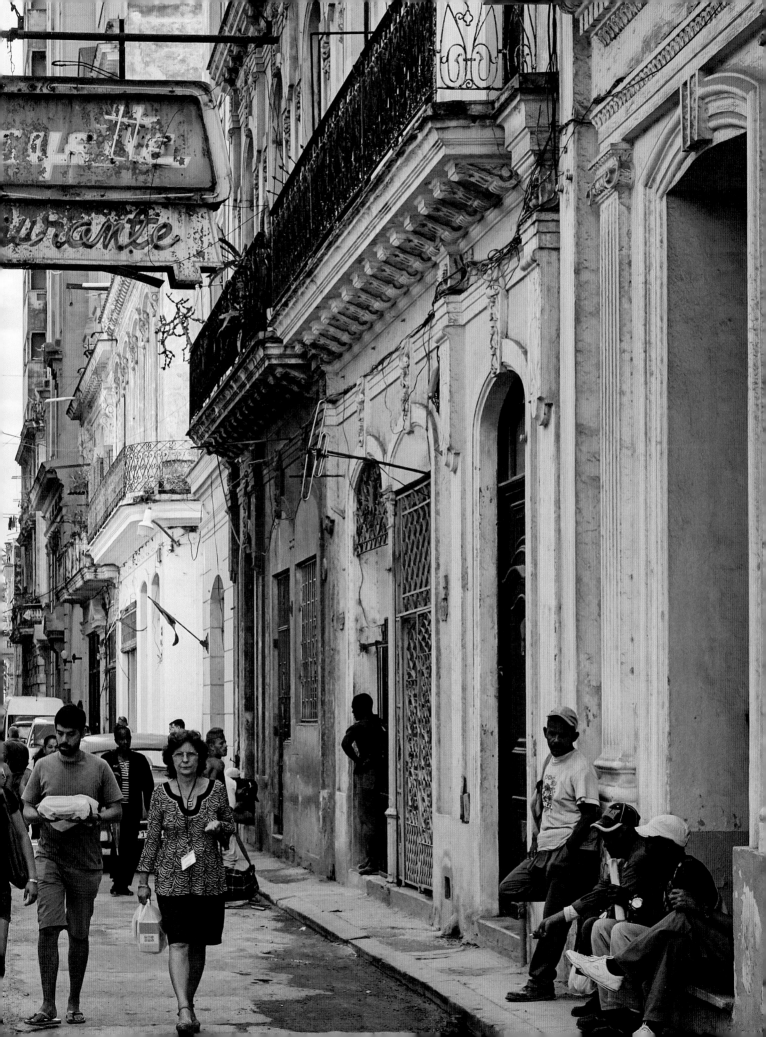

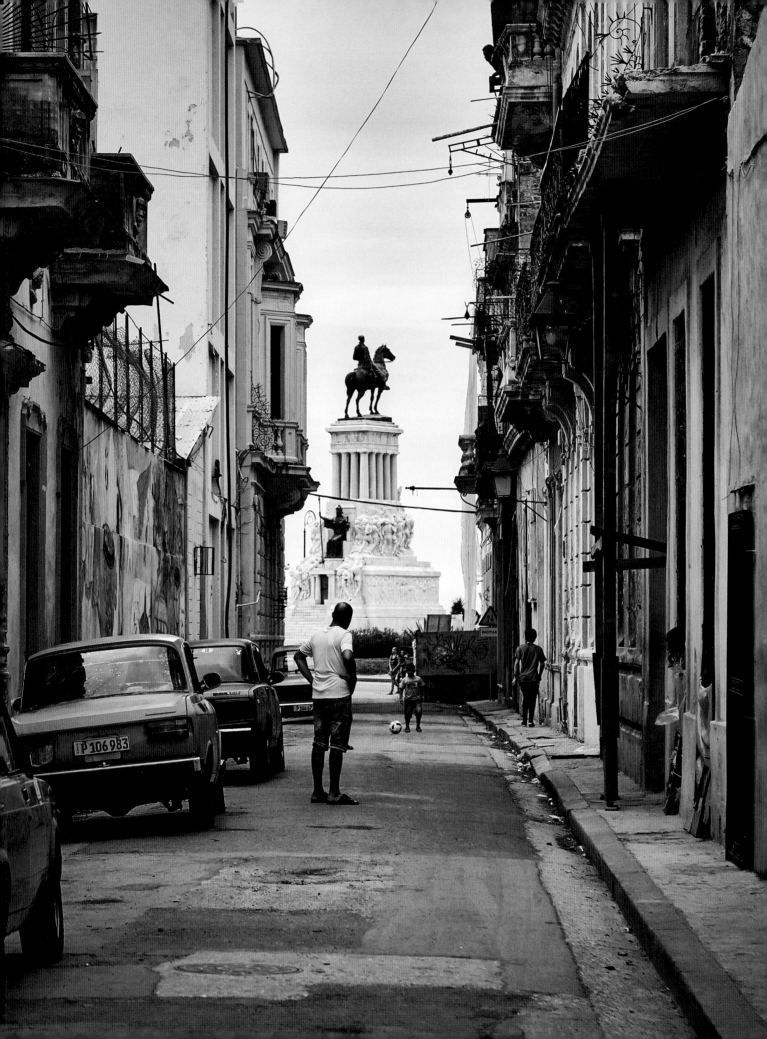

BOCADITOS Y APERITIVOS
Snacks and Appetizers

Fried Plantain Chips *Mariquitas* 29

Plantain Fritters *Tostones* 30

Curried Chicken Empanadas *Empanadas de Pollo al Curry* 32

Ham and Cheese Empanadas *Empanadas de Jamón y Queso* 35

Pork Empanadas with Chimichurri *Empanadas de Cerdo con Chimichurri* 38

Malanga Fritters *Frituras de Malanga* 40

Sweet Corn Fritters *Frituras de Maíz Tierno* 43

Fried Stuffed Potatoes *Papas Rellenas* 44

Pilar's Blue Cheese Croquettes *Croquetas de Cabrales Casa Pilar* 46

Curried Fish Croquettes *Croquetas de Pescado al Curry* 48

Tomato Toast with Jamón *Pan con Tomate con Jamón* 53

Flatbread with Tomatoes, Jamón, and Olives *Focaccia con Tomate, Jamón, y Aceitunas* 56

Chicken Tapas with Jamón and Cheese *Tapas de Pollo con Jamón y Queso* 59

Picadillo-Stuffed Peppers *Pimientos Rellenos con Picadillo* 60

Midnight Sandwich *Medianoche* 63

SOPAS
Soups

Black Bean Soup *Puré Africano* 72

White Bean Soup *Caldo Gallego* 74

Ajiaco 78

Grandma Tona's Chicken Soup *Sopa de Pollo de la Abuela Tona* 80

Pilar's Salmorejo *Salmorejo Cordobés Casa Pilar* 83

Avocado and Apple Gazpacho *Gazpacho de Aguacate y Manzana* 84

Pumpkin Soup with Blue Cheese *Sopa de Calabaza con Queso Azul* 86

Spinach Crema with Blue Cheese *Sopa Crema de Espinacas con Queso Azul* 89

Garlic Soup Otramanera *Sopa de Ajo Otramanera* 92

Crab and Corn Soup *Harina con Cangrejos* 94

Yuca and Chard Crema *Sopa Crema de Yuca y Acelgas* 95

Solianka *Irina's Zesty Smoked Meats Soup with Olives and Pickles* 100

VEGETALES Y VIANDAS
Vegetables and Roots

Pumpkin Salad with Garlic Chip Mojo *Ensalada de Calabaza con Mojo de Ajo* 109

Avocado Salad *Ensalada de Aguacate* 114

Tamarind Caesar Salad *Ensalada Caesar con Aliño de Tamarindo* 117

Fried Sweet Plantains *Plátanos Maduros Fritos* 118

Yuca with Onion Mojo *Yuca con Mojo* 121

Baked Eggplant with Parmesan *Berenjenas a la Parmesana* 124

Plantain Fufú with Pork *Fufú de Plátano con Carne de Cerdo* 127

Okra Curry with Papaya *Curry de Quimbombó con Fruta Bomba* 130

Pumpkin and Spinach with Saffron *Puré de Calabazas y Espinacas con Azafrán* 133

Vegetable Tacos with Escabeche *Tacos de Verdura con Escabeche* 134

Katia's Quiche *Quiche de Katia* 137

ARROZ, FRIJOLES, Y TAMALES
Rice, Beans, and Tamales

White Rice *Arroz Blanco* 145

Yellow Rice *Arroz Amarillo* 146

Black Beans *Potaje de Frijoles Negros* 150

Black Beans and Rice *Moros y Cristianos* 152

Red Beans and Rice *Congri* 153

Red Bean Stew *Potaje de Frijoles Colorados* 154

Fried Rice *Arroz Frito* 161

Fried Chickpeas with Chorizo *Garbanzos Fritos* 162

Smashed White Bean Cake *Muñeta de Frijoles Blancos* 165

Pumpkin Rice *Arroz con Calabaza* 168

Rice with Okra and Ham *Arroz con Quimbombó y Jamón* 171

Pork Tamales *Tamal en Hojas con Cerdo* 172

Cuban Polenta *Tamal en Cazuela* 175

PESCADOS Y MARISCOS
Fish and Seafood

Seviche Amigos del Mar 182

Ceviche with Avocado and Tomato *Seviche con Aguacate y Tomate* 183

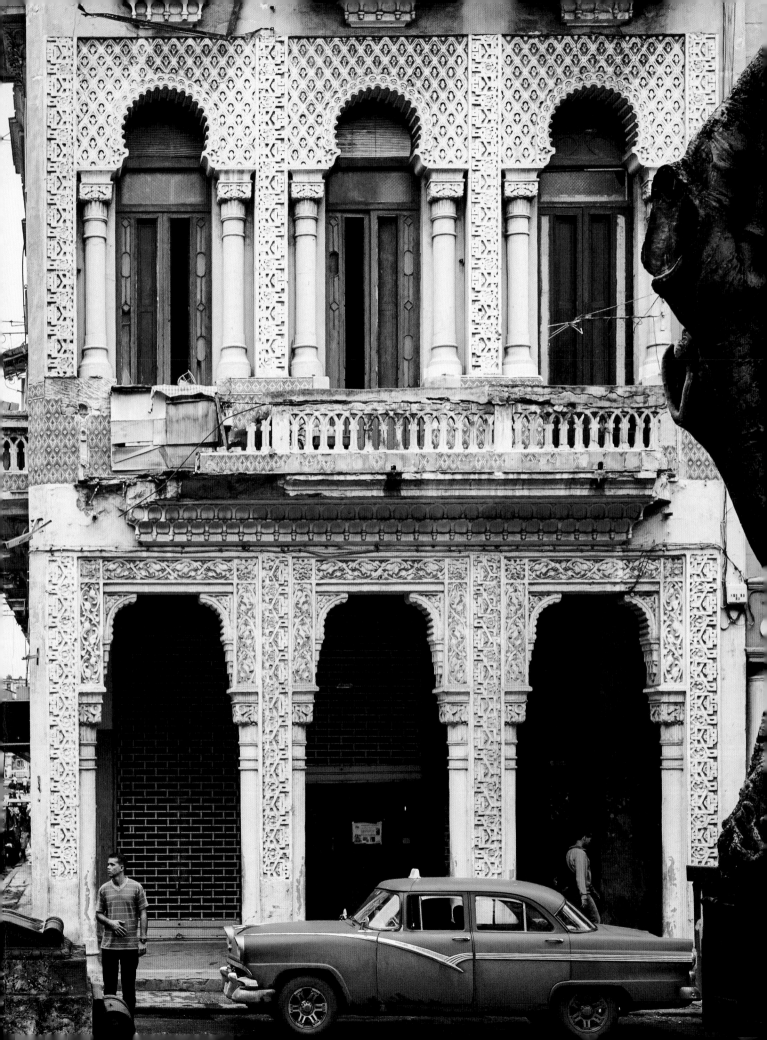

INTRODUCTION

The early 1990s in Cuba. Recently dumped by its economic patron, the USSR, this revolutionary island nation in the Caribbean was on the brink of starvation. Stomachs rumbling from a supper sometimes consisting of nothing more than sugared water—euphemistically called sopa de gallo [rooster soup]—Cubans sat glued to their TV sets, distracted from their daily struggles and privations by a sexy Brazilian telenovela called *Vale Todo* (*Anything Goes*). Its rags-to-riches Cinderella plot revolved around a leggy beauty named Raquel who moved to Rio from the Brazilian hinterlands, started selling sandwiches from a basket on Copacabana beach, and eventually turned into a capitalist princess after setting up her own chain of small restaurants. Paladares—meaning "palates"—is what she called them.

"Our entire suffering island was besotted with this clever, enterprising Raquel," remembers the Havana restaurateur Niuska Miniet. Raquel, her sandwiches, her wild business success—"they were the envy of Cuba," adds local food journalist Alicia García. Cubans hadn't seen such entrepreneurship themselves since Fidel Castro banned all private economic activity in 1968 and nationalized pretty much everything, including restaurants. But in 1993, in the so-called Período Especial, when Cuba faced economic catastrophe and drastic shortages of basic essentials, El Comandante announced a wave of economic reforms. These included legalizing more than one hundred self-employment occupations—among them, those in the food sector. And so were born Cuba's paladares: small, homegrown eateries officially licensed to sell food to both locals and tourists, their name borrowed from that Brazilian telenovela. Tiny islands of capitalism in a socialist sea (as they were later dubbed), the first paladares were mere homey mom-and-pop speakeasies, rudimentary eateries required by law to operate out of private homes, with no more than doce sillas [twelve chairs] and at least two family members as employees, and no serving of beef, shellfish, or—inexplicably—horsemeat.

Then what *did* they serve?

"Call it survival fare," says Niuska, with a sardonic laugh. Her paladar, Decamerón, is one of the few originals remaining from the '90s. "We improvised from whatever scant 'foodstuffs' were available—even while authorities were constantly trying to close us down on bogus law violations."

Fast-forward two and a half decades. Havana, circa 2017. A hipster crowd of international DJs and local designers and artists gathers on the rooftop terrace of El Del Frente, a Habana Vieja boîte where dinners often morph into dance parties. Jimi Hendrix cranks from the sound system. Coolest of hosts José Carlos Imperatori delivers gin and tonics strewn with fresh rose petals to a posse of models cling-wrapped in tight dresses, as servers rush around with plates of curried

fish croquetas with citrusy avocado dip, tangy ceviches, and seductively charred baby octopus. If it weren't for the humid air polluted with fumes from ancient American Chevys—plus a sudden electrical blackout, typical in this ramshackle part of Habana Vieja—this could be Berlin or Miami.

Earlier, a few miles west of here in the stately Miramar district, a beat-up delivery truck from the organic uber-farm Finca Marta pulled up outside the strikingly modern gastro-bistro Otramanera to unload dewy mustard greens and artisanal honeys. On the menu at Otramanera tonight: guava gazpacho, a tartare of avocado and creamy mozzarella made by a not entirely legal local cheesemaker, and pork cooked sous vide for ultimate succulence. Deeper in Miramar, at paladar Casa Pilar, Spanish expats, international diplomats, and Cuban entrepreneurs order the ultra-smooth salmorejo [a type of gazpacho] that owner Pilar Fernandez whirs in a high-tech Spanish gadget called a Thermomix. They'll follow that with a bowl of her earthy stew of garbanzos and lobster.

Elsewhere in Havana, one can sample molecular-gastronomy-inspired tapas at Paladar Elite, enjoy soulful Russian soups with a sea view at Soviet-themed Nazdarovie, have an expertly charred Italian flatbread at paladar Mediterraneo Havana, or inhale the sweet earthy scent of tamales made with just-grated corn at the locavore paladar Hecho en Casa. In Old Havana, the Platonic ideals of ropa vieja and frijoles negros await at folkloric Doña Eutimia, followed by a slice of rich chocolate tart at boho-chic Dulceria Bianchini or perhaps a slushy mojito sorbet at the bright ice cream boutique Helad'oro. Where to eat the next day? Why not log on to the still-unreliable Internet and consult the nifty site from an innovative digital start-up called AlaMesa, dedicated to Cuba's emerging restaurant scene.

All of this is recent in the extreme, made possible by a powerful wave of liberalizing reforms kicked off in 2011 by Fidel's brother, Raul—policies that allowed paladares to expand in scope and ambition. All of this is extremely precarious, too, as occasional crackdowns on paladares continue, restaurant owners still struggle, and every time we return to Cuba we hold our breaths wondering if the places we love are still there (indeed some of the paladares we feature closed as this book went to print). Raul's socialist government still hems and haws about private enterprise, and the one-step-forward two-steps-back pace of reform remains classically Cuban. Still. The sea change in Cuba's dining landscape, ravaged by decades of shortages, has been extraordinary. It's a miracle, really, to find so much sabor and ambition in a country where the most enduring joke has been: *What are the three greatest failures of Fidel's Revolution? Breakfast, lunch, dinner.*

Alas, that joke is not obsolete—*yet*. Certainly not for those who can't afford private restaurants, which is to say most average Cubans who wheel, deal, and still queue up for essentials, perfecting the art of inventar, that Cuban talent for improvising out of thin air. Creativity and improvisation are crucial for running a paladar, too. At times Cuba's current dining-out boom seems altogether improbable given the obstacles restaurateurs must overcome every day to put food on their tables. As we write this, no wholesale market yet exists in Cuba—but the black market thrives. There are no legal food imports aside from the "suitcase trade," no certainty that basics like onions, butter, or salt won't go perdído [lost] tomorrow. "How can I write my menu when I have no idea what ingredient will appear—or has vanished—each morning?" laughs one paladar owner, shaking her head. "My chalkboard, that's my salvation," declares another. "I can simply write menus last minute depending on what's available." And yet, Cuba's dining options are growing more abundant and tasty each day. In feats of DIY ingenuity, restaurateurs defy the odds by cultivating informal networks of farmers and fishermen, copying furniture from foreign design magazines, smuggling spices and olive oil in their luggage,

researching recipes and decor on the Internet—infusing each meal with invention and optimism.

The invention, the optimism—that Cuban spirit and grit spiced with the requisite dash of dark humor—is what we celebrate in *Paladares*, the book, which chronicles in recipes, stories, and images the panoramic narrative of the new Cuban cuisine.

Paladares began with Megan's first trip to Havana. A photographer, food stylist, traveler, and recipe maven, Megan headed to Cuba on a seemingly irrational mission: to uncover delicious food that would defy the stereotypes of stale socialist pork and sludgy rice and beans. Megan landed in Havana on a humid day in May and was instantly smitten—with *everything*: the magical light that drives photographers mad, the city's colonial streets in various states of decay and repair/disrepair, the vibrant cacophonous life taking place on the ramshackle rooftops she saw from her thirteenth-floor window, the vistas that reminded her of tropical snowballs. On that first trip she found good food, too, from the homemade salumi at paladar Mediterraneo Havana to the majestic suckling pig at paladar Ivan Chef Justo; from silky black bean puree at Hecho en Casa to the addictive mojo-spiked plantain chips accompanying fantastical cocktails at O'Reilly 304. Every few months, Megan returned to Cuba, captivated as much by new flavors and images as by the vitality of the island's life and the generous, gracious people who welcomed her into their kitchens.

Anya joined the journey midway. Author of books on Spanish and Latin American foods as well as a memoir about Soviet life, Anya has always felt a special connection to Cuba. Growing up in the former USSR during the glory days of Soviet-Cuban socialist friendship, she watched endless TV images of bushy-bearded Fidel locked in an eternal embrace with bushy-browed Leonid Brezhnev. She also attended a showcase communist school where Russian children learned Spanish and recited poems glorifying Fidel to visiting Cuban dignitaries. Arriving in Cuba in 2016, Anya felt catapulted back to that socialist time warp, overcome by a feeling that Cuba and Russia were siblings who went their own separate ways but still shared the same difficult past, and similar survival skills—to say nothing of the current nostalgia for the same vanished Eastern Bloc foodstuffs. When Cubans talked to her about the challenges of life on the island, Anya felt like she could almost finish their sentences.

While Megan photographed and gathered recipes, Anya interviewed restaurateurs, chefs, food historians, farmers, and fellow food journalists—tasting their food and recording their stories of hope, frustration, and triumph. Intimate storytelling is important to Cubans. In a country where official state narratives are never quite trusted, personal tales and urban legends—even gossip and anecdotes—have the existential power of truth. To do proper justice to the inimitable voices and personal histories of the people behind Cuba's food revolution and convey a sense of immediacy, we feature their stories as told to us, in first person, following a brief profile of their paladares. The food personalities you'll meet on these pages are a diverse, vibrant cast of characters. There are Spanish, French, and Italian expats from all walks of life who fell for Cuba for all sorts of reasons, stayed, and ended up opening restaurants, often because they simply wanted a good place to eat. There are cosmopolitan Cubanos who returned after living abroad and local hipster millennials who've barely set foot outside their island but know global culture and food from foreign movies and magazines. In *Paladares* you'll be introduced to professional chefs who cooked for Fidel, like the owner of the Ivan Chef Justo, and dedicated home cooks like Alina Menendez of Hecho en Casa who set out to recapture the exquisite Cuban home cooking she remembered from childhood. You'll

even hear from a former homicide cop who ended up enthralled by Spanish food guru Ferran Adrià, and from a formerly globe-trotting Swedish-Greek producer of music videos who came to Havana on business and overnight fell for the city as his true home.

The new Cuban recipes in *Paladares* are as vivid and colorful as the people behind them. But what exactly *is* this "new Cuban cuisine," you might be wondering. The answer is sometimes harder to articulate than it is to find good beef at a state store. Culled from fragments of fractured pre-Revolutionary culinary traditions, a new influx of Western ideas and tastes, black market ingredients that unexpectedly arrive via back doors, and—ever and always—creative ways to circumvent shortages, Cuba's emerging cocina is a project in progress. Maneuvering the Kafkaesque whims of the supply situation, the menus are in a continual flux.

In *Paladares* we tried our best to interpret this ever-shifting and often deliciously contradictory foodscape, adapting to American kitchens and appetites the recipes that Cuban cooks graciously shared with us—while carefully balancing the new and the old. Those looking for traditional Cuban workhorses like earthy bean stews, luscious fried plantains, saucy picadillo, and ropa vieja won't be disappointed. Crunchy malanga fritters, empanadas and pastelitos, soulful tamales, and chicken steeped in citrusy mojo are here, too, plus creamy flans and natillas and a Gulf Stream of cocktails. The ingredients called for in our traditional recipes (butter or cream cheese, for instance) are often easier to find on American shores than they are in Cuba. Most of them—staples like long-grain rice, dried beans, cornmeal, tomato paste or puree, dusky chorizo or bacon, and classic seasonings such as cumin and oregano—are probably already part of your pantry. Other essentials, such as tropical tubers like yuca, malanga, and plantains, and fruit such as mango and mamey, can be easily spotted at the Hispanic markets now found in most American cities and "ethnic" sections of many mainstream supermarkets. Whenever something is harder to find (for example the mild aromatic Cuban cachucha peppers), we offer substitutions without sacrificing the flavor.

But the recipes in *Paladares* also reflect the current aspiration of Cuban cooks and diners to *finally* catch up with the world after decades of isolation and scarcity. Sometimes "modernity" can just mean putting a ring mold around a traditional bean dish, or overworking the squeeze bottle, or dipping a pastry brush into pesto. Some chefs, on the other hand, are eager to reinterpret the ceviches and tacos they've tasted on their recent trip to Cancún, tackle recipes from a modern Spanish chef's cookbook copied onto a USB drive, or adapt fusion dishes found in a frayed American food magazine passed around like contraband goods. Parmesan and blue cheese, one must remember, are still a big deal in Cuba—balsamic vinegar an even bigger deal, arugula a very new thing, and the presence of super-scarce beef, potatoes, and strawberries is always reason to celebrate. It's worth understanding that the consequences of Fidel's 1959 Revolution fractured and shattered Cuba's traditional floodways. While Cuban exiles channeled their nostalgia for a lost patria into rich family recipes they cooked in Madrid or Miami, Cubans who remained on the island often fought for survival, especially during the privations and traumas of the 1990s, the Período Especial that turned a "cuisine" into a mere substance diet.

But now Cuba's cocina is off to a delicious fresh start. A culinary culture is being reborn, and in *Paladares* we joyously savor this revolution.

Fried Plantain Chips
Mariquitas 29

Plantain Fritters
Tostones 30

Curried Chicken Empanadas
Empanadas de Pollo al Curry 32

Ham and Cheese Empanadas
Empanadas de Jamón y Queso 35

Pork Empanadas with Chimichurri
Empanadas de Cerdo con Chimichurri 38

Malanga Fritters
Frituras de Malanga 40

Sweet Corn Fritters
Frituras de Maíz Tierno 43

Fried Stuffed Potatoes
Papas Rellenas 44

Pilar's Blue Cheese Croquettes
Croquetas de Cabrales Casa Pilar 46

Curried Fish Croquettes
Croquetas de Pescado al Curry 48

Tomato Toast with Jamón
Pan con Tomate con Jamón 53

Flatbread with Tomatoes, Jamón, and Olives
Focaccia con Tomate, Jamón, y Aceitunas 56

Chicken Tapas with Jamón and Cheese
Tapas de Pollo con Jamón y Queso 59

Picadillo-Stuffed Peppers
Pimientos Rellenos con Picadillo 60

Midnight Sandwich
Medianoche 63

BOCADITOS Y APERITIVOS

———

Snacks and Appetizers

It's early evening in Havana, and like the rest of the country, the city is snacking. On the battered pavement along the famed Malecón boulevard by the sea, couples idle with cans of Bucanero beer and slender white paper cones of maní [roasted peanuts] and plantain mariquitas [chips], while Cubaton blasts from passing Soviet-era Ladas and waves hurl spray over the seawall. Inland a few blocks, in Habana Centro where dilapidated colonial houses are fronted by delicate columns, old ladies gossip and laugh and munch chicharrones and batons of fried yuca. Elsewhere lines have formed at takeout windows for chorizo sandwiches and styrofoam boxes full of boniato fries and croquetas. And at hundreds of restaurants and bars all over Cuba, plates of golden crispy tostones, malanga frituras, and smoky garbanzos fly out of kitchens to accompany icy mojitos.

Despite chronic food shortages, despite hardships of everyday life that mean queuing for hours for basic essentials, the islanders remain a breed of gleeful grazers—especially now that economic reforms have returned small private concession stands, carts and windows, and the baskets of itinerant vendors to Cuban streets.

At 5 A.M. in Havana, some enterprising cuentapropistas [self-employed comrades] fire up their home ovens to bake guava or coconut-filled pastelitos to sell to morning commuters. Come lunchtime, government workers who make thirty dollars a month leave their offices to scarf down small doughy circles of pizza Cubana, or a "pan con" [bread with]—be it jamón; wedges of plantain omelet; fried breaded fish called minuta; or lechon, the juicy roast pork—all tucked into squishy white rolls or buns. After school, gaggles of kids in white and maroon uniforms crowd around hawkers of chiviricos, sugarcoated (and disastrously unhealthy) bits of fried dough. Nearby a tamalera hunches over her steaming pot filled with husk-swaddled corn mush. She won't be around long—tamales always sell out in a flash. Much later, post-midnight, there might be after-hours pork burgers with a strange but much-loved topping of cream cheese and strawberry jam. And above all, in Havana and elsewhere, the island relishes its never-ending parade of different fritters.

"Frying, Dios mío—my God!—it's our national cooking method!" exclaims Acela Matamoros, a scholar and cookbook author. "Es una adicción Cubana!" The origins of this addiction? Perhaps they lay in the countryside, where rural families would annually slaughter their pig and render masses of lard, which they'd bury underground in clay tubs for the year. Once a tub was unearthed it had to be used. It didn't hurt that Cuba's super-starchy root vegetables deliver such excellent crunch. Or that the art of frying was perfected in the early colonial days by Cuba's Andalusian settlers, who had inherited the taste for fried food from the Moors.

Before the 1959 Revolution, crispy pick-me-ups sustained Havana's legendary club scene and nightlife. "The 1950s were the golden era of fritters," sighs cultural historian Rafael Lam, as he lists the line-up of hits: "Battered bacalao, pork chicharrones, and croquetas of béchamel! Frituritas of black-eyed peas, malanga, and boniato! Fried, stuffed mashed-potato balls and tiny fried burgers called fritas!" Outside clubs and on crowded street corners, fry shops and puestos [stands], many Chinese-owned, competed for revelers' stomachs. "But then Havana's nightlife paradise—and its snacking marvels—fell victim to the new regime," Rafael explains. The Revolution brought shortages of crucial ingredients, followed by Fidel's 1968 ban on all private business activity, down to fry carts and fruit vendors. But Cubans kept on snacking somehow! Lacking beef, the ubiquitous hamburguesas and fritas were reinvented with pork and ironically christened McCastros. The repurposing of

leftover food into croquetas and fritters became something of an economic imperative. And in the decades of Soviet patronage, pizza entered the scene—to remain Cuba's national street snack—thanks to an overabundance of cheap Russian wheat paired with Fidel's sudden embrace of Italian food.

Fast-forward to today. Cuba's saladitos and aperitivos (the local term for snacks) are entering a second golden age. At Havana's new-wave, internationally savvy paladares, appetizers are often the most exciting part of the menu—and the cocktail scene rocks. Modern Spanish tapas flourish at restaurants run by Iberian expats; Italian paladar owners bake up authentic pizzas and flatbreads. Undeterred by intermittent supplies, hip young Cuban chefs are reinventing and updating the island's rich frituras repertoire. In this chapter you'll find recipes for modern remakes of stuffed potato balls from Ivan Chef Justo and fish croquetas from the hot-spot paladar O'Reilly 304; flaky empanadas from Havana's best bars and bakeries; and enticing variations on plantains zapped with garlicky mojos. Pass these around at a party or serve as a sit-down first course—and make sure your mojitos are potent.

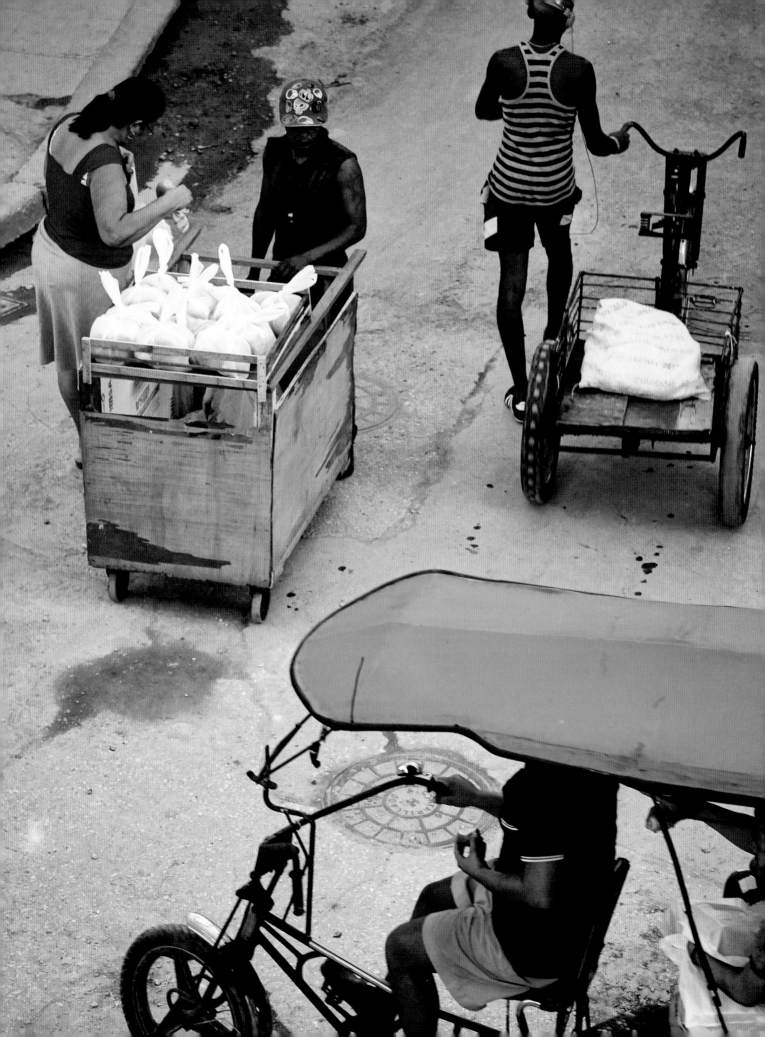

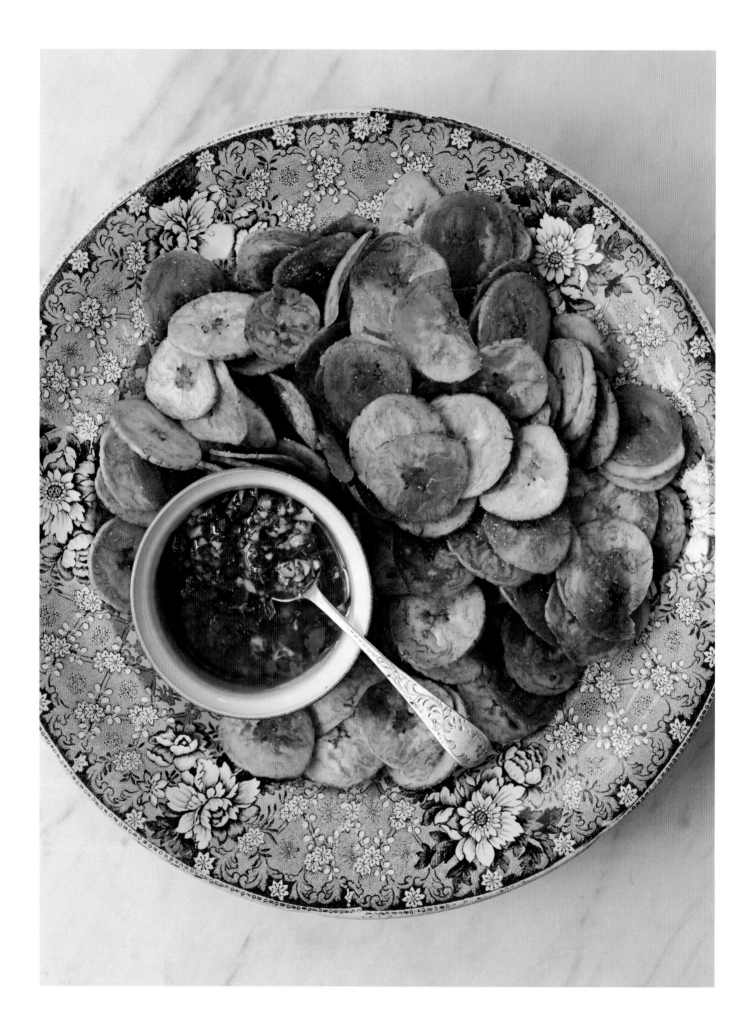

FRIED PLANTAIN CHIPS

Mariquitas

Cuba's answer to potato chips, mariquitas (also called chicharritas) are the golden-crisp, faintly fruity plantain crisps that usually vanish the minute they hit the table or bar counter. At the hot-spot paladares O'Reilly 304 and El Del Frente, these are served free instead of bread, spiked with a tangy garlic, parsley, and lime mojo. Who even needs dinner?

Using a mandoline or a similar gizmo, the mariquitas should be sliced very thin into rounds on the diagonal, or lengthwise if you like your chips long and wavy. The trick is to fry the plantains as soon as you slice them—they toughen when exposed to air. Another trick is to peel the plantains under cold running water. Some Cuban chefs also suggest soaking the plantains in very cold salted water before slicing and frying, to render the chips extra-crisp.

Serves 4

FOR THE MOJO

4 cloves garlic, chopped with ½ teaspoon salt

2 tablespoons chopped fresh parsley

¼ cup (60 ml) olive oil

1 tablespoon fresh lime juice

FOR THE MARIQUITAS

2 cups (480 ml) vegetable oil or peanut oil, for frying

2 green plantains, peeled and thinly sliced on a mandoline or with a very sharp knife

Salt

1 **Make the mojo:** Mix together the salted garlic, parsley, olive oil, and lime juice. Set aside.

2 **Make the mariquitas:** In a large, high-sided 10- to 12-inch (25- to 30.5-cm) skillet, heat the vegetable oil over medium-high heat until a drop of water sputters and sizzles when added to the pan. Working in batches if necessary to avoid crowding the pan, add the plantain chips one by one so they don't stick together, and cook, turning them as they brown, about 2 minutes per side.

3 Remove with a slotted spoon to paper towels to drain, and sprinkle with salt while hot. Repeat with the remaining plantains until all have been fried and salted.

4 Drizzle the mojo over the chips and serve the rest on the side for dipping.

PLANTAIN FRITTERS

Tostones

We're not done with awesome plantain snacks yet! Here are tostones—alias: patacones—which is to say, plantain fritters that are slowly fried once to cook until soft, then smashed to flatten and quickly fried again over higher heat to crisp up. Heftier than mariquitas, tostones are traditionally served on their own or with a mojo of sour orange and cumin. Dunked in the mojo, this version makes a terrific appetizer with cocktails. Or top them with a bit of leftover picadillo, ropa vieja, or guacamole—Cuban nachos, of a sort. Or float them in soup, as Cubans love to do, as a kind of crouton that readily absorbs other flavors. If you live near a Hispanic market and love tostones as much as we do, look for a nifty plantain-smashing tool called a tostonera. Otherwise use a jar as directed here, or place the chip between two pieces of plantain peel and give it a whack with your fist.

Makes 12 tostones

FOR THE MOJO CRIOLLO

⅓ cup (75 ml) olive oil

5 cloves garlic, chopped

½ cup (120 ml) sour orange juice, or an equal mixture of lime and orange juice

¼ teaspoon ground cumin

FOR THE TOSTONES

3 cups (720 ml) vegetable oil, for frying

3 green plantains, peeled and cut into 2-inch (5-cm) pieces

Salt

1 **Make the mojo:** In a bowl, whisk together the olive oil, garlic, sour orange juice, and cumin. Set aside.

2 **Make the tostones:** In a large, high-sided skillet, heat the vegetable oil until a drop of water sputters and sizzles when added to the pan. Working in batches to avoid crowding the pan, add the plantains to the hot oil and fry, turning once, until golden brown, 2 to 3 minutes per side.

3 Remove with a slotted spoon to paper towels to drain. Keep the oil hot.

4 Using a flat-bottomed glass jar covered with a piece of brown paper bag, press the plantain slices until flattened. Return the plaintains to the oil, a few slices at a time, and refry until very golden and crispy on both sides, about 2 to 3 minutes more. Drain on paper towels and sprinkle with salt while still hot.

5 Serve the tostones immediately with the mojo on the side for dipping.

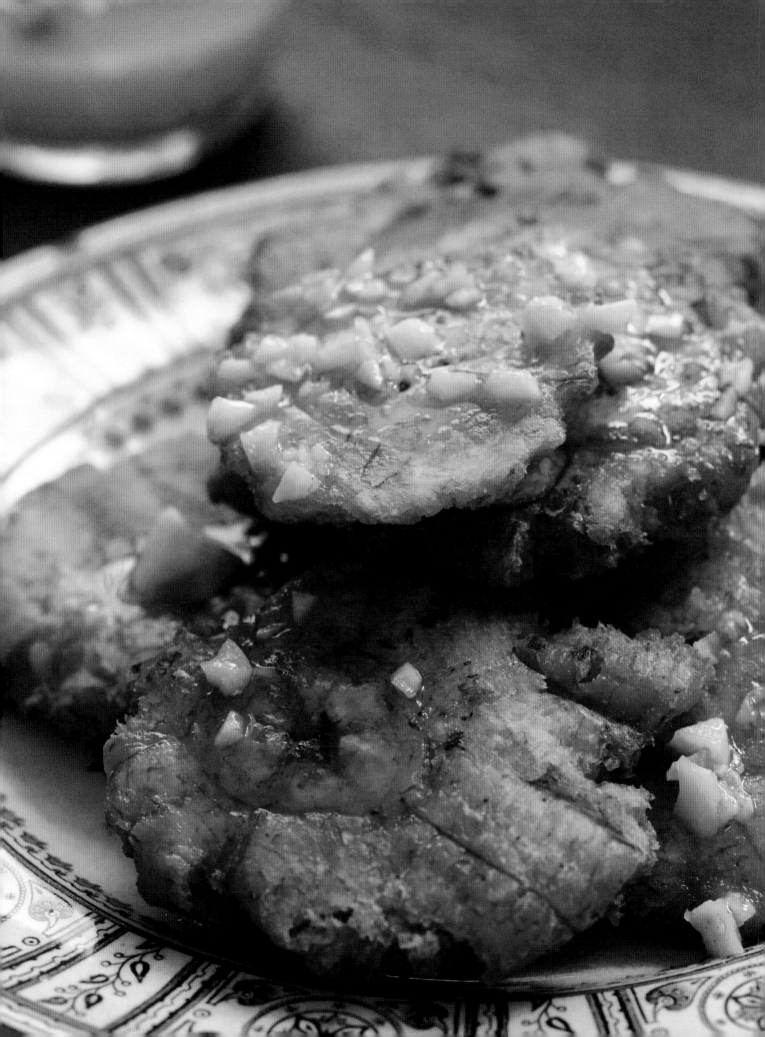

Curried Chicken Empanadas

Empanadas de Pollo al Curry

In their original Iberian version, empanadas (Spanish for "breaded") were mostly large savory pies cut into wedges or squares. As empanadas traveled around the New World with the Spanish colonists, they became daintier, acquiring their signature half-moon shape and a plethora of delectable filling options. In Cuba you might taste empanadas with the classic oozy fillings of ham and cheese, this memorable stuffing of curried chicken, leftover ropa vieja, or picadillo—and sweet versions with pineapple or coconut. Nothing in Havana beats the empanadas baked at PP Boutique de Pan, owned by the charming Evelyn Perez Alonso, who seems heroically undeterred even by chronic butter shortages. In an old house in the leafy Vedado neighborhood, she served us these golden curried chicken empanadas with pride and told us how much her customers love them.

We've adapted her dough recipe for the home cook, using cream cheese instead of vegetable shortening, which is easier to handle and puffs beautifully when baked.

Makes 12 empanadas

FOR THE DOUGH

1½ cups (190 g) all-purpose flour, plus more for rolling

½ teaspoon salt

1 tablespoon sugar

1 teaspoon baking powder

1 (8-ounce / 225-g) package cream cheese, chilled

4 tablespoons (55 g) unsalted butter, chilled

2 tablespoons dry white wine

6–8 tablespoons (90–120 ml) ice water

1 egg yolk, for egg wash

FOR THE FILLING

2 tablespoons olive oil

1 cup (125 g) finely chopped onion

2 cups (390 g) shredded cooked chicken breast

4 teaspoons curry powder

Salt and pepper

1 **Make the dough:** In a mixing bowl or the bowl of a food processor, combine the flour, salt, sugar, and baking powder. Cut the cream cheese and butter into cubes and add to the flour mixture. With your fingers, a pastry cutter, a fork, or using the food processor, work the cream cheese and butter into the dry ingredients until only ¼-inch (6-mm) pieces of the butter and cream cheese remain. Pour in the wine and gradually add the ice water, mixing the liquid into the dough until it just comes together. (You may not use all the ice water.) Wrap the dough tightly with plastic and let it rest in the refrigerator for at least 30 minutes.

2 **Make the filling:** In a skillet over medium heat, combine the olive oil and onion and cook for 3 to 4 minutes, or until the onion is soft but not brown. Add the shredded chicken, curry powder, and salt and pepper, to taste, and heat until warmed through. Stir to combine, and adjust seasoning if necessary, then scrape the filling into a bowl and let cool before assembling the empanadas.

3 Preheat the oven to 400°F (205°C).

4 Roll out the dough on a lightly floured surface until ⅛-inch (3-mm) thick. Using a cookie cutter or a glass, cut out twelve 2½-inch (6-cm) rounds and top each with a packed ¼ cup (35 g) of the filling. In a small bowl, mix the egg yolk with 2 tablespoons water. Lightly brush the circumference of each round of dough with some of the egg wash. Fold the dough over to make half-moons and seal with the tines of a fork. Arrange the empanadas on a baking sheet and brush them with the remaining egg wash. Bake for 20 to 25 minutes, until golden brown.

Ham and Cheese Empanadas
Empanadas de Jamón y Queso

For this ham-and-cheese filling inspired by Evelyn Perez Alonso, we've opted for a mixture of smoky ham, mild white cheese, and a dash of crumbled oregano, an herb that flavors so many dishes in Cuba. The result is a delicious take on a classic.

Makes 12 empanadas

FOR THE DOUGH

See recipe on page 32

FOR THE FILLING

1 cup (125 g) diced smoked ham or Canadian bacon

2 cups (230 g) shredded mild white cheese, such as cheddar, Monterey Jack, or mozzarella

1 teaspoon dried oregano

Salt and pepper

1 **Make the dough:** Follow the instructions on page 32, allowing the dough to rest in the refrigerator for at least 30 minutes.

2 Preheat the oven to 400°F (205°C).

3 **Make the filling:** In a mixing bowl, toss together the ham, cheese, oregano, salt and pepper, to taste.

4 Roll out the dough on a lightly floured surface until ⅛-inch (3-mm) thick. Using a cookie cutter or a glass, cut out twelve 2½-inch (6-cm) rounds and top each with a packed ¼ cup (85 g) of the filling. In a small bowl, mix together the egg yolk from the dough recipe (page 35) with 2 tablespoons water. Lightly brush the circumference of each round of dough with some of the egg wash. Fold the dough over to make half-moons and seal with the tines of a fork. Arrange the empanadas on a baking sheet and brush them with the remaining egg wash. Bake for 20 to 25 minutes, until golden brown.

IVAN CHEF JUSTO

AN INSTANT CLASSIC

Ivan Chef Justo and Al Carbon, its new grill-centric sibling, occupy a stately little eighteenth-century colonial building across from the grandeur of the Museum of Revolution. Opened fairly recently, both restaurants have the soulful well-worn feel of classics: always packed, incredibly fun, fueled by stiff drinks. The bluesy baritone of Benny Moré, Cuba's beloved musical son, wafts from the sound system. There are potted tropical plants, old vinyl records serving as place mats, walls festooned with film-festival posters, sepia images of Old Havana, and color photos of visiting dignitaries. The decor reflects the worldly taste of Ivan Rodríguez and Justo Perez, the poised, well-traveled chef-owners who met years ago when they both cooked for the government. "Between us we fed every visiting dignitary," says the fiftyish Ivan with a calm grin. The Creole-Mediterranean fare coming out of his kitchen is both classic and fresh, Cuban and cosmopolitan, powered by stellar ingredients from the chefs' favorite farmers and fishermen. Here one tastes refreshing ceviches, tacos rolled around shreds of fall-apart pork, and folksy arroz con pollo dramatically served in a hollowed-out bamboo log. Ivan's lechoncito, crispy-skinned suckling pig, might well be the most sought-after dish in Havana. We forgive Ivan for not showing up for our first interview: "I had to run like mad to the port to greet a shipment of food supplies from Cancún," he apologized. "In Cuba, man proposes, and the Gods of Customs dispose. But at least now I have fresh rosemary and Spanish paprika."

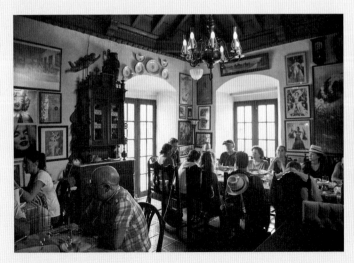

Ivan's Story

Everyone asks me, What was it like to cook for Fidel?

Not so nerve-racking, actually. Fidel had a reassuringly simple manner: friendly and chatty. All the cooks in Havana know that he appreciated good honest food. Pasta, fried rice, good Cuban fish like pez perro [hogfish] and cherna [grouper]. And Fidel knew his wines. I got to cook for him several times, usually at Casas de Protocolo, guesthouses where the ministry of foreign affairs hosted visiting dignitaries. For state occasions, we tried to put on authentic Cuban spreads—lots of tropical juices, sustainable root vegetables, roasted meats—especially featuring our Cuban pride, the lechon asado, a whole roasted pig. We Cuban chefs whine a lot about the ingredient situation, but I'll tell you: Our white, juicy pork makes up for a lot. Cuban pigs roam everywhere. They eat palmiche [the seed-like fruit of the palm tree] and the same viandas [tubers] that the guajiros [peasants] eat. For a hog it's a good, healthy life!

I come from Galician-Asturian stock—northern Spanish. My mom cooked during the week; like many Cuban guys, my dad was a great weekend cook. I decided to become a chef right after doing my military service. I cooked for the government, then worked at some Cuban restaurants abroad in places like Portugal. The Período Especial (see page 68) was the low point for any cook here: almost a decade of rice, beans, boniatos, and a tiny bread roll a day. That's when Cuban national cuisine completely deteriorated. Until the 1959 Revolution, our cooking was robust and filling, with big meals based on Spanish-style guisos [stews] and much meat. But that cuisine is now gone; there's no reviving it. Perdído are common ingredients like tasajo [dried beef] and bacalao [salt cod] that were once abundant and cheap enough to feed Cuba's African slaves. We were a nation of fish-lovers, too, but we've lost the wealth of our old seafood recipes. On the other hand, pre-Revolutionary cuisine didn't have the "special measures" ingredients like rabbits and ducks that we started breeding during the Período Especial. Now they're part of all menus. Ropa vieja, picadillo . . . these are the few Cuban national dishes that transcended our difficult history and survived. As chefs we have a responsibility to cook these with special attention.

For as long as we cooked professionally, my partner Justo and I wanted a place of our own. In 2012 we opened Ivan Chef Justo. We were totally unprepared to be such a hit—to host the likes of Naomi Campbell, Geraldine Chaplin, and all these famous American diplomats. We decorated the place with posters and mementos from here and from our travels. Why old records as place mats? Because vintage vinyl is a million times easier to find in Havana than doilies! We went out of our way to hunt up agros [organic markets] and farmers to supply our kitchen with stuff like the fantastic wild mushrooms nobody else has in Havana. We tweaked and perfected old Cuban recipes such as arroz con pollo a la chorrera, which must be authentically soupy. Mexico inspires our tacos; the Mediterranean gave us our respect for ingredient-driven simplicity. Yes, we struggle to find those ingredients, but you know what keeps saving us? Our pizarra. The chalkboard! We just wipe off anything that's suddenly vanished and replace it with whatever the farmer delivers. To accommodate demand we just opened Al Carbon, where the grill is king. And so we keep on: working like crazy, helping Cuban cuisine evolve into something new and exciting. But without losing our roots.

Pork Empanadas with Chimichurri

Empanadas de Cerdo con Chimichurri

At his paladar Al Carbon, chef Ivan Rodríguez often fills these empanadas with juicy leftover roast pork and serves them with a zesty sauce he calls chimichurri that, unlike the classic Argentinean version, is whisked from oil, vinegar, garlic, and minced cachucha peppers. We've adapted the recipe slightly with sabroso [tasty] results.

Note: *The colorful cap-shaped cachucha pepper (sometimes called aji dulce) is a mild, fragrant chile used with abandon in Cuba. Look for them at your favorite Latin market, but* do not *confuse them with the almost identical-looking and diabolically hot habaneros.*

Makes 12 empanadas

FOR THE DOUGH

See recipe on page 32

FOR THE FILLING

1 tablespoon olive oil

½ cup (55 g) thinly sliced onion

½ cup (45 g) thinly sliced green bell pepper

3 cups (585 g) shredded cooked pork (Crispy Pork Shoulder, page 272)

¼ cup (60 ml) dry white wine

1 teaspoon tomato paste

FOR THE CHIMICHURRI

2 tablespoons minced onion

1 clove garlic, minced or pressed

3 cachucha peppers (see Note) or 1 jalapeño pepper, seeded and minced

2 tablespoons white wine vinegar

3 tablespoons olive oil

Salt and pepper

1 **Make the dough:** Follow the instructions on page 32, allowing the dough to rest for at least 30 minutes in the refrigerator.

2 **Make the filling:** In a large skillet over medium heat, combine the olive oil, onion, and bell pepper and cook for 3 to 4 minutes, stirring frequently, until the vegetables are starting to soften. Stir in the pork, white wine, and tomato paste and cook for another 5 minutes to cook off the alcohol and combine the flavors. Scrape into a bowl and cool for at least 30 minutes before assembling the empanadas.

3 Preheat the oven to 400°F (205°C).

4 Roll out the dough on a lightly floured surface until ⅛-inch (3-mm) thick. Using a cookie cutter or a glass, cut out twelve 2½-inch (6-cm) rounds and top each with a packed ¼ cup (85 g) of the filling. In a small bowl, mix together the egg yolk from the dough recipe (page 32) with 2 tablespoons water. Lightly brush the circumference of each round of dough with some of the egg

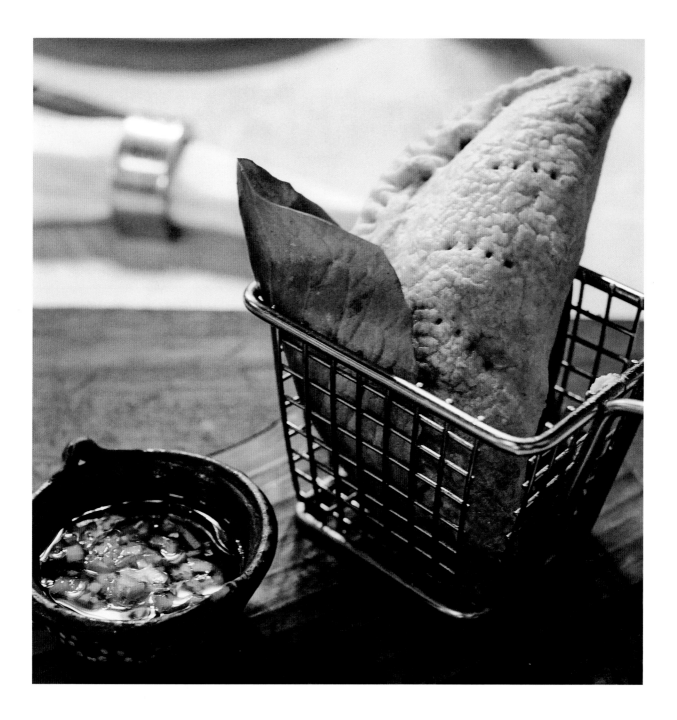

wash. Fold the dough over to make half-moons and seal with the tines of a fork. Arrange the empanadas on a baking sheet and brush them with the remaining egg wash. Bake for 20 to 25 minutes, until golden brown.

5 **Meanwhile, make the chimichurri:** In a bowl, mix together the onion, garlic, cachucha peppers, vinegar, and olive oil. Season with salt and pepper to taste. Spoon the sauce over the hot empanadas to serve.

MALANGA FRITTERS

Frituras de Malanga

A crucial starchy staple of cocina cubana, malanga is a fairly bland root that needs to be artfully cooked to make it delicious. As all Cubans know, malanga fries up to a truly spectacular crunch when it meets sizzling oil. Case in point: These terrific malanga fritters are served as a snack at every Cuban paladar, bar, and state restaurant. A bit salty, often flavored with garlic and onion, and usually served with honey for dipping, these bites fuel the Cuban love of combining salt, sweetness, and zest all in one bite. Sometimes these fritters are prepared with boiled and grated malanga, but we prefer this crisp version made with grated fresh root. Some cooks like them flat and round and crispy all over, a kind of Caribbean latke; others give them a cylindrical look (and a softer center) by shaping them with two spoons into small oblong shapes.

Note: *A tropical rhizome most likely of African origins, the potassium- and fiber-rich malanga is related to taro and often confused with it, but isn't exactly identical. Malanga is considered so essential in Cuba, its puree is given to babies and the infirm. In the United States you're more likely to encounter malanga under its Puerto Rican name, yautia. The elongated, sometimes hairy root looks like a shaggy-skinned extra-long very brown sweet potato and has flesh that ranges in color from white to creamy to pinkish. Look for roots that are healthy-looking and firm.*

Makes 18 fritters

2 cups (260 g) finely grated malanga or taro root

2 tablespoons grated onion or 1 clove garlic, crushed

1 teaspoon chopped fresh parsley or chives

Salt and pepper

1 large egg

3 cups (720 ml) vegetable oil, for frying

½ cup (120 ml) honey, slightly warmed, for serving, or ½ cup (120 ml) mojo (page 29)

1 In a mixing bowl, mix the malanga, onion, parsley, salt and pepper, to taste, and egg until well combined. Set aside while the oil heats.

2 In a high-sided skillet, heat the vegetable oil over medium-high heat until it reaches 375°F (190°C) on a deep-fry thermometer. Working in batches to avoid crowding the pan, add tablespoons of the batter to the hot oil and cook, turning once, until golden brown, about 2 to 3 minutes per side. Drain on paper towels before serving with the honey or mojo.

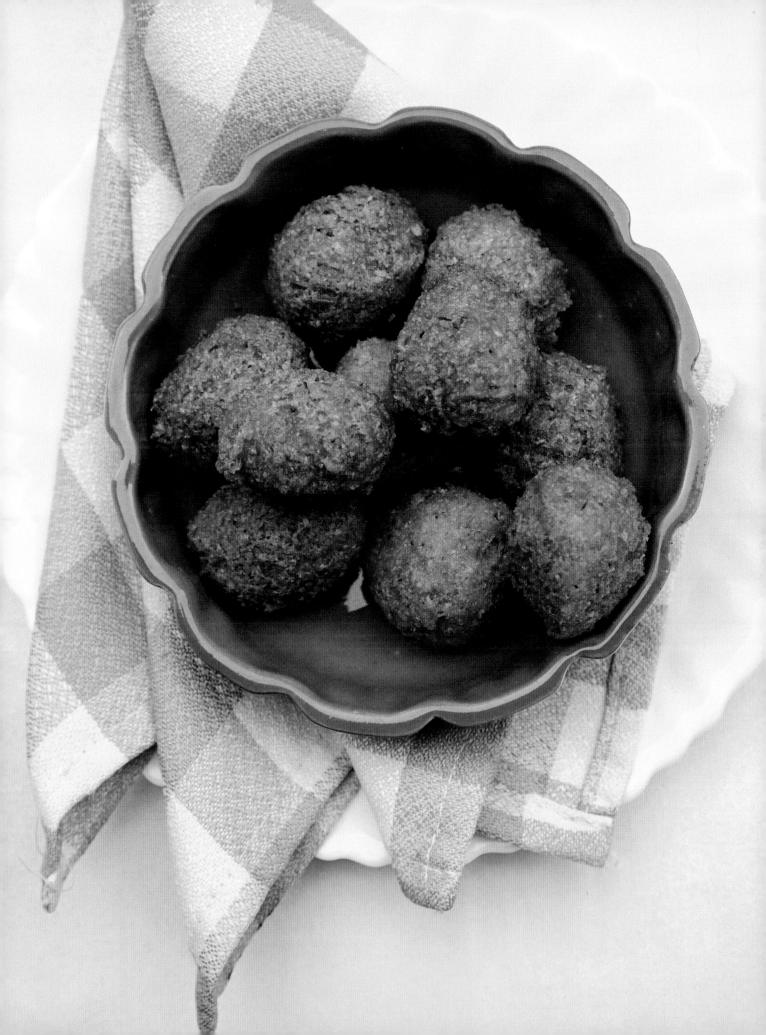

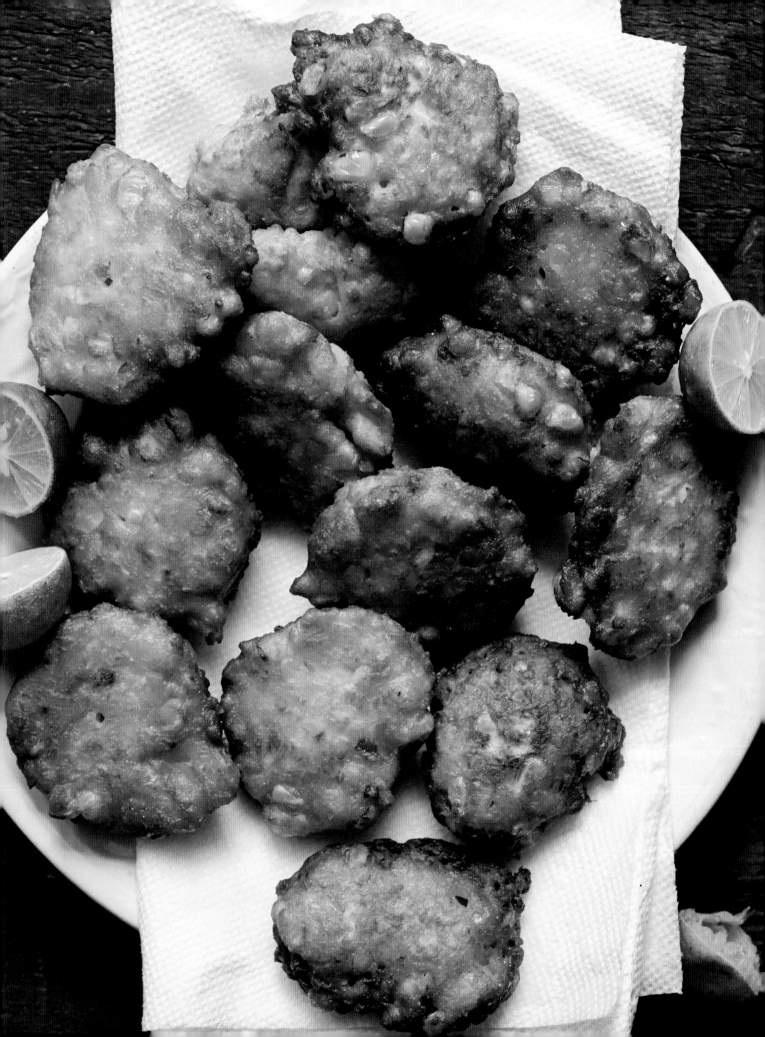

SWEET CORN FRITTERS

Frituras de Maíz Tierno

The corn in Cuba tends to be starchier and less sweet than the American variety, so one often finds sugar added to this lovely traditional recipe—a kind of Cuban hush puppy. In our version half of the corn is cut from the cob and pureed with eggs; the rest of the kernels are added in whole, for texture. Serve these plump, faintly sweet fritters on their own with a frosty glass of beer, or with saucy dishes such as Chicken Fricassee (page 217) or Ropa Vieja (page 244).

Makes 18 fritters

2 cups (290 g) fresh corn kernels, cut from the cob

¼ cup (30 g) chopped onion

2 cachucha peppers or 1 jalapeño pepper, seeded and chopped

1 large egg

1 tablespoon sugar

Black pepper

1 cup (125 g) all-purpose flour

1 teaspoon baking powder

½ teaspoon salt

3 cups (720 ml) vegetable oil, for frying

Lime halves, for garnish

1 Reserve ½ cup (75 g) of the corn kernels. In a blender or food processor, combine the remaining 1½ cups (215 g) corn, the onion, cachucha peppers, egg, sugar, and black pepper to taste. Pulse 5 to 6 times until coarsely blended. Scrape into a mixing bowl, stir in the reserved corn kernels, and set aside.

2 In another bowl, sift together the flour, baking powder, and salt. Mix the flour mixture into the corn mixture and set the batter aside until the oil is hot.

3 In a high-sided skillet, heat the vegetable oil over medium-high heat until it reaches 375°F (190°C) on a deep-fry thermometer. Working in batches to avoid crowding the pan, add tablespoons of the corn batter to the hot oil and cook, turning once, until golden brown, about 2 minutes per side. Drain on paper towels.

4 Serve the fritters hot with halves of lime.

Fried Stuffed Potatoes

Papas Rellenas

While these days potatoes have become a scarce, seasonal commodity in Cuba, papas rellenas were once a beloved dish, traditionally filled with beef picadillo—a tasty way to use leftovers. At the creative paladar Ivan Chef Justo, the talented chef Ivan Rodríguez elevates the humble papas rellenas to something special by serving the spuds as a trio: one filled with meat, another with cheese, and the third one with crab. He sends out the plate garnished with beet-puree pesto and sour cream. We've re-created his incredible papas here with a combination of picadillo, sour cream, and pesto.

Makes 12 balls

8 medium russet potatoes, peeled and quartered

½ cup (50 g) grated Parmesan cheese

1 ounce (30 g) cheddar cheese, cut into 6 cubes

¼ cup (60 ml) leftover Picadillo a la Habanera (page 248)

2 large eggs, beaten

2 cups (200 g) fine dry bread crumbs

4 cups (960 ml) vegetable oil, for frying

½ cup (120 ml) sour cream

½ cup (120 ml) prepared pesto

Lettuce leaf (optional)

1 In a pot filled with water over medium-high heat, add the potatoes, bring to a boil, and cook for 10 to 15 minutes, or until a fork pierces a potato easily. Drain the potatoes and place them in a bowl and allow to cool slightly. Mash with a potato masher or electric mixer at low speed, adding the Parmesan cheese in batches until fully combined. Allow to cool to room temperature.

2 Using about ⅓ cup (113 g) of the mashed potato, form a 2½-inch (6-cm) ball, place a piece of cheddar or 2 teaspoons picadillo in the center, and completely enclose the filling with the mashed potato. Repeat, alternating the fillings, to form twelve balls total.

3 Place the eggs and bread crumbs in separate shallow bowls. Coat the balls in the beaten eggs and then with the bread crumbs. Set aside on a plate while heating the oil for frying.

4 In a high-sided skillet, heat the vegetable oil over medium-high heat until it reaches 375°F (190°C) on a deep-fry thermometer. Working in batches to avoid crowding the pan, fry the papas in the hot oil until golden, flipping once to ensure they brown evenly, 2 to 3 minutes per side. Drain on paper towels.

5 Serve hot with sour cream and pesto on the side, and a lettuce leaf (optional).

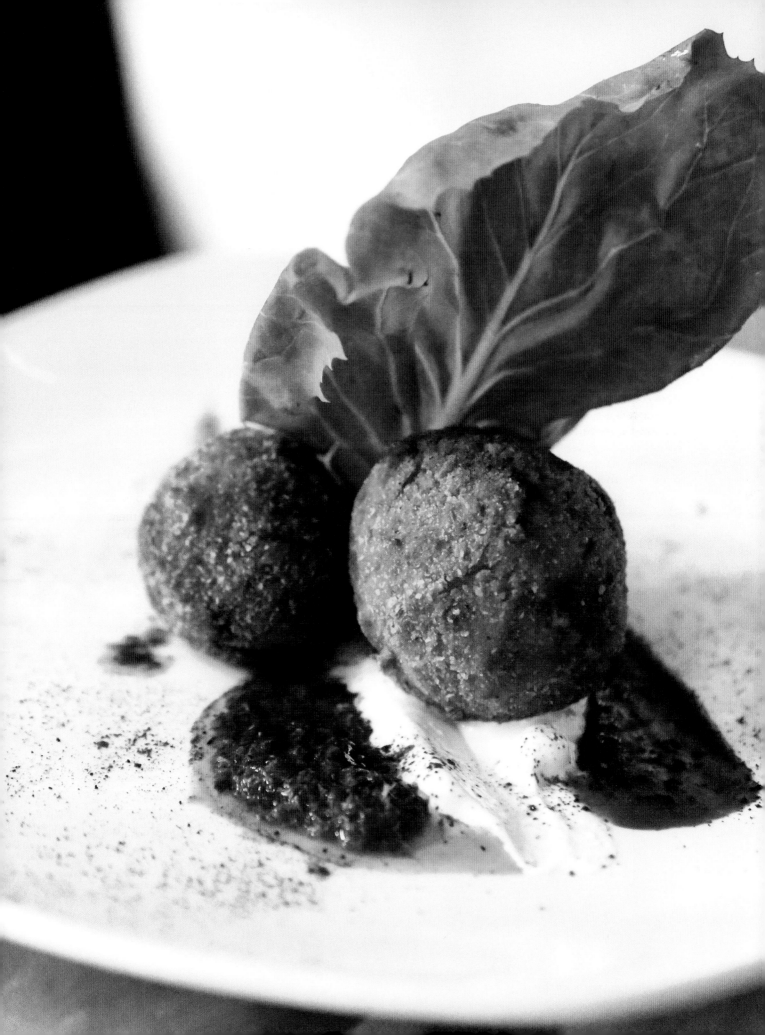

Pilar's Blue Cheese Croquettes

Croquetas de Cabrales Casa Pilar

Some of our favorite croquetas in Havana are fried at the paladar Casa Pilar, run by the vivacious Spanish expat Pilar Fernández, who still uses her grandmother's recipe. You need very strong arms, Pilar claims, to make the béchamel for croquetas properly smooth. And she brings the Cabrales blue cheese made in her native region, Asturias, from her trips to Spain to make her croquetas truly authentic and special.

Makes 18 croquettes

2 tablespoons olive or peanut oil

¼ cup (35 g) finely chopped onion

6 tablespoons (85 g) unsalted butter

12 tablespoons (¾ cup) flour, plus more for rolling

2 cups (480 ml) whole milk

¾ cup (100 g) Cabrales or other blue cheese, crumbled

¼ teaspoon ground nutmeg

Salt and pepper

3 large eggs

2 cups (200 g) fine dry bread crumbs

2–3 cups (480–720 ml) peanut or vegetable oil, for frying

1 Heat 2 tablespoons of the olive oil in a medium saucepan. Cook the onion over medium-low heat until soft, not letting it brown. Add the butter and cook until melted. Add the flour and cook, stirring, until a smooth paste forms, about 1 minute.

2 Increase the heat to medium-high and gradually add the milk, whisking constantly, until the mixture is thickened and completely smooth, 1 to 2 minutes. Add the blue cheese, nutmeg, and salt and pepper, to taste, and stir well.

3 Reduce the heat to low and stir the mixture with a wooden spoon until it begins to pull away from the sides of the skillet, about 1 minute. Scrape the mixture into an oiled shallow bowl and let cool to room temperature, then place a piece of plastic wrap directly on top of the croquette mixture and chill until firm, at least 2 hours. (The mixture can be prepared up to a day ahead.)

4 Place some flour in a shallow bowl; beat the eggs in a second shallow bowl. Place the bread crumbs in a third shallow bowl. Arrange the bowls in that order for easy breading. Lightly flour your hands, then scoop a tablespoon of the croquette mixture. Lightly roll it in the flour, shaking off the excess, then roll it

gently between your hands to form a ball. Dip the croquette in the beaten egg, then cover it in the bread crumbs.

5 Transfer the croquettes to a small baking sheet lined with waxed paper. Repeat with the remaining mixture. Croquettes rolled in bread crumbs will keep in the refrigerator, covered, for at least a day. They can also be frozen at this point and then thawed for about an hour before frying.

6 Set a small rack over a baking sheet and line it with a double thickness of paper towels. Pour peanut oil to a depth of 1 inch (2.5 cm) in an 8-inch (20-cm) skillet and heat it over medium-high heat to 350°F (175°C). (A croquette placed in the oil should sizzle on contact.) Fry the croquettes, six or seven at a time, until deep golden, turning once and adjusting the heat so the oil doesn't burn. Using a slotted spoon, transfer the fried croquettes to the rack to drain. Once all the croquettes have been fried, serve them immediately.

Curried Fish Croquettes

Croquetas de Pescado al Curry

These crispy croquettes loaded with curried fish and potatoes come from El Del Frente, chef José Carlos Imperatori's new hot-spot paladar, which sits directly across the street from his massively successful paladar O'Reilly 304. Welcome to the New Havana! With their killer cocktails, breezily creative food, and a clientele of Havana hipsters, neither spot would feel out of place in any cosmopolitan capital. A delicious twist on the classic, these croquettes are bound both with potato and an egg-enriched béchamel accented with smoky Spanish paprika. The curry seasoning adds a worldly touch, and the mashed lime-spiked avocado is the perfect cool counterpoint. Use any flaked, poached, meaty fish, such as haddock or cod.

Makes 18 croquettes

FOR THE CROQUETTES

1 medium potato, boiled and peeled

2 tablespoons olive oil

1 tablespoon curry powder

½ pound (225 g) poached whitefish, flaked, or 1½ cups (225 g) leftover cooked fish, flaked

1 clove garlic, minced

2 tablespoons grated yellow onion

½ teaspoon salt

1 teaspoon chopped fresh parsley

6 tablespoons (45 g) all-purpose flour

½ teaspoon smoked sweet paprika

3 large eggs

2 cups (200 g) fine dry bread crumbs

2–3 cups (480–720 ml) peanut or vegetable oil, for frying

FOR THE DIP

½ ripe Florida avocado

2 tablespoons fresh lime juice

1 teaspoon chopped fresh parsley

¼ teaspoon salt

Black pepper

Thinly sliced yellow onion, for garnish (not pictured)

1 **Make the croquettes:** In a mixing bowl, mash the potato with 1 tablespoon of the olive oil and the curry powder. Add the flaked fish, garlic, grated onion, salt, and parsley. Mix well and set aside.

2 In a small saucepan over medium heat, bring ¾ cup (180 ml) water and the remaining tablespoon of the olive oil to a boil. Stir in the flour and paprika. Cook for 30 seconds and remove from heat. Allow to cool slightly, then beat in 1 egg.

3 Add the cooled flour mixture to the fish-and-potato mixture and stir well to combine. Cover and chill for at least 1 hour or up to overnight.

Recipe continues on page 51

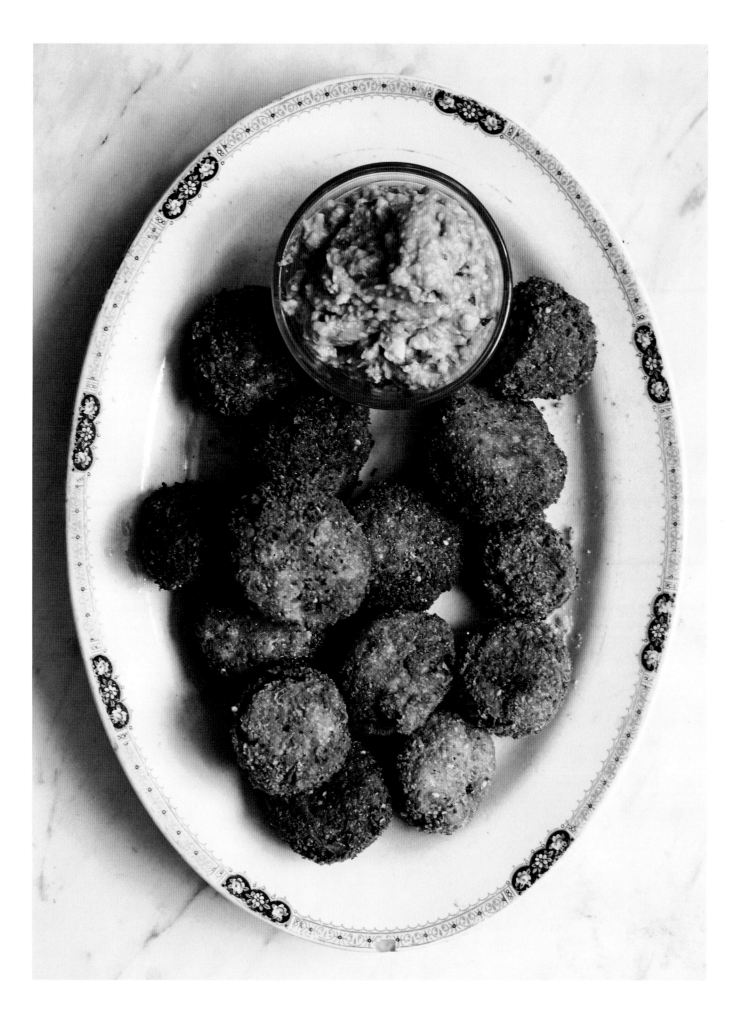

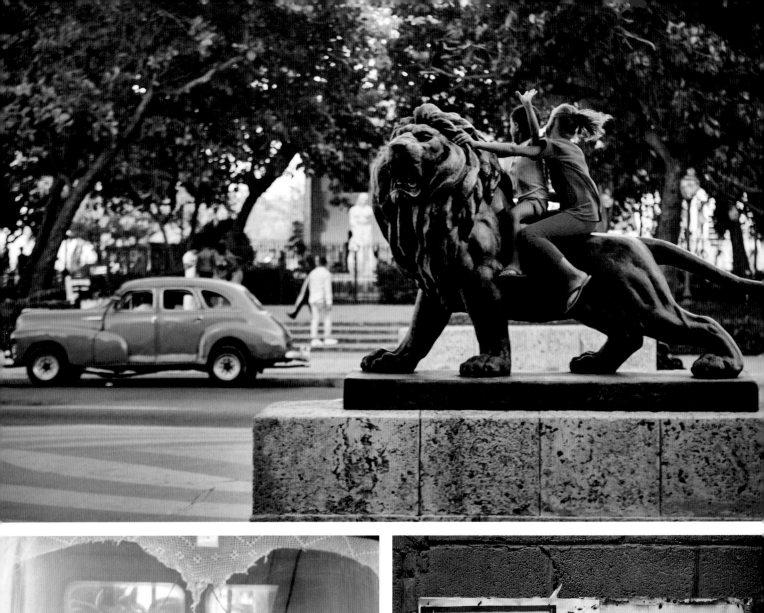

4 When you're ready to fry the croquettes, add the remaining 2 eggs to a shallow bowl and beat well. Place the bread crumbs in another shallow bowl. Scoop large tablespoons of the batter, dip in the beaten egg and then cover in bread crumbs to make eighteen 2-inch (5-cm) balls. Set aside on a plate while you heat the oil.

5 Set a small rack over a baking sheet and line it with a double thickness of paper towels. Pour peanut oil to a depth of 1 inch (2.5 cm) in an 8-inch (20-cm) skillet and heat it over medium-high heat to 350°F (175°C). (A croquette placed in the oil should sizzle on contact.) Fry the croquettes, six or seven at a time, until deep golden, turning once and adjusting the heat so the oil doesn't burn. Using a slotted spoon, transfer the fried croquettes to the rack to drain. Once all the croquettes have been fried, serve them immediately.

6 **Make the dip:** Scoop the avocado flesh into a bowl. Mash the avocado with the lime juice, parsley, salt, and pepper to taste. Top with thinly sliced onion. Eat the hot fritters with the cool avocado dip.

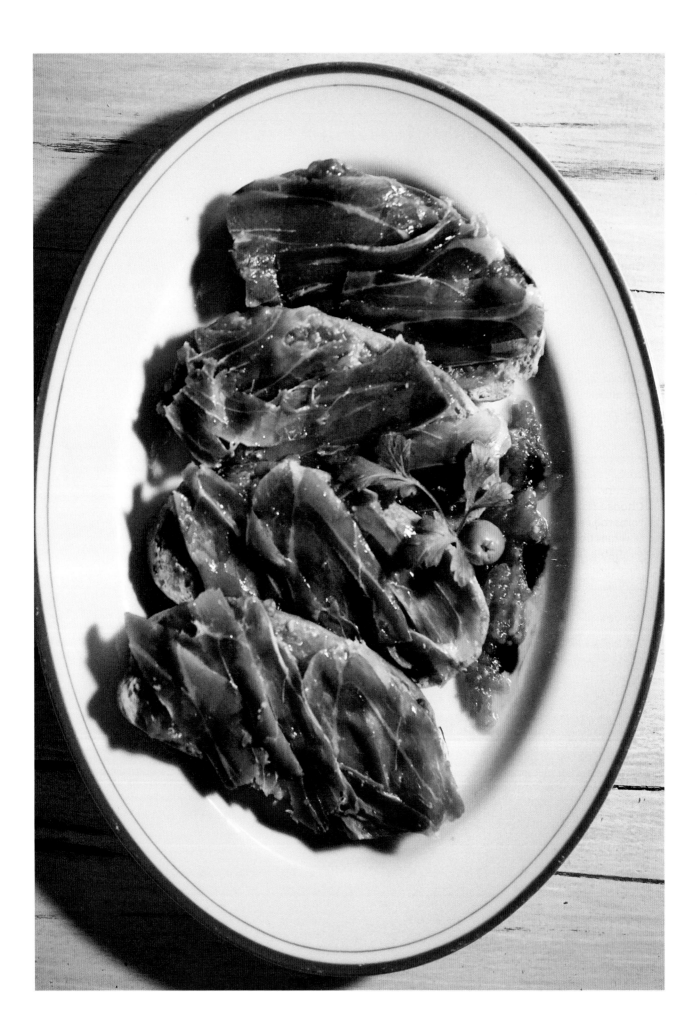

Tomato Toast with Jamón

Pan con Tomate con Jamón

One of the unexpected perks of dining out in Havana is encountering great Spanish ingredients—either imported or smuggled in suitcases by homesick Spanish expats. At Casa Pilar, run by a Spanish señora who's lived in Cuba for almost two decades, locals indulge in her classic Catalan pan con tomate [tomato-rubbed toast] draped with sweet-dusky curls of excellent Spanish serrano or Iberico ham. Choose flavorful red-ripe tomatoes and the best jamón you can find. Iberico, now available in this country, is best, but a good serrano isn't bad either.

Serves 4

2 medium, ripe tomatoes, cut in half crosswise, seeds gently squeezed out

4 thick slices country-style bread, toasted

Salt and pepper

4 thin slices jamón Iberico or serrano, or prosciutto

4 teaspoons extra-virgin olive oil, for drizzling

1 Preheat the oven to 350°F (175°C).

2 Place a grater over a bowl and, with cut sides down, grate the tomato flesh to make about 1 cup (240 ml) fresh tomato pulp (discard the skins).

3 Spoon ¼ cup (60 ml) of the tomato pulp over each piece of toast. Season with salt and pepper. Top each with 1 slice jamón and drizzle with 1 teaspoon olive oil per slice. Eat immediately while the bread is still crisp.

MEDITERRANEO HAVANA

SARDINIA ON
THE CARIBBEAN

Discreetly tucked away on a residential side street in the leafy Vedado district, paladar Mediterraneo Havana is a handsome blue-and-white Italian world of plump ravioli, tangles of al dente tagliolini sauced with bottarga and clams, and supple pizzas and flatbreads singed by the fire. Eating this food, you could almost be at a family-run trattoria in a small Italian town. Except this is Havana, where procuring a good wedge of Parmesan can be all but a pipe dream, and even such staples as olive oil can simply vanish any day without notice. Farm-to-table isn't just a trendy buzzword at Mediterraneo, it's an urgent necessity. Supplying the meat and produce for the kitchen of chef Luigi Fiori are two fertile farms— Vista Hermosa and La Mora—that belong to an agricultural cooperative in the rural area of Guanabacoa, on the outskirts of Havana. Whatever else Luigi can't find he produces himself: handmade pastas; cloudlike ricotta; chewy, dusky salami. Tall, broad-shouldered, and amiable, with a receding hairline and a small stylish ponytail, Luigi shared his story over snifters of profoundly aged rum.

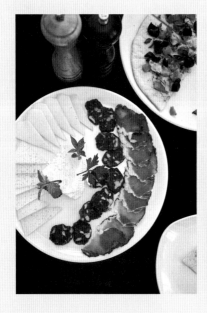

Luigi's Story

Believe it or not, I first came to Cuba for baseball!

As much as I'm addicted to cooking, my passion is baseball. Growing up in Sardinia, I played, pretty seriously. Always rooted for the Red Socks, defying my friends who were Yankees fans. For credibility and class, our team hired a Cuban coach—the Cubans are aces at baseball, and Italians relied on them to raise the level of play. The coach kept chewing my ear off about Cuba, so around 1995 I finally came. What can I say: It was instant amore. The sun, the sea, the fiesta—the beautiful girls and the baseball! The tragic part? The food: Every day just rice and beans and tough chicken. I'm Italian! Imagine an Italian without a decent piatto di pasta!

After about five days here I almost went mad. But I kept coming back, fantasizing about eating at a good Italian restaurant. In the end I realized that if I wanted to move to Cuba I'd just have to open that place myself. Where I grew up, almost every day Mamma made giant meals for us all—two hundred ricotta ravioli a day was nothing for her—and as the eldest of seven children, I was her helper. I'm a special-ed teacher by profession, but most summers I worked in the kitchens of Sardinia's Costa Smeralda hotels. Our family also owned a small trattoria serving favas with lardo, snails, and other delicious Sardinian things in my little hometown of Sassari.

So with Raúl Relova, my Cuban partner and friend, we finally opened Mediterraneo. Of course it was hard! The Raul Castro reforms kept coming and going—Cuba remains a country in flux. We opened in 2013, but in our heads the project was seven years in the making. Dealing with the plumbers and electricians and government inspectors was nightmarish, of course. Ingredients, though, were the hardest part. The only market that exists here in Cuba is black—el mercado negro. The state uses its scarce hard-currency resources to import Parmesan, jamón serrano, cream, and other luxury food items from Canada, Spain, and yes, from America, though indirectly. All these foodstuffs are strictly destined for tourist hotels, from where they end up being siphoned off to the black market. Working here is about cultivating relationships. My partner has a boat, and his fishermen friends bring us snapper, hogfish, and Caribbean grouper. Our farms supply us with organic vegetables, herbs, sheep, baby goats, and yes, beef and milk, though all the cows and their milk here are government property and the state takes 90 percent of what our farmers produce. I make my own Sardinian cheeses, like the salty sheep's milk Pecorino Sardo. Right off our dining room we have a curing chamber for salumi; I'm really proud of our peppery lomo and Sardinian sausages. Another challenge? To train our cooks in real Italian flavors, because if you don't, they'll sneak criollo cumin and a sofrito even into a plate of spaghetti. I still can't believe it! Somehow we managed to put some seventy dishes on our opening menu. But what a thrill watching Cuban clients enjoy our pizzas. Cubans love pizza, but the local pizza variety is a sad, spongy bread with a smear of awful tomato sauce that locals eat folded up. I'm Italian! Imagine how happy I feel serving real pizza and pasta!

Flatbread with Tomatoes, Jamón, and Olives

Focaccia con Tomate, Jamón, y Aceitunas

Luigi Fiori, the gregarious Italian expat who served us this dish, comes from Sardinia and has lived in Havana for almost fifteen years. He was one of the first chefs to introduce fresh pasta to Cuba. Proudly flying the Italian food flag at his paladar, called Mediterraneo, Luigi makes his own salumi and cooks with tip-top ingredients grown for him by several farmers. This recipe is a kind of yeasty focaccia, blind-baked and scattered with Mediterranean toppings. Luigi recommends dressing the flatbread while still hot to lightly warm the topping ingredients.

Makes two 10-inch (25-cm) flatbreads; serves 4 to 6

FOR THE DOUGH

1 teaspoon active dry yeast

1 cup (240 ml) warm water

1 teaspoon honey

2¼ cups (280 g) all-purpose flour, plus more if needed

1 teaspoon kosher salt

Extra-virgin olive oil, for greasing

FOR THE TOPPING

3 tomatoes, cored and diced

1 cup (155 g) sliced green or black olives

Leaves from 3 sprigs fresh oregano

⅓ cup (65 g) chopped thinly sliced jamón serrano or prosciutto

4 slices smoked bacon, cooked and chopped

Extra-virgin olive oil, for drizzling

1 **Make the dough:** In a small bowl, combine the yeast, warm water, and honey and stir to dissolve. Allow the mixture to sit for 3 minutes to make sure the yeast is active. It should foam and start to bubble.

2 Combine the flour and salt in the bowl of an electric mixer with a dough-hook attachment. On low speed, mix in the yeast mixture until a ball starts to form. Increase the speed to medium and mix for 8 minutes more. The dough should be soft and sticky. Mix in a little more flour if the dough is too wet.

3 Remove the dough from the mixer with oiled hands and form it into a ball. Place it in an oiled bowl and cover with plastic wrap. Set the bowl in a warm place for 1 hour, or until the dough has doubled in size. Punch down the dough and divide it into two balls. Place each ball of dough on its own oiled baking sheet and cover with plastic wrap. Allow the dough to rise for another 1 hour.

4 Preheat the oven to 400°F (205°C).

5 Using your hands, punch down each ball of dough on its own baking sheet and form it into a flat round approximately 10 inches (25 cm) in diameter. Dock the dough with a fork to prevent the flatbread from baking too thick. Bake until crispy, 15 to 20 minutes.

6 **Make the topping:** In a bowl, combine the tomatoes, olives, oregano leaves, jamón serrano, and bacon. Divide between the two hot flatbreads and drizzle with olive oil. Slice and serve immediately.

Chicken Tapas with Jamón and Cheese

Tapas de Pollo con Jamón y Queso

How to create a super-sabroso chicken tapa to accompany cocktails or a glass of sangria? Fill a chicken tidbit with cheese, wrap it in a long thin slice of shaved carrot, further wrap the package with a savory slice of jamón—and send it for a brief sizzling stint on the plancha like we had at paladar Melen Club. You can use a skillet with similarly delicious results.

Serves 4

1½ pounds (680 g) boneless, skinless chicken breast, cut into twelve 2-inch (5-cm) pieces

12 (½-inch / 12-mm) pieces sharp cheddar cheese

1 large carrot with 12 thin lengthwise slices peeled from it with a vegetable peeler, plus remainder for serving

6 thin slices jamón serrano or prosciutto, cut in half lengthwise

Salt and pepper

2 tablespoons olive oil

Lettuce for serving

1 Cut a small pocket into each piece of chicken. Stuff each chicken piece with one piece of cheese. Wrap a slice of carrot around each chicken piece, then wrap a half slice of jamón around the carrot and chicken. Season the chicken with salt and pepper to taste. Hold the bundles closed with a toothpick.

2 Place a large flat griddle or shallow skillet over medium heat and add the olive oil. Add the chicken pieces and cook for 2 to 3 minutes per side, turning once, or until golden brown and cooked through. Serve over a bed of lettuce and slices of the remaining carrot.

Picadillo-Stuffed Peppers

Pimientos Rellenos con Picadillo

Alina Menendez treats classic Cuban flavors with love at her paladar, Hecho en Casa. One of her menu's standouts is these sweet roasted peppers stuffed with a juicy beef picadillo and served atop basil oil–seasoned grilled eggplant slices. Alina poetically called this dish la casita cubana—"a little Cuban house"—with the eggplant as the foundation, the pepper as the house, and the roof represented by a topping she made from bits of fried plantains and a drizzling of honey blended with sour orange juice for that quintessentially Cuban bittersweet taste.

Note: *Also known as bitter orange or Seville orange—in Spanish, naranja agria—sour orange is a thick-skinned bumpy-looking orange-green-colored citrus that tastes like a cross between faintly bitter orange and lime. Sour orange imparts its particular citrusy tang to Cuban dipping sauces [mojos] and marinades. While sour orange is easy to find at Hispanic markets and even some regular supermarkets, its juice can also be substituted with equal parts fresh orange and lime juice.*

Serves 6

4 tablespoons (¼ cup) extra-virgin olive oil

¼ cup (10 g) fresh basil leaves, torn

2 medium eggplants, each cut into six ½-inch (12-mm) thick slices

3 tablespoons vegetable oil

1 ripe sweet plantain, peeled and cut into six ½-inch (12-mm) slices

6 whole jarred piquillo peppers, patted dry

1½ cups (350 g) Picadillo a la Habanera (page 248)

1 tablespoon honey

2 tablespoons sour orange juice, or an equal mix of lime and orange juice

Salt and pepper

1 Preheat oven to 400°F (205°C).

2 In a small saucepan, heat the olive oil over medium heat until small bubbles start to rise to the top, about 3 to 4 minutes. Turn the heat off, add the basil, and let steep uncovered for 15 minutes. Strain out the basil leaves and set the oil aside.

3 On a baking sheet lined with foil, place the eggplant slices and season on both sides with 2 tablespoons of the basil oil. Roast for 10 to 12 minutes, or until golden brown. Remove from the oven and set aside.

4 In a skillet, heat the vegetable oil over medium heat for 1 minute. Add the plantain slices and cook for 2 to 3 minutes per side, or until golden brown. Remove to a plate until ready to use.

5 Stuff each of the peppers with a generous 3 tablespoons picadillo and set aside on a plate.

6 In a small bowl, combine the remaining 2 tablespoons of the basil oil with the honey and sour orange juice. Add salt and pepper.

7 To serve, place one stuffed pepper on one slice of eggplant. Top with one slice of fried plantain and drizzle with sauce.

MIDNIGHT SANDWICH

Medianoche

A late-night snack after an evening of dancing and partying—medianoche means "midnight"—this toasted ham, roast pork, and cheese sandwich is similar to a Cubano but daintier, layered on the sweetish egg bread called pan suave. Some say it got its name from being served at Havana's pre-Revolution nightclubs. Others argue that the late-night reference is to the ingredients one could find in one's fridge coming home.

Makes 2 sandwiches

2 challah rolls or other egg-based rolls, split

4 thin slices Swiss cheese

8 round pickle slices

4 thick slices smoked ham

4 slices cooked pork (Crispy Pork Shoulder, page 272)

1 Open the rolls and set them on a board. Place a slice of Swiss cheese on both halves of each roll. Add 4 pickle slices and 2 slices of ham and roast pork to each sandwich.

2 Close the sandwiches and place them on a skillet over medium heat. Place another skillet on top of the sandwiches. Use a couple of cans or other ad hoc weights on top of the skillet to press the sandwiches. Cook for about 4 minutes per side, or until the cheese melts and the bread is crusty and browned. Cut the sandwiches in half and serve.

Black Bean Soup
Puré Africano 72

White Bean Soup
Caldo Gallego 74

Ajiaco 78

Grandma Tona's Chicken Soup
Sopa de Pollo de la Abuela Tona 80

Pilar's Salmorejo
Salmorejo Cordobés Casa Pilar 83

Avocado and Apple Gazpacho
Gazpacho de Aguacate y Manzana 84

Pumpkin Soup with Blue Cheese
Sopa de Calabaza con Queso Azul 86

Spinach Crema with Blue Cheese
Sopa Crema de Espinacas con Queso Azul 89

Garlic Soup Otramanera
Sopa de Ajo Otramanera 92

Crab and Corn Soup
Harina con Cangrejos 94

Yuca and Chard Crema
Sopa Crema de Yuca y Acelgas 95

Solianka
*Irina's Zesty Smoked Meats Soup
with Olives and Pickles* 100

SOPAS

Soups

Watching Cubans polish off steaming bowls of soup with such gusto, you'd think they resided in sub-zero Lapland. Then again, locals would say, why let one-hundred-degree heat and humidity stand between them and their love of bone-warming potajes, ajiacos, pucheros, and guisos—all names for thick, multi-ingredient soups that have nourished Cuba since colonial times. The grandmother pot of such meal-in-a-bowl Cuban soups? Historians point to Spain's proverbial medieval olla podrida, or rotten pot, a baroque potage left to simmer for days. After Iberians settled Cuba in the 1500s, their ollas eventually augmented and fused with the clay-pot tuber stews of Amerindian natives and the iron cauldrons of African slaves that brimmed with okra, beans, or malanga. One such creolized pot—ajiaco—with its complex, symbolic layers of influences, became something of a Cuban national icon (page 78). Just as essential are Cuban variations on Spanish bean pots, smoky with cured porkstuffs, followed closely by chicken and fideo soup, for which everyone's abuela has the best recipe.

In Cuba's late-colonial days, lunchtime soups were so important, the seminal 1857 cookbook *El Manual Cocinero Cubano* declared that an entire huge volume was needed to do justice to them all—and thereupon proceeded to offer three dozen different soup recipes and as many for potajes [brothy stews]. Among these was a rich saffron-hued veal broth "for the infirm" and a soup of small feathered game and hutia, a native wild rodent. French, Mexican, German, and Russian soups are featured alongside different regional versions of Cuba's own ajiacos. One particular curiosity: Sopa Habanera, supposedly Havana Soup, constructed from towers of toasted bread slices layered with parsley and cheese, then moistened with broth thickened with crushed toasted almonds and scented with cloves. It's a taste more evocative of medieval Spain than modern Havana.

Of the nineteenth-century elaborations, some have taken genuine root. For instance, the cremas: creamy, pureed first-course soups that entered middle-class households in the 1800s as a refined Gallic touch. The popularity of cremas today makes plenty of sense, given Cuban cooks' almost irrational attachment to their batidoras [blenders], and the profusion of local tubers and roots starchy enough to produce thick, creamy soups without flour or cream. In this chapter, you'll find a delicious crema of yuca and chard from our favorite traditional paladar, Hecho en Casa. You'll also enjoy a smooth black bean sopa called Puré Africano, along with such modern Cuban creations as spinach cream with crispy jamón and a celestial pumpkin puree zapped with blue cheese.

Cold soups, so well-suited for tropical climes, are alas given short shrift in old and new Cuban cookbooks—and are rarely prepared at home. But they positively shine on today's new paladar menus, especially Spanish gazpachos, both traditional, like the coral-hued salmorejo from paladar Casa Pilar, and new-wave soups, like the avocado and tart green apple gazpacho from young chef Javier Gomez.

Whether summer refreshers, creamy first courses, or meals-in-a-bowl that only need white rice and a salad for company, the soups offered here are distinctive, delightful, and full of sabor.

PERÍODO ESPECIAL: WHEN CUBA WAS STARVING

Any discussion of food in Cuba rarely takes place without, at some point, a somber sigh and reference to the "special period in time of peace"—Castro's euphemistic term for the economic disaster that engulfed the island for most of the 1990s. The Período Especial was a collective trauma, a time of such intense deprivation its dark shadow still lingers over every Cuban meal, every daily shopping transaction. Until the USSR went bust in 1991, it subsidized Cuba's socialist economy for almost three decades, to the tune of some 3 billion dollars a year. Under Soviet sponsorship, Cubans ate not lavishly but sufficiently. Government food rations, established by Castro in 1962, provided monthly rice, beans, cooking oil, milk, and coffee, along with weekly chicken, pork, picadillo mincemeat, and pork—sometimes fish. And what middle-aged Cuban doesn't fondly recall the cold-weather exotica that poured in from the socialist bloc, be it huge jars of Russian apples and pear compotes, Hungarian cucumber pickles, or the sorely missed Bulgarian stuffed-pepper conserves.

All that came to a crashing halt when Gorbachev resigned in 1991; trade relations with the entire ex-Soviet bloc stopped dead. "Almost overnight, our food-supply system unraveled," recalls Madelaine Vazquez, currently Cuba's Slow Food advisor and a TV food personality, who back in those hungry years worked in public nutrition. "It was as if the bottom just dropped out from every family table." Cuba's imports fell by almost 80 percent. Besides grain and petroleum, these included pesticides, fertilizers, tractors, and cattle feed. Farming came to a halt: Whatever boniatos or yucas still grew couldn't be transported for lack of gasoline. "Average calorie intake shrank by a third," says Madelaine. "Government rations dropped by half, and kept dropping, until one day you went to a bodega clutching your ration libreta . . . and saw nothing on the shelves." El tiempo de los flacos, the skinny years, is how Cubans refer to the period. The average citizen lost fifteen pounds. The 1996 U.S. embargo delivered a further shattering blow. "Suddenly all you could think of was hunger," says Madelaine.

Natalia, a jolly, middle-aged vendor at our favorite Havana market, still remembers her Período Especial family meals. Breakfast was a cup of hot water sweetened with brown cane sugar. For lunch, a tiny ration of rice and beans, dusty and wormy and totally flavorless because there were no seasonings, no cooking oil, barely any salt. And dinner? "Dinner?" she laughs ruefully. "For dinner, if you didn't snag your state ration of picadillo [minced meat] that was so stretched with soy it was disgustingly white, you gobbled down a boiled boniato or your 80-gram [3-ounce] government bread roll and went to bed with your stomach gnawing." But the worst? Natalia gives a theatrical shudder. The worst was enduring a six-hour line for something, anything, to put in your fridge—then seeing it spoiled by the tropical heat after a daylong electrical outage. "These ugly Russian refrigerators we had at home," snorts Natalia. "They betrayed us over and over!"

To cope, Cuba became a country of inventors. "Sí—una pais de inventores," agrees Alicia García, a prominent food journalist, nodding emphatically. "And those survival skills still come in handy today." Cubans in the 1990s improvised picadillo from tannic-tasting minced plantain peel, made soap from smuggled glycerin, conjured up toothpaste from baking soda. "We wheeled and dealt and bartered and black-marketeered," says Alicia. "We gagged on masas carnicas, vile meat-flavored pastes, trying not to think what the government put in them. We sprinkled cane

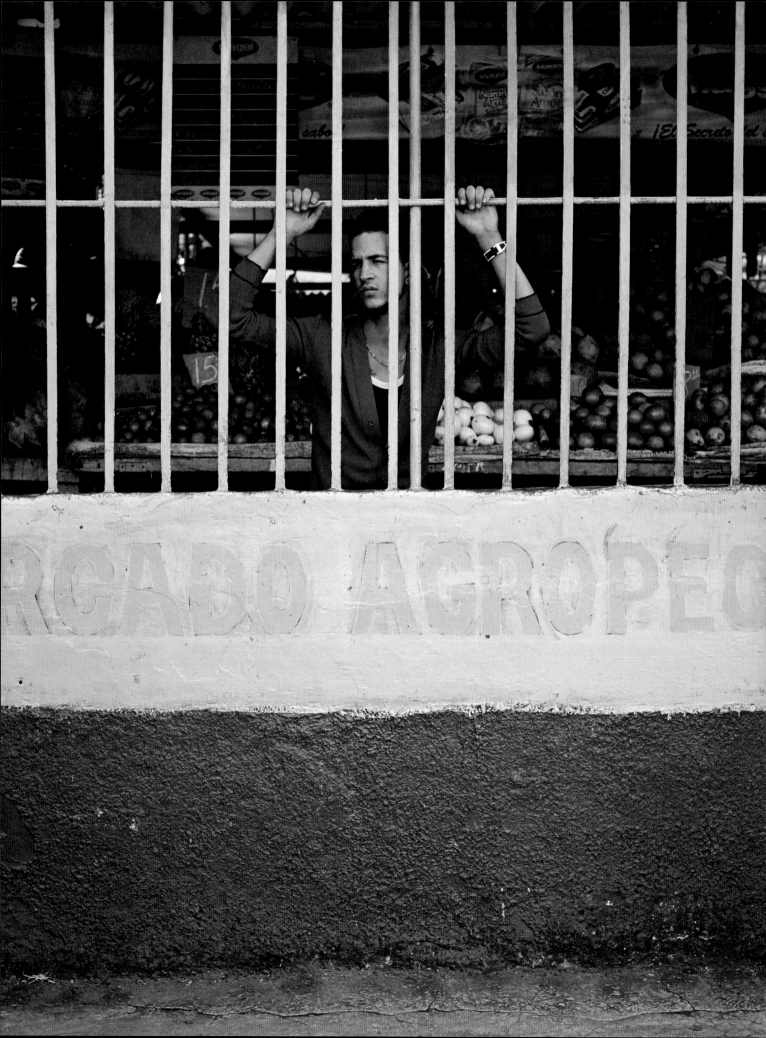

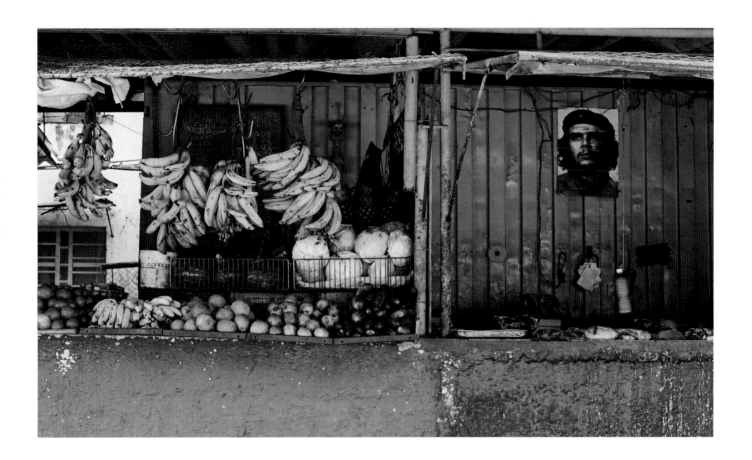

sugar on watery rice to make it look appetizing." On television, cooking diva Nitza Villapol showed how to make breaded "steaks" out of grapefruit rind.

Dark jokes and sinister urban myths swirled. People were said to be eating animals from Havana Zoo, or raising and slaughtering pigs in their bathtubs. There were "reports" of condoms melted on pizza instead of cheese, of floor mops added to croquetas and ropa vieja—"the latter an obvious lie," notes Alicia, "because back then even floor mops were scarce." But surreally euphemistic ingredients and dishes were a daily reality. What actually constituted pasta de oca [goose paste], a mysterious substance supposedly flavored with goose, or fricandel, a vile fake sausage? Cubans described such fare with the ironic acronym OCNI: objetos comestibles non-identificados, non-identifiable edible objects. "But the meta-euphemism of that time," sighs Alicia, "was our sad expression, comerse un cable—literally, to eat a cable wire."

"And as a result we became this country of inventors!" exclaims Slow Food's Madelaine Vazquez, echoing Alicia's phrase. "Ingenuity was needed to survive!" So during the skinny years, ingenious Cubans foraged, fished, and planted whatever they could on ad hoc urban plots. They raised chickens and rabbits on rooftops and patios, trudged on foot or cycled to agromercados, the new private farmers' markets that were allowed by the government beginning in 1994. "We, this nation of meat addicts," says Madelaine, "began for the first time to embrace our tropical veggies and fruits." The island's agriculture went organic and green—not by ideology but from dire necessity, because Cuba couldn't afford hard-currency pesticides, and shortages of gas and energy left only manual farming. "Back then, if anyone told me that we'd become a model for sustainable agriculture," Madelaine exclaims, "I'd have laughed." And then she laughs—happily.

Black Bean Soup

Puré Africano

Most likely introduced to Cuba from the Yucatan Peninsula via the trade routes, black beans were part of the indigenous diet well before Columbus arrived. By the mid-nineteenth century, beans of all sorts (along with rice) were key crops grown on the island. Not surprisingly, this soulful, velvety soup is one of Cuba's best-loved traditional dishes. When beans are mashed or pureed, the dish is called Puré Africano, possibly because of the color or, some historians reckon, because of the connection to African slaves. In this recipe, the trick to the silky texture is to puree the sofrito so it almost disappears into the soup, a non-traditional method that we've adopted. Some cooks add ham or bacon for depth, but filling vegetarian versions also abound. A splash of dry sherry or vinegar and some fresh-chopped onion and parsley make a nice finish. For a light, one-dish meal, spoon the soup over white rice.

Serves 4

½ cup (55 g) chopped onion

½ cup (75 g) chopped green bell pepper

1 clove garlic, chopped

1 tablespoon olive oil

1 teaspoon dried oregano

½ teaspoon ground cumin

4 cups (740 g / three 15-ounce cans) cooked black beans, drained if canned

Salt and pepper

1–2 tablespoons dry sherry or vino seco

¼ cup (35 g) minced red onion

2 tablespoons chopped fresh parsley or cilantro

1 In a blender or food processor, combine the onion, bell pepper, and garlic and blend on high speed to form a puree, 1 to 2 minutes.

2 In a pot, heat the olive oil over medium heat. Scrape in the pureed vegetables, add the oregano and cumin, and cook for 2 to 3 minutes. Add 2 cups (370 g) of the black beans to the pot. Add enough water so that it comes an inch above the beans and bring to a boil. Meanwhile, puree the remaining black beans in a blender or food processor on high speed for 1 to 2 minutes, until smooth. Add the pureed beans to the pot. Stir and cook until heated through. Season with salt and pepper to taste. Add the sherry and garnish with the red onion and parsley.

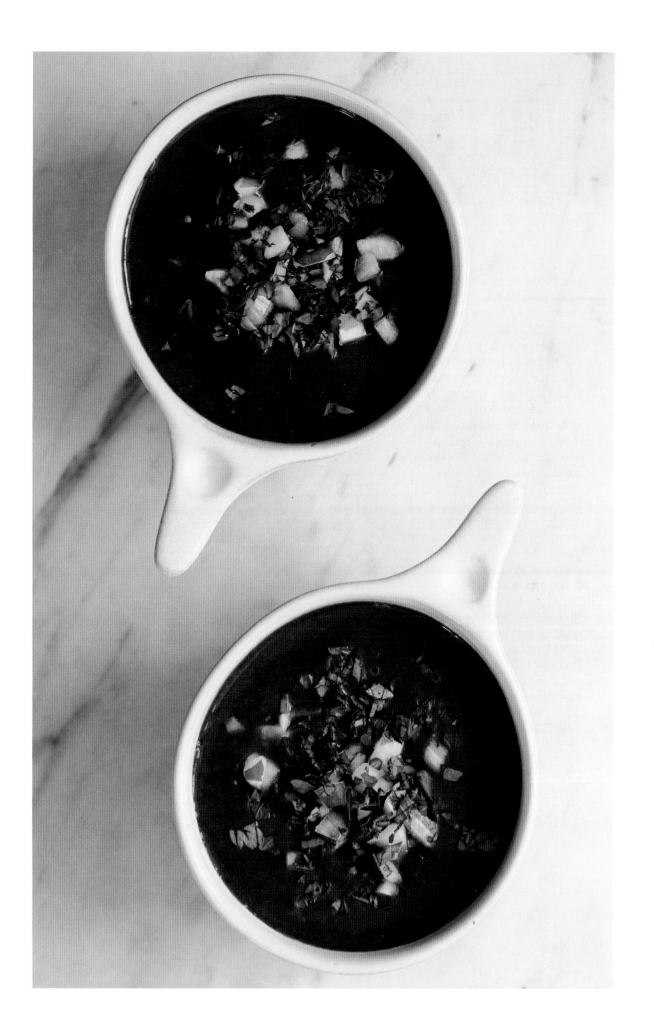

WHITE BEAN SOUP

Caldo Gallego

The provenance of this soup is Galicia, a verdant province in northwestern Spain. From here, thousands of Gallegos immigrated to Cuba, fleeing poverty in the mid-nineteenth century to become the island's largest and most influential group of Iberians. (Fidel Castro's father was of Galician origin.) This version of the Galician stalwart is flavored with meaty ham hock. It also entices with a smoky dose of chorizo and sturdy shredded greens that simmer to tenderness. In Galicia, the greens of choice are called grelos [a kind of turnip green], but chard, favored in Cuba, or mustard greens, kale, or young collards also work well. All this soup needs is a loaf of good bread and a puckery salad to make a terrific family meal.

Serves 8 to 10

1½ pounds (680 g) ham hock

1 tablespoon olive oil

2 (3-ounce / 85-g) Spanish chorizos, chopped

1 cup (110 g) chopped onion

½ cup (75 g) chopped green bell pepper

1 cup (200 g) white beans, soaked overnight in water and drained

2 cups (280 g) potatoes, peeled and cubed

5 cups (275 g) chopped young collard greens, tough stems removed

Salt and pepper

1 Bring a large pot with 2 quarts (2 L) water to a simmer over medium-low heat. Add the ham hock and simmer for 1½ hours to make a broth, occasionally skimming the fat. Remove the ham hock, shred any meat attached to it, and return the meat to the pot. Remove from the heat.

2 Add the olive oil to a skillet over medium-high heat. Add the chorizo and cook for 2 minutes to release some of the fat. Add the onion and green pepper to the skillet and cook for 4 to 5 minutes, until the vegetables are beginning to soften. Add the chorizo and vegetable mixture to the broth along with the beans. Cook the soup over medium heat, partially covered, for 30 minutes. Add the potatoes and collard greens. Season with salt and pepper and cook for another 25 to 30 minutes, or until the potatoes and beans are soft.

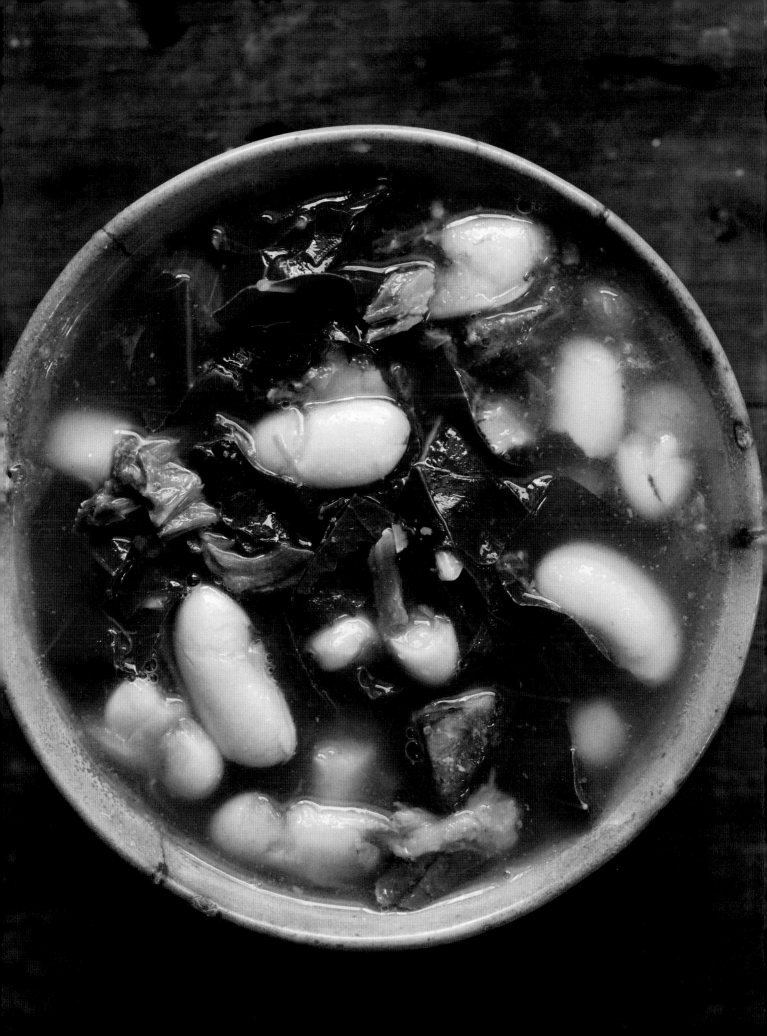

AJIACO

Ajiaco—mostly likely derived from "aji," the native Taíno word for "hot pepper"—is a post-Columbian interplay in a cauldron: a rich, soupy stew loaded with meats and viandas [tropical tubers] that can feed a whole neighborhood. In Venezuela and Panama, a similar pot might be called sancocho. Colombia and Peru have their own iterations of ajiaco as well. But it's in Cuba where the dish has achieved the status of a truly national icon, though one of the earliest recorded accounts of it wasn't so flattering. In 1598, Hernando de la Parra, a conquistador serving the Spanish governor in Havana, wrote with exemplary colonialist scorn: "The foods here are seasoned in a way that is so strange that they are repugnant at first, but Europeans eventually become so accustomed to them that they forget those of their own country." The principal dish of "these primitive inhabitants," de la Parra continued, was "a union of fresh and salted meats cut into small chunks, boiled with various roots, spiced by means of a small, caustic pepper [aji-ji-jí], and colored with a small seed [vija]." By the late nineteenth century, ajiaco had gotten a lot more respect—it was then served at colonial households from grand silver tureens. Come the mid-twentieth century,

the renowned Cuban folklorist Fernando Ortiz was describing ajiaco as nothing less than a metaphor for the Cuban experience: a dish whose ingredients symbolize Cuba's rich melting pot of peoples and cultures. To this pot the Amerindians contributed corn, yuca, boniatos, and squash; the Spaniards tossed in pork, tasajo [jerked, salted beef], and spices such as saffron and cumin; the enslaved Africans added plantains and ñame yams. Some versions even include seasoning brought by Chinese immigrants.

"Cuba's ajiaco is also emphatically regional," insists our learned friend Acela Matamoros, a food historian who features half a dozen ajiaco recipes in her cookbook, *Cocina Cubana*. Some regions favor pork head as animal protein, others the strong-tasting tasajo de caballo [horse jerky]. The most classic version, Ajiaco Criollo, hails from the central Cuban province of Sancti Spiritus, settled by Spaniards in the early sixteenth century. Sancti Spiritus's ajiaco once brimmed with four types of meat and at least four types of viandas, along with lots of salsa criolla to season it. "But with our chronic shortages," Acela sighs, "we're losing those regional differences. Today we make ajiaco with whatever we find—and not often."

Noemia Lorenzo, one of Havana's great traditional cooks, is one who takes whatever she can find for her ajiaco—all of it. "I go to the agro [the farmers' market] and essentially empty it," confesses Noemia, whose daughter, Amy, co-owns the modern paladar Otramanera. One evening Noemia treated us to an ajiaco feast on the tropical patio of her sleek, white, mid-century-modern house in the Miramar district. Out came photos of Fidel with Noemia's ex-husband Diocles Torralba, once Cuba's powerful sugar minister. In another photo, the elegant Noemia herself wears an evening gown to a government function. Then the vast tureen of ajiaco appeared, and the conversation fell silent. Noemia's stew demanded our full attention: velvety and comforting from the half-disintegrated viandas and fortified with three kinds of meat, it tasted both baroque and somehow elemental.

"Today I used beef, fresh pork, and smoked pork loin for the broth," Noemia said. "Tasajo would have been nice, but nowadays who can find it?" For vegetables she'd added a heroic shopper's haul of carrots, calabaza, yuca, malanga, plantains, corn—even potatoes she's managed to find. The trick, she insisted, was to respect the cooking time for each vegetable—and to boil plantains and yucas separately, so the liquid wasn't too starchy. But the ultimate secret? "Time, lots of time—and patience and love."

Dayron Avila, the Cuban-born chef at Otramanera, which is right next door, stopped in for a quick bowl before dashing back to the restaurant. "Ah, ajiaco!" he mused. "It's not just a dish, if you please. It's a symbol, a fiesta, a beloved childhood memory." That's because, Amy explained, ever since the Revolution, on September 27—the eve of the anniversary of CDR (Defense of Revolution Committees)—every barrio prepares ajiaco outdoors in vast pots, with all the neighbors contributing. "As a kid," she enthused, "I adored running after the fiesta organizers as they went door to door, collecting the yucas, malangas, and meats for the pot." Dayron then waxed lyrical about lolling as a boy by the enormous communal pot bubbling over huge open flames. "I'd be like Oliver Twist," he grinned, "holding out my little tin jarra [container] waiting for my portion, salivating, swallowing hard."

Everyone at Noemia's table agreed that ajiaco just didn't taste the same eaten out of fine china as it did scarfed down from tin jarras during the fiesta. Unless, of course, it's the ajiaco made by Noemia. And we sat there refilling our bowls, thinking of Fernando Ortiz's evocative description of Cuba as a "mestizaje [blending] of kitchens, a mestizaje of races, a mestizaje of cultures, a dense broth of civilizations that bubbles on the stoves of the Caribbean."

AJIACO

Cuba's national dish, ajiaco is a rich, soupy stew that can feed a whole neighborhood. This particular recipe, inspired by one from our ajiaco goddess Noemia Lorenzo, is rich with different meats and thick with yuca, boniato, calabaza, plantains, and corn, plus the sought-after potatoes Noemia managed to find. If you can find tasajo at a Hispanic market, by all means use it here as well, first soaking it overnight in cold water. Serve with Avocado Salad (page 114) on the side.

Note: *Boniato [aka batata, camote, batata dulce, and white sweet potato] is the Caribbean's purple-skinned, white-fleshed sweet potato. It is drier and less sweet than North American sweet potato varieties; it tastes a bit like a tropical chestnut when cooked and makes for a truly adored Cuban dessert called boniatillo. For moister tubers, choose boniatos with light-red skin and store for no more than a week. Boniatos turn brown very quickly, so place them in water immediately after peeling.*

Serves 8 to 10

1 pound (455 g) smoked pork loin, chops, or Canadian bacon

1 pound (455 g) flank steak or top round

2 pounds (910 g) country-style pork ribs

1 cup (140 g) malanga, peeled and cut into 1-inch (2.5-cm) cubes

1 cup (130 g) yuca, peeled, cored, and cut into 1-inch (2.5-cm) cubes

1 cup (140 g) boniato, peeled and cut into 1-inch (2.5-cm) cubes

1 cup (140 g) yellow potatoes, preferably Yukon Gold, peeled and cut into 1-inch (2.5-cm) cubes

2 green plantains, peeled and cut into thirds (6 pieces total)

Salt and pepper

3–4 tablespoons (45–60 ml) olive oil or lard

2 cups (220 g) chopped yellow onion

1½ cups (220 g) chopped green bell pepper

5 cloves garlic, chopped

1 jalapeño, seeded and diced

2 bay leaves

1½ cups (250 g) canned chopped tomatoes

2 cups (230 g) pumpkin, peeled and cut into 1-inch (2.5-cm) cubes

2 ears of corn, each cut crosswise in thirds (6 pieces total)

2 tablespoons chopped fresh parsley, for garnish

1 In a large, wide pot, add enough water to the smoked pork, flank steak, and pork ribs so the water comes an inch above the meat. Bring to a boil. Skim off the foam, cover the pot, and simmer over low heat, maintaining the water an inch above the meat, until all the meats are very tender, 1½ to 2 hours. Remove all the meats to a cutting board and let cool. Discard the bones from the pork ribs and cut meat into 1-inch cubes or desired size.

2 Bring the broth to a boil. Add the malanga, yuca, boniato, potatoes, and plantains. Add enough additional water to cover the vegetables by 1 inch. Reduce the heat to medium-low and simmer, covered, for 25 to 30 minutes, or until the vegetables are tender, making sure to test each type for doneness. Season generously with salt and pepper to taste.

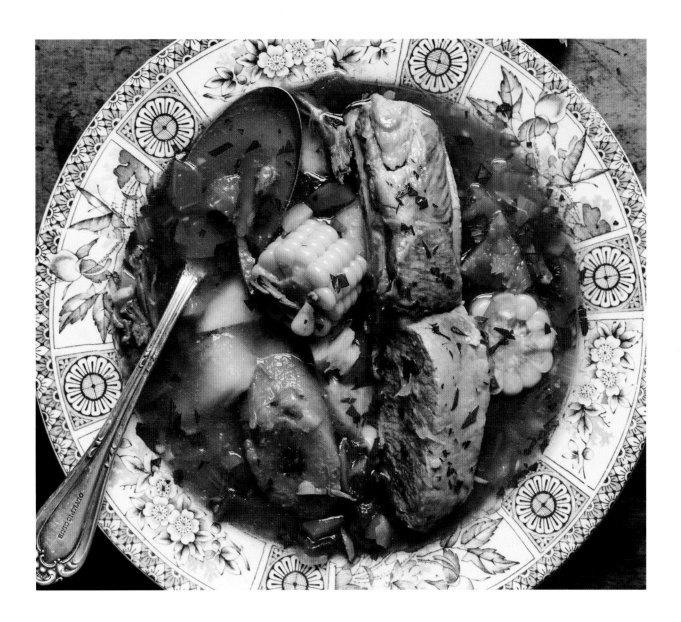

3 While the vegetables are cooking, in a large skillet heat the olive oil over medium-high heat. Add the onion and bell pepper and cook for 7 to 8 minutes, stirring a couple of times, until soft. Add the garlic and jalapeño and cook for 1 minute more. Add the bay leaves and chopped tomato and cook for 3 minutes to combine the flavors. Add the contents of the skillet to the pot of simmering soup, along with the reserved meats, chopped pumpkin, and corn wheels. Cook for 10 to 15 minutes more, or until the pumpkin is soft and the rest of the vegetables are starting to disintegrate. If the broth seems thin, mash a little of the pumpkin to thicken it. Season with salt and pepper as needed.

4 Garnish with chopped parsley and serve to a crowd.

Grandma Tona's Chicken Soup

Sopa de Pollo de la Abuela Tona

Abuela Tona was the beloved grandmother of our friend Alicia García, the grand dame of Cuban food journalism whose family started the famous El Aljibe chicken restaurant in Havana. The soup was so nourishing, Alicia recalls, "it could raise you from your deathbed!" She mused about what makes a chicken soup Cuban: Certainly the addition of the indispensable cumin. Also a splash of yellow coloring from annatto or saffron, because "Cubans consider pale, white soups very ugly," Alicia said. Back in the time when potatoes were plentiful, they'd be added to chicken soups, but nowadays most cooks use viandas [tubers] such as yuca or calabaza. Fideos, the vermicelli-like noodles, are also a must. Cubans prefer their soups on the bland side, but we couldn't resist adding an extra layer of toasted cumin and some lime juice to liven things up.

Serves 4

7 cups (1.7 L) chicken broth or water, plus more as needed

1½ pounds (680 g) bone-in chicken breast

1 tablespoon cumin seeds

Salt

1 teaspoon dried oregano

4 cloves garlic, sliced

3 cachucha peppers or 1 jalapeño, seeded and diced

Large pinch crumbled saffron threads or 1–2 tablespoons annatto oil (page 146)

1 tablespoon unsalted butter

1 small white onion, quartered and thinly sliced

2 slender carrots, cut into 1-inch (2.5-cm) pieces

1½ cups (210 g) 1-inch (2.5-cm) cubes of peeled boiling potatoes or cooked yuca (see page 121)

1 cup (85 g / about 3 ounces) broken-up fideo noodles or thin spaghetti

Snipped chives or chopped cilantro, for garnish

Squeeze of sour orange or lime juice, to taste

1 Combine broth and chicken in a snug pot and bring to a boil, then reduce heat and simmer, covered, about 20 minutes, until chicken is just tender. Let chicken cool a bit in the broth, then remove with a slotted spoon to a bowl.

2 While the soup is cooking, toast the cumin seeds in a dry skillet, stirring, for 1 to 2 minutes, until fragrant. In a mortar with pestle, crush the toasted cumin seeds, a large pinch of salt, the oregano, garlic, cachucha peppers, and saffron threads to make a paste. (If using annatto oil instead of saffron threads, add it to the finished paste.) Add a few tablespoons of warm broth and set aside.

3 In a soup pot, heat the butter over medium heat and sauté the onion and carrots until slightly softened but not browned, about 5 minutes. Add half of the paste, stir for

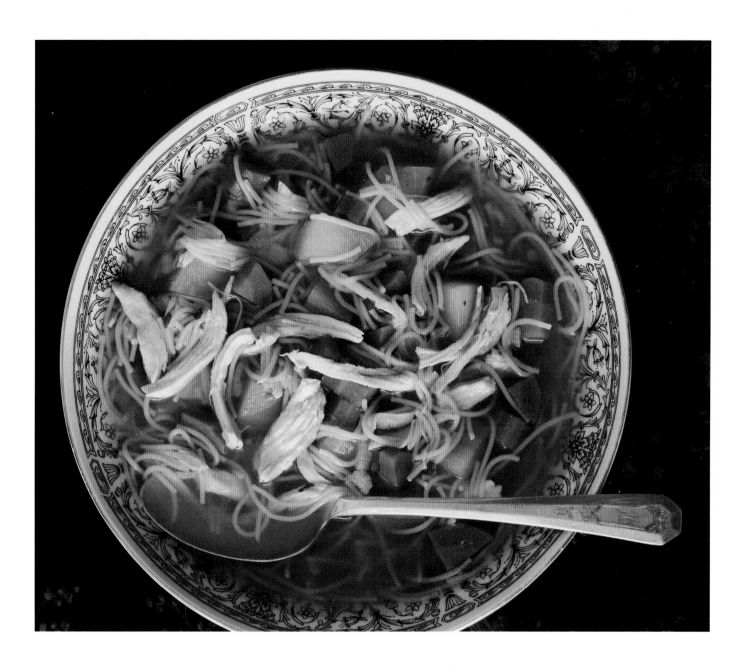

a few seconds to combine, and add the broth from cooking the chicken. Bring to a simmer, add the potatoes (if using the cooked yuca, add it later) and cook until the potatoes are almost tender, about 12 minutes. Bring back to a full simmer, add the noodles (and the yuca, if using), and cook until the noodles are tender, 4 to 6 minutes or as directed on the package.

4 While the soup is cooking, remove the skin and bones from the chicken and shred the meat into bite-size pieces. Add the rest of the paste to the soup along with the chicken and cook to warm through, 1 to 2 minutes more. If the soup seems too thick, add a bit more broth. Serve with chives and a squeeze of sour orange.

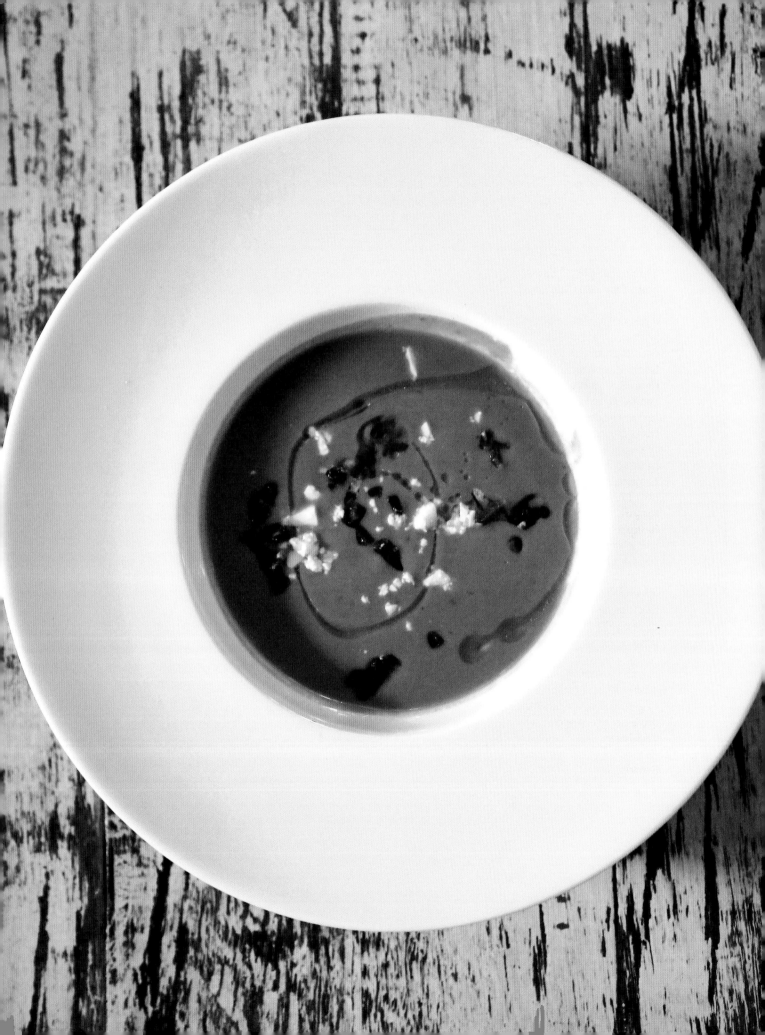

Pilar's Salmorejo

Salmorejo Cordobés Casa Pilar

This coral-pink Spanish soup from Andalusia's Córdoba region is essentially a smooth gazpacho made without water—so thick it can double as a dip. The Spanish owner of paladar Casa Pilar says that this recipe is an heirloom from her grandmother who lived in the Andalusian countryside, where farmers made salmorejo when tomatoes were at their peak. But, Pilar happily adds, Cuban tomatoes are even more flavorful. The success of this simple dish depends on the best tomatoes and olive oil you can find and a long, vigorous stint in a blender to achieve that super-velvety texture. (Pilar uses a high-tech gadget called a Thermomix.) Slivers of crispy serrano or Iberico ham, chopped hard-cooked egg, and extra drizzles of olive oil are the traditional garnishes.

Serves 4

2 cups (70 g) cubed day-old country bread, crusts removed

8 medium, very ripe tomatoes, chopped (5 cups / 900 g)

1 clove garlic

2 tablespoons sherry vinegar

¾ teaspoon salt

2 hard-boiled eggs, chopped

1 cup (240 ml) extra-virgin olive oil, plus more for drizzling

3 thin slices jamón serrano, for garnish

1 Cover the bread in cold water and soak for 10 minutes. Drain, squeeze the bread, and set aside.

2 Working in batches, pulse the tomatoes in a food processor or blender with the garlic, bread, sherry vinegar, salt, and half the chopped eggs until smooth. With the processor still running, slowly drizzle in the olive oil until incorporated. Process until completely smooth.

3 In a small skillet, sauté the jamón until crispy. Transfer to a cutting board and finely chop.

4 Serve the soup in bowls topped with crispy jamón, the remaining chopped egg, and drizzles of olive oil.

Avocado and Apple Gazpacho

Gazpacho de Aguacate y Manzana

The recipe for this silky, super-refreshing gazpacho is from the paladar Elite in Havana, whose chef-owner, Javier Gomez, often takes inspirations from contemporary Spanish cuisine. "To you an apple might be nothing special," he said of his soup, "but for Cubans, it's a big deal—a rarity!" Javier likes to show off by presenting his gazpacho in glass bottles nestled in ice buckets—to be poured with great drama over the garnishes. If you feel like adding a small handful of green grapes to the blender, go with the feeling.

Serves 6

- 1 large Florida avocado or 2 small Hass avocados, peeled, pitted, and chopped, plus more for garnish
- 1 large Persian cucumber, peeled and chopped, plus more for garnish
- 1 medium Cubanelle pepper, seeded and chopped, plus more for garnish
- 1 medium green apple such as Golden Delicious, peeled, cored, and diced, plus more for garnish
- 2 small red shallots, chopped
- 2 cloves garlic, chopped
- Large pinch cumin seeds, crumbled
- 2½ cups (600 ml) ice water, plus more as needed
- 5 tablespoons (75 ml) extra-virgin olive oil, plus more for garnish
- 4 tablespoons (60 ml) sherry vinegar, or more to taste
- Salt and pepper
- ⅓ cup (12 g) ¼-inch (6-mm) bread cubes, fried in olive oil or tossed with olive oil and baked

1 Working in batches if necessary, in a blender puree the avocado, cucumber, Cubanelle pepper, apple, shallots, garlic, and cumin seeds with 2½ cups (600 ml) of the water until completely smooth. Scrape into a mixing bowl. Whisk in the olive oil, vinegar, and salt and pepper to taste. If the mixture seems too thick, add more water until it has the consistency of a smoothie and correct the seasoning. Cover with plastic and refrigerate for at least 2 hours for the flavors to develop.

2 Stir or shake before serving and transfer to a glass carafe, pitcher, or milk bottle.

3 To serve, place some of the chopped avocado, cucumber, Cubanelle pepper, apple, and croutons into each soup bowl or a pretty glass bowl and have the diners pour the gazpacho themselves, adding drizzles of olive oil to their portions.

Pumpkin Soup with Blue Cheese

Sopa de Calabaza con Queso Azul

While pumpkin soup is pretty standard on most paladares menus, the fashionable O'Reilly 304 presents an outstanding version garnished, unexpectedly, with crumbled blue cheese and crunchy croutons. When you mix the cheese into the soup and wait for a minute, it melts into the velvety, slightly sweet pumpkin puree for a nice, pungent note. "I just played and played with different versions of pumpkin soup," says chef-owner José Carlos Imperatori, "until I came up with this recipe. Now it's such a hit, my customers would howl if I take it off the menu."

Serves 6

2 tablespoons unsalted butter

2 tablespoons olive oil

1 cup (110 g) chopped onion

1½ pounds (680 g) peeled and cubed pumpkin or butternut squash

1 teaspoon ground chili pepper

½ teaspoon ground cumin

2 sprigs fresh thyme

Salt and pepper

4 cups (960 ml) chicken stock

½ cup (120 ml) heavy cream

½ cup (70 g) crumbled blue cheese, for garnish

2 thick slices crusty bread, cubed and toasted

Extra-virgin olive oil, for drizzling

Parsley, for garnish (optional)

Cachucha pepper, for garnish (optional)

1 In a large saucepan, melt the butter and olive oil over medium heat. Sauté the onion until tender, about 4 to 5 minutes. Add the pumpkin, chili pepper, cumin, thyme, and salt and pepper, to taste. Add the stock and simmer until the pumpkin is tender, about 20 minutes. Remove the thyme stems and stir in the cream to warm it. Let the soup cool slightly and puree in a food processor or blender until smooth.

2 Garnish with the crumbled blue cheese, croutons, parsely, and pepper (optional), and drizzles of extra-virgin olive oil.

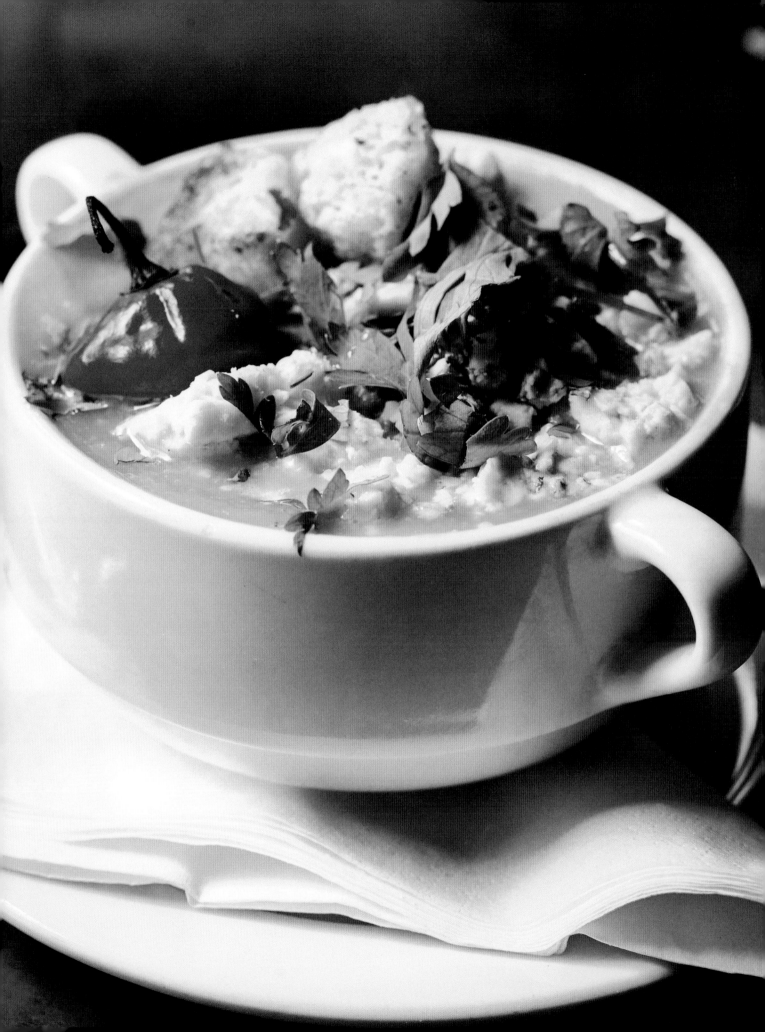

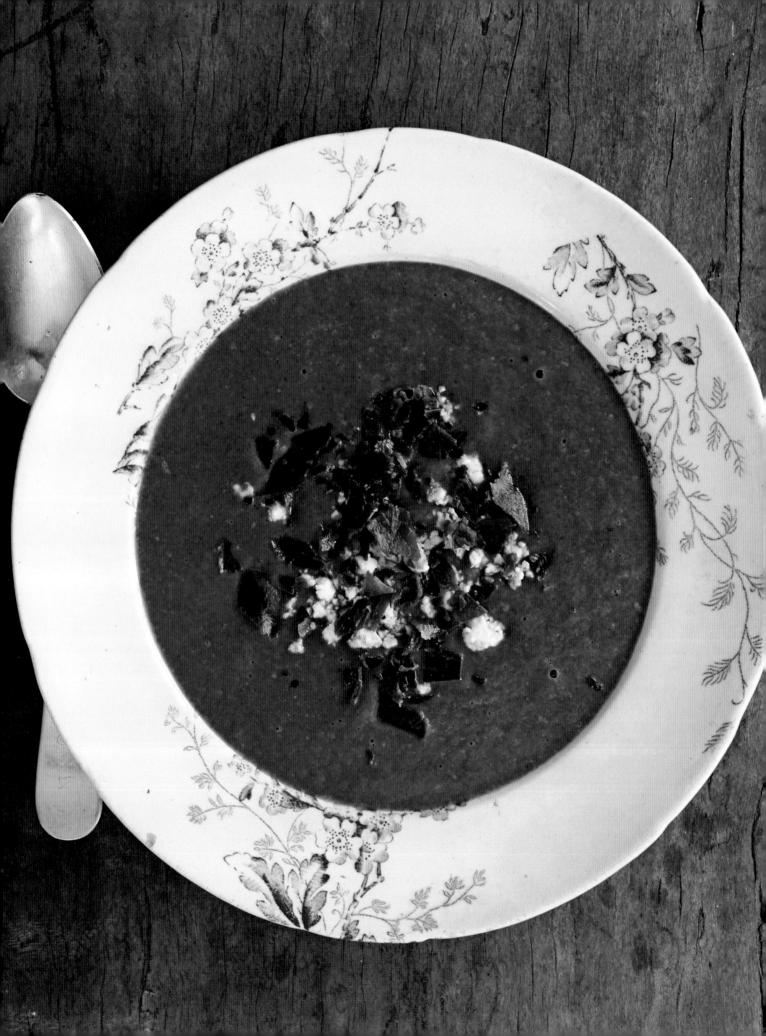

Spinach Crema with Blue Cheese

Sopa Crema de Espinacas con Queso Azul

When Casa del Queso Le Marriage, a gourmet shop stocked with imported and national cheeses, opened in Old Havana in 2014, its owners were slightly surprised to discover how much their Cuban customers relish blue cheeses. And Cuba does produce some very decent blue cheeses—such as Azul Atabey or Guaicanamar—if you can find them. In this recipe, Ariel Mendoza Amey, the creative chef at paladar La Foresta, purees the blue cheese into a rich and unusual spinach soup. Topping the bowl is a slice of oven-crisped serrano ham—another current "it" gourmet item—and a scattering of edible flowers. We're chopping our ham here and omitting the flowers, but if you're feeling inspired, try it the La Foresta way.

Serves 6

2 tablespoons unsalted butter

3 tablespoons all-purpose flour

3 cups (720 ml) vegetable broth

Salt and pepper

2 tablespoons olive oil

1 cup (110 g) chopped onion

5 cloves garlic, chopped

1 pound (455 g) baby spinach leaves

2 ounces (55 g) or 4 thin slices jamón serrano

¾ cup (100 g) crumbled blue cheese

1. In a large pot, melt the butter over medium heat. Stir in the flour and cook for 3 to 4 minutes. Add the broth, whisking to combine, then increase the heat to medium-high and bring to a boil, steadily whisking to avoid lumps. Boil for 3 to 4 minutes. Season with salt and pepper to taste, cover, and remove from the heat.

2. In a skillet over medium-high heat, add the olive oil and onion and cook for 3 to 4 minutes to soften. Add the chopped garlic and cook for 1 minute more. Stir in the spinach and cook for 3 to 4 minutes, then add the sautéed vegetables to the pot and stir to combine.

3. Working in batches in a blender or food processor, blend the soup on high for 1 to 2 minutes until pureed; pour into another pot. Warm the soup over low heat and season with more salt and pepper if needed.

4. In a large skillet over medium-high heat, fry the jamón, turning once, until crisp, about 2 minutes per side. Drain any excess fat on a paper towel, then crumble or chop the jamón.

5. Ladle the soup into bowls and divide the crumbled blue cheese and crispy jamón evenly on top.

OTRAMANERA

THE GASTRO-BISTRO

Álvaro Diez and Amy Torralbas are a young Spanish-Cuban husband-and-wife team who met in Madrid. Opened in 2014, their gastro-bistro Otramanera serves up some of the most sophisticated, contemporary food in Havana. The thoughtfully minimalist, white-walled restaurant sits adjacent to Amy's tropical-modern family house in the Miramar neighborhood. Their paladar was a labor of love—heavy accent on the labor. Álvaro still recalls the dreamy-eyed innocence of Otramanera's conception. "It was 2010, we were with friends on Catalunya's Costa Brava gazing out at the Mediterranean, talking and talking about what we wanted to do with our lives—and suddenly this restaurant vision appeared!" Their ultimate reward for all the grueling construction that followed was the kind of chefy, intimate place that would win critical raves even in such foodie capitals as Barcelona and Copenhagen. Fusing avant-garde Spanish techniques, sun-kissed Cuban produce, and far-flung spices, their chef, Dayron Avila, creates vibrant, beautiful dishes: a whole-roasted snapper dressed with gingery-coconut vinaigrette, a pork loin cooked sous-vide for six hours for ultimate succulence, a classic Spanish gazpacho flavored with Cuba's aromatic guavas. Álvaro, a professional sommelier, pours an interesting Riesling from his short but sharp wine list. Amy, a local belle who counts half of Havana as friends, delivers a bowl of addictive caramel popcorn to a table of regulars. At another table, Amy's mom, Noe, one of the best traditional cooks in Havana, enjoys the fish curry, her favorite dish—thrilled to have the children back by her side.

Amy and Álvaro's Story

Until the 1950s, Cuba had a great, rich cuisine, one of the best in the Americas—and in our own way we're trying to resurrect it for the twenty-first century.

Amy comes from a grand Cuban family. Her dad was Fidel's sugar minister, a pretty huge job, as you can imagine. He and Fidel were good pals—they'd get together to fish for snapper or roast a cocodrilo, an alligator, out on the patio. Amy studied art in Madrid and lived in Spain for six years. Álvaro is a Madrileño; he trained as a sommelier with the famed Catalan Roca brothers, the best chefs in the world. Then he worked at some of Spain's most adventuresome restaurants and also in London. We're a modern couple. We met on an Internet dating site and were married soon after. Our life in Spain was full of excitement, incredible food. But what we really wanted was a place of our own: a small, chefy, personal gastro-bistro just like the spots we adored in Madrid and Barcelona's bohemian neighborhoods. We envisioned opening one in Havana, researched the market. But was Cuba ready, we wondered, for a restaurant where the focus would squarely be on the food? We weren't so sure.

It so happened that Amy's mom, who ran a famous traditional paladar called A Mi Manera [My Way] out of her house, was getting tired of constantly cooking. So we took over the adjoining space, calling it Otramanera [Another Way]. During the honeymoon stage of our restaurant opening, we were possessed by planning fever. We took measurements and photos of our space back to Madrid. All night we'd sit at cafés and bars drinking massive Spanish gin and tonics with our designer friends, plotting colors and details and fixtures. Then, back in Havana, reality hit. The only way to create a dream restaurant, we realized, was to do it ourselves. From scratch. We watched YouTube tutorials about how to paint distressed walls. We searched forever for repurposed wood to panel the bar. We had to learn engineering, plumbing, carpentry. The restaurant tables? We made them ourselves! From Spain we brought skillets. On a trip to Venezuela we found this great piece of Asian art that now hangs on the restaurant wall. We'd consulted well-known chefs abroad on the menu, but the problem was finding a chef de cuisine in Havana. After interviewing two hundred people, we almost despaired. Until, a month before opening, Dayron walked into the restaurant. He'd worked at several of Havana's top paladares, and he blew us away with the Catalan escalivada he reinterpreted with local sardines and a simple, perfect, charred octopus salad.

We are all evolving and growing together, delighted how open young Cuban guests are to new flavors. Every day is a learning curve. We get more and more attuned to the growing seasons. We blend our own curries from twenty different spices we've collected from trips. We've trained a sausage maker in proper Spanish chorizo. Every dish here is a bit of a fusion—Caribbean-Mediterranean, just like we are as a couple. Shortages force us to improvise when writing our menu. How can you list a particular fish when you have no idea what will appear on your doorstep each morning? Although to assure supply we now work with seven different fishermen, each one dedicated to a particular fish—aguja [marlin], say, or pez perro [hogfish]. Our best discovery is a secret guy who shall not be named. He produces mind-boggling mascarpone and mozzarella from government milk—better than anything you'd find in Italy. Our pork supplier? Yes, he does have a name, because Cuban pork is phenomenal and totally legal.

GARLIC SOUP OTRAMANERA

Sopa de Ajo Otramanera

Loads of garlic, leftover bread that deliciously swells up in the broth, smoked Spanish paprika, eggs, olive oil, and bits of jamón—these elemental ingredients create this boldly flavored classic Spanish-Castilian soup that was eagerly adapted in Cuba. Originally, sopa de ajo was a kind of poor-man's porridge. But at the ultramodern Havana paladar Otramanera, the classic is cleverly updated, pureed and served up daintily as an amuse bouche in cute repurposed baby food jars. The chef, Dayron Avila, garnishes it with chopped egg, chives, and crispy serrano ham for a treat that really deserves a big bowl of its own. A good dense, day-old country loaf is crucial for a good sopa de ajo.

Serves 4

12 cloves garlic, chopped

2 tablespoons olive oil

1 cup (35 g) cubed bread, toasted

1 tablespoon sherry vinegar

Salt and pepper

¼ cup (49 g) minced jamón serrano

1 hard-boiled egg, finely chopped, for garnish

1 teaspoon minced fresh chives, for garnish

1 In a saucepan over medium heat, cook the garlic in the olive oil until the garlic is just starting to turn golden, 3 to 4 minutes. Remove from the heat and add the toasted bread cubes.

2 In a blender or food processor, combine the garlic-bread mixture, 1¾ cups (420 ml) water, and the sherry vinegar. Season with salt and pepper to taste and blend on high speed for 2 to 3 minutes, or until very smooth.

3 Strain the puree through a fine-mesh strainer and return to the pot. Simmer over medium-low heat for 10 minutes to blend the flavors.

4 In a small skillet over medium-high heat, cook the minced jamón for 2 to 3 minutes, or until crispy. Scrape onto a plate and set aside.

5 Taste the soup and adjust the seasoning if needed. Ladle into soup bowls and top each serving with chopped egg, crispy jamón, and minced chives.

CRAB AND CORN SOUP

Harina con Cangrejos

This ultra-comforting dish—essentially a version of tamal en cazuela, a stove-top tamal—is more reminiscent of Southern seafood and grits than anything we know as soup. Here a thin porridge of yellow cornmeal stews together with sweet, flavorful crab legs and a peppery sofrito base. Licking the cornmeal off the crab legs and cracking the shells is all part of the messy fun of this dish. Can't find crab legs? You can add another ¾ pound (340 g) of crabmeat to the soup.

Serves 6

3 tablespoons annatto oil (page 146)

1 cup (110 g) chopped onion

1 cup (145 g) chopped green bell pepper

⅓ cup (50 g) chopped red bell pepper

5 cloves garlic, chopped

1 cup (165 g) seeded and chopped fresh tomato

¾ pound (340 g) crabmeat, picked through for shells and well drained

½ teaspoon smoked paprika

⅛ teaspoon cayenne pepper

1 cup (120 g) coarse cornmeal

Salt and pepper

¾ pound (340 g) snow crab legs, cracked (optional)

1 In a large, deep pot, add the annatto oil over medium-high heat. Add the onion and green and red peppers and cook for 5 to 6 minutes, or until the vegetables start to soften. Add the garlic and cook 1 minute more. Add the tomato and cook for 3 to 4 minutes, or until starting to soften. Remove from the heat and stir in the crabmeat, smoked paprika, and cayenne pepper.

2 In a large pot, bring 5 cups (1.2 L) water to a boil over medium-high heat. Slowly add the cornmeal in a thin stream, stirring continuously. Reduce the heat to medium and cook the cornmeal at a slow boil for 20 to 25 minutes, or until thickened. Season with salt and pepper to taste. Stir in the crab and vegetable mixture and the crab legs, if using.

3 Let stand for 5 minutes to allow the flavors to meld and the soup to thicken further before serving.

YUCA AND CHARD CREMA

Sopa Crema de Yuca y Acelgas

Thick, soothing crema soups are found on practically every paladar menu and are enthusiastically prepared at homes—but don't expect any dairy cream. In Cuba, crema usually refers to super-smooth purees of vegetables or tropical tubers. At paladar Hecho en Casa, chef Alina Menendez uses the recipe from her Spanish grandmother that transports her, she says, back to her childhood. She garnishes her soup with big croutons and sprigs of fresh dill.

Serves 6

1½ cups (195 g) peeled and cubed yuca

4 cups (120 g) chopped chard leaves

2 tablespoons olive oil

1 cup (110 g) chopped onion

1 medium green bell pepper, chopped

4 cups (960 ml) vegetable or chicken broth, plus more if needed

Leaves of 1–2 sprigs cilantro, chopped

Salt and pepper

Croutons, for garnish

Dill, for garnish

1 In a pot over medium-high heat, cover the yuca with water and bring to a boil. Cook for 20 to 25 minutes, until the yuca is tender. When just cool enough to handle, drain the yuca and remove any fibrous strands. Set aside.

2 Rinse the chard and pat dry. In a large saucepan, heat the olive oil over medium heat. Add the onion and green pepper and sauté until soft, about 5 minutes.

3 Add the cooked yuca and the broth to the sautéed vegetables and bring to a boil. Stir in the chard and cook until tender. Turn off the heat and stir in the cilantro.

4 Working in batches, puree the soup in a blender or directly in the pot with an immersion blender. Return the soup to the pot, add salt and pepper to taste, and thin with additional broth to desired consistency.

5 Garnish with croutons and dill.

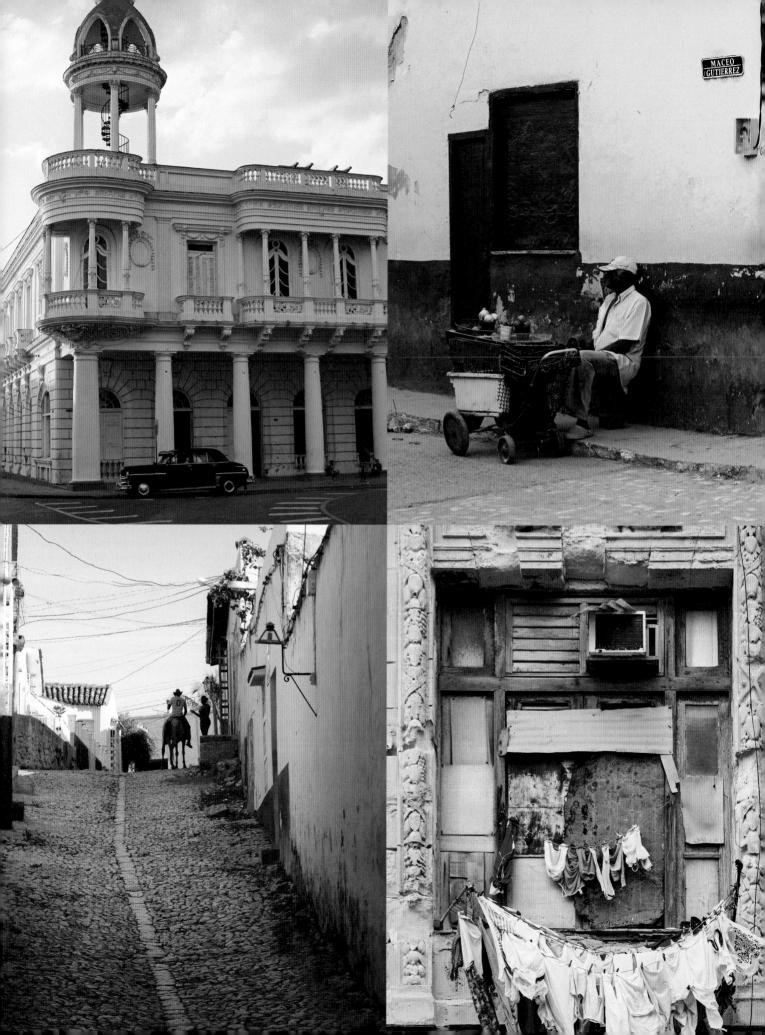

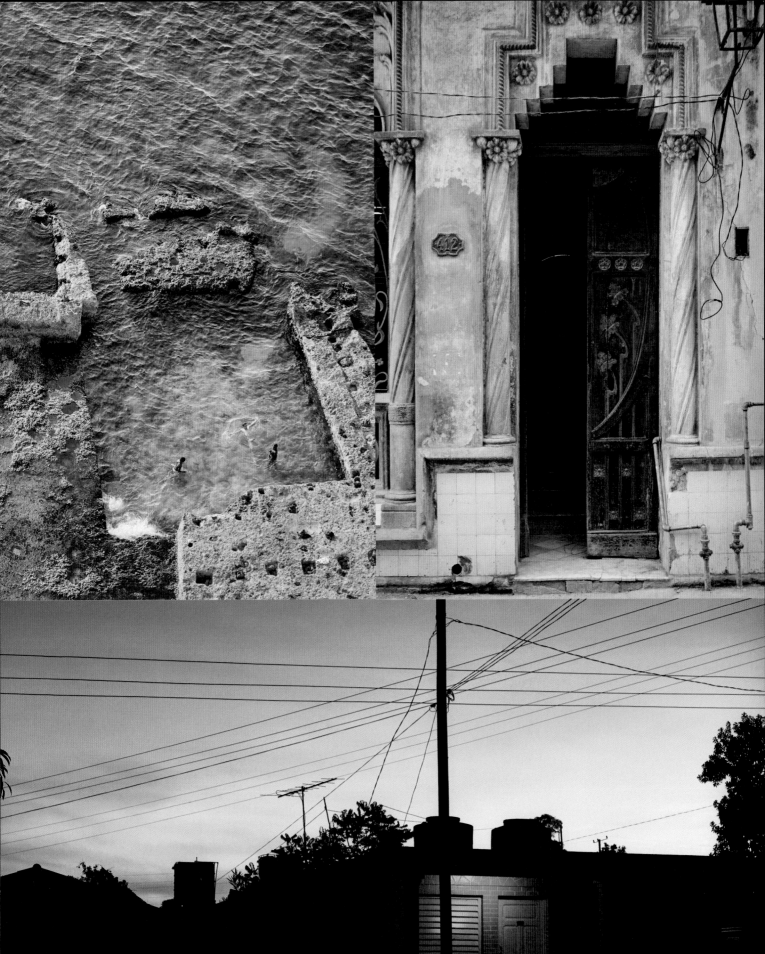

NAZDAROVIE

BACK TO THE USSR

The political side of the Cuban-Soviet story? Years of lavish patronage by Moscow, ending with disastrous suddenness after the Soviet Union went into free fall in 1989. The plug was pulled on all support, including food subsidies, leaving Cuba nearly starving. The human and cultural side? Thousands of Cubans had gone to study in the diverse Soviet republics, bringing Soviet wives to their tropical island. Their stories, too, often ended in wrenching divorce, with the Russian ex-wives stranded in Cuba, many destitute and forgotten by post-Soviet governments. And yet, despite the bitter fallout, much nostalgia and great affection survives among both Cubans and Russians for the glory days of their relationship. "This was the story that I wanted to tell through my restaurant," says Gregory Biniowsky, a Canadian lawyer of Ukrainian descent who a few years ago opened the retro-Soviet paladar Nazdarovie in what was then his top-floor apartment. "I wanted to create a hub for reuniting Cubans and Russians," he says of his cozy, balconied spot that is bright with Soviet posters and memorabilia. Biniowsky himself moved to Cuba in the mid-1990s as a young, lefty student who believed in Fidel's Revolution. He wound up living through Cuba's most difficult days, losing seventeen pounds and spending three hours daily queuing for food. But he remains optimistic about the Cuban experiment, especially now that small private businesses, such as his own, can offer individual incentives to enrich community life. So he couldn't be happier seeing Russians and Cubans clinking their vodka glasses at Nazdarovie over nourishing borscht, crisp chicken Kiev, and pelmeni, plump Siberian dumplings. The soul of the restaurant is the head chef, Irina Butorina, one such Russian who followed her husband to Cuba. On the restaurant balcony overlooking the Malecón, she told us her story as the waves flung their spray over the stone seawall below.

Irina's Story

I'm ethnic Russian from Kyrgyzstan, an independent Central Asian country since 1991—but in my years there, it was a Soviet republic. In the 1970s, the Cuban government started sending students to the USSR. My husband was one of the first. These Cuban students were so different from us glum-faced Soviets! They were noisy, happy, ebullient charmers. I met my husband at the Lenin Hall of our dorm, and we went to a dance. He called me mi vida [my life], mi amor [my love], linda [beautiful]—the kind of endearments you'd never hear from Soviet men. At first I resisted—then love happened. He asked his teacher how one proposes in Russian. People laughed in my village, "You'll give birth to a green alien baby," they said. But I ended up in Cuba—a bride. It was 1978. We lived in his small house in Havana with eleven other family members. And they laughed when I tried to make Cuban food. Like the time I put chicken in a pot of black beans, a big no-no in Cuba. My mother-in-law said she didn't like Russian food, but one night I caught her devouring my cabbage soup straight from the pot! I felt vindicated!

The Russian colony in Cuba back then was huge. Cuban stores were filled with Soviet and Eastern European imports, from our beloved condensed milk to tushonka [canned beef] to big jars of our pickles, jams, and compotes. Back then, Cubans turned up their noses at Soviet food. They whispered that tushonka is made with bear meat! Now that it's lost to them, they miss it like crazy. Starting in 1989, Russian food imports all stopped, and suddenly the stores were just empty. How did our family survive? By then, we'd moved to a house with a garden in a provincial town. I raised and grew everything: boniato, bananas, piglets, chickens, ducks, ferocious geese that terrorized everybody. I went to the dairy farms and bartered for milk and used the cream on top as my cooking oil, because there was no other oil. We even made our own soap! They called me la luchadora russa, the Russian fighter. It's true. After all, our Soviet parents survived the Second World War by growing and making things.

Like most Cuban-Russian marriages, mine fell apart. The Soviet Union, it fell apart, too, which ended direct cheap subsidized flights between here and home. I moved to Havana, where I worked as a hydraulic engineer. My job was prestigious. I supervised major state budgets. But the state pay was meager. As prices here were rising, I worried. And then Gregory asked me to work at his Soviet paladar. My mom was a chef. As a kid I helped her make borscht, piroshki, Central Asian pilafs, and pelmeni. But here in Cuba, I thought, how does one even make borscht? When the short potato season arrives, cabbage vanishes; as beets appear at markets, the carrots are gone. But we jump hoops and make miracles to keep a steady menu of Russian deliciousness. One farmer grows dill, another supplies us with milk to make sour cream. We pickle and preserve what's in season, make Russian mustard, bake black Slavic sourdough bread. We Russians know how to deal with shortages. Expats come here to eat and practically cry, saying the food transports them back to their grandmothers. Cubans who'd studied in Russia come, too, all misty-eyed. Me—I never thought I could love working this much! Even on my days off I rush to the restaurant, to be with fellow émigrés, to swap stories and recipes from our childhoods. We lost our past and our country, our USSR. But food has this power to heal wounds and recover the past.

Solianka

Irina's Zesty Smoked Meats Soup with Olives and Pickles

This Slavic soup called solianka is wondrous: hefty with a mix of fresh and cured meats and sausage, and delightfully zesty from olives, capers, and pickles. The soup is always a hit at the cheery Soviet-themed paladar Nazdarovie, which overlooks the Malecón in Havana. Irina Butorina, the big-hearted Russian chef there, prepares the soup base with a mix of beef, lamb, and pork, then adds ham and Russian-style sausage or frankfurters. But the stock, she suggests, is equally delicious just with the beef (increase the amount to 2 pounds / 910 g), and for smoked meats you can use diced salami or bacon. "My Cuban clients go wild for our solianka," Irina says, "because its smoked, meaty taste and the brine from the capers and olives remind them of Cuban flavors—but with a twist." Like all Russian soups, this one calls for an iced shot of vodka.

Serves 8

1 pound (455 g) beef chuck, trimmed

½ pound (225 g) lamb shoulder or meaty neck

1 pound (455 g) country-style pork ribs

4 whole black peppercorns

1 bay leaf

2 cloves garlic, smashed

1 small onion, peeled, plus 2 medium onions quartered and thinly sliced

4 tablespoons (55 g) unsalted butter, plus more as needed

2 slender carrots, peeled and sliced

4 ounces (115 g) kielbasa sausage, diced

4 ounces (115 g) Canadian bacon or boneless ham steak, diced

4 tablespoons (65 g) tomato paste

2 teaspoons sweet paprika

2 large ripe tomatoes, grated, skins discarded

3 tablespoons capers, drained

¼ cup (40 g) sliced pimento-stuffed olives or pitted black olives

2 large dill pickles, diced, plus 2–3 tablespoons of their brine, to taste

Half a lemon, sliced very thinly

Chopped parsley, dill, and sliced scallions, for garnish

Sour cream, for garnish

1 Place the beef, lamb, and pork in a large pot, add 2½ quarts (2.4 L) water, and bring to a boil, skimming as necessary. Gather the peppercorns, bay leaf, and garlic in a piece of cheesecloth and tie with string to make a bouquet garni. Add the bouquet garni and the small whole onion to the pot, reduce the heat to low, and simmer until all the meats are tender, 1½ to 2 hours.

2 Remove the meats from the stock and let cool until manageable. Discard the bouquet garni and the onion. Chop the meats into bite-size pieces, discarding any bones, and set aside. Measure the stock and reserve; you should have 10 to 11 cups (2.4 to 2.6 L).

3 In another large soup pot, melt the butter. Add the sliced onions and carrots and cook, covered, until softened, about 5 minutes. Add the kielbasa and bacon and sauté for 2 to 3 minutes, until they begin to color. Add the tomato paste and stir for 1 to 2 minutes. Add the paprika and stir for 15 to 20 seconds. Add the grated tomatoes and cook until they cook down a bit, about 5 minutes. Stir in the reserved stock and bring to a boil over high heat, skimming if necessary.

4 Stir in the reserved meats and the capers, reduce the heat to very low, and simmer, covered, for 20 to 25 minutes for all the flavors to meld. Stir in the olives, pickles, and the pickle juice, to taste, and cook for 5 minutes longer. Add the lemon slices and let stand for 5 minutes. Ladle into bowls and serve garnished with chopped herbs and a dollop of sour cream.

VEGETALES Y VIANDAS

Vegetables and Roots

Down a bumpy dirt road off a highway a short drive west of Havana lies a vision of Arcadia—an organic Arcadia. On its twenty bountiful acres, radishes, peas, and emerald lettuces gleam like modest gems in neatly tiered beds. Beehives painted a Caribbean turquoise cluster under spindly palms. Sheep and horses graze by banana and cedar trees while yoked oxen do the labor of tractors. Farmhands in high rubber boots pick slender carrots and cherry tomatoes, and a glossy black dog snoozes by a rustic barn that's nevertheless equipped with a state-of-the-art solar panel.

Welcome to Finca Marta, Cuba's internationally lauded agro success story, a poster child of the island's burgeoning agroecology movement. And here's Fernando Funes, its visionary founder and owner, a man dedicated to reviving traditional sustainable farming. Grizzled-handsome in his straw sombrero and denim overalls, Fernando is a glamorous guajiro [farmer, peasant] with a PhD in agronomy who looks the part of a celebrity food revolutionary. Back in 2011, however, everyone, including his agro-scientist father, thought he was loco, a madman, for leaving his academic job to start an organic farm on this rocky terrain covered with thorny marabou brush. The first thing Fernando did was dig a well by hand without as much as a drill—a Sisyphean labor that took seven months. But putting in the well was a metaphoric journey toward a sustainable future, as Fernando (who recently did a TEDx talk) likes to tell the international press who just won't leave him alone. The well's excavated rock went into building the thatch-covered barn for his cows, which supply milk and the natural waste that Fernando, using a biodigester, converts into fertilizer, electricity, and the gas for his kitchen. Among his farm's other innovations are not only an irrigation pump powered with solar energy but—crucially—higher wages and better conditions for workers.

Fernando and his wife hawked Finca Marta's first avocados and mangoes in front of their home in Havana and went on to knock on restaurant doors, offering baskets of vegetables. Now Finca Marta's almost two annual tons of fragrant organic honey is in demand internationally, and Havana's best paladares compete for the sixty types of crops that he grows, including zucchini, arugula, radishes, spinach, herbs, and avocados. These might star in dishes like the beautiful tamarind-dressed Caesar salad at Elite. Or a still life of tender arugula, purple mustard greens, and red-leaf lettuce dressed with Fernando's honey at paladar La Foresta. "Everything is so damn unpredictable here in Cuba," says La Foresta's chef, Ariel Amey. "But at least we can count on Fernando's greens to bring alegria—joy—to our customers."

Finca Marta isn't the only Cuban organic farm bringing joy to tables. On the mineral-rich twenty-seven acres of Vivero Alamar—a pioneering farming co-op launched in 1997 just east of Havana—the philosopher-agronomist-farmer Miguel Salcines grows beautiful cauliflower, jade-green bok choy, tomatoes that taste truly ambrosial, succulent Caribbean oregano, and spearmint that can alchemize any mojito. But almost everywhere on the island, really, organaponicos [organic garden allotments] both rural and urban do an excellent job of supplying Cubans with vitamins. Cuba's organic agriculture is an inspiring success story, usually the rare bright spot amid bleak reports about food shortages in this tiny country still forced to import some 60 percent of its edibles.

Quite improbably, Cuba's organic farming revolution was sparked by a crisis, one that engulfed the island in 1991, when its state-run industrialized agriculture unraveled after the Soviet Union withdrew its support and machinery. Needing to feed people—fast!—Cuban authorities took the radical steps of decentralizing

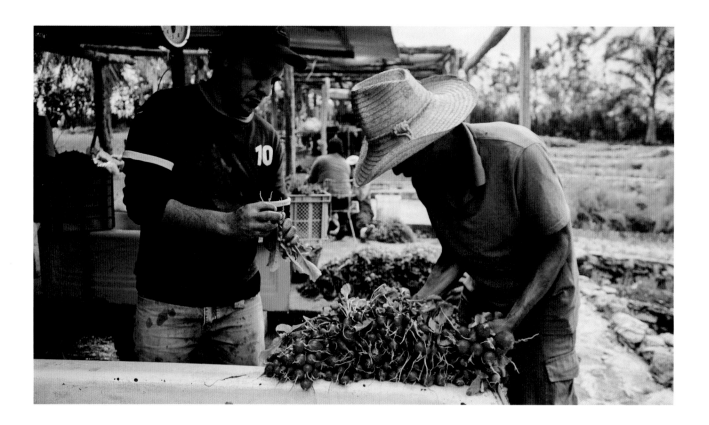

farm management and promoting a kind of back-to-the past self-sustaining agricultural system. Organic? Yes—out of dire necessity, since Cuba no longer had access to the Soviet chemical fertilizers and pesticides. The desperate experiment worked. By the end of the aughts, organic allotments by the thousands were supplying Cuba with produce, and the numbers kept growing. By 2012, wrote Fernando Funes of Finca Marta in a scholarly paper, some 383,000 urban farms were providing more than 1.5 million tons of vegetables.

These days, according to Miguel Salcines of Vivero Alamar, fresh produce accounts for a third of the island's diet—even though Cuba continues to be a land of traditionalists attached to their pork-rice-beans-and-plantains routine. True, back in the early twentieth century, the country's original miracle farmers, the Chinese, managed to hook the island on bok choy, longbeans, scallions, and cucumbers, all still sold at most farmers' markets. But outside of paladares serving boutique greens and those ever-adorable cherry tomatoes, a "salad" is usually a simple affair—room-temperature cooked beans, say, or pumpkin with sprightly aliño [dressing] or mojo; minimally dressed sliced avocados; a retro cooked/raw assemblage of shredded lettuce or cabbage, boiled green beans, and perhaps corn and sliced beets. "Yes, we're delivering the actual vegetables," says Salcines. "But Cubans still need to learn how to cook them creatively." Organic farmers are certainly doing their part. So, too, are nutritionists and the modern paladar chefs preparing veggies with gusto and flair. In this chapter, along with the comforting Caribbean recipes starring avocados, okra, and beans, you'll find delicious crispy baked eggplant with Parmesan from paladar La Cocina de Lilliam, a striking molded side dish of spinach and pumpkin with saffron from artist-chef Alexis Alvarez Armas, and tacos of vegetables (from Finca Marta, of course) with a zesty hot sauce from the hipster O'Reilly 304. As you enjoy them, please salute the island's green revolutionaries like Salcines and Funes and their quest to change Cuba through sustainable agriculture.

PUMPKIN SALAD WITH GARLIC CHIP MOJO

Ensalada de Calabaza con Mojo de Ajo

Tender slices of cooked pumpkin were zapped with a mojo of olive oil, garlic chips, cumin, and lime juice in a delicious salad we've tasted at a gathering of adorable teenage chef apprentices at Havana's Casa del Chef cooking school. For this autumnal dish you can use a number of substitutes for Cuban pumpkin—butternut squash or kabocha squash work nicely here. Make it a hearty meal and serve with Stuffed Pork Loin with Malta (page 267). While it's comforting warm, it's nice at room temperature and holds well as a leftover lunch.

Serves 6

1 (2-pound / 910-g) piece of cheese pumpkin, butternut squash, or kabocha squash, seeds removed, and cut into 1-inch (2.5-cm) wedges

½ cup (120 ml) extra-virgin olive oil

5 cloves garlic, thinly sliced

½ teaspoon ground cumin

1 teaspoon salt

2 tablespoons fresh lime juice

Black pepper

1 tablespoon minced chives

1 Place the pumpkin or squash in a large pot, add water to cover, and bring to a simmer over medium-high heat. Cook the pumpkin until tender, 10 to 12 minutes. Drain and arrange on a large serving platter.

2 In a small skillet, heat the olive oil over low heat. Add the garlic and cook, stirring, until very fragrant but not colored, about 2 minutes. Remove from the heat and whisk in the cumin, salt, and lime juice and pour over the pumpkin wedges. Season with pepper to taste and sprinkle with the minced chives.

HANGING OUT AT THE AGRO

Agros—short for Mercados Agropecuarios—are the farmers' markets scattered every few blocks in all Cuban cities. Agros can be dank warehouses selling little but coconuts, half-rotten yucas, and sugarcane juice, or they can be cheery outdoor stalls festooned with pineapples and sunshine-yellow clusters of baby bananas. They can be cheap, cacophonous sprawls stretching one city block or expensive, well-groomed affairs for those with convertible currency. State-run agros usually carry an inadequate supply of bruised produce at subsidized prices. Private agros— "los caros," the expensive ones—are where farmers bring their surpluses for those who can afford better boniatos and yucas. One such agro, on 19th and B streets in Havana's Vedado, is called "el boutique" for its glowing offerings: un-Cuban rarities like cauliflower and broccoli, misshapen but exuberantly tasty tomatoes costing a Cuban's weekly wage—even exotica like apples and pears, on occasion.

More than simply places to haggle for five kilos of guavas (that crucial vitamin C!), agros in general are vital community hubs. Here citizens exchange recipes, curse government price hikes and the U.S. bloqueo (embargo), bemoan the ever-inexplicable disappearance—the infamous perdído!—of avocados, say, or mangoes, that defies any seasonal logic. In ramshackle, bustling Centro Habana we often soak up local color and gossip at the large, always-busy agro off the main thoroughfare of calle San Lazaro. Outside the market, chatty girls peddle roses in flamboyant tropical pinks, small-leaf albahaca [basil] that tastes vaguely minty, yerba buena [spearmint] for mojitos—and mariposas, the fragrant white ginger flowers offered to Yemaya, the mother of all Orishas [gods] in the Santeria religion. Beside the girls, a toothless pensioner supplements his eight dollars a month by hawking a ragtag miscellany: matches, single cigarettes, home-rolled cigars, clothespins, bags of stale cookies, batteries well past their expiration date. Here, too, scurry the whisperers—the shady black marketeers muttering "patatas patatas" or "langostas langostas," nodding and winking toward their backpacks of illicit potatoes or lobsters. Today someone's selling eggs bought from a state shop—for double the price. An old lady in a frayed housedress apportions strong coffee from a thermos into flimsy paper cups.

Inside the market, the humid air is thick with the cloying perfume of over-ripe papayas and the slurred, garbled, rapid-fire Habanero vernacular. "Don't buy guavas from Yamiley, they're full of worms!" giggles a voice from a stall. "Your mouth is full of worms!" Yamiley zings back, before enticing a passerby with mameys shaped like fuzzy brown baseballs, gouged open a little to display their perfect, bright-orange flesh.

The entire market erupts in sardonic laughter upon hearing we're here to research a book on Cuban cocina.

"Ha ha ha! What cocina?"

"When was the last time Cuba had any food?"

"In Miami," roars a pork butcher in a splotched tank top, "I hear they argue which meats to put in their beans? In Cuba we got no such problems. 'Cause no beef, no tasajo—and no bacalao, and no calamar!"

The backbone of any agro is the aisles of viandas, or tubers: yucas oozing milky liquid from the white hacked-off ends, dense-fleshed calabazas hued Day-Glo orange. The boniatos, malangas, and ñames are so thickly caked in red, iron-rich mud, one shopper urges us to wash them with laundry detergent—if laundry detergent isn't perdído.

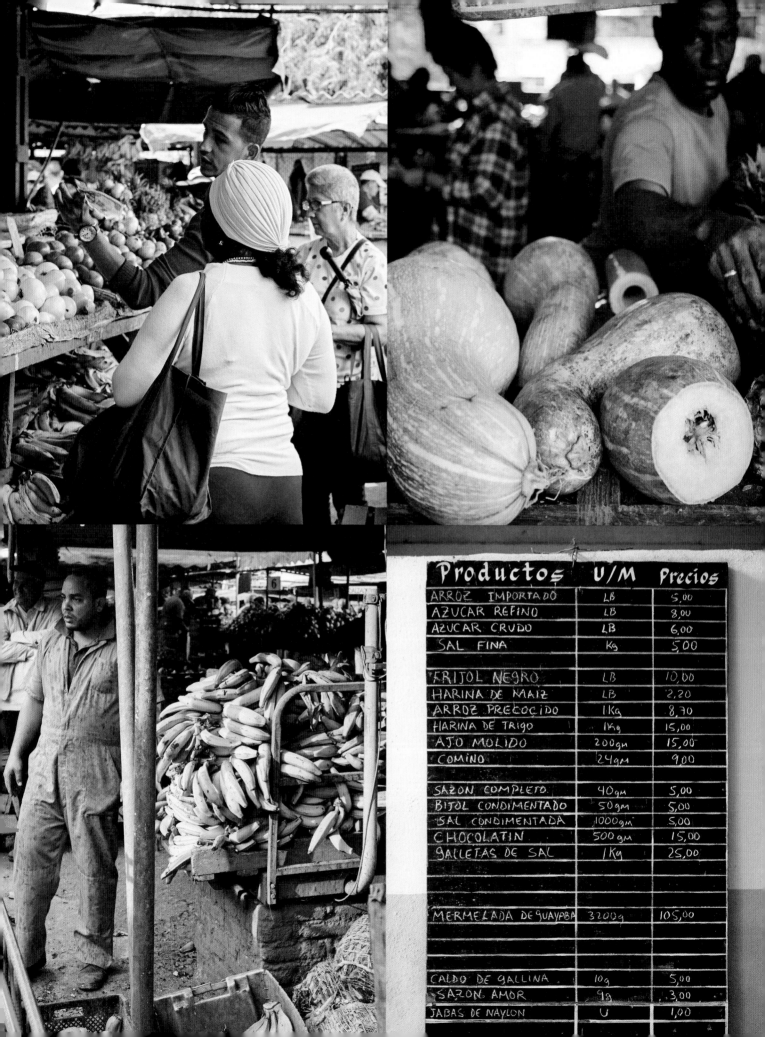

Productos	U/M	Precios
ARROZ IMPORTADO	LB	5,00
AZUCAR REFINO	LB	8,00
AZUCAR CRUDO	LB	6,00
SAL FINA	Kg	5,00
FRIJOL NEGRO	LB	10,00
HARINA DE MAIZ	LB	2,20
ARROZ PRECOCIDO	1 Kg	8,70
HARINA DE TRIGO	1 Kg	15,00
AJO MOLIDO	200 gm	15,00
COMINO	24 gm	9,00
SAZON COMPLETO	40 gm	5,00
BIJOL CONDIMENTADO	50 gm	5,00
SAL CONDIMENTADA	1000 gm	5,00
CHOCOLATIN	500 gm	15,00
GALLETAS DE SAL	1 Kg	25,00
MERMELADA DE GUAYABA	3200 g	105,00
CALDO DE GALLINA	10 g	5,00
SAZON AMOR	9 g	3,00
JABAS DE NAYLON	U	1,00

All these arrays of earth tones are punctuated by small patches of green from longbeans, bok choy, culantro [cilantro's sappier cousin], and bouquets of slender chives that are grown in profusion in Cuba. Here's a granny dressed in a hot-pink, clingy dress, meticulously snapping off the tips of dozens of slender, long quimbombó [okra pods]—to check for that prerequisite crunch—before buying only a handful. The quimbombó seller doesn't seem to mind in the least.

Among the vianda sellers is our new pal Xiomara, who likes to dispense cooking tips with a meaningful, conspiratorial narrowing of her eyes, as if revealing some deep life secret—or a source of black-market shrimp. "So, calabaza," she confides. "Toss some into a pot of white beans cooked with a tomato sofrito, a bouillon cube, and a link of chorizo. But never never add calabaza to black beans!" And always, she instructs, make extra yuca con mojo because fried leftover yuca with mojo "es una maravilla [is a marvel]." *What of boniato?* we ask. Xiomara snorts. "Here in Cuba," she informs us, "dogs, infants, adults—they all eat boniato. So which recipe you want, for dogs or for humans?" She lets out an explosive laugh: "Anyway, it's the same recipe!" Not to be outdone, Xiomara's neighboring vendor with a strange name, Gudelia, gestures at her pile of glossy small berenjenas [eggplants], the season's first. "Wanna lower cholesterol?" she growls. "Cut up one berenjena, steep overnight in water, and drink." Xiomara looks on, narrow-eyed. "They," she whispers, "put eggplants on graves, nine per grave." *They who?* we whisper back. "The santeros!" Xiomara harrumphs. "The priests!"

We drift off toward the giant industrial corn grinder whirring away behind a counter selling harina [flour], in Cuba a term for both the dry flour and the freshly grated corn masa for making tamales. Husks are sold here, too. The cola [queue] for harina is truly eternal, not because corn is almost perdído but because the vendor is recounting the entire plot of a Mexican telenovela. "And then," she informs everyone, "they kidnapped the boy . . . " The corn-buyers collectively gasp. Tamales can wait.

Near the exit, we stop by a small condiment stall crowded with a motley collection of repurposed bottles, each with its own designation. Havana Club rum bottles hold home-made vinegar steeped from pineapple skins. Containers for TuCola, the Cuban cola, harbor rustic tomato puree that tastes slightly fermented, as if left out too long in the tropical sun. Bucanero [Cuban beer] bottles are for picante, the hot sauce, while ones for Cristal [another Cuban beer] contain sour orange juice. The juice is "para adobar todo," the young, flirtatious condiments vendor announces. For marinating everything. "But our vino seco [cooking wine] is the first to sell out," she declares, "because there can be no black beans without vino seco." She sells spices, too: pithy plastic packets, the size of a postage stamp, filled with broken bay leaves, paprika, ground black pepper, cumin, and the all-important Bijol yellow coloring. *How's the curry selling?* we ask. "People buy it for the prestige," she replies, "but they don't really love it." Cumin, though, is another story. "How do you start a revolution in Cuba?" she declares with a chuckle. "Just deprive cooks of their cumin!"

We buy the cumin, vino seco, and some oregano, then head back to our rented apartment kitchen to make a pot of black beans.

AVOCADO SALAD

Ensalada de Aguacate

Native to Mexico and Central America, avocados have for centuries been happily planted and naturalized in the Caribbean and Latin America. A buttery-textured blank canvas to soak up other flavors, the aguacate is cherished in Cuba as a basis for salads, perhaps because it is raw while still tasting like something "cooked." Dress it as Cubans do, with thinly sliced onion and a simple, puckery vinaigrette with lots of black pepper. In season, add slices of mango or orange or grapefruit. The avocados grown on the island are mostly what we call Florida types, large and smooth-skinned, and those are best in this salad.

Serves 4 to 6

2 large Florida avocados, peeled, pitted, and thinly sliced

1 small onion, thinly sliced into rounds

2 tablespoons fresh lime juice

2 tablespoons olive oil

Salt and pepper

1 mango, peeled, pitted, and thinly sliced (optional)

2 oranges or grapefruits, peeled and segmented (optional)

1 On a large platter or serving plate, arrange the avocado slices in a single layer and top with the onion slices. Drizzle with the lime juice and olive oil, and season with salt and pepper to taste.

2 For a refreshing variation on this salad, add either sliced fresh mango or segments of orange or grapefruit.

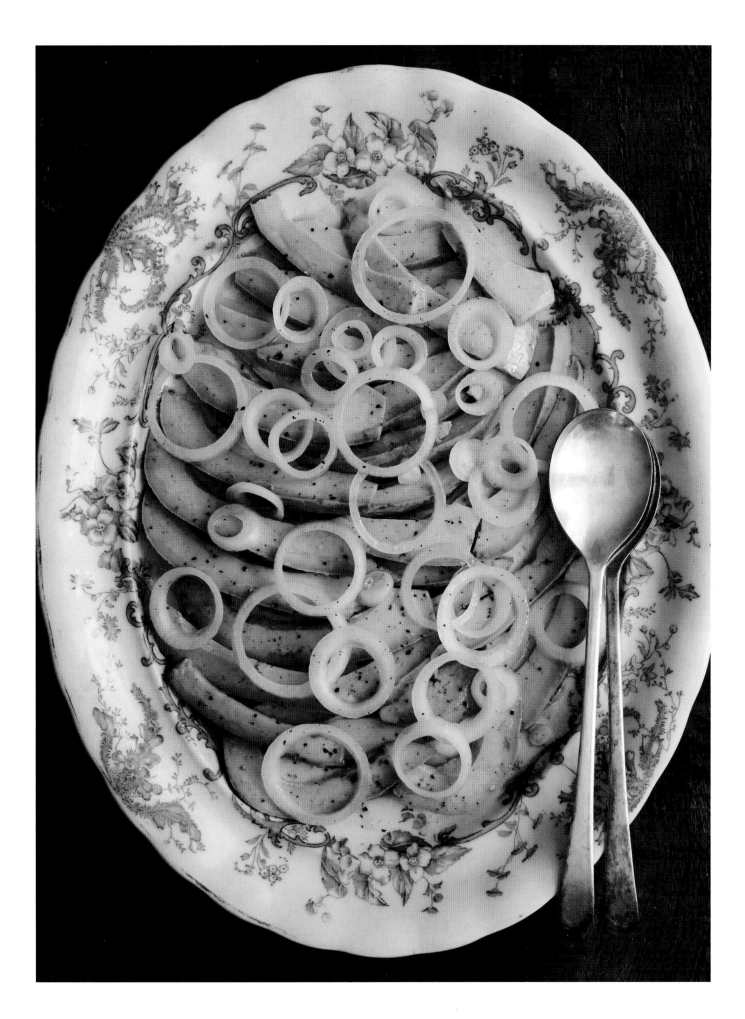

Tamarind Caesar Salad

Ensalada Caesar con Aliño de Tamarindo

Javier Gomez, the playful chef-owner of Elite, took the idea of a Caesar salad and made it his own. Clinging to the Finca Marta mix of tender, bitter greens (arugula, mustard, frisee, and more) and crunchy croutons is his fabulous anchovy dressing, fairly classic but with the distinct sticky-sweet-tart accent of tamarind. Serve with Katia's Quiche (page 137) or Pork with Chickpeas and Sausages (page 271).

Serves 4

1 teaspoon olive oil, plus 3 tablespoons for dressing

½ cup (17 g) sourdough or country bread, cut into 1-inch (2.5-cm) cubes

1 clove garlic, minced

2 tablespoons tamarind paste

½ teaspoon Worcestershire sauce

Salt and pepper

8 cups (320 g) loosely packed mixed baby greens

4 anchovy fillets

¼ cup (25 g) Parmesan cheese shavings

1 In a skillet over medium heat, add 1 teaspoon of the olive oil and toast the bread cubes, tossing frequently, until light golden brown, 3 to 4 minutes. Set aside to cool.

2 In a small bowl, whisk together the garlic, tamarind, Worcestershire, remaining 3 tablespoons olive oil, and salt and pepper to taste.

3 In a large bowl, toss the greens with the tamarind dressing. Place 2 cups of dressed greens on each plate and top each serving with 1 anchovy fillet, 1 tablespoon shaved Parmesan, and 2 tablespoons of the croutons.

FRIED SWEET PLANTAINS

Plátanos Maduros Fritos

To a Cuban palate, nothing tastes sweeter than a plate of fried overripe plantains that caramelize so addictively as to almost veer into dessert. Even the slight greasiness is part of the authentic charm! For optimum sweetness, look for plantains that are almost completely blackened (maduros means "ripe"). If they aren't, let them ripen on your kitchen counter for a few days. To get rid of the extra fat, drain these on brown paper bags, since they tend to make a mess out of paper towels. Serve as a side dish with Picadillo a la Habanera (page 249), a classic combination.

Serves 4

1½ cups (360 ml) vegetable oil or peanut oil, for frying

3 black or heavily spotted plantains, peeled and cut into slices on the diagonal

1 In a high-sided skillet, heat the vegetable oil over medium heat until a drop of water sputters and sizzles when added to the pan.

2 Working in batches to avoid crowding the pan, add slices of plantain to the hot oil and cook, turning once, until well browned and caramelized, 2 to 3 minutes per side. Remove from the oil to drain on a brown paper bag. Repeat with the remaining plantains and eat while hot.

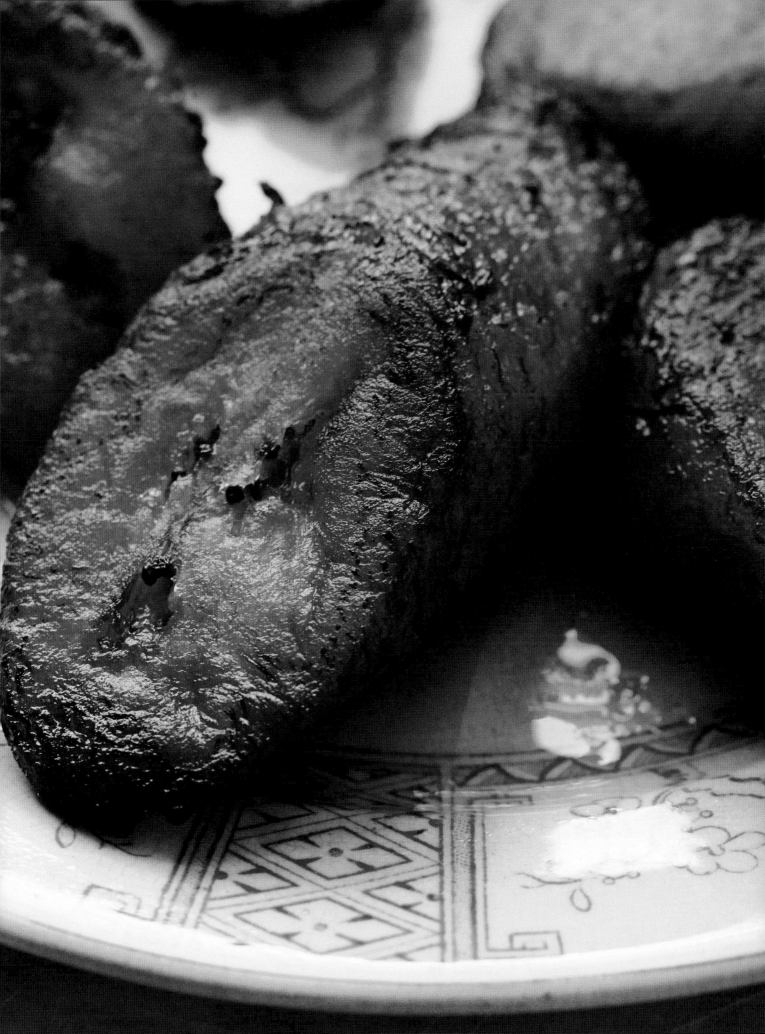

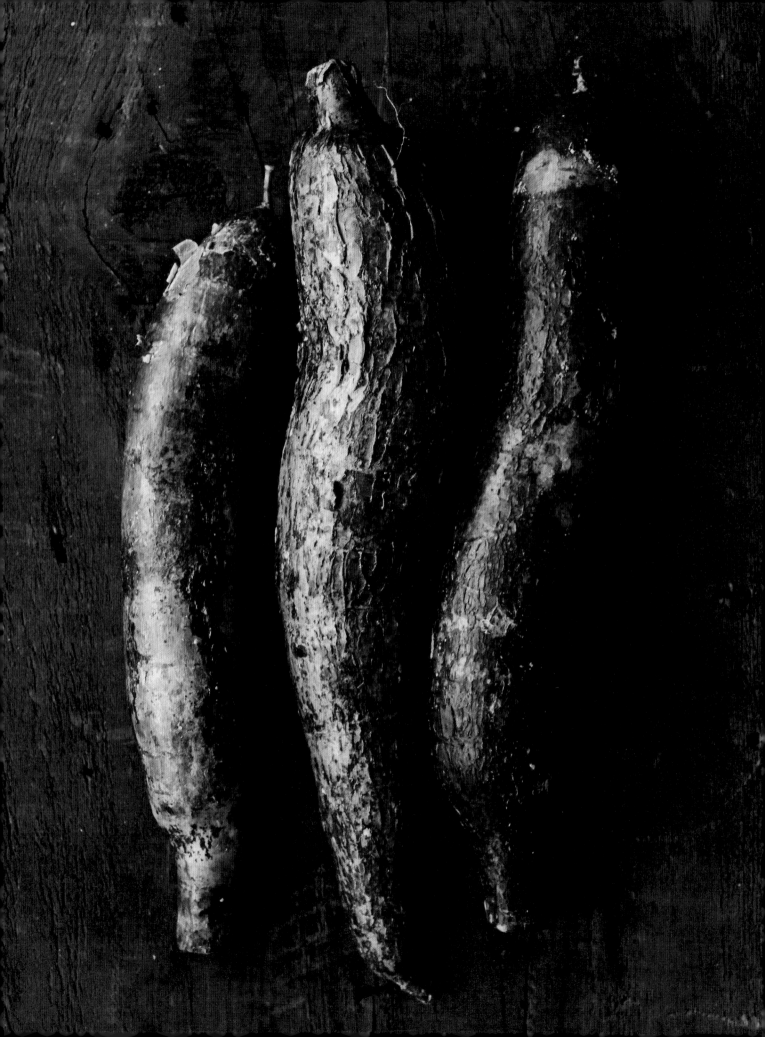

Yuca with Onion Mojo

Yuca con Mojo

Yuca [aka cassava or manioc] is the source of your tapioca. It's also a hugely popular source of carbohydrates in many Caribbean countries, and especially Cuba, enjoyed there as potatoes are in America: boiled, fried, creamed in soup, mashed into fritters—even, believe it or not, mashed and flattened into a pizza base! The slightly nutty taste of this dense, filling tuber becomes positively irresistible when enlivened with a sprightly mojo of sliced onion and sour orange juice. Traditionally served with roast pork, yuca with mojo also makes an excellent side for almost any meat dish in this book. A crucial Cuban trick to achieve a soft, velvety texture is to "asustar la yuca"—scare the yuca—with a splash of very cold water at the end of cooking. Another important tip: time the yuca so it finishes cooking right as the hostess says "a la mesa" [to the table], since it hardens when exposed to air for too long. A delightful folkloric name for this recipe is yuca bautizada, or baptized yuca— baptized with mojo, that is.

Serves 6

2 yuca roots (about 2 pounds / 910 g total), peeled

1 cup (240 ml) cold water

¼ cup (60 ml) olive oil

4 cloves garlic, chopped with 1 teaspoon salt

1 small red onion, peeled and sliced into thin rounds

¼ cup (60 ml) sour orange juice, or an equal mix of lime and orange juice

1 tablespoon chopped fresh parsley, for garnish

Salt and pepper

1 Cut the yuca crosswise into 3-inch (7.5-cm) pieces. Place the yuca in a large pot and cover with water. Bring to a boil and cook until almost tender, about 20 minutes or longer.

2 Add the cold water, then bring the pot back to a boil and continue cooking until completely soft, another 5 to 7 minutes or longer. Let the yuca cool a little in the liquid. When just cool enough to handle, drain and cut the yuca pieces in half lengthwise, using a small knife to remove the tough fibers. Transfer to a serving bowl.

3 While the yuca cooks, in a small pot, heat the olive oil, salted garlic, and onion over medium heat until small bubbles form around the garlic, 2 to 3 minutes. Add the sour orange juice and remove from heat.

4 Top the yuca with the onion mojo and chopped parsley. Season with salt and pepper to taste.

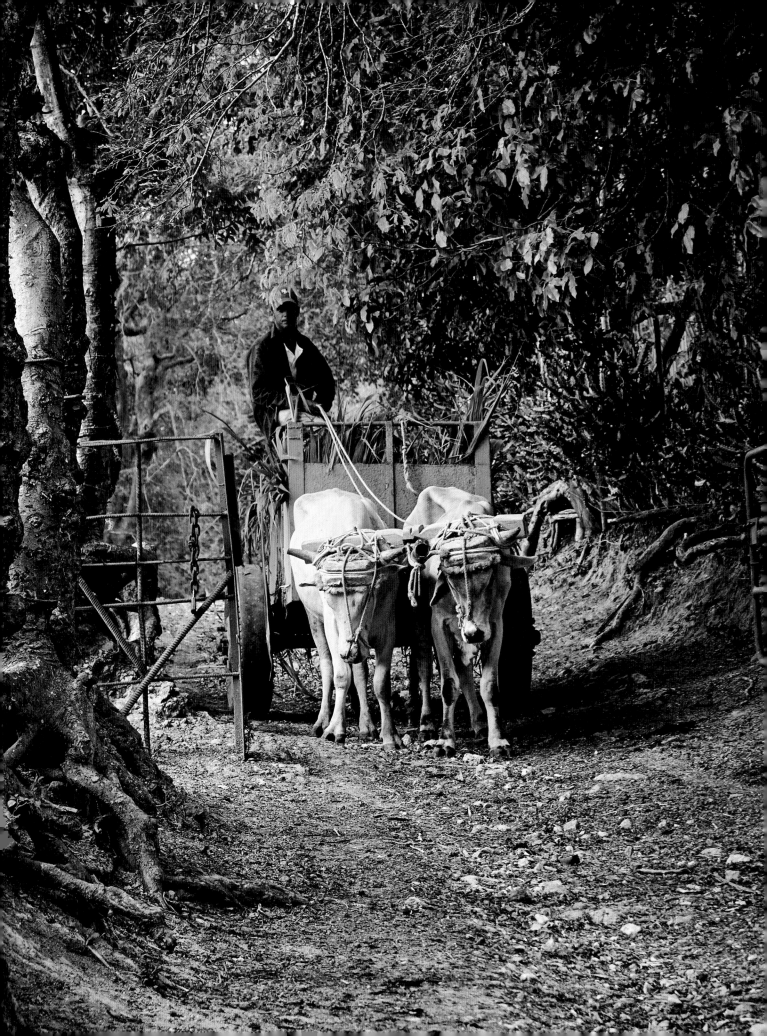

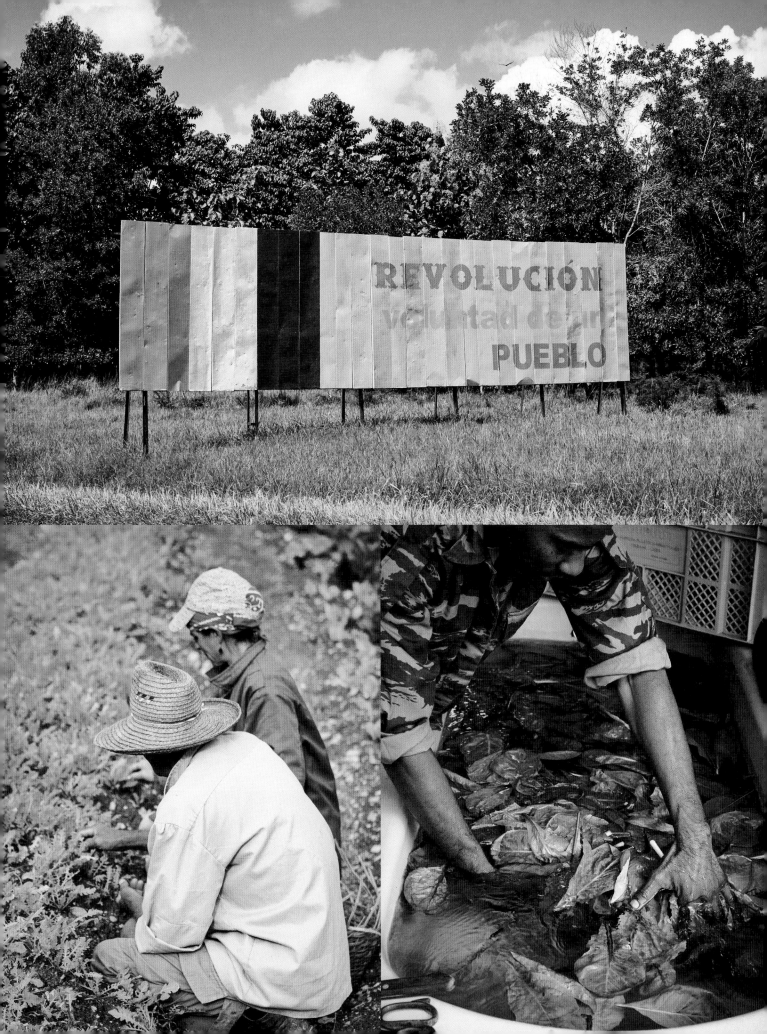

Baked Eggplant with Parmesan

Berenjenas a la Parmesana

This modern take on the Italian classic served at paladar La Cocina de Lilliam involves baby eggplants: thinly sliced, roasted until crisp, and stacked and covered with Parmesan—to be baked until the cheese melts. This goes great with Chicken Tapas with Jamón and Cheese (page 59) as part of a cocktail spread.

Serves 4

3–4 small eggplants (1½–2 pounds / 680–910 g total), thinly sliced lengthwise

Salt

⅔ cup (165 ml) olive oil, plus more for greasing the pans

¾ cup (70 g) grated Parmesan cheese

Black pepper

1 Preheat the oven to 400°F (205°C). Grease four individual ovenproof serving dishes.

2 On a large baking sheet with sides, arrange the eggplant slices in a single layer and sprinkle them with salt and 2 tablespoons of the olive oil. Roast for 12 to 15 minutes, or until lightly brown and soft, flipping once midway. Do not turn off the oven.

3 Place one quarter of the roasted eggplant slices in each of the four baking dishes, arranging them in a flowerlike pattern. Sprinkle each serving with 3 tablespoons of the grated cheese and drizzle with 2 tablespoons of the olive oil. Bake for 10 minutes, or until the cheese melts and bubbles and starts to brown.

4 Remove from the oven, let cool, and season with pepper to taste.

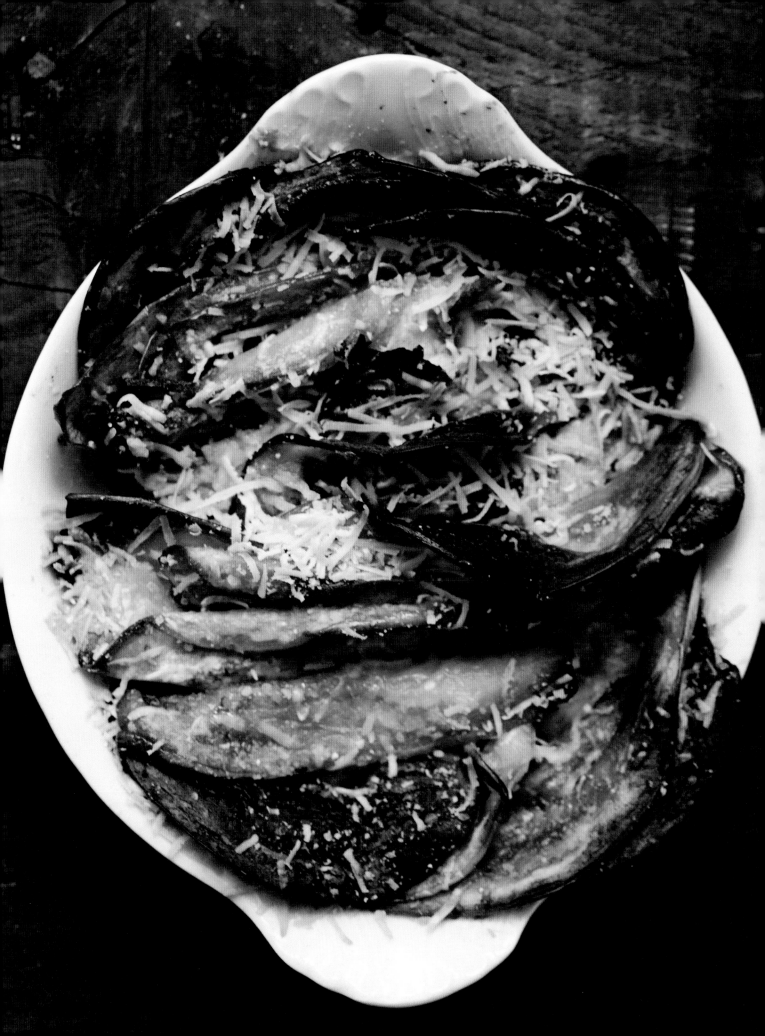

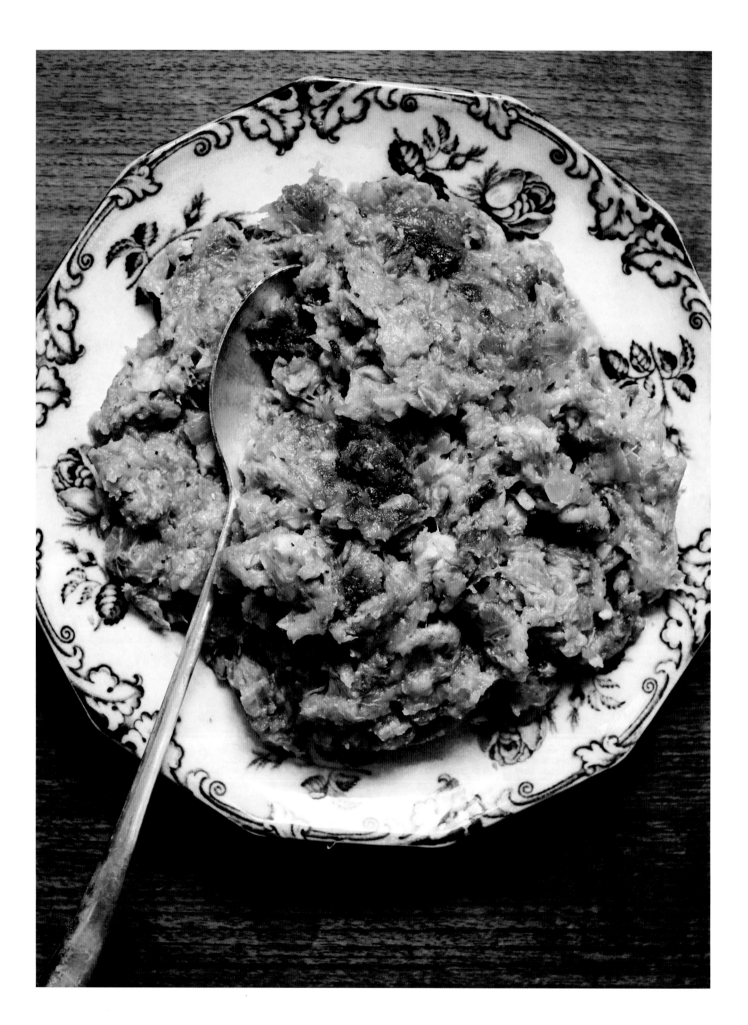

Plantain Fufú with Pork

Fufú de Plátano con Carne de Cerdo

A hearty mush introduced from West Africa to the Caribbean, fufú is prepared in various parts of the world from mashed starchy tubers or flours such as semolina or maize. Cousin of the Dominican and Puerto Rican mofongo, the Cuban version, prepared with green, ripe, or semi-ripe plantain, or a combination of the three, is our favorite. This substantial, garlicky version is flavored with bacon and pork ribs, with sour orange juice contributing tartness, and is an excellent accompaniment to roast pork or other roasted meat. The trick to working with cooked plantains is to keep them submerged in the liquid until ready to use, lest they become gluey and tough. The softer semi-sweet plantains will need almost no additional liquid when you're mashing them. With greener plantains, add extra broth. For a vegetarian version, swap the pork with ¼ cup (60 ml) of olive oil.

Serves 4

3 cups (720 ml) chicken or vegetable broth

3 medium semi-ripe or green plantains, peeled and cut into 3-inch (7.5-cm) slices

½ pound (225 g) boneless pork ribs with some fat, diced

2 slices bacon, diced

4 cloves garlic, chopped

½ cup (55 g) chopped onion

2–3 tablespoons sour orange juice, or an equal mix of lime and orange juice

Salt and pepper

1 In a large saucepan over medium-high heat, bring the chicken broth to a boil. Add the plantains and boil until soft, 20 to 25 minutes.

2 While the plantains cook, in a skillet over medium heat, cook the pork ribs and bacon until they start to crisp and give up their fat, 4 to 5 minutes. Add the garlic and onion and cook for an additional 3 to 4 minutes, until the onions are soft. Set aside and keep warm until the plantains are cooked.

3 With a slotted spoon, transfer the plantains to the skillet. Set the broth aside. Using a potato masher, mash the plantains with the pork and onions. If you used green plantains, add ¾ cup (180 ml) of the reserved broth. (If you used semi-sweet plantains, no reserved broth is needed.)

4 Season with the sour orange juice and salt and pepper to taste.

ALEXIS

LUNCH WITH ALEXIS

A short drive south of Havana lies San José de la Lajas, a drowsy small town where time seems to stand still and donkeys compete on dusty streets with rumbling 1950s Chevys. Here, in a sweetly modest house with a ramshackle tropical garden, the elfin artist, chef, and movie designer Alexis Alvarez Armas lives and cooks with his elegant octogenarian mom. Alexis spends much of his time in their old-fashioned, color-splashed, indoor/outdoor kitchen, one that opens onto a patio with a miniature round swimming pool, bright murals by his own hand—and the table where Alexis gathers friends for his multi-course feasts. These meals are something of a legend in Havana's bohemian circles. The food Alexis prepares is unlike anything anyone has tasted in Cuba: vibrant with spices from his travels, with flavor combinations only he can devise. Chocolate mayonnaise, anyone? Alexis, a slender, merry, bespectacled sprite, whirrs a bright juice of pineapple, parsley, and rosemary in his overworked blender. He drapes a sky-blue fabric over the table and sets out rustic bowls of coconut rice and a curry of papaya and okra. "These albondigas should be as soft as little soufflés," he insists, bringing out a platter of meatballs. Then he returns to his blender—to froth a chilled mango dessert.

"For me each menu is a performance piece full of emotions," he declares.

"And for me—a better cook than my son—I'm left washing the dishes," Señora Yaima, his mom, jokingly grumbles. Alexis chuckles and plants a kiss on her forehead.

Alexis's Story

By profession I'm a movie production designer, though I write novels, too, and film scripts and plays. Knowing my passion for food, Cuban directors often create a food scene just for me—so I can design it and cook!

Recently I worked on *Fast and Furious 8* when they shot here in Havana. Wow! We had to come up with two hundred maquinas [vintage American cars] for the big scene, and we transformed a city park into an impeccable vision of 1950s Havana. How did it all end? With three Cubans hiding inside the American cargo ship with the movie equipment—and escaping to Florida! This was life imitating a film.

I had a charmed childhood here in San José de las Lajas. My parents entertained constantly. They entertained with magic and ceremony, transforming our patio into a stage set with decorations, '50s music, twinkling lights, and big tropical plants. My mom is a real lady, with a penchant for old Hollywood glamour: oversize sunglasses, lace, fans. She adores beautiful china and tablecloths. She decorated her salads as if they were art pieces, made fabulous pig roasts, invented her own fancy dishes like "sorpresa de pan," a bread loaf filled with fruit, custard, and caramel. People say gran cocina cubana is dead, but it lived on in our house. Then, when I was thirteen, my mother got sick and was bedridden for almost a year. I started cooking things like rice and maduros for her. Sitting by her bedside, I prodded her for her kitchen secrets (though I still can't make black beans like she does!). The 1980s were repressive here in Cuba—even listening to Western music could get you in trouble—but we had enough to eat thanks to help from the USSR. Then the Russian subsidies ended, the Período Especial came. We survived thanks to my dad, a prominent doctor. His patients would bring him a scrawny hen or some milk or homemade cheese or things we could barter for.

In the 1990s I moved out of my parents' house into a sea-view flat in Havana. I decorated it with a riot of colors and started inviting foreign friends for potlucks. They brought Brazilian and Spanish and Mexican dishes. It amazed me that you could flavor meat with cinnamon, say, or chocolate. These foreign dishes opened up a whole universe. I started inventing dishes myself. We matched ethnic food with ethnic music, too. Through these parties we discovered the world without having to actually travel. Some years later a friend from the historic town of Trinidad asked me to consult on a paladar she was opening there. So I created the menu. Soon all the other paladares in town were stealing my dishes: my cream of legumes with a subtle perfume of star anise; my pork with a secret accent of coffee. Ultimately, I didn't want the straight-jacket of running a food business. I refused to engage with the black market or with bureaucrats whose answer is always "no, no puede"—"you can't." Who wants to be bribing officials who then show up at your restaurant with seven friends—plus a guitar—and expect a free meal? Now, living in San José again with my mom, surrounded by greenery and my artwork and the objects I bring from Madrid or Berlin, I cook for my friends, and occasionally for some private clients. It's futile asking me for exact recipes! I never cook a dish the same way twice! But you can count on exotic spices and the sweet-sour flavors I love. I travel as much as I can, absorbing the world through its foods. But my home, my garden, my kitchen always call me back. It's a strange, unique place, our Cuba. An island where nothing is possible and everything is possible, too.

Okra Curry with Papaya

Curry de Quimbombó con Fruta Bomba

In the idyllic garden of his home outside Havana, chef, artist, and spice-lover Alexis Alvarez Armas treated us to this intriguing sweet-sour dish of okra, ripe papaya, and onions all heightened with coriander, curry, and lemon juice. The dish, he says, was inspired by a papaya-and-okra salad he once tasted at an artist friend's house in the historic Cuban city of Trinidad. If you like, top the curry with grated white cheese, Alexis suggests. And he adds that even if okra isn't your thing, this dish will convert you. Serve it with steamed white rice and beans.

Serves 4

3 cups okra (465 g), trimmed and sliced into 1-inch (2.5-cm) pieces

Juice of 1 lemon

1 tablespoon olive oil

¾ cup (85 g) chopped onion

½ teaspoon crushed coriander seeds

1 cup (150 g) diced peeled and seeded ripe papaya

1 teaspoon Jamaican curry powder

2 tablespoons fresh lemon juice

Salt and pepper

1 Soak the okra in a large bowl filled with water and the juice of 1 lemon for 15 minutes. Drain, add fresh water, and let it sit for 15 minutes more. (Soaking helps reduce the mucilage, the combination of sugar and protein found in okra pods that can result in a slick texture.)

2 In a large skillet over medium heat, combine the olive oil and onion and cook for 4 to 5 minutes, or until the onion is soft. Add the coriander seeds and papaya and cook briefly, crushing the papaya until it becomes saucy. Drain the okra and add it to the pan along with the curry powder, 2 tablespoons lemon juice, and 3 tablespoons water. Bring to a simmer, cover, and cook for 5 to 6 minutes, or until the okra is just tender. Season with salt and pepper to taste.

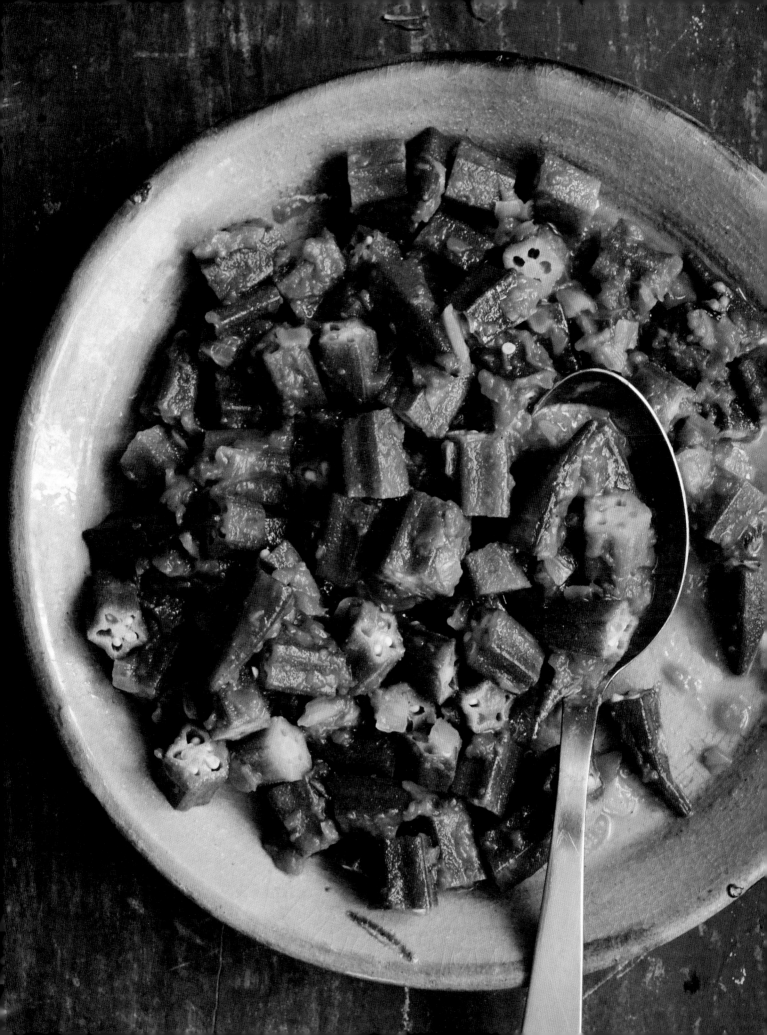

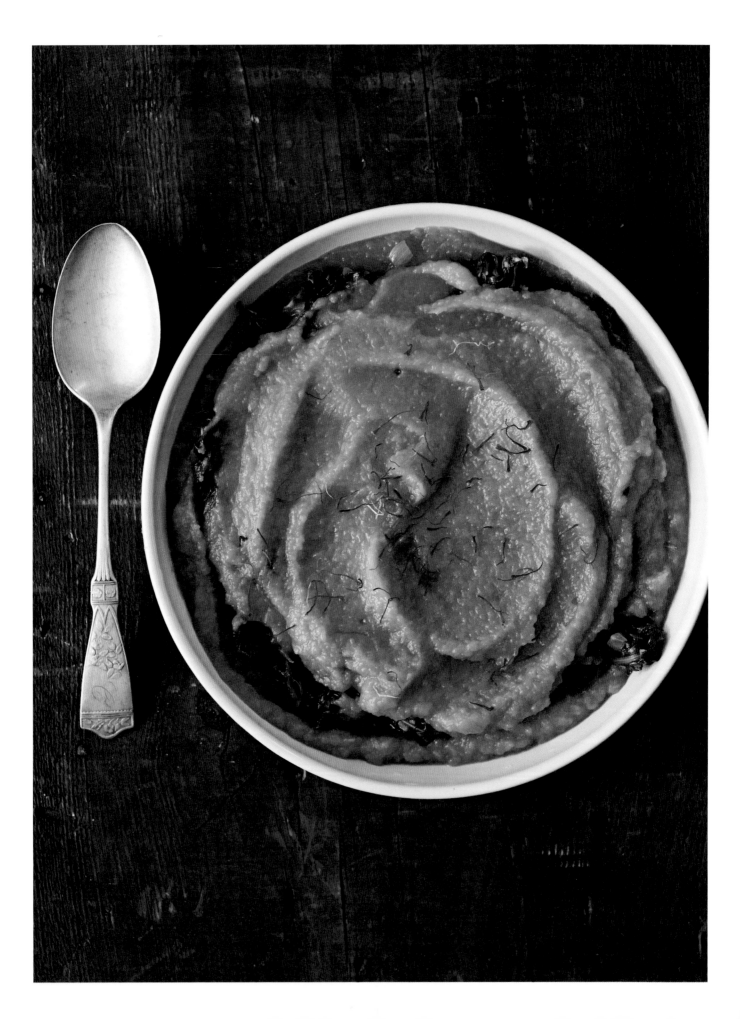

Pumpkin and Spinach with Saffron

Puré de Calabazas y Espinacas con Azafrán

Alexis Alvarez Armas is also the talent behind this lovely, unusual side dish. It was a big hit on the menu of his short-lived paladar in the city of Trinidad. Alexis layers saffron-scented pumpkin puree and spinach into cups and unmolds them onto dinner plates for a striking effect. Here, we use a baking dish, but feel free to improvise. He also suggests serving the dish with a warm sour-orange mojo to heighten the flavors. Serve with a festive main course such as Coffee-Rubbed Pork (page 268) or Trout with Black Bean Sauce (page 142), both from Alexis.

Serves 8

1 tablespoon olive oil

3 cloves garlic, chopped

¼ cup (35 g) finely chopped onion

4 cups (80 g) loosely packed baby spinach

3 pounds (1.4 kg) pumpkin, peeled, seeded, and cut into cubes

3 tablespoons toasted hulled pumpkin seeds

¼ cup (30 g) all-purpose flour

Salt and pepper

¼ teaspoon saffron threads

1 In a skillet over medium-high heat, combine the olive oil, chopped garlic, and onion and cook for 2 to 3 minutes until softened. Add the spinach and cook for 3 to 4 minutes, until wilted and the liquid has cooked out.

2 Bring a pot with 5 cups of water to a boil over medium heat. Add the pumpkin and cook until tender, 20 to 30 minutes, or until easily pierced by a fork. Drain the water and set the pumpkin aside to cool.

3 In a blender or food processor, combine the pumpkin cubes with the pumpkin seeds and flour, season with salt and pepper, and puree on high speed for 2 minutes, or until smooth.

4 Spread half of the pumpkin puree in the bottom of a round 1-quart (1-L) baking dish. Cover with a layer of the spinach mixture and top with the rest of the pumpkin puree. Sprinkle with the saffron and serve.

Vegetable Tacos with Escabeche

Tacos de Verdura con Escabeche

Seasonal vegetables from the wonder-farm Finca Marta provided inspiration for these vegetarian tacos served at the hipster paladar O'Reilly 304 in Old Havana. On the day we visited, the chef stuffed wheat tortillas with carrots, cachucha and bell peppers, zucchini, and thinly sliced radishes for a cool contrast of textures. Even better was his escabeche-like sauce of chipotle chilies and pickled vegetables.

Serves 4

FOR THE FILLING

2 tablespoons olive oil

½ small eggplant, thinly sliced (about 1 cup / 80 g)

1 cup (140 g) julienned carrots

½ cup (60 g) halved and sliced radishes

1 cup (115 g) sliced zucchini

1 cup (110 g) sliced onion

6 cachucha peppers or 2 jalapeño peppers, seeded and chopped

¼ cup (25 g) sliced green bell pepper

Salt and pepper

FOR THE ESCABECHE

1 tablespoon olive oil

½ cup (45 g) thinly sliced fennel

½ cup (55 g) thinly sliced onion

½ cup (60 g) thinly sliced carrot

½ cup (125 g) finely chopped chipotles en adobo, reserving adobo

1 tablespoon white wine vinegar

1 tablespoon light brown sugar

12 small tortillas

1 **Make the filling:** In a large skillet over medium heat, combine the olive oil, eggplant, carrots, and radishes and cook for 3 minutes. Add the zucchini, onion, cachucha peppers, and bell pepper and season with salt and pepper. Cook for 4 to 5 minutes more. Transfer to a bowl and set aside.

2 **Make the escabeche:** In another saucepan over medium-high heat, combine the olive oil, fennel, onion, and carrot and cook for 4 to 5 minutes, or until the vegetables have softened and are starting to brown. Add the chipotles and adobo sauce, vinegar, brown sugar, and 2 tablespoons water and cook for 2 minutes more. Remove from the heat and let the sauce sit for 5 minutes. (The escabeche will keep for up to a month in a sealed jar in the refrigerator.)

3 Heat the tortillas in a dry pan until just warmed. Fill each taco with vegetables and top with escabeche. Serve with half a lime (optional)

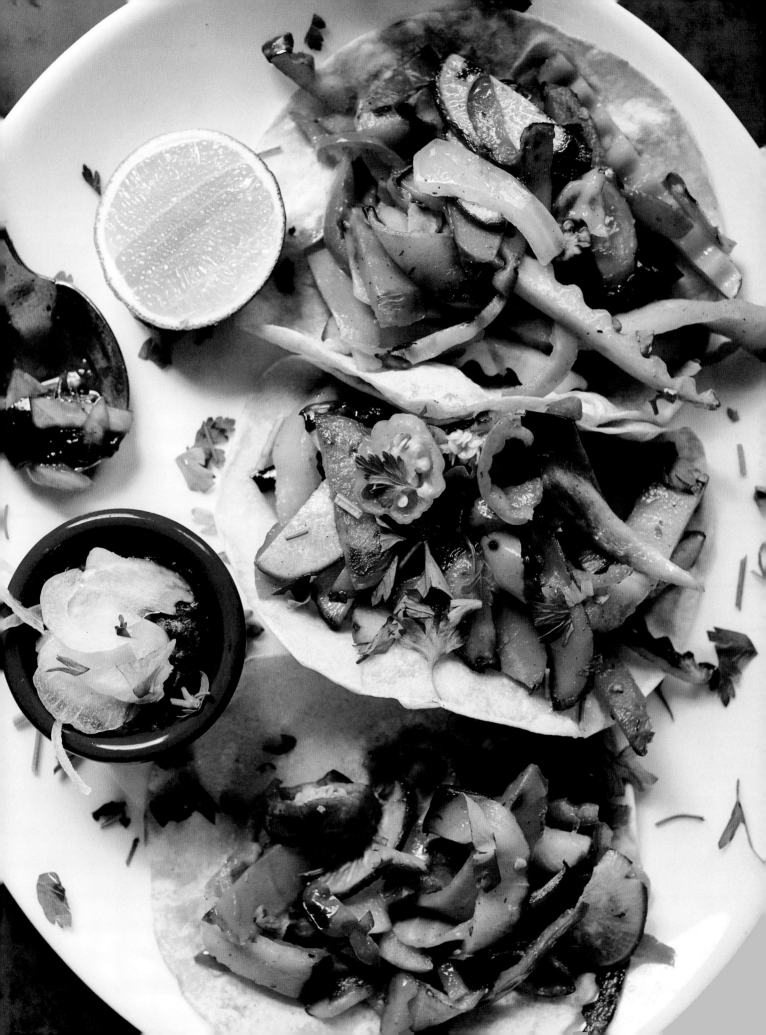

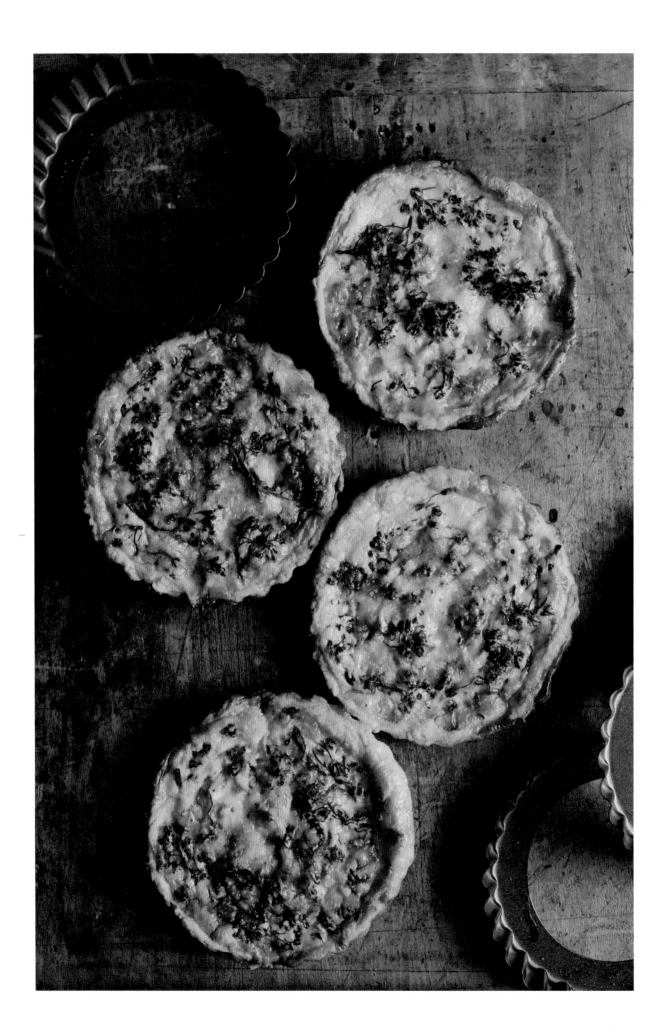

KATIA'S QUICHE

Quiche de Katia

On a cobblestoned lane in Habana Vieja, the boho-chic café Dulceria Bianchini is a sweet spot to escape the afternoon heat with an iced coffee or tea and chic European-style pastries baked from family recipes of the owner, Katia Bianchini. Katia, who came to Havana from Switzerland as a child in 1969, was the one who hooked the city on properly flaky French-style croissants. Her quiches—such as this cheesy beauty with broccoli—are also the talk of the town. Little surprise that Bianchini is the current brunch queen of Havana. Because of Cuba's chronic butter shortages, Katia often uses a shortening-based puff pastry for her quiches and tarts. It has an interesting shaggy texture, she says. Here we offer instead a flaky pastry prepared with cream cheese. Enjoy with a green salad for a light dinner or lunch with Candied Papaya with Grated Cheese and Lime (page 304) for dessert.

Makes six 5-inch (12-cm) individual quiches

1 recipe empanada dough (see page 32)

4 large eggs

¾ cup (180 ml) whole milk

¼ cup (60 ml) heavy cream

⅛ teaspoon ground nutmeg

Salt and pepper

1 teaspoon unsalted butter, plus more for buttering the pans

2 cups (140 g) chopped broccoli

1 teaspoon minced or pressed garlic

¼ cup (35 g) finely chopped yellow onion

¾ cup (85 g) grated sharp cheese, such as cheddar

1 Preheat the oven to 375°F (190°C).

2 Butter six 5-inch (12-cm) pans. Divide the dough into six portions and press the dough into the bottom and sides of the pans. Place the pans on a baking sheet and set aside.

3 In a mixing bowl, whisk together the eggs, milk, cream, nutmeg, and salt and pepper to taste. Set aside.

4 In a skillet over medium heat, combine the butter and broccoli and cook for 3 to 4 minutes. Add the garlic and onion and cook for 2 minutes more, then add ¼ cup (60 ml) water. Increase the heat to medium-high and cook, stirring, until the water evaporates, 3 to 4 minutes. Season with salt and pepper to taste. Transfer the broccoli mixture to a bowl and let cool.

5 Add 2 heaping tablespoons of the broccoli mixture to each of the prepared crusts and ladle about ⅓ cup (75 ml) of the egg mixture over the broccoli in each. Sprinkle 2 tablespoons of the cheese over the top of each of the quiches. Slide the baking sheet in the oven and bake for 15 to 16 minutes, or until the quiches are golden brown on top.

White Rice
Arroz Blanco 145

Yellow Rice
Arroz Amarillo 146

Black Beans
Potaje de Frijoles Negros 150

Black Beans and Rice
Moros y Cristianos 152

Red Beans and Rice
Congri 153

Red Bean Stew
Potaje de Frijoles Colorados 154

Fried Rice
Arroz Frito 161

Fried Chickpeas with Chorizo
Garbanzos Fritos 162

Smashed White Bean Cake
Muñeta de Frijoles Blancos 165

Pumpkin Rice
Arroz con Calabaza 168

Rice with Okra and Ham
Arroz con Quimbombó y Jamón 171

Pork Tamales
Tamal en Hojas con Cerdo 172

Cuban Polenta
Tamal en Cazuela 175

ARROZ, FRIJOLES, Y TAMALES

Rice, Beans, and Tamales

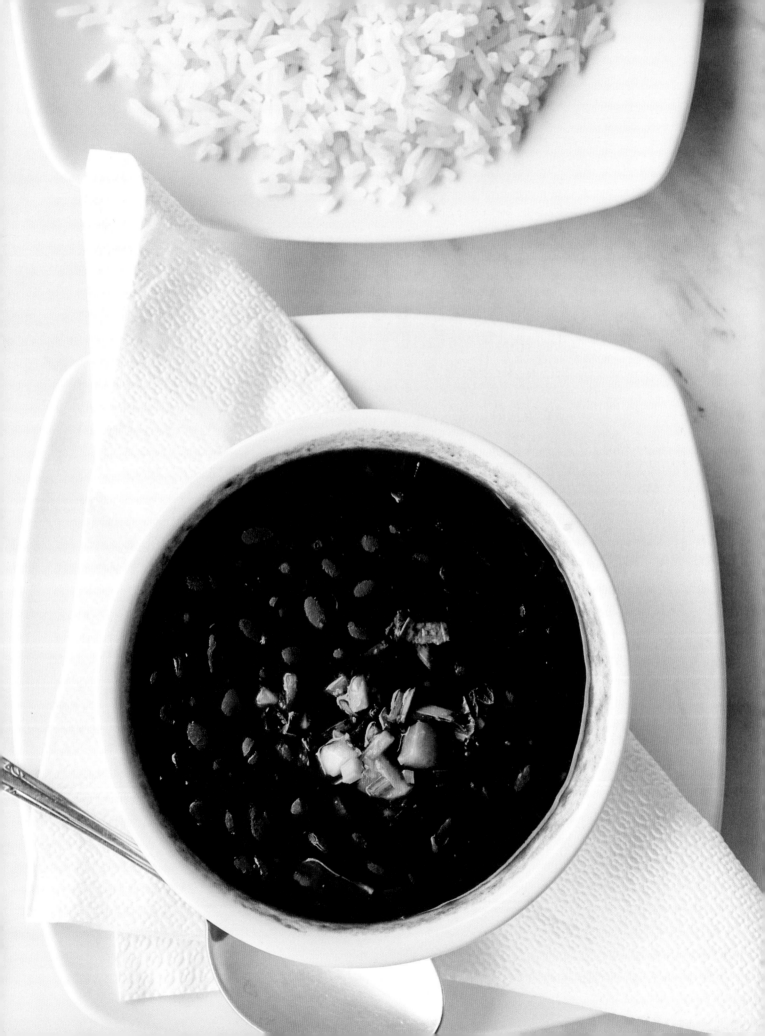

Rice. Beans. Corn. If any ingredients illustrate the phrase "staff of life" to Cubans, these are it.

To celebrate their primal significance—and to just enjoy a long lunch with fellow cooks and plenty of Santiago rum—a great Havana chef, Enoch Tamayo, invited us for a cooking session at his modest house in Playa, a neighborhood of tropical greenery shading slightly ramshackle Art Deco bungalows. Enoch is the founder of Ajiaco Cimarron, an association dedicated to preserving Cuban culinary traditions. We arrived to find Enoch's well-stocked kitchen pungent with the aroma of diced cachucha peppers, garlic, and purple onions for the sofrito base. Enoch and his pal Yasser, the young chef at Havana's Memories Hotel, were prepping away: sautéing different combinations of pork and sofrito, each specific to the recipes they planned to showcase. Enoch's wife, Luanda (yes, named for the Angolan capital), scribbled a last-minute shopping list—plantains, more garlic, scallions, parsley "if it's available!"—for her dad, an elderly academic economist who took off for the agro, the farmers' market, in his beat-up 1984 Fiat.

On the lunch menu: dishes Enoch and his fellow cooks considered the essence of Cubanness. Definitely white rice and black beans, an elemental two-step that, in Enoch's words, "sustained us through poverty and prosperity." Also congri, red beans and rice cooked together in the manner of Cuba's Oriente region, where the food is influenced by Haitian migrants. There'd be tamales, of course, a trio of them: en hojas [wrapped in corn husks], en cazuela [a kind of polenta cooked on the stove-top], and bacanes [the plantain packets particular to Baracoa in Cuba's intensely tropical easternmost province]. For viandas, Yasser made crispy malanga fritters while Enoch planned to impress by turning a homey plantain soup into a foam tour-de-force inspired by his idol, the avant-garde Spanish chef Ferran Adrià.

We were still discussing the menu, sipping guarapo, the refreshing sugar cane juice, when Acela Matamoros and Niove Díaz, both renowned food scholars, chefs, and tamaleras, arrived—lugging along an eight-pound plastic bag of harina, the dry flour that Cubans use for their maize dough for tamales ("masa" to Mexicans).

"Gracias a Dios, our agros still grind fresh corn!" panted Niove. "Otherwise we'd be here all day in this heat, shucking and grating."

"No sweat, mi amor," chuckled Enoch, "I have three mega-blenders!" Enoch also had three pressure cookers, one of which he filled with black beans, and another with red colorado beans for congri. Meanwhile, the women started on the tamales en hoja. After cooking down the ground corn—"with zero dried cornmeal," boasted Acela, because Cuban fresh corn has enough starch to set the tamales— they stirred in a pork and sofrito mix. And suddenly, in seeming minutes, Luanda, Acela, Niove, and Alicia García dexterously transformed the flavored harina into a mountain of neatly wrapped bundles ready for boiling.

"Tamales—it's about women getting together," declared Alicia. "It's about giggling and gossiping," agreed Acela. "It's about Cuban dudes watching them and doing nada, just drinking rum!" said Enoch, taking a swig.

The tamales en cazuela, up next, proved to be more labor intensive. Yasser and Enoch took turns laboriously squeezing white "milk" from ground corn through a sieve, repeating until it was deemed perfectly smooth and ready for simmering— with more pork and sofrito—into a softly creamy polenta-like porridge. "Divine, a pure spirit of corn," Acela enthused, "made just from the milk!" She explained that regional variations of tamales en cazuela abound on the island—some as basic as

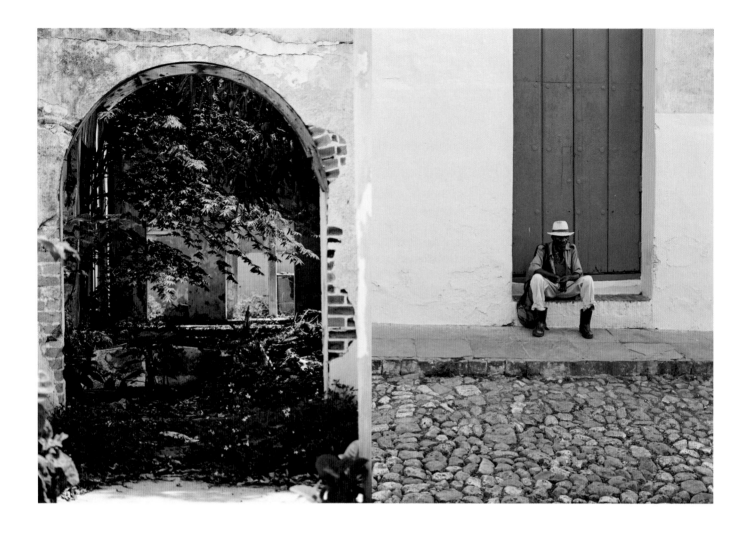

dried cornmeal, water, and salt, others involving complex sofrito and meats cooked over a traditional wood fire.

"Our Taíno ancestors," Acela explained, "ate their corn grilled on the cob, in soupy stews, as popcorn, and as dough wrapped in leaves and baked over coals."

"But tamal en cazuela—it's the dish of African slaves on the sugar plantations," noted Niove, a specialist in Afro-Cuban cuisine. Whereas the bacanes from Baracoa, for which they were now grating the plantains, were a different story entirely. No paved road even existed to that isolated, remote region until the mid-1960s; its pre-Hispanic tropical cooking survived almost intact, more akin to coastal Colombian foods than to anything known in Havana. "In Baracoa, we'd be filling our bacanes with succulent local shrimp," sighed Acela. "But in Havana we have to make do with more pork." But at least the wrapper situation was easy: From his backyard Enoch toted in a giant banana tree branch, and we all sat in his dining room cutting the sappy leaves into squares to bundle the coconut-fragrant masa.

While the tamales and beans steamed and simmered in their pressure cookers and pots, we snacked on Enoch's plantain foam and Yasser's malanga fritters and talked viandas. Niove noted that this Cuban term for root vegetables derives from the French for meats, viandes, which in turn stems from the Latin vivere, meaning "to live." Cubans, she declared, take this "life-giving" meaning quite literally. "Indeed!" said Alicia. "A puree of malanga is the first thing given to babies. It also nourishes the sick and the old."

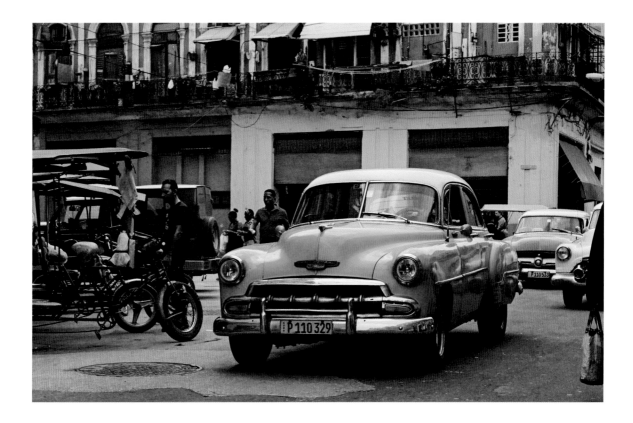

"Tamales, rice, beans, congri—las viandas," Acela pronounced. "These foods are our criollo melting pot that gives life!" Corn, already a staple when Columbus arrived, was in fact called mahiz—life giver—by the Taínos. As for rice, after the Spaniards introduced it to Cuba in the early 1500s, African slaves, for whom the grain was a meaningful and traditional sustenance, became the island's main arroz cultivators. Enoch chimed in that Chinese migrants later brought their own rice savvy. Congri was a contribution from Haitians. And black beans? Originally from the Yucatán, imported to Cuba perhaps in Pre-Columbian times by Maya canoe traders—but cooked Spanish-style by the Iberian colonists.

"And so here we are," Acela summed up. "A table of white, black, and mulatto about to enjoy a super-Cubano meal that intermarries Taíno, Spanish, African, Haitian, and Meso-American influences." As if on cue, suddenly all the dishes were ready: the deep-flavored black beans, the bouncy grains and beans of congri flavored with traditional lard and pork chicharrones, the various tamales with their different inflections of irresistible earthiness.

We sat there discussing black beans (see page 149) when Enoch's father, Leonardo Tamayo, an athletic, dignified Afro-Cuban gentleman, dropped in for a bite. *And what line of work are you in, Papa*, we asked, forks busy with congri. "Me?" said Papa. A small, meaningful pause. "I was Che Guevara's aide and long-time right hand, one of the three Cubans who survived the Bolivian jungle." Our turn to pause. *And what . . . what did, um, Che . . . what did he like to eat?* we asked, too awed to think of a more substantial question. "Che ate pretty much what we're eating today," replied Papa. "Rice, beans, viandas—and he always dined with his guard. But as an Argentinean and a doctor," he added, "Che always lectured us on nutrition and insisted on a side dish of a big green salad, whatever he ate."

That, Papa observed with a hint of a smile, didn't seem very Cuban to his comrades.

WHITE RICE

Arroz Blanco

An indispensable foil for saucy bean dishes and stews, a bowl of white rice anchors most Cuban meals. The Cuban state's libreta, or ration card, guarantees five pounds of rice per person a month at subsidized prices. For a family of two adults, that's a whopping ten pounds of arroz, and Cubans use every grain. Traditionally rice was prepared on the stove-top (method follows), but modern Cuban cooks are as attached to their electric arroz cookers (Hitachi brand, usually) as Asian cooks are. That's because rice cookers—and pressure cookers for beans—were distributed and subsidized by the government.

"Rice for us is as basic as tap water," our friend Niove Diaz, a wonderful chef and cooking teacher, grumbled one day. "But who even knows these days how to cook it well in a pot?" Meanwhile, she added, at cooking schools, chefs are still quizzed on entrance exams about the different varieties of rice and their cooking techniques. To a Habanero [Havana] palate—and eye—white rice should look shiny, with the grains perfectly desgranado [separate]. Here cooks who still make rice in a pot might quickly sauté raw grains in lard or olive oil with garlic before adding water. In the Oriente province, however, Niove explained, folks tend to prefer their rice a little bit asopado, or soupy-sticky, usually adding more water. Whether to wash the rice or not is an eternal dilemma. Does rinsing wash away all the nutrients? Or are thorough rinsing and ample resting time keys to fluffy, perfectly separate grains? We say: Rinse, because a well-rinsed rice requires a lot less water and delivers the bouncy grains that we love. In the United States, older Cuban émigrés swear by Mahatma brand long-grain rice, if only because it was available in Cuba B.C. (Before Castro, that is). Younger Cubans, meanwhile, have been converted to Uncle Ben's. We recommend Goya.

We've included a recipe for one cup so you can easily double or triple the recipe for a crowd (or leftovers!).

Serves 4 as a side

4½ teaspoons olive oil

1 clove garlic, smashed

1 cup (185 g) long-grain white rice, rinsed in a fine-mesh strainer until the water runs clear

¾ teaspoon salt

In a saucepan with a tight-fitting lid over medium-high heat, add the olive oil and garlic and cook until the garlic is golden, about 1 to 2 minutes. Remove the garlic and add the rice, 1¼ cups (300 ml) water, and the salt. Cook the rice, uncovered, until most of the water is absorbed and small holes form on the top, 10 to 11 minutes. Reduce the heat to very low, cover the rice, and cook for 5 minutes. Remove from the heat and let stand, covered, for 5 minutes more. Uncover and fluff the rice with a fork.

YELLOW RICE

Arroz Amarillo

Because saffron is expensive and hard to procure in Cuba, many cooks rely on an artificial-tasting (but dearly loved) Bijol brand seasoning mix containing powdered annatto seeds and cumin, among other ingredients. But why reach for Bijol when a homemade orange-hued oil infused with achiote seeds does the coloring trick beautifully? This sunny-hued arroz amarillo, sweetened with onions, will dance a perfect two-step with bean dishes and saucy stews.

Serves 4 as a side

2 tablespoons annatto oil (recipe follows)

¼ cup (35 g) finely chopped yellow onion

1 cup (185 g) long-grain white rice, rinsed in a fine-mesh strainer until the water runs clear

Salt and pepper

In a saucepan over medium heat, combine the annatto oil and onion and cook for 2 to 3 minutes to soften. Add the rice and 1¼ cups (300 ml) water and cook, uncovered, until most of the water is absorbed and small holes form on the top, 10 to 11 minutes. Reduce the heat to very low, cover the pan, and cook for 5 minutes. Remove from the heat and let stand for 5 minutes more. Season with salt and pepper to taste, and fluff with a fork.

ANNATTO OIL

2 tablespoons achiote seeds

½ cup (120 ml) olive oil

In a small saucepan over medium-low heat, combine the achiote seeds and olive oil and cook for 5 to 7 minutes. Remove the pan from the heat and let cool. Strain the seeds out of the oil and keep the oil in a jar with a tight lid. Annatto oil can be stored for up to a month as a seasoning for yellow rice, meat, and poultry dishes.

A POT OF BLACK BEANS

Feeling blue or stressed? Hungover, lovesick—or just plain starving? Take heart: There isn't a problem in the world that can't be solved with a pot of earthy, mellow black beans and rice—especially if you're Cuban. The secret to perfect frijoles? Well, that depends on who's at the stove. Because when it comes to cooking black beans, cada cocinera tiene su librito—broadly, there's more than one way to skin a cat. The hallowed "never tomato" orthodoxy? It's contradicted by a famed frijoles a lo menocal recipe, wildly popular in 1950s Havana, which uses tomatoes. Plus today's Cubans "would rather be without tap water than without their tomato paste," as one food journalist put it. Then there's *Delicias de la Mesa*, a 1920s Cuban kitchen bible, which suggests thickening beans with cornstarch, while Nitza Villapol, Cuba's Julia Child, insists that beans must be soaked with a chile, then cooked in the same liquid. Flavorings? They range from ham hocks to sour orange juice to sherry or vinegar. And my-bay-leaf-is-better-than-your-cilantro arguments are profound enough to ruin friendships. In the end, your own abuela's recipe is always the best, the purest, the ultimate—because a bowl of black beans has a Proustian power to transport you back to your childhood.

Not wanting to miss out on any crucial frijoles wisdom or cooking tips, recently we sat down with a distinguished group of Havana's food scholars and chefs to seriously talk beans.

"People argue over seasonings," led off chef Enoch Tamayo. "But in a dish this fundamental and simple, you start with good, noble beans, and the rest will follow." Alicia García, grande dame of Cuban food journalism, nodded approvingly. Frijoles negros, she declared, is one of those dishes "que mas sabe con menos"—where less is more. Enoch continued that it was fascinating how one pot of beans gave you three different textures. "First they're soupy and slippery," he noted. "The next day, you reduce them over high heat and get the creamy frijoles dormidos [sleeping beans]—then you whiz what's left in a blender and it becomes what we Cubans call a puré africano."

Acela Matamoros, a food scholar who tends to talk about food as if it were political science, spoke next. Frijoles, she insisted, is "un plato muy disputado," a much-disputed dish. In Oriente province, for example, beans are flavored with cilantro and a strong-tasting sofrito, and viandas are added to thicken the sauce. "Kind of like a feijoada!" Enoch jumped in. Whereas Habaneros, Acela continued sternly, "would spit" at any trace of calabaza or plantain in their black beans. "A recipe is a dialectical process," concluded Acela. Everyone grinned. "Acela is a profa [professor], too smart by half—and a Marxist!" chuckled Alicia.

"I used to be a Marxist," Acela corrected, with dignity. "But now, I'm not so sure . . . "

"When we talk about beans," proclaimed Niove Diaz next, "we're really talking about our raíces, our roots." Niove, the ebullient chef of paladar Santa Ana, is working on a book on Afro-Cuban cuisine. "In our family, generations of cooks mashed a cupful of beans with the sofrito before adding it to the pot," Niove offered. "Plus, Grandpa had a secret weapon: A splash of red wine for beans so exquisite, they tasted to us like food for the gods!"

BLACK BEANS

Potaje de Frijoles Negros

This recipe features a sofrito of onions, garlic, and peppers, with splashes of vinegar and a pinch of sugar added in the end to bring out the flavors. To this vegetarian sofrito base, feel free to add sautéed bacon or a bit of chopped smoked ham if you desire a meatier flavor. Sliced pimento-stuffed olives and / or chopped roasted peppers? Why not! And if you're feeling experimental, try a heretical grating of dark chocolate instead of the sugar to add secret depth.

These beans are pretty soupy, meant to be spooned over rice; if you like your beans thicker, mash about a cupful and add them back to the pot. If you'd rather not soak the beans, cook them for about 45 minutes longer, adding an extra ½ cup (120 ml) of water. Another neat trick to prevent the beans from bursting while cooking is to add about ½ cup (120 ml) cold water every once in a while to slow down the boiling. Goya brand dried black beans are a good choice: They are creamy and hold their shape nicely. If buying beans in bulk, go for legumes that are shiny and brightly colored (and free of tiny holes, which might be insect marks). Many Cuban exiles in the States flavor their beans with Artañan brand vino seco, a cooking wine beloved by Cuban cooks in this country. Dry sherry or dry white wine will also do fine, and some cooks in Cuba favor red wine.

Serves 8

FOR THE BEANS

1 pound (455 g) black beans, washed and picked over

1 bay leaf

½ cup (75 g) chopped green bell pepper

1 clove garlic, smashed

FOR THE SOFRITO

3 tablespoons olive oil

1 cup (110 g) chopped onion

½ cup (75 g) chopped green bell pepper

3 large cloves garlic, chopped

1 tablespoon salt

2 teaspoons ground cumin

1 teaspoon dried oregano

2 tablespoons red wine vinegar

1 teaspoon sugar

1 **Make the beans:** Quick-soak the beans to soften them: Place the beans in a pot, add water to cover, and bring to a boil. Immediately turn off the heat and let the beans soak for 2 hours. Drain the beans and leave them in the strainer until ready to use.

2 Place the beans in a large pot and add the bay leaf, green pepper, garlic, and 10 cups (2.4 L) water to cover. Bring to a boil over high heat, reduce the heat to low, and simmer the beans for 45 minutes to an hour, adding more water if necessary to keep the beans covered.

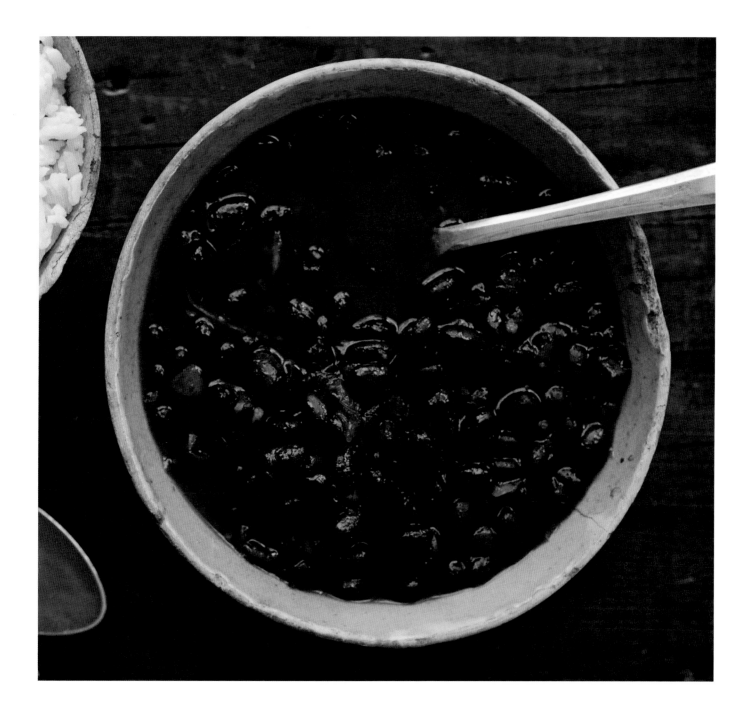

3 **While the beans are cooking, make the sofrito:** In a large skillet, heat the olive oil over medium-high heat. Add the onion and green pepper and cook until they start to soften, about 7 minutes. Add the garlic, salt, cumin, and oregano and continue cooking until the garlic is fragrant, about 1 to 2 minutes.

4 Taste the beans for tenderness; they should be smooth and creamy. Stir in the sofrito, red wine vinegar, and sugar and cook for 10 minutes more to blend the flavors.

Black Beans and Rice

Moros y Cristianos

In medieval Spain, Moros [Moors] and Cristianos [Christians] had been at each other's throats for several centuries. But in this emblematic and festive Cuban pot, classic to Havana and the western part of the island, black beans and white rice steam together in the beans' inky-black cooking liquid to achieve a spectacular harmony. The traditional proportion is two parts raw rice to one part cooked beans, but that doesn't mean you can't take any liberties. What's important is to cook the beans to the point where they are tender but still slightly firm—so that the finished dish isn't mushy. The final color of your moros is a personal preference; add more or less of the black bean cooking liquid as you desire. Either way, in this recipe the sofrito is blended so as to melt into the beans, leaving them smooth and flavorful.

Serves 8

¼ cup (30 g) chopped onion

¼ cup (35 g) chopped green bell pepper

3 cloves garlic, chopped

1 tablespoon olive oil

1 cup (185 g) long-grain white rice, rinsed in a fine-mesh strainer until the water runs clear

1 cup (185 g) cooked black beans, or one 15.5-ounce (440 g) can, drained with liquid reserved

Reserved black bean cooking liquid

Salt and pepper

1 In a blender or food processor, puree the onion, bell pepper, and garlic until thoroughly combined.

2 In a saucepan with a tight-fitting lid over medium heat, combine the olive oil and pureed vegetables and cook for 3 to 4 minutes, until the onion juice cooks down. Add the rice, black beans, black bean liquid, and ¼ cup (60 ml) water. Cook, uncovered, for 10 minutes, or until small holes form in the top of the rice.

3 Cover the pan, reduce the heat to very low, and cook for 5 minutes more. Remove from the heat and let stand for 5 minutes. Fluff with a fork and season with salt and pepper to taste.

Red Beans and Rice

Congri

A common heritage connects Cuba's congri with the red beans and rice of Louisiana. In 1791, the revolution in Saint-Domingue (present-day Haiti) that was to last thirteen years unleashed a massive multiracial exodus. The French fled with the slaves they managed to keep, as did free people of color. Thousands ended in eastern Cuba; thousands more, both black and white, found shelter in North America, especially in southern Louisiana. Wherever they went, the French-speaking Creoles cooked red beans and rice. Cuba's famed folklorist Fernando Ortiz explains: "The term 'congri' comes from Haiti, where the colored beans are known as congo and rice is riz, as in French." So in Haitian Creole, "congri" is a happy contraction of "congo" and "riz." During the early part of the 1900s, Haitians continued to flock to Cuba to work as braceros [manual laborers, from the Spanish brazo, meaning "arm"] in the sugarcane fields. By the late 1930s, when the market for sugar fell, many were simply kicked out and sent home—but their cooking and culture greatly influenced Cuba's Oriente region.

Serves 4

FOR THE SOFRITO

2 tablespoons olive oil

1 small onion, chopped

1 small green bell pepper, chopped

4 cloves garlic, chopped

1 teaspoon ground cumin

½ teaspoon oregano

FOR THE RICE AND BEANS

1 cup (185 g) long-grain white rice, rinsed in a fine-mesh strainer until the water runs clear

1 cup (185 g) cooked red beans, or one 15.5-ounce (440 g) can, drained with liquid reserved

Reserved red bean cooking liquid

Salt and pepper

1 **Make the sofrito:** In a saucepan with a tight-fitting lid, heat the olive oil over medium-high heat. Add the onion and green pepper and cook until the vegetables start to soften, about 7 minutes. Add the garlic, cumin, and oregano and continue cooking until the garlic is fragrant, about 1 to 2 minutes.

2 **Make the rice and beans:** Turn the heat to medium and add the rice, stirring to combine for about 2 minutes. Add the red beans, red bean liquid, and ¼ cup (60 ml) water and bring to a boil. Reduce the heat to low and cook, uncovered, for 10 to 12 minutes, or until most of the liquid has been absorbed and small holes form in the top of the rice.

3 Cover the pan, reduce the heat to very low, and cook for 5 minutes more. Remove from the heat and let stand for 5 minutes. Fluff with a fork and season with salt and pepper to taste.

Red Bean Stew

Potaje de Frijoles Colorados

Frijoles colorados, or red beans, rule in Oriente, the island's lush southeastern region where it is customary to add some viandas [tubers] to the pot to add some lush creaminess. Derived from Spanish potajes [soupy one-dish meals], this version, loaded with pork and smoked ham hock, is more of a stew—a rib-sticking meal for a blustery day. Traditionally the sofrito for this dish is fried in lard, but you can substitute olive oil. Nitza Villapol, Cuba's answer to Julia Child, recommends marinating the pork in sour orange juice before cooking and adding a bit of pureed canned red peppers and a splash of white wine to the pot.

Serves 8 to 10

FOR THE BEANS

- 1 pound (455 g) dried red kidney beans, soaked overnight in 10 cups (2.4 L) water
- 1 smoked ham hock
- 1 pound (455 g) smoked pork shoulder, cut into cubes
- 1 medium potato or small boniato, peeled and cut into cubes
- 1 pound (455 g) calabaza or butternut squash, peeled and cut into cubes
- 2 bay leaves

FOR THE SOFRITO

- 2 tablespoons olive oil
- 1 small onion, chopped
- 1 small green bell pepper, chopped
- 4 cloves garlic, chopped
- 4 ounces (115 g) Spanish chorizo, sliced
- ¼ cup (60 ml) dry white wine
- Salt

1 **Make the beans:** Bring the beans, in their soaking water, to a boil. Add the ham hock and pork shoulder and add enough water to keep covered by 2 inches (5 cm). Reduce the heat and simmer, covered, skimming foam and adding water to keep covered until the beans are nearly tender, about 1½ hours.

2 Add the potato, calabaza, and bay leaves and cook until the beans and vegetables are tender, about 20 to 25 minutes more. Discard the bay leaves. Remove the ham hock, shred any meat attached to the hock, and return the meat to the pot.

3 **Meanwhile, make the sofrito:** In a large skillet, heat the olive oil over medium-high heat. Add the onion and green pepper and cook until they start to soften, about 7 minutes. Add the garlic and chorizo and continue cooking until the garlic is fragrant, about 1 to 2 minutes. Pour the wine into the skillet and cook until it is reduced by half.

4 Add the sofrito to the pot and simmer for 20 minutes. Add salt to taste. Serve in bowls, accompanied by rice.

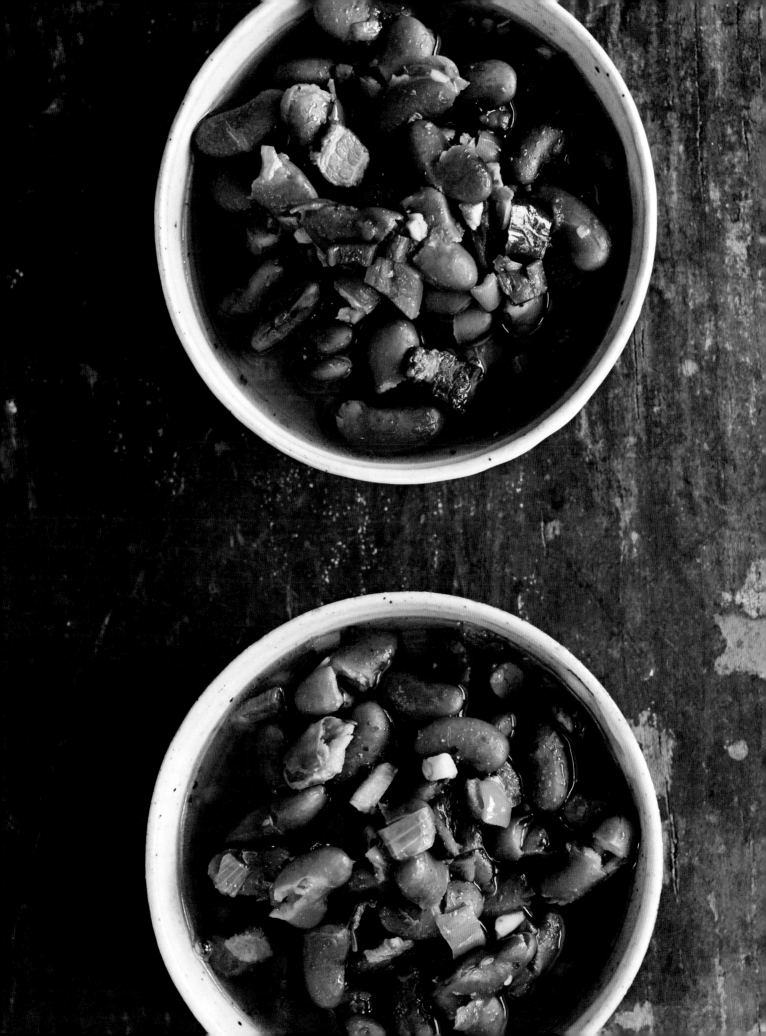

LUNCH IN BARRIO CHINO

Though you enter it through the imposing faux Ming Dynasty Dragon Gate, Havana's once-illustrious and notorious Barrio Chino is today nothing more than a few restored streets with a handful of actual Chinese residents. Along its petite main drag, the pedestrianized calle Cuchillo, paper lanterns dangle above a string of touristy restaurants as non-Asian Cuban girls in red cheongsams lure passersby with fried wontons and sticky-sweet pork ribs. There is a Chinese association here, decorated with a mural of the Great Wall of China; in nearby shade a few straw-hatted old Chinese gents clack on their dominoes. The little neighborhood's most visible landmark remains the ornate white 1920s Pacifico building, whose panoramic top floor once housed a famed Chinese restaurant where Hemingway lunched and Castro ordered fried rice and chop suey—never mind that El Comandante called Mao "a shit," nationalized Chinese businesses in 1959, and essentially drove the community off the island.

"You need mucho imagination," says our Cuban-Chinese friend Rafael Lam, "to realize that our little Barrio Chino was once the beating heart of Havana—the largest and most vibrant Chinatown in all of the Americas." Not to mention a celebrated hive of vice and pleasure. The floor below where Hemingway lunched held an opium den; two blocks away stood the infamous Teatro Shanghai, internationally popular for its sex shows. Rafael, in his seventies, wire-thin, and ever ready to eat, is a renowned journalist and chronicler of Havana's street life and musical culture. He offered to take us on a lunchtime Barrio Chino tour.

"The first Chinese arrived in Cuba in 1847," Rafael explains as we pass under Dragon Gate toward the restaurant row. They were indentured labor, brought to work on sugar and coffee plantations to supplement dwindling African labor after much of Europe had outlawed slavery. "The life of those chinos was brutal," Rafael sighs. Paid four pesos a month, beaten, fed maize instead of the familiar rice—many died from the terrible working conditions. But the descendants of the survivors eventually thrived, many of the men marrying Cuban women—starting small farms and businesses. "And don't forget," he notes with pride, "our chinos fought alongside Cubans to overthrow the Spanish in the War of Independence in the 1890s." By the twentieth century, the Chinese in Cuba numbered some 150,000, their ranks augmented by American-Chinese from California and new arrivals from China. Barrio Chino bustled with Chinese fondas [small restaurants], pharmacies, laundries, and schools, along with brothels, sex clubs, and gambling dens. There were four Chinese-language newspapers, a big Chinese cemetery, and hugely popular Chinese opera shows.

"My own father came from Canton in the 1920s for business," Rafael tells us. "He married a Cuban, had ten children, and ended up owning half of the real estate in this neighborhood." The arrival of a dish of plump Shanghainese dumplings pauses his narrative.

We're having lunch at Tien-Tan, Havana's only authentic Chinese paladar, run by a brother and sister from Shanghai. The brother, Tao Yan, a handsome young former businessman, joins us to relate how he and his sister ended up in Havana. It's quite a story. In the mid 1990s their father, a Shanghai artist and businessman, was visiting Bolivia when he saw a small newspaper notice about Cuba's new business openings. So he went to Havana to see—and found none for himself. Just to be sure, he sent over Tao Yan's sister, Tao Qi, to double-check. "And my sister wound up falling in love with a local Cuban-Chinese kung-fu celebrity," Tao

Yan declares with a laugh, "who was this paladar's original owner." Rafael's eyes widen. "You mean kung-fu star Master Roberto Vargas Lee? Their wedding was *huge* news in Cuba!" Tao Yan beams. "It was the first Cuban-Chinese marriage after decades and decades. My sister restarted a dynasty just as the relationship between Cuba and China was warming." As for Tao Yan himself, he came to visit Tao Qi here—and he too fell in love with a Cuban and stayed! "And then our chef came from Shanghai—" Tao Yan is now snorting with laughter, because the chef also fell in love, got hitched, and refused to return to China.

While Tao Yan has been yarning, Rafael has managed to wolf down an astounding amount of food. After the dumplings came lobster spiced with Sichuan peppercorns, a green mound of stir-fried bok choy, and a vast plate of gingery, sweet-sour pork. "Today's Cubans don't even realize," he declares between eager mouthfuls, "how much the Chinese contributed to the country's cuisine!" Havana's bodegas, pork butchers, fondas, and the ubiquitous fry shops selling mariposas fritas [fried wontons], maduros, and malanga fritters? All Chinese. The Chinese helped hook Cubans on rice, and also grew the country's first mangoes on their small plots outside Havana. They ran the city's best greengrocers. And Havana's music scene, according to Rafael, ran on fuel supplied by Chinese take-out windows, which dispensed small burgers called fritas, sopa de camarones [shrimp soup], and fried rice to late-night revelers and hungover musicos. There was even a rumba genre called "la musica de fritas." And forget ropa vieja or black beans! The most important dish of Havana, according to Rafael, was arroz frito chino, Chinese fried rice. As he says this, Tien-Tan's fried rice, laced with scallions, ham, and a strip of delicate omelet, arrives. "This rice is good," declares Rafael, helping himself. But the old-days chino-cubano fried rice, he says, tasted different. It was made with leftover Cuban white rice and included at least ten ingredients: chorizo, diced smoky porkstuffs, black beans, shrimp, salsa china [soy sauce], and a lot more.

Still, he finishes up the platter of Tien-Tan's fried rice and concludes wistfully, "Eso era Habana—that was Havana. A Chinese city at heart. And don't let anyone tell you otherwise."

FRIED RICE

Arroz Frito

We sampled this satisfying rice at Tien-Tan, the only truly Chinese restaurant in Havana's rather forlorn Chinatown. The co-owner, Tao Qi, makes it the traditional Chinese way, with leftover rice topped with strips of thin egg omelet, a julienne of smoked ham, and lots of chopped scallions.

Serves 4

2 tablespoons plus 1 teaspoon vegetable oil

1 large egg, beaten

1½ cups (188 g) julienned thick-cut smoked ham or Canadian bacon

4 cups (820 g) leftover cooked white rice (page 145), at room temperature

2 cups (110 g) sliced scallions, white and green parts kept separate

1 clove garlic, chopped

¼ cup (60 ml) soy sauce

1 In a small skillet over medium-high heat, combine 1 teaspoon of the vegetable oil and the beaten egg, tilting the pan to cover the bottom with a thin layer of egg. Cook the egg for 2 minutes, then flip the egg with a spatula and cook for 1 minute more. Remove the egg to a plate to cool.

2 Once the egg is cool, roll and slice it into ¼-inch (6-mm) strips and reserve for serving.

3 In a large skillet or wok over medium-high heat, combine the remaining 2 tablespoons vegetable oil and the ham and cook for 2 to 3 minutes, or until lightly crisp. Add the rice and cook for 2 minutes without disturbing it, until the rice gets crispy on the bottom.

4 With a spatula, turn the rice over, add the white parts of the scallions, and stir-fry for 2 minutes. Add the garlic and stir-fry for 1 minute more. Increase the heat to high and stir in the soy sauce, moving the rice the whole time. Stir-fry for 2 minutes more, or until the soy sauce is incorporated.

5 Remove the pan from the heat, stir in the scallion greens, and top with the thinly sliced egg.

FRIED CHICKPEAS WITH CHORIZO

Garbanzos Fritos

This Cuban take on a classic Andalusian tapa of garbanzos stewed with Swiss chard is dusky with chorizo, bacon, and smoked Spanish paprika and brightened with greens. Cubans, who relish garbanzos fritos almost as much as they love their malanga fritters, eat them as a snack with drinks or as a first course. This recipe is inspired by the garbanzos served at paladar Los Mercaderes, a romantic second-floor restaurant located in a colonial building in a restored section of Habana Vieja. For a richer taste, make it the day before.

Serves 6 to 8

3 tablespoons olive oil

½ pound (225 g) dry Spanish chorizo, thinly sliced

2 slices bacon, diced

1 cup (110 g) chopped onion

2 cachucha peppers or 1 jalapeño pepper, seeded and finely chopped

1½ cups (220 g) chopped green bell pepper

3 cups (475 g) canned chickpeas

3 tablespoons chopped garlic (about 5 cloves)

½ cup (120 ml) dry white wine

1 tablespoon smoked sweet paprika

Salt and pepper

1 In a large skillet, heat the olive oil over medium heat. Add the chorizo and bacon and cook until lightly browned and the fat is rendered (the fat will be slightly reddish-orange), 4 to 5 minutes. Add the onion, cachucha peppers, and bell pepper and cook for an additional 4 to 5 minutes, or until the vegetables begin to soften.

2 Stir in the chickpeas and garlic and cook until heated through, about 5 minutes. Stir in the white wine, scraping up the browned bits from the bottom of the pan. Bring to a boil and heat for 2 to 3 minutes, until the mixture has slightly reduced. Stir in the paprika and season with salt and pepper to taste.

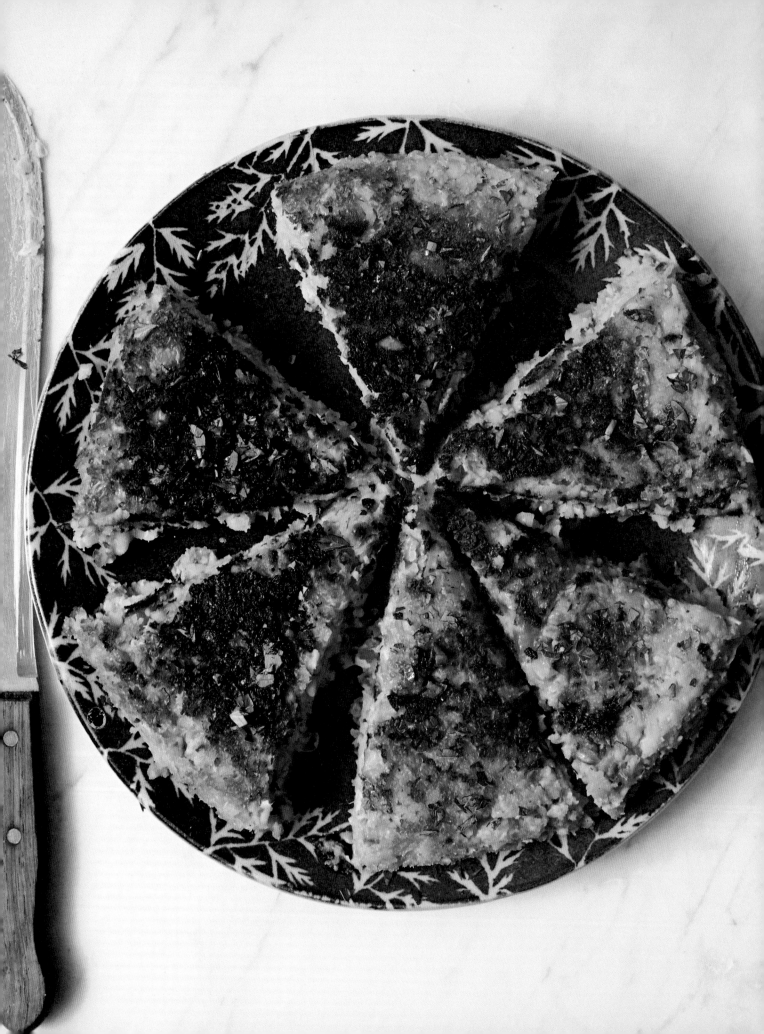

Smashed White Bean Cake
Muñeta de Frijoles Blancos

We found a recipe for this old-world Catalan-style white bean mash in *Delicias de la Mesa*, a 1925 Cuban cookbook. Unusual and totally satisfying, it deserves to be resurrected and served—often!—as a simple savory course with rice and a salad of ripe avocados. The beans for this dish are mashed with some crispy bacon and a bit of their cooking liquid. These are formed into a skillet-size cake that is served cut into wedges much like the Spanish potato tortilla. If using dry beans, quick-soak them in boiling water, but in a pinch, canned white navy or cannellini beans should also do fine. For a vegetarian version, omit the bacon and add two extra tablespoons of olive oil.

Serves 8

- 3 tablespoons olive oil
- 2 thick slices smoked bacon, diced
- 2 cups (220 g) chopped onion
- 3 cloves garlic, chopped
- 2 teaspoons smoked sweet paprika
- 1 cup (150 g) diced smoked ham or thickly sliced Canadian bacon
- Salt and pepper
- 4 cups (716 g) cooked small white beans (reserve 3–4 tablespoons (45–60 ml) of the cooking liquid)
- 1 tablespoon chopped fresh parsley, for garnish

1 Heat 1 tablespoon of the olive oil in a 9-inch (23-cm) skillet over medium heat. Add the bacon and cook, stirring, until almost crispy, 3 to 4 minutes. Add the onion and cook for another 7 to 8 minutes, stirring occasionally, until the onions are well browned. Add the garlic and cook 1 minute more. Add the paprika and ham and stir to combine. Taste for seasoning, add salt and pepper to taste, and add the beans to the skillet.

2 With a potato masher, mash the beans until coarsely mashed, adding the bean cooking liquid as needed, 1 tablespoon at a time, to achieve a creamy consistency. Pat the mixture into an even layer. Reduce the heat to low and cook for 10 to 12 minutes, turning the bean cake once and drizzling 1 tablespoon of the olive oil around the sides of the pan to help when flipping the cake. The bean cake is done when it browns (and any little steam vents that occur during the cooking are gone).

3 Turn off the heat and let stand for 5 minutes. Place a plate over the pan and a kitchen towel under the pan, as it will still be hot. Grasp the pan and plate with both hands and flip the cake onto the plate.

4 Cut into eight wedges, garnish with the chopped parsley, and drizzle with the remaining tablespoon of olive oil.

HECHO EN CASA

A TASTE OF HOME

Up a flight of stairs, past pretty displays of seasonal vegetables, you emerge into the sweet little dining room of Hecho en Casa, a paladar pointedly named "Made at Home." Welcome to the world of Alina Menendez, one of the most passionate and talented cooks in Havana, a woman dedicated to preserving Cuba's home cooking and local ingredients. In the dining room or on the small, dreamy balcony adorned with pots of basil and rosemary, Alina serves feathery tamales that taste like the pure essence of corn; a simple but perfect sauté of juicy Cuban pork accented with nothing more than onions and peppers; ultra-creamy natilla pudding with dark caramel swirls made by her mom; an insanely rich ice cream (homemade, of course) of dark chocolate from Baracoa, Cuba's province of chocolate. "We have five hundred years of food history here," Alina insists, "and our cuisine is still full of treasures."

Alina's Story

Both sides of my family immigrated from Spain at the turn of the twentieth century, my paternal grandmother from Galicia, my maternal folks from Leon in Castille. Spanish food adapted to local ingredients was the cuisine I knew as a child. My grandmother was an astonishing cook; the kitchen was her world that she ruled. I still dream of her cremas, the delicate cream soups she made with Cuban viandas [tubers]. It's profound, our connection to our Iberian roots. In 2012, Spain began granting citizenship to Cubans descended from Spanish immigrants. I love being a Spanish citizen. But my home is here. How could I ever leave our intense, crazy, beautiful island?

By profession I am a geographer. Like many of my generation I studied in Russia—at the prestigious Institute of Cartography in Moscow. After college I ended up working in tourism, and then I entered the professional hospitality world, first at the Ritz Carlton in Cancún, Mexico, then at a tourist agency here specializing in VIP clients. Throughout those "professional hospitality" years, I kept flashing back to something I once blurted out to my grandmother: "Abuela, I promise one day I'll open a restaurant." I'd always imagined that restaurant with incredible clarity: a small, warm, homey space dedicated to the exquisite Cuban home cooking I remembered from childhood. "Cocina de corazón," I dubbed that cuisine—food to win people's hearts. Not their money.

In 2011, the Cuban government began issuing paladar licenses. Before then, dining options in our country were utterly scarce, and then suddenly Havana was filled with cafés and restaurants. And so I opened Hecho en Casa, and my little intimate dream got buried deep in a bureaucratic rabbit hole, a surreal universe of impossible permits and licenses. But I never gave up! With very small, grueling steps I kept winning. Working in government tourism convinced me that the cocina we showed to the world wasn't true Cuban food. So with each meal I serve my guests, I'm on a mission: to cleanse and correct the image of cocina cubana as boring, plain rice, beans, and greasy pork, all drowned in cumin and commercial tomato sauce. Despite all that we've been through, Cuban homes have maintained their cherished recipes, their beautiful family china, their truly hospitable ways. Here we had treasures like food writer Nitza Villapol! What do I want to communicate to my guests? That the kitchen is both an intimate space and an important window onto our culture.

So what exactly is Cuban cuisine, this cocina cubana? It's a grand cazuela criolla—a creole melting pot of our indigenous roots, Spanish heritage, the experience of the African slaves, the traditions of immigrants who arrived on our island from places like neighboring Haiti and China from the other side of the world. A tamal prepared with real grated corn, not with masa, made with patience and love! This is true Cuban cooking, and once you discover it, it's hard to forget.

Yes, I want to salvage Cuban cuisine from its bad reputation for my foreign guests. But my most precious clients are locals. If I help them rediscover and take pride in their heritage, I've accomplished something important.

PUMPKIN RICE

Arroz con Calabaza

Rice steamed with plush cubes of pumpkin is a staple throughout the Caribbean—more popular in eastern Cuba, where Caribbean cooking and culture are felt more strongly. Local pumpkins are denser than ours, closer in texture and flavor to butternut or kabocha squash. Some cooks like to add a cupful of corn kernels to the pot.

Serves 8

2 tablespoons olive oil

1 cup (110 g) chopped onion

½ cup (75 g) chopped green bell pepper

1 teaspoon fresh thyme leaves or ¼ teaspoon dried thyme

1 small bay leaf

1½ cups (275 g) long-grain white rice, rinsed in a fine-mesh strainer until the water runs clear

3 cups (720 ml) water, vegetable stock, or chicken stock

2 cups (230 g) peeled and cubed pumpkin or butternut squash

Salt and pepper

1 In a large saucepan with a tight-fitting lid over medium heat, combine the olive oil, onion, green pepper, thyme, and bay leaf and cook for 5 minutes, stirring, until the vegetables are soft.

2 Add the rice and cook for 2 to 3 minutes more. Add the water, cover, increase the heat to medium-high, and bring to a boil. Add the pumpkin, cover the pot, reduce to a very low heat, and cook for 20 minutes, or until the pumpkin is tender.

3 Remove from the heat and let rest for 5 minutes. Fluff the rice with a fork and season with salt and pepper to taste.

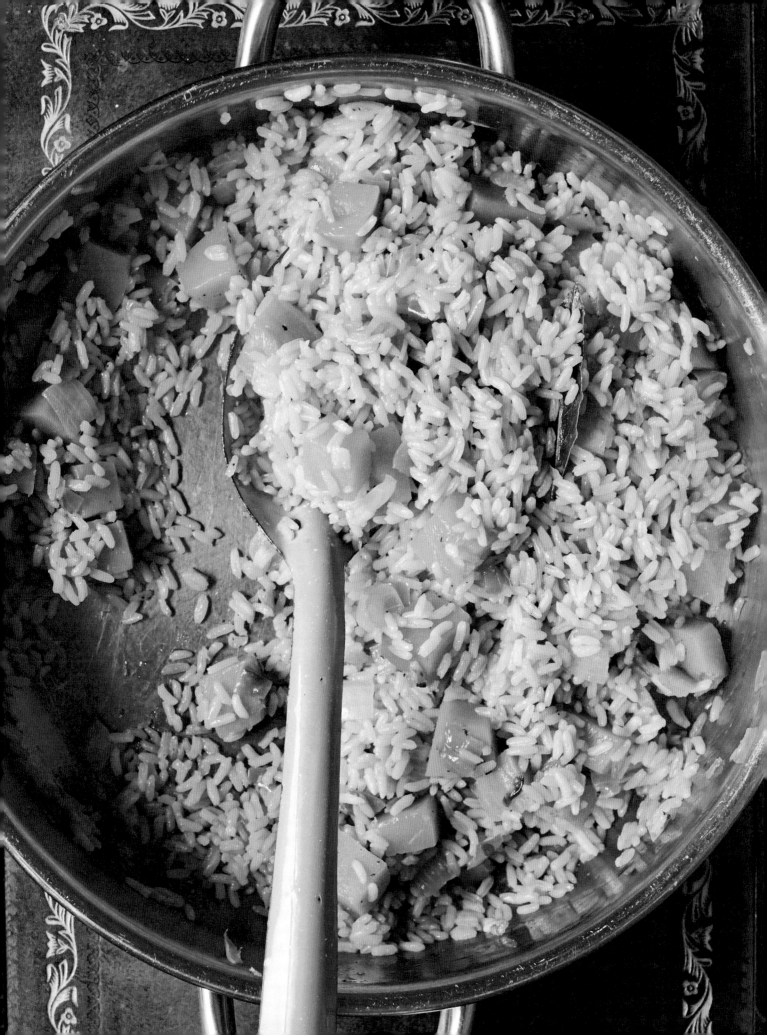

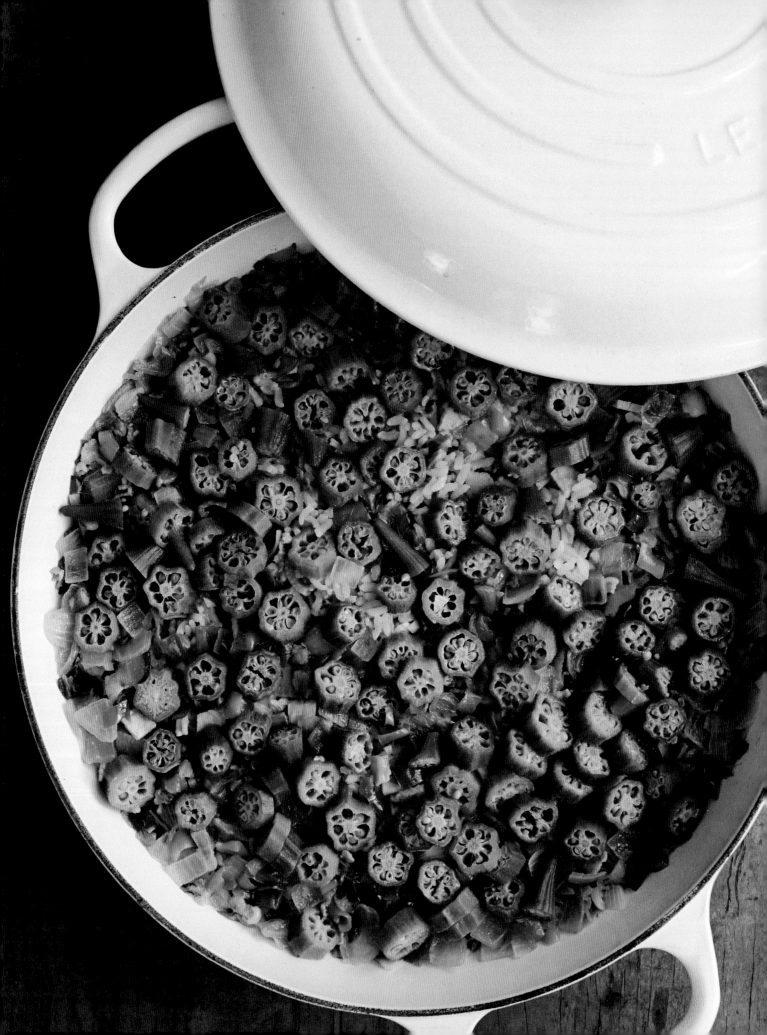

Rice with Okra and Ham

Arroz con Quimbombó y Jamón

This old-school, rustic dish is so delicious and comforting, we challenge you not to devour the whole pot by yourself. Okra was introduced to the New World in the seventeenth century with the African slave trade. The Cuban word for it is "quimbombó," which might be related to the Creole "gumbo." In this recipe, the quimbombó cooks with smoky diced ham and long-grain rice, which is pleasantly starchy and chewy. The resulting dish is not dissimilar to the Creole jambalaya. The neat trick of soaking the okra in lemon water helps reduce its slight sliminess. Serve this as a one-pot meal with nothing more than a bright salad to accompany it, or serve with Fried Sweet Plantains (page 118) and any kind of beans for a complete Cuban meal.

Serves 4 to 6

2 cups (310 g) trimmed and sliced okra

Juice of 1 lemon

1 tablespoon olive oil

2 slices bacon, diced

1 cup (110 g) chopped onion

1 cup (150 g) chopped cubanelle (Italian frying) pepper

1 cachucha pepper or ½ jalapeño pepper, seeded and chopped

3 cloves garlic, chopped

1½ cups (225 g) cubed smoked ham

1½ cups (275 g) long-grain white rice, rinsed in a fine-mesh strainer until the water runs clear

3 cups (720 ml) chicken stock

Salt and pepper

1 Soak the okra in a large bowl filled with water and the lemon juice and let sit for 15 minutes. Drain, add fresh water, and let sit for 15 minutes more. (Soaking helps reduce the mucilage, the combination of sugar and protein found in okra pods that can result in a slick texture.)

2 While the okra soaks, in a large skillet with a tight-fitting lid over medium heat, combine the olive oil and bacon and fry until the bacon starts to brown, 3 to 4 minutes. Add the onion, cubanelle and cachucha peppers, and garlic and cook, stirring frequently, until the vegetables are soft and the bacon is well cooked, about 10 minutes more. Add the ham and cook for 1 minute more to combine the flavors.

3 Add the rice and stock to the skillet, cover, and bring to a boil. Reduce the heat to low and simmer for 10 minutes. Drain the okra and add it to the skillet. Cover and continue to cook for 10 minutes more, until the okra is tender. Remove from the heat and let stand for 5 minutes. Serve hot.

PORK TAMALES

Tamal en Hojas con Cerdo

Whereas most Mexican tamal varieties rely on masa harina and plenty of lard, the Cuban version usually involves grated kernels of starchy yellow fresh corn and little fat. To make people's lives easier, grated corn for tamales is sold in huge plastic bags at most agros [farmers' markets]. The corn is then cooked down to a thick mass, flavored, trussed in corn husks, and steamed for a tamal that tastes lighter and more vividly "corny" than its Mexican cousin.

Alina Menendez, from Hecho de Casa, makes her comforting fresh corn tamales with a filling of roasted pork. She serves them with ketchup (we substituted tomato puree, but no judging here!) and a smooth puree of nicely seasoned black beans.

Makes 12 to 15 tamales

5 cups (725 g) fresh corn kernels, cut from 4 or 5 cobs

½ cup (60 g) coarse-ground cornmeal

2 tablespoons olive oil

½ cup (65 g) finely chopped onion

2 tablespoons chopped fresh cilantro

1 cup (195 g) cooked pork, shredded (Crispy Pork Shoulder, page 272)

¼ cup (60 ml) tomato puree

Salt and pepper

24–30 corn husks, soaked in hot tap water for 30 minutes

1 In a blender or food processor, blend the fresh corn and cornmeal together on high speed for 1 minute to make a coarse mixture. Heat 1 tablespoon of the olive oil over medium-high heat and add the corn mixture. Cook for 10 to 15 minutes, or until it becomes very thick. Scrape into a bowl and set aside to cool.

2 Wipe the skillet and heat the remaining tablespoon of the olive oil over medium-high heat. Add the onion and cook until soft, 2 to 3 minutes. Stir in the cilantro, pork, and tomato puree and cook until heated. Season with salt and pepper. Stir the pork mixture into the corn mixture and let rest for 15 minutes.

3 To assemble the tamales, arrange 2 corn husks side by side and overlapping. Scoop ½ cup (70 g) of the filling in the center. Fold the bottom of the husks up and over the filling and fold the sides in over that. Fold the top of the husks down over the whole tamal to create a small package and tie tightly with kitchen twine to secure. Repeat with the rest of the husks and filling.

4 Bring a pot with 1 inch (2.5 cm) of water and a steamer insert to a simmer over medium heat. Add the tamales to the steamer insert, cover the pot, and cook for 1 hour, adding more water if needed to maintain the water level. Drain the tamales and let them cool slightly before serving.

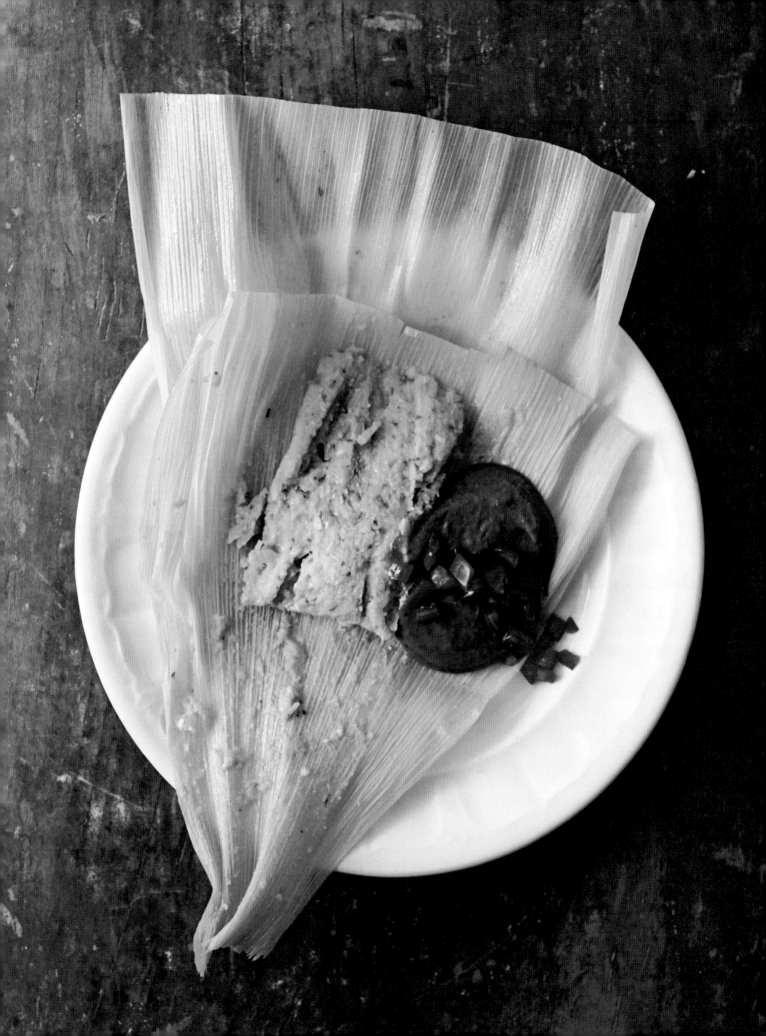

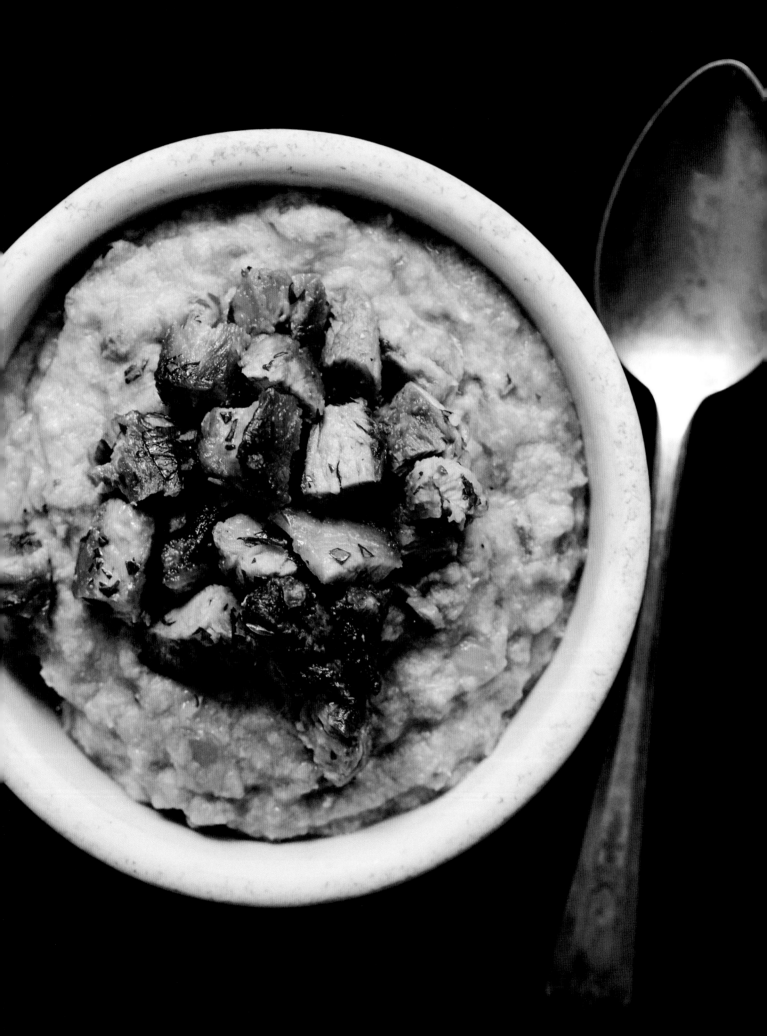

CUBAN POLENTA

Tamal en Cazuela

"Tamal en cazuela is our ultimate comfort food," insists Acela Matamoros, one of Cuba's top cooking teachers and food historians. A kind of Cuban polenta—or a stove-top tamal—at its most basic, tamal en cazuela can be just a soft mush of water, cornmeal, and salt, sometimes eaten with milk and a sprinkle of sugar. Other versions use grated corn or the strained "milk" of the corn puree, which thickens when cooked. The flavorings range from classic pork, such as here, to chicken to seafood. This recipe, using pork ribs and a combination of grated corn and some cornmeal to thicken it, is easy and fairly quick but delivers plenty of that comforting, grandmotherly flavor.

Serves 8

4 tablespoons olive oil

1 pound (455 g) country-style pork ribs, cut into ½-inch (12-mm) cubes

1 cup (110 g) chopped yellow onion

1 cup (145 g) chopped cachucha pepper or 1 chopped jalapeño pepper

1 clove garlic, chopped

½ cup (90 g) chopped tomatoes, canned or fresh

Salt and pepper

7 cups (1 kg) fresh corn kernels, cut from 3 or 4 cobs

4 tablespoons (¼ cup) chopped fresh parsley, for garnish

8 lime wedges, for garnish

1 In a skillet over medium heat, warm 1 tablespoon of the olive oil. Add the pork and cook until browned on all sides, 6 to 8 minutes. Remove the pork to a plate.

2 In the same skillet over medium heat, cook the onion and cachucha pepper in 2 tablespoons of the olive oil for 4 to 5 minutes, or until the vegetables are soft and starting to brown. Add the garlic and cook for 1 minute more. Stir in the tomatoes, return the pork to the pan, and cook for 4 to 5 minutes more. Season with salt and pepper to taste. Remove from the heat.

3 Place the corn kernels in a blender or food processor and blend on high speed for 2 for 3 minutes to make a fairly smooth puree. In a separate skillet over medium heat, add the remaining 1 tablespoon of the olive oil. Add the corn puree and cook, stirring continuously, until thick, 10 to 15 minutes. Stir 1 cup (250 g) of the pork stew into the corn mixture. Season with salt and pepper to taste.

4 Serve the tamal polenta in bowls, topped with the remaining pork stew, garnished with the parsley and lime wedges.

PESCADOS Y MARISCOS

——

Fish and Seafood

The newish paladar Amigos del Mar [Friends of the Sea] might be the most enchanting place in Havana—a charmed, nautically themed hideaway by the Almendares River. On the shady terrace here, one hoists ice-cold micheladas as sea grape trees and slender palms stir in the tropical breeze and fishermen repair their nets on tattered but colorful boats docked right below. A plate of stupendously crunchy shrimp and malanga fritters arrives to start. Then a ceviche of pargo [snapper] so fresh it practically gleams, followed by sliced petals of cured emperador [swordfish]. Fernando Cabrera Valle, the owner, approaches the table with a plate of tender charred little pulpitos [baby octopus]. "They're so abundant this season," he declares, "you can gather them right on the beaches near Havana." Do we want pasta con camarones, a Havana seafood classic? he asks. Or a fillet of succulent snow-white pez perro [hogfish] that a fisherman friend just delivered from Pinar del Río? Or perhaps a ruby-red tuna steak—a rare find since most of Cuba's atun goes straight to Japan?

Back in his kitchen, Fernando might show off a shimmery-green parrotfish he's just caught. Or propound how a ceviche of super-fresh pargo would be ruined by anything more than a judicial splash of tropical lime juice, while a rich oily fish—cherna [grouper], for example—benefits from a good long soak in a spiced vinegary escabeche. That emperador we just tasted? Cured overnight in a light mixture of sugar and salt. The pez perro? It's among Cuba's most coveted catches, Fernando elucidates, because it scorns bait, only eats clams, and lives at such depths it's best fished from a submarine. With his striped sailor shirt, head bandanna, and burly build, Fernando resembles a jolly pirate—but he's no old sea-dog type. He happens to be one of the few lucky (and privileged) Cubans to own not only a fishing license but his own sailboat. Conveniently, his wife has a paladar license, and together they recently realized their dream of opening this semi-secret word-of-mouth mariners' restaurant in a sportily ramshackle building that once upon a time, pre-Castro, housed a yacht club.

You leave Fernando's fish paradise overfed, woozy from his postprandial aged rum, and delighted—but also heartbroken that such a marine bonanza is inaccessible to an average Cuban, because the fish situation here is so woefully complicated. An island surrounded by coral-rich Caribbean waters, teeming with rivers, keys, and mangrove lagoons, Cuba is said to boast at least five hundred species of fish and crustacean: From the marlin celebrated by Hemingway to all kinds of snapper, from tender shrimp to spiny lobster to giant land crabs that swarm country roads during their migration season. And yet good, fresh seafood hasn't been in regular stores since the late 1980s. "Imagine how it feels," one journalist lamented to us, "to be an island with 3,500 miles of coastline where fish are so tantalizingly close and yet so out of reach."

Prior to the Revolution, Cuba had seafood enough for domestic consumption, but no large-scale fishing industry. Come the 1970s and '80s, however, the USSR helped it develop a fishing fleet that was the envy of the Caribbean. But with the loss of Soviet aid in the '90s, the Cuban fishing industry pretty much sank; today its decaying old vessels are good mostly for scrap. Even *Granma*, the official Party newspaper, recently huffed that the piscatorial situation in Cuba is as espinoso [bony] as the fish Cubans rarely get to taste. The island's catch, *Granma* lamented, went from two hundred thousand tons in the '80s, when ration cards included weekly portions of fish, to less than a quarter of that today. Currently

most of that catch is destined for export or for hard-currency domestic menus—meaning, overpriced, overcooked lobster at tourist resorts. Any excess beyond the quota should theoretically go to state fishmongers, but in reality ends up in other hands, sold por la izquierda—to the left—in shady dealings. "Cast a net in our waters," goes a popular joke, "and you'll pull out a chicken," a reference to the "pollo por pescado" [chicken for fish] substitution of state rationing cards. As for private fishing, it's pretty much a wash. Just owning a boat—or a raft or canoe—requires draconian licenses for fear of citizens fleeing to Florida. Actual fishing requires still more crazy red tape. "Even passengers on a fishing boat need a permit in Cuba!" quipped Fernando at lunch.

But then again, the most powerful word in the Cuban vocabulary is *inventar*. Exhibit A: "balloon fishing," the surreal practice whereby pescadores [fishermen] attach inflated condoms—yes, condoms—to the end of baited lines that are sent floating nine hundred feet out into the water. Or the daredevil sport of fishing while riding on blocks of industrial foam rubber. Or the illicit but thriving lobster trade that often takes place in choppy seas at night, to escape the attentions and fines of the vigilant coast guard.

The paladares are likewise inventive in putting fish on their tables. The first rule of paladar ownership, declares one restaurateur, is to cultivate a network of law-evading fishermen who then show up at your restaurant with their incredible catch. Ivan Rodríguez of Ivan Chef Justo agrees: "My pescadores are the most important guys in my life," he says, speaking for most paladar owners. Thanks to such informal relationships, a dine-a-thon in today's Havana can easily become a collage of great seafood moments and recipes: sparkling-fresh ceviches at fish-centric places like Rio Mar or Amigos del Mar; an alabaster dorado tartare skillfully accented with salsas of almonds and chives at Decamerón; saucy garbanzos with lobster at Casa Pilar; and garlicky shrimp accented with lime at Habana Mia 7. Enjoying this bounty, you have to sigh, counting the days until Cuba's fantastic seafood and fish are rightfully available to the Cuban people at large.

Seviche Amigos del Mar

On a sweltering Cuban day when the thermometer climbs past 100°F, the humid air seems to stand still and a hot meal is out of the question—that's when a plate of tangy ceviche comes to the rescue. The idea of preserving fresh fish by lightly "cooking" it in something acidic has been around for centuries, maybe millennia. But the origins of ceviche, both the dish and the term, still confound gastronomic historians. Is it ceviche, sebiche, cebiche, or seviche (the preferred Cuban spelling)? Does it derive from Latin cibus [food], Spanish cebo [fish bait], Quechua swichi [fresh fish or tender fish], or Arabic sibech [meaning "acidic food" and sharing an etymology with the term "escabeche"]? And historically speaking, did Amerindian natives preserve their raw fish in juices of tart indigenous fruit, such as passion fruit, or did the Americas "discover" ceviche only after Spaniards introduced citrus trees to the continent? While in Cuba ceviche isn't quite the edible life force it is in Ecuador or Peru, local domestic goddess Nitza Villapol did include a deliciously zesty recipe for fish marinated with citrus, red onion, and chilies in her seminal cookbook, *Cocina al Minuto*. And these days, when good fresh fish is finally accessible after decades of shortages, and chefs pride themselves on their networks of fishermen who deliver the freshest catch right to their doorstep, ceviche is on seemingly every paladar menu as chefs try to outdo each other with different riffs on this citrusy classic.

The recipe below is from Amigos del Mar. Fernando uses alabaster cubes of snapper fillet and soaks them "al momento," right before serving, in lime juice with a colorful confetti of peppers and wisps of red onion, then garnishes with lime wedges and olives. "The less you do to a ceviche, the better," insists Fernando. "Snapper that fresh and delicious hardly needs any seasonings."

Serves 4

1 pound (455 g) fresh, firm, white-fleshed fish, such as red snapper, grouper, sea bass, or halibut, cut into ½-inch (12-mm) cubes

Salt and pepper

⅓ cup (75 ml) fresh lime juice

2 tablespoons olive oil

3 cachucha peppers or 1 jalapeño pepper, seeded and finely diced

⅓ cup (35 g) thinly sliced red onion

A few small pitted green olives, for serving

1–2 tablespoons snipped chives

Lime wedges, for garnish

In a bowl, gently massage the fish with salt and pepper, to taste. Mix together the lime juice, olive oil, cachucha peppers, and onion and pour over the fish. Let stand for 10 minutes, until the fish just begins to turn opaque. Transfer to a serving platter and decorate with the olives, chives, and lime wedges.

CEVICHE WITH AVOCADO AND TOMATO

Seviche con Aguacate y Tomate

In this version from the lovely paladar Nautilus, avocado, cucumber, cilantro, and parsley get thrown into the citrusy mix to refreshing effect. We were served pez perro, or hogfish, a meaty fish common in Cuba, but you can use any firm white fish for this dish.

Serves 4

¾ pound (340 g) fresh, firm, white-fleshed fish, such as swordfish, halibut, or red snapper, cut into ½-inch (12-mm) cubes

¾ cup (100 g) peeled and diced cucumber

1 cup (180 g) seeded and chopped fresh tomato

1 cup (155 g) diced ripe avocado

¼ cup (30 g) chopped yellow onion

2 tablespoons chopped fresh cilantro, plus more for garnish

¼ cup (60 ml) fresh lime juice (from 2–4 limes)

3 tablespoons extra-virgin olive oil

Salt and pepper

In a bowl, gently mix together the fish, cucumber, tomato, avocado, onion, chopped cilantro, lime juice, and olive oil. Season with salt and pepper to taste. Let stand for 5 minutes to marinate. Garnish with a cilantro sprig.

Ceviche with Mango and Black-Eyed Peas

Seviche con Mango y Frijoles Carita

In this delightful ceviche—yet another standout from the super-creative paladar El Del Frente—the day's catch, marinated in sour orange and lime juices, is played against sweet mango, savory peppers, and earthy black-eyed peas. The combination sings.

Serves 6

1 pound (455 g) fresh mahi-mahi or other white-fleshed fish, cut into ½-inch (12-mm) cubes

½ cup (85 g) cooked black-eyed peas

6 cachucha peppers or 3 jalapeño peppers, seeded and diced

¾ cup (125 g) diced ripe mango

4 tablespoons (30 g) thinly sliced shallot (1 large shallot)

6 tablespoons (90 ml) extra-virgin olive oil

3 tablespoons fresh lime juice

2 tablespoons sour orange juice, or an equal mix of lime and orange juice

Salt and pepper

1 tablespoon plus 1 teaspoon chopped fresh parsley, for garnish

In a large bowl, gently mix together the fish, black-eyed peas, cachucha peppers, mango, 3 tablespoons of the shallot, the olive oil, lime juice, and sour orange juice. Season with salt and pepper to taste. Chill in the refrigerator for 15 minutes to marinate. Serve chilled, garnished with the remaining 1 tablespoon shallot and the parsley.

DECAMERÓN

COOKING TO SURVIVE

Decamerón sits in a nondescript building near the corner of Linea and tree-flanked Paseo, two of Havana's busiest avenues. But inside, this charmingly cluttered place exudes intimacy and the deeply personal hospitality of owner Niuska Miniet. A renowned singer-songwriter, Niuska has decorated the place with old musical instruments, a motley collection of vintage grandfather clocks that chime unexpectedly, and contemporary Cuban art. The result brings to mind an artsy Parisian bistro. The eclectic menu of simple but lusty dishes maintains the resonance: a rolled loin of rabbit in a rosemary sauce you want to mop up with good bread, yuca empanadas with a lush, flavorful crab filling. For starters, there's an ultra-fresh tartare of swordfish with almond sauce. A famous Cuban film star, Daisy Granados (*Memories of Underdevelopment*), drops by for a cocktail and chat. Out on the terrace, a boisterous table of artists and poets talk politics over platters of coconut shrimp. On the sound system, Elena Burke, grand songstress from the '60s and '70s, croons a bolero. One of the pioneers of the paladar movement, Decamerón opened back in 1995 and still feels just as vital today.

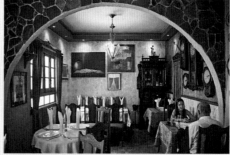

Niuska's Story

I opened Decamerón to survive—literally! In Cuba one has career aspirations and dreams, but in the end survival trumps all.

My degree is in literature. I wrote my thesis on Latin America's avant-garde, and I worked at a literary magazine. But since age fourteen, my passion has been music. I play guitar and write and sing ballads. Nueva trova is my genre, a movement of deeply personal songs that's been important in Cuba since the '70s. What are my songs about? My life, usually. What did I want most in that life? To be a famous, full-time musician. But then came the '90s and the Período Especial. Almost overnight, Cubans were nearly starving after Russia pulled its food aid. Losing my magazine job left me on the brink of disaster. Desperate just to survive, I started baking and selling pizza out of my house. In 1995, as a crisis measure, the government began issuing paladar licenses. These small private restaurants had to be in your house, no more than twelve seats, and employing at least two family members. Being a literary scholar, I called mine Decamerón after Boccaccio—his fourteenth-century stories about people coming together to tell diverting tales in the midst of the plague, the Black Death. To Cubans during the Período Especial, understand, Boccaccio's tales about refugees from catastrophe seemed uplifting and real.

I had zero idea about running such a restaurant. Back then, who did? Friends pitched in, my sister came from Oriente province to help—we learned on the job every day. What did we serve? Mostly Italian: pizzas and pasta. Cubans love doughy things, and paladar food had to be filling and cheap. How did I find the ingredients? They found me. When word got out we had a restaurant, strangers came knocking on our door selling anything from lobster to chicken to floor mops. They sold to survive; I bought to survive. Survival—that was our collective imperative. There wasn't one difficulty in running a paladar, there was a mountain of them piling up every day until you wanted to scream. The worst was the government: It permitted private paladares to exist with one hand but with the other hand did everything to take them away. The persecution of illegal paladares was fierce. Inspectors kept coming and bothering us until one day in 1998, due to some paperwork "issues," they ordered us to close. What did I do? I covered my windows, locked the doors, and kept on feeding my customers, running the place as a speakeasy. For some reason I wasn't afraid of "them." I just said, "Screw the authorities." Closing the restaurant would most likely leave me out on the street, starving. After 2011, I got proper paperwork, but in the end I worked more years "underground" than I did in the open. And through those impossible years I never left our country and never lost my sense of humor, that Cuban lightness of being.

Life's still precarious here, but nothing like was in the '90s. I'm able to travel, taste things, devise new dishes, and collect books by such inspiring Spanish chefs as Ferran Adrià and Juan Mari Arzak. Though pizza will always be on our menu, our dishes evolve; today I have a network of suppliers I deeply trust, who bring us amazing seafood and fish. Because of my grandfather, who'd immigrated from Galicia, Spain, I'm a Spanish citizen now, too, and I love Spanish culture. That small bust of Don Quixote over there? It travels with me wherever I go. Sure, okay, I could live in a fancy house in Madrid or Miami and gorge on beef and drink three *huge* Coca-Colas out on a terrace every day. But you know what? Who cares about Coca-Cola?

Mahi-Mahi Tartare with Almond Salsa

Tartar de Pescado con Salsa de Almendras

We love the homey, slightly quirky feel of paladar Decamerón, decorated with grandfather clocks and old musical instruments. Even more we love its chefs' flair with seafood. Here, a tartare of spanking-fresh dorado (we call for mahi-mahi or swordfish, readily available in most fish markets) is served with two sauces: one green with chives and enlivened with lime juice; the other made with chopped eggs, crushed almonds, garlic, and olive oil. At Decamerón the fish arrives on a bed of julienned lettuce under a topping of tortilla chips. For the tartare, make sure to chop the fish finely before blending in a bit of the chive sauce.

Serves 4

FOR THE CHIVE VINAIGRETTE

½ cup (25 g) minced chives

¼ cup (55 g) minced cornichons

1 teaspoon minced or pressed garlic

3 tablespoons olive oil

2 tablespoons fresh lime juice

½ teaspoon balsamic vinegar

Salt and pepper

FOR THE TARTARE

1 pound (455 g) fresh mahi-mahi or swordfish, or other firm, white-fleshed fish, skin and bones removed

FOR THE ALMOND SALSA

⅓ cup (45 g) finely chopped hard-boiled egg whites (from 2 large eggs)

½ teaspoon minced or pressed garlic

2 tablespoons olive oil

1 tablespoon fresh lime juice

3 tablespoons blanched almonds, finely chopped

Salt and pepper

2 cups (110 g) shredded green-leaf lettuce

20 best-quality, unsalted tortilla chips

1 **Make the chive vinaigrette:** In a small bowl, mix together the chives, cornichons, 1 teaspoon of the garlic, 3 tablespoons of the olive oil, 2 tablespoons of the lime juice, the balsamic vinegar, and salt and pepper to taste. Set the chive vinaigrette aside.

2 **Make the tartare:** With a sharp knife on a clean board (or in the bowl of a food processor fitted with a chopping blade), chop the fish into approximately ¼-inch (6-mm) pieces. If you're using a food processor, take care not to over-chop the fish (it should take just four or five pulses).

3 In a medium bowl, toss the chopped fish with 2 tablespoons of the chive vinaigrette. Chill in the refrigerator for 10 minutes to marinate.

4 **Make the almond salsa:** In a small bowl, combine the hard-boiled egg whites, ½ teaspoon of the garlic, 2 tablespoons of the olive oil, 1 tablespoon of the lime juice, almonds, and salt and pepper to taste.

5 To serve, divide the shredded lettuce and the fish mixture evenly among four plates. Spoon 1 tablespoon of the chive vinaigrette and 2 tablespoons of the almond salsa on each serving, and serve with tortilla chips.

Lemony Snapper
with Crispy Sweet Potatoes

Pargo al Limón con Chicharritas de Boniato

This simple dish of sautéed snapper fillets with a citrusy sauce hails from the breezy paladar Starbien, which serves some of Havana's most popular lunches in a handsome colonial house on a leafy street in Vedado. What makes the dish memorable is the garnish of fried, thinly shredded boniato [white sweet potato] to contribute texture and crunch. "Restaurant food in Cuba should be simple for now," said Starbien's co-owner José Raul Colomé, a former lawyer for Cuban military counterintelligence. "We don't have many spices or gadgets or fancy techniques; what we do have are fresh, delicious ingredients and a lot of enthusiasm for feeding our clients."

Serves 2

FOR THE GARNISH

1 medium boniato or 1 small sweet potato, peeled and cut into matchsticks

1 cup (240 ml) vegetable oil, for frying

Salt

FOR THE FISH

¼ cup (30 g) all-purpose flour

Salt and pepper

1½ pounds (680 g) fresh, firm, white-fleshed fish fillets, such as snapper, mahi-mahi, or halibut

2 tablespoons vegetable oil

1½ teaspoons lemon zest

1½ teaspoons fresh lemon juice

FOR THE SAUCE

½ white onion, chopped

1 stalk celery, chopped

2 tablespoons dry white wine

¼ cup (60 ml) fresh lemon juice (from 1½ lemons)

1½ teaspoons cornstarch

Salt and pepper

1 **Make the garnish:** Rinse the boniato with cold water until the water runs clear. Drain and dry thoroughly.

2 In a large, high-sided skillet, heat the vegetable oil over medium-high heat until a drop of water sputters and sizzles when added to the pan, 375°F (190°C). Working in small batches, fry the boniato until golden, about 2 minutes.

3 Remove with a slotted spoon to paper towels to drain and sprinkle with salt while hot. Repeat with the remaining boniato until all have been fried and salted. Keep warm in a low oven until ready to serve.

4 **Make the fish:** Place the flour in a shallow bowl and season with salt and pepper. Pat the fish dry and dredge in the seasoned flour. In a large skillet, heat the vegetable oil over medium-high heat. Brown the fish on one side, about 3 minutes. Turn the fillets, add 1 tablespoon water and the lemon zest and juice, and cook until the liquid has evaporated, about 4 minutes more. Remove from the heat and cover to keep warm.

5 **Make the sauce:** In a saucepan, combine 2 tablespoons water, the onion, celery, wine, and lemon juice. Bring to a boil and cook until slightly reduced, about 4 minutes. In a small bowl, combine the cornstarch with 1½ teaspoons water to make a slurry. Add the cornstarch slurry to the pan, stirring until the sauce thickens. Season to taste with salt and pepper.

6 Strain the sauce through a fine-mesh strainer, ladle it onto serving plates, and top with the fish. Garnish with the fried boniato to serve.

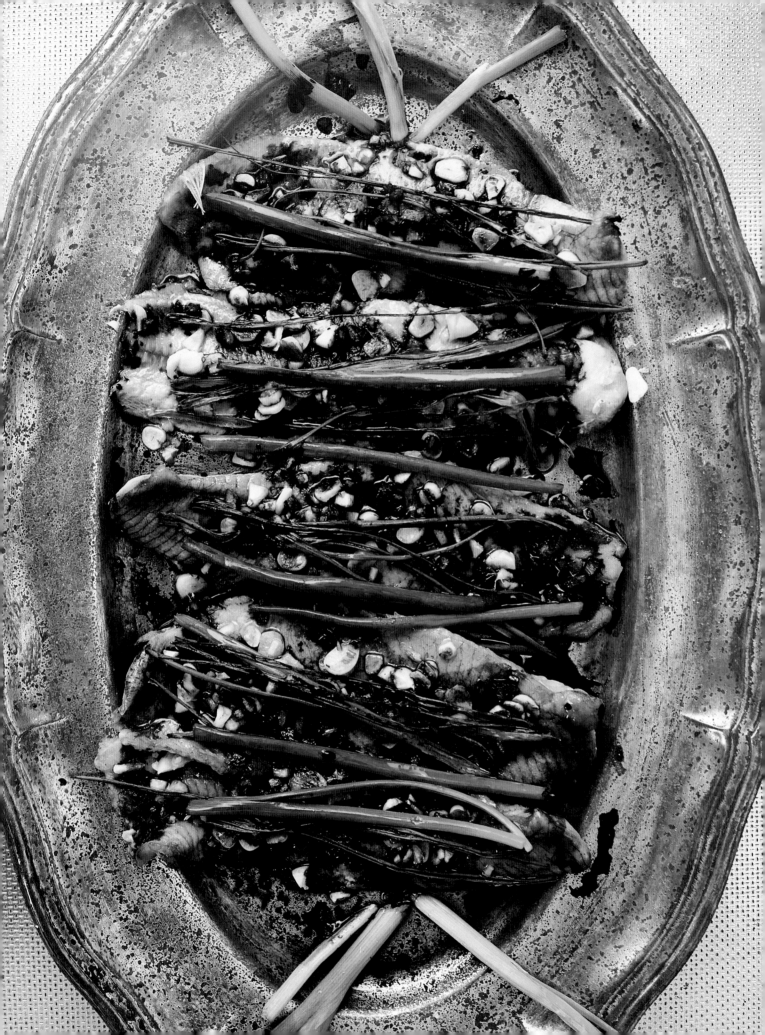

Trout with Black Bean Sauce

Trucha al Vapor con Salsa Negra

A favorite from Alexis Alvarez Armas, this dish is inspired by Cuba's Chinese-Criollo cuisine. After cooking delicate trout fillets in a bamboo steamer, Alexis dresses them with a Chino-Latino blend of soy sauce, fermented black beans, olive oil, and lots of scallions and chives. It's a dish we could eat every day. Serve with White Rice (page 146) and Coconut Flan (page 284).

Serves 4

4 trout fillets (about 1½ pounds / 680 g total)

4 scallions, green parts only

½ bunch chives

2 tablespoons olive oil

1 (2-inch / 5-cm) piece of ginger, peeled and cut into matchsticks

4 cloves garlic, thinly sliced

2 tablespoons fermented black beans, chopped

6 tablespoons (90 ml) sherry wine

1 tablespoon sugar

6 tablespoons (90 ml) soy sauce

4 scallions for garnish (optional)

1 Pour 3 inches (7.5 cm) water in the bottom of a large stockpot fitted with a steamer insert. Cover the pot and heat over medium-high. When the water is boiling, arrange the fillets, skin side down, in the steamer and top with the scallions and chives. Cover the steamer and cook for 7 to 8 minutes, checking every few minutes to avoid overcooking, until the trout is firm and pale.

2 Meanwhile, in a sauté pan, add the olive oil over medium heat and sauté the ginger and garlic until tender. Add the black beans and deglaze with the sherry wine. Stir in the sugar and soy sauce and reduce until the sauce thickens.

3 Place the trout on a serving platter and spoon the sauce on top. Arrange scallions (optional) and serve.

Lobster with Creole Sauce

Langosta en Salsa Criolla

From the abundance and quality of lobsters served at the paladares of Cuba, one might conclude that this king of local crustaceans is as cheap and plentiful on the island as it was in colonial Maine. Alas, this is far from the truth. Technically, lobster fishing is a strictly controlled government industry with most of the catch reserved for hard-currency exports and the tourist economy. Then again, this being Cuba, illegal lobster fishing for the black market trade is its own thriving industry, despite draconian fines, and if you live in Havana and look like a big spender, shady-looking hawkers will be sure to knock on your door muttering "langosta, langosta." In Cuba one might sample the precious langosta cooked in this Creole manner, with the sweet meaty tails gently poached in a slightly piquant sauce of sofrito, tomatoes, and a touch of white wine. The same simple but luscious foil will work well for large shrimp or even chunks of firm white fish. Serve with Yellow Rice (page 146) and cooked white beans or chickpeas.

Serves 4

2 tablespoons olive oil

1 cup (125 g) finely chopped onion

1 cup (145 g) finely chopped red bell pepper

1 clove garlic, chopped

1 cachucha pepper or ½ jalapeño pepper, seeded and chopped

1½ cups (360 ml) tomato puree

1 tablespoon tomato paste

½ cup (120 ml) dry white wine

2 pounds (910 g) lobster tails, cut into thirds

Salt and pepper

¼ cup (13 g) chopped parsley

1 In a large, high-sided skillet, heat the olive oil over medium-high heat. Add the onion and bell pepper and cook for 3 to 4 minutes, or until the vegetables are soft. Add the garlic and cachucha pepper and cook 1 minute more. Add the tomato puree, tomato paste, and white wine and simmer for 10 to 12 minutes to blend flavors.

2 Add the cut lobster tails, cover the pan, and cook for 5 to 6 minutes, or until the lobster is opaque and firm to the touch. Season with salt and pepper to taste and stir in parsley.

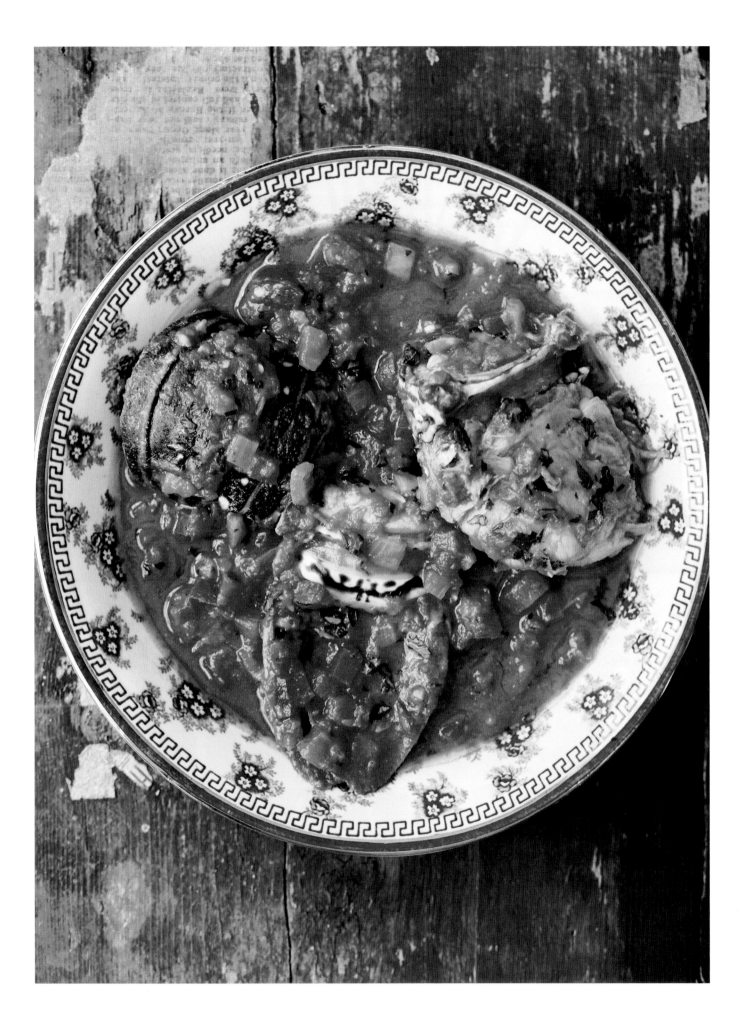

CASA PILAR

THE REIGN OF SPAIN

Until it closed unexpectedly as this book went to print, Havana's Spanish expats and Cuban foodies alike had been deeply devoted to Casa Pilar, an outpost of modern Iberian flavors ensconced in a handsome Miramar residence. Strikingly designed with a mix of contemporary Cuban art, towering tropical greenery, evocative African artifacts, and antiques from the former home of owner Pilar Fernandez, this much-missed paladar was the source of vibrant gazpachos, tender chickpeas with lobster, and now-legendary blue cheese croquettes. "My reservation list—they're all familiar faces," insisted Pilar, a designer, entrepreneur, cigar connoisseur who favors Montecristo Piramides, and one of Cuba's most successful restaurateurs. "I've called my place Pilar's House," she went on, "because I wanted it to feel like a home, to create a meeting place of interesting people." Mission accomplished.

Pilar's Story

It feels natural for a Spaniard to open a restaurant in Cuba: The gastronomic connections run deep. The first wave of Iberian influence on Cuban cuisine was colonial: all these castizo potajes [soupy stews] and rich, eggy sweets made by Spanish nuns, which eventually combined with the foods of the African slaves. The second wave came in the late nineteenth century, with immigrants from Asturias, Galicia, and the Canary Islands. The third Spanish wave came in the 1990s: Spanish companies began investing in Cuba, and entrepreneurs such as myself flocked here. Most hotels in this country, for instance, are government owned, but they're managed by large Spanish chains. And so all the Spanish expats eventually end up here at Casa Pilar, eating my tapas and stews. Offering them a taste of the old home— I feel alegría [joy].

I started doing business with Cuba in the mid-'90s, working for a powdered-milk factory, then for a tourist complex. For about eight years I'd come and go, until one day I realized: I'm not returning to Spain. Being an expat is like that: Suddenly the connection to your old country just fades.

But of course I grew up in Asturias in the north of Spain, a region of mountains and sea famous for bean stews, chorizo, seafood, hard cider, and incredible mountain cheeses. To this day I can't live without our stinky blue cheese, Cabrales. I always bring it back from visits to use in our croquetas, until my booty runs out— and I practically cry. Growing up, I had the best of Spain north and south at our family table. My grandmother from Andalusia was the queen of fried fish and gazpachos. Perhaps because everyone else cooked in my family, I couldn't even fry an egg until I was thirty-five. And then I caught the entertaining fever! In Spain I started throwing elaborate dinner parties for friends, wanting to be the world's greatest hostess. The menu was always the same: seafood soup, roasted fish, and a stuffed beef roll called boliche relleno. My friends and I would hold these mad eating contests, devouring twenty tapas in a seating. Then in Cuba I entertained like crazy, too. My friends begged me to open a restaurant— until I finally did, amazed that my cooking hobby had turned into my profession.

Visiting celebrity Spanish chefs like José Andrés and Dani García often end up at my restaurant. Listening to them talk about trendy "market cuisine"—I just laugh. They have no idea what's it's like having nothing but sporadic market cuisine. How do you run a restaurant with potatoes available only a few months a year? How do you write your menu each morning, scrambling to substitute canned peaches when suddenly mangoes are perdído, not available? What to do when a former vice president of Colombia is your regular guest who always orders a tortilla de patatas? So you spend a whole day frantically turning Havana inside out to locate those darned patatas? But on the plus side, what little we have here is organic and bursting with flavor, from pork to fish to those Cuban tomatoes that might look misshapen but deliver a taste you'll never find back in Spain.

I don't aspire to serve avant-garde Spanish cuisine. My cocina is sophisticated, flavorful home cooking. Still, I did import some high-tech cooking gadgets from Spain, including a Thermomix, a kind of futuristic food processor. Now I live in fear that it breaks. Truly, it's easier to find spare parts for a '50s Chevrolet here than for broken cooking equipment.

Lobster with Chickpeas

Langosta con Garbanzos

One doesn't immediately think of lobster and chickpeas as a match made in heaven. But this earthy yet elegant dish popular in coastal Spain during Lent and served at Casa Pilar makes the case perfectly. Sautéed with nutty garbanzos flavored with smoked pimentón and sofrito, this saucy lobster dish is something you'll find yourself making again and again. Serve with Tamarind Caesar Salad (page 116), and Coconut Flan (page 284) for dessert.

Serves 4

2 tablespoons olive oil

1 cup (125 g) finely chopped onion

½ cup (75 g) chopped red bell pepper

1 clove garlic, chopped

½ cup (90 g) chopped seeded tomato

½ teaspoon smoked Spanish paprika

2 cups (480 ml) fish stock, or equal parts clam juice and water

2 tablespoons brandy

1 bay leaf

4 cups (636 g) cooked chickpeas

¼ cup (10 g) fresh bread crumbs, toasted

2 pounds (910 g) lobster tail meat (if available, reserve shells for the stock)

¼ teaspoon saffron threads, crushed

Salt and pepper

1 In a large skillet over medium-high heat, combine the olive oil, onion, and red pepper and cook for 3 to 4 minutes, or until the vegetables begin to soften. Add the garlic and cook for 1 minute. Add the tomato and cook for 4 to 5 minutes, until the juices are released. Add the paprika and stir for a few seconds.

2 Stir in the fish stock (and shells, if using), brandy, bay leaf, and chickpeas, bring to a boil, and let boil for 1 to 2 minutes. Reduce the heat to low and cook for 15 minutes more to blend the flavors.

3 Ladle 2 cups (480 ml) of the garbanzo mixture into a bowl and let it cool slightly, then transfer to a blender with the toasted bread crumbs and blend on high speed for 1 to 2 minutes, or until smooth. Return to the skillet and cook for 3 to 4 minutes more to further blend the flavors and thicken up the sauce.

4 Add the lobster meat and saffron to the skillet and cook for 3 to 4 minutes, or until the lobster is opaque and firm to the touch but not rubbery. Season with salt and pepper to taste.

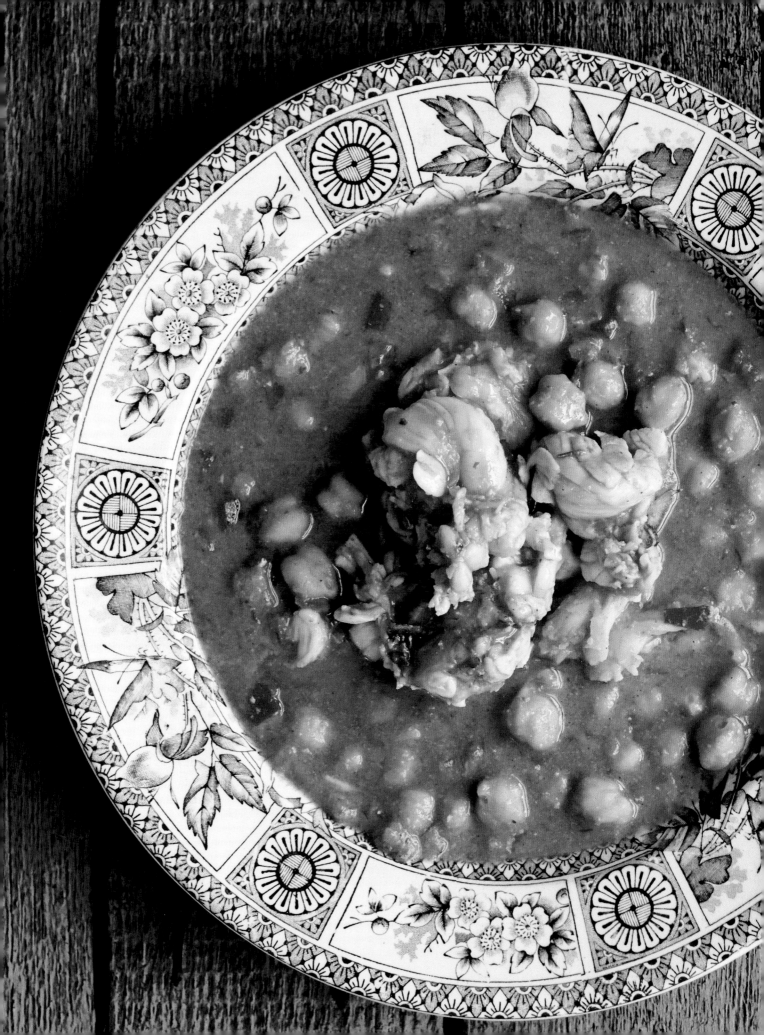

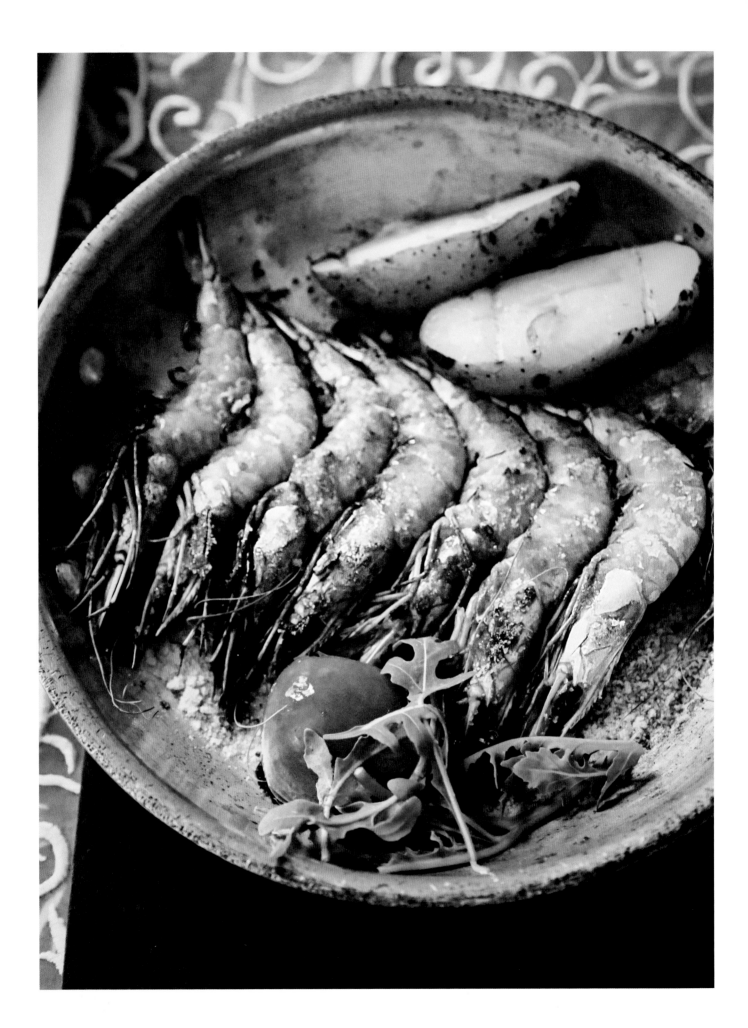

SALT-ROASTED SHRIMP

Gambas a la Sal

For this simple but striking preparation from paladar Ivan Chef Justo, jumbo shrimp are baked in their shells on a bed of coarse salt (a nifty Mediterranean technique that helps concentrate flavors) along with wedges of potatoes. Garnished with good olive oil, peppery arugula leaves, and tomatoes, it makes a satisfying, elegant meal.

Serves 4

½ cup (120 g) kosher salt

1 pound (455 g) jumbo shrimp (16–20 count), heads on

1 pound (455 g) cooked new potatoes, halved

⅓ cup (75 ml) olive oil, plus more for drizzling

Salt and pepper

1 Preheat the oven to 450°F (230°C).

2 Pour the salt into the center of a deep metal baking pan and bake for 15 minutes.

3 In a bowl, toss the potatoes with the olive oil and season with salt and pepper to taste. Arrange the potatoes on the salt in a single layer. Bake for 25 minutes.

4 Move the potatoes to the side of the pan, and place the shrimp on the salt in a single layer.

5 Roast the shrimp and potatoes for 5 minutes, or until the shrimp are opaque, pink, and cooked through. If they are not cooked through, roast for a few more minutes.

6 Remove the shrimp and potatoes to a serving platter, brushing off any excess salt. Drizzle olive oil over the shrimp, and serve.

GARLIC SHRIMP

Camarones al Ajillo

These sizzling Spanish shrimp with enough garlic to stun a vampire are almost a default treat on most paladares menus. And why not? Who can resist dunking bread into the garlicky oil even after the shrimp are long gone? Our favorite treatment comes from the stylish paladar Habana Mia 7, where the dish is served in a cast-iron skillet and finished with parsley and a nontraditional sprinkle of lime. The key to success here is to choose excellent olive oil and to simmer the shrimp in it gently, until just heated through rather than fried. Plenty of country bread for sopping up sauce is obligatory. Serve with Pumpkin Rice (page 168) and Tamarind Caesar Salad (page 117).

Serves 4

1 cup (240 ml) olive oil

10 cloves garlic, chopped

1½ pounds (680 g) extra-large shrimp, peeled and deveined

½ cup (120 ml) fresh lime juice (from 4–6 limes)

Salt and pepper

2 tablespoons chopped fresh parsley

In a large skillet over medium-high heat, combine the olive oil and garlic and cook for 3 minutes, or until the garlic just starts to turn golden brown. Reduce the heat to medium and add the shrimp and the lime juice. Continue to cook for 4 to 5 minutes, turning the shrimp, until they turn pink and opaque. Season with salt and pepper to taste and garnish with the parsley.

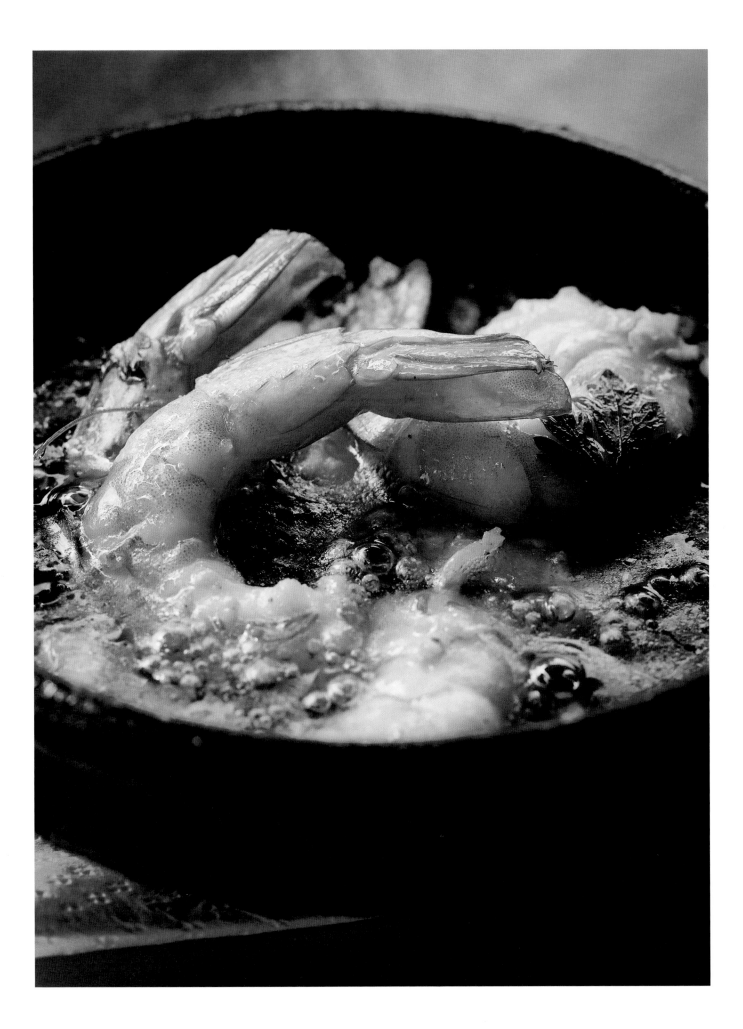

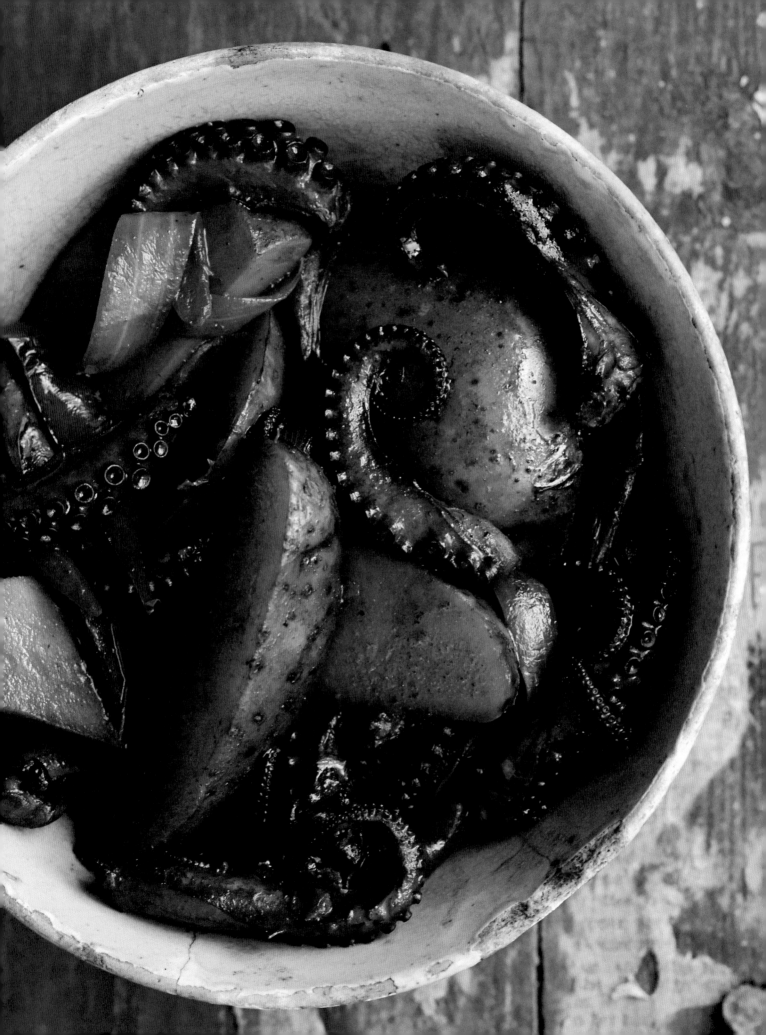

BRAISED OCTOPUS WITH NEW POTATOES

Pulpo a la Ibicenca

Located near Havana's famed Malecón in the fancy Miramar neighborhood and decorated with bullfighting posters, Toros y Tapas competes with Casa Pilar as Havana's best Spanish restaurant. Mauricio Estrada, its gregarious owner, is a Cuban who immigrated to Spain in the early aughts, worked as a cook at a hotel in Ibiza, then on a whim returned to the island to open a restaurant. Toros y Tapas has been packed from day one—a repatriation success story! For this delicious, brawny dish of octopus braised in wine along with red-skinned potatoes, the chef instructs you to dip the octopus in boiling water three times and then braise it. Our own tip: Freeze the octopus before cooking or buy it already frozen to kick-start the tenderizing process. Still fearful of tackling the beast? Buy your octopus precooked, either in a jar or vacuum-packed, and finish, as instructed here, with the wine and potatoes.

Serves 4

1 pound (455 g) frozen octopus, dipped in boiling water 3 times and cooled (see headnote)

2 tablespoons olive oil

½ cup (55 g) thinly sliced onion

½ cup (45 g) thinly sliced green bell pepper

1 bay leaf

1½ cups (210 g) red potatoes, briefly boiled until just tender and cut into 8 wedges each

½ teaspoon smoked sweet paprika

1 cup (240 ml) dry red wine

Salt and pepper

1 Cut the octopus into pieces, separating the head from the legs, then cut into bite-size pieces. Set aside.

2 In a skillet over medium heat, combine the olive oil, onion, and bell pepper. Cook for 3 to 4 minutes to soften. Add the bay leaf, potato wedges, paprika, and red wine. Bring to a simmer and cook for 4 to 5 minutes. Add the octopus and cook for 10 to 15 minutes, or until the wine is reduced by half. Season with salt and pepper to taste and serve.

Fried Fish with Tropical Salsa

Eperlan de Pescado en Salsa de Frutas

At his home outside Havana, artist and cook Alexis Alvarez Armas dreams up magical feasts featuring exotic spices and sweet-sour flavors. One of the courses might be this fish, his take on Cuba's ever-popular eperlan [breaded fish fingers]. Alexis dips the fish in bread crumbs scented with nutmeg, fries until crisp, and proudly presents it with a tropical sauce of carrot juice, mango, pineapple, and homemade pineapple vinegar. We like this with any firm white fish, like mahi-mahi or cod.

Serves 6

FOR THE FISH

- 1½ pounds (680 g) firm white-fleshed fish, such as snapper, mahi-mahi, or swordfish, cut into 3-inch (7.5-cm) pieces
- 2 large eggs, beaten
- ¾ cup (95 g) all-purpose flour
- 1 cup (100 g) dry bread crumbs
- ½ teaspoon salt
- ½ teaspoon pepper
- ¼ teaspoon ground nutmeg
- ½ cup (120 ml) vegetable oil, for frying

FOR THE FRUIT SALSA

- Scant 1½ teaspoons vegetable oil
- ½ medium white onion, diced
- ½ cup (120 ml) fresh carrot juice
- ½ cup (120 ml) fresh orange juice
- ½ cup (120 ml) apple cider vinegar
- ½ cup (100 g) sugar
- 2 tablespoons soy sauce
- 4½ teaspoons cornstarch (optional)
- ½ cup (85 g) diced pineapple
- ½ cup (85 g) sliced mango

1 **Make the fish:** Pat the fish dry. Place the beaten eggs, flour, and bread crumbs in three separate bowls. Season the bread crumbs with the salt, pepper, and nutmeg.

2 In a large skillet, heat the vegetable oil over medium-high heat. Dip the pieces of fish first in the egg, shaking off any excess, then the flour, then the bread crumbs. Fry the fish, turning once, until golden brown and cooked through, about 2 to 3 minutes per side. Remove to a paper towel–lined plate.

3 **Make the fruit salsa:** In a saucepan, heat the vegetable oil over medium heat. Add the onion and cook over medium heat until soft, 3 to 4 minutes. Add the carrot juice, orange juice, vinegar, sugar, and soy sauce and cook, stirring, until the sugar has dissolved. If a thicker sauce is desired, make cornstarch slurry by combining the cornstarch with 1 tablespoon water and adding it to the pan. Add the pineapple and mango and cook until just heated through. Serve with the fish.

POLLO, PATO, Y CONEJO

Chicken, Duck, and Rabbit

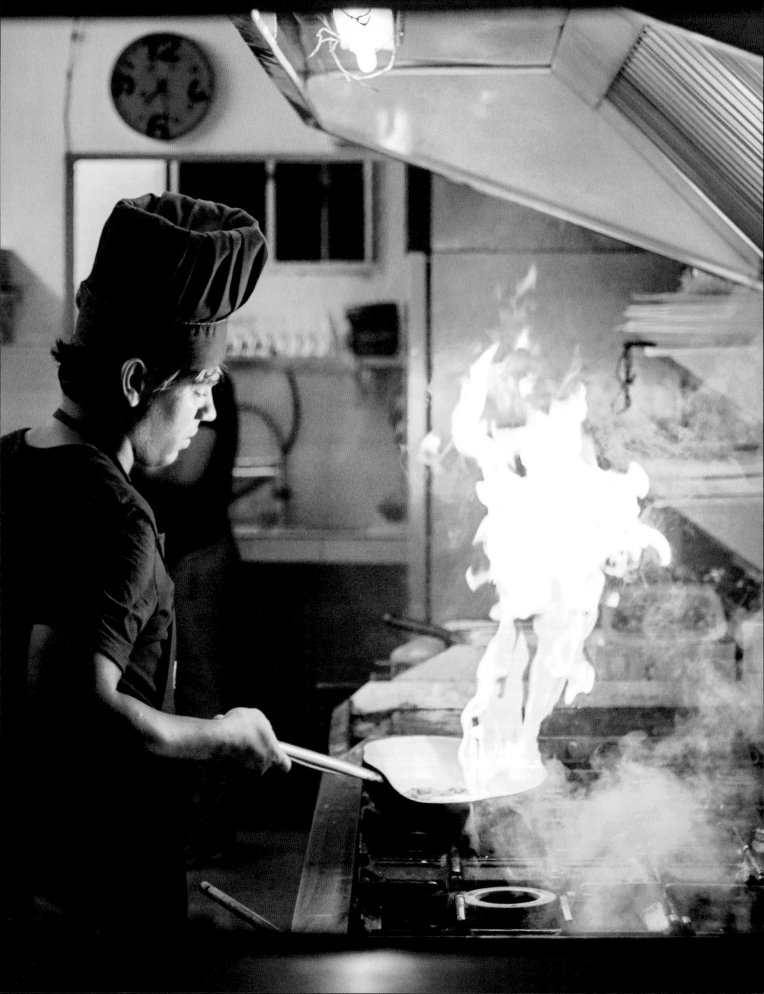

"How much does el cubano love chicken?" the Havana food journalist Alicia García was asking. Rhetorically.

"Mucho—a lot!" chorused our table at lunch. But Alicia shook her head no. The correct answer? "Muchisimo—very much!"

The scene around us was proving Alicia right. We were seated under a rustic thatched-palm ceiling on the thronged terrace of El Aljibe, a vast and vastly popular chicken restaurant in Havana's Miramar district. All around us, families were polishing off truly mountainous portions of all-you-can-eat pollo asado, chicken croquetas, chicken empanadas, and stuffed chicken wings—then more roast chicken. A small musical band played Cuban classics. Waiters rushed about with tureens of black beans, rice, viandas [tubers], maduros [plantains], and above all that fall-apart tender roast chicken, marinated in an adobo of sour orange, loads of garlic, and a few other "very secret ingredients." At about fifteen dollars per person, the price for the feast is expensive for average Cubans. But as one patron put it: "For Habaneros a Sunday lunch at El Aljibe is a sacred family ritual. So we save up for it. Or our visiting Miami relatives take us!" Like daiquirís at El Floridita, El Aljibe's roast chicken is a proudly beloved Cuban icon.

Alicia in particular knows a thing or two about pollo. El Aljibe was founded in the late 1940s by her late father and uncle. It started in the countryside, under a different name: Rancho Luna. Its burnished mahogany-skinned roasted bird— Alicia's grandmother's recipe—became such an epic hit, the Garcías' rustic ranchón [ranch] fed Errol Flynn, Ava Gardner, gangster Meyer Lansky, boxing champ Rocky Marciano, and scores of Cuban celebs. In 1959, the García family expanded with a branch in Havana, but in the wake of the Revolution, Rancho Luna was eventually shuttered. "But there's a happy ending to our story!" exclaims Alicia. Come 1993, the Cuban government asked her dad to help revive Rancho Luna. It was reborn there in Miramar under a new name, El Aljibe, drawing the likes of Jimmy Carter and Jack Nicholson and, most important, nostalgic Cubans hungering for that pollo asado. "Why did my dad agree to manage his own restaurant for the state?" mused Alicia. "Because he believed in Fidel's Revolution. He was happy, for instance, that the profits would contribute to Cuba's universal health-care system." And he was happier still that chicken lovers could come together again at his restaurant.

While El Aljibe is Cuba's most famous poultry landmark, scores of other more modest eateries satisfy the pollo asado yen of Sunday lunchers. And when chicken isn't roasted whole in the oven, it comes braised en cazuela or en cacerola or en fricasé—all moist stews involving a zesty tomato base and often potatoes—or crisp-fried in chunks, or sautéed with pineapple, or barbecued on a beach, or marinated in mojo and seared. Or even breaded and fried à la cordon bleu, a retro hit that will forever remain in fashion in Cuba. "The lucky thing about chicken," Alicia declares gleefully, "is that it's not only adored, but, unlike lobster or beef, say, it's also pretty much available!" Decades ago, she notes, government rationing coupons included weekly portions of fish. When fish became scarce and state shops began pulling their "chicken for fish" switcheroos, Cubans didn't complain. "As long as chicken was in our canastas [shopping baskets]," says Alicia, "we felt fed and looked after." Of course, the chewy barnyard gallina criolla, a creole hen, is mostly a memory. But with other things so scarce, most Cubans are grateful for the frozen American imports (chicken is not subject to the embargo laws), or the Middle Eastern or Brazilian poultry that shows up at the supermarkets.

Chicken, it's widely believed, was introduced to South America by the Spanish in the late 1500s—although certain competing hypotheses point to the puzzling cache of pre-Columbian chicken bones that were found in Chile about a decade ago and suggest Polynesian traders. We do know for sure that Columbus took a flock of about two hundred hens on his second voyage, in 1493, and that the European *gallus gallus* bred and multiplied easily in the New World. In early colonial pots, chickens were often cooked with rather medieval Arab-Iberian sauces of spices and pounded nuts. "Even nineteenth-century Cuban chicken recipes look pretty ornate," says Alicia. Luckily nowadays—as you'll see from this chapter's flavorful recipes—the preparations tend to be much more straightforward: a zesty fricassee, a tasty salad served on plush rounds of roast pumpkin, a super-savory mojo-steeped bird, or a chicken-and-tuber stew called la caldosa that's generous enough to feed a whole neighborhood. And let's not forget festive chicken-and-rice combinations such as arroz con pollo, or the parallel modern-Cuban riffs on rabbit and duck.

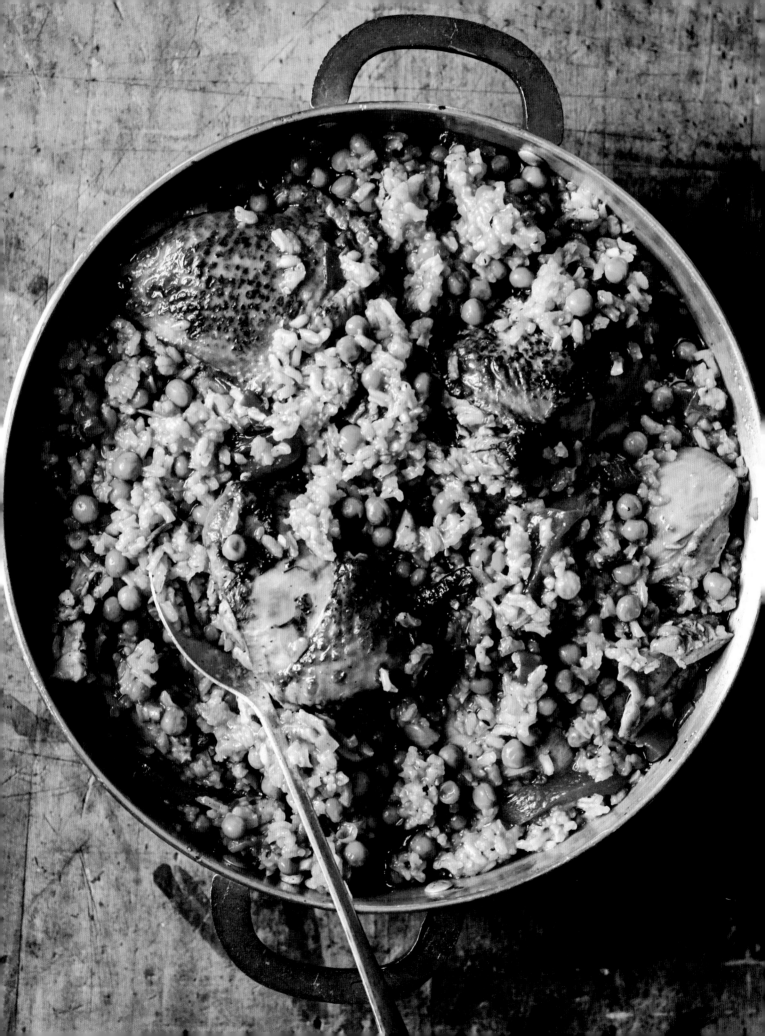

CHICKEN AND RICE

Arroz con Pollo a la Chorrera

A flamboyant Latin-American answer to the Spanish paella, the festive one-pot treat known as arroz con pollo is adored across Latin America and the Spanish Caribbean. This Cuban iteration was a famous late-nineteenth-century dish served at Casa Arana, a stately restaurant located at the mouth of the Almendares River near Havana's emblematic seventeenth-century Chorrera Tower. According to novelists and historians, the chicken rice named after the tower was a big hit among Spanish colonial officers in the last dying days of Spain's reign over Cuba. Now often resurrected at restaurants and eaten at homes for a late Sunday lunch, the deliciously soupy arroz features chicken and medium-grain Valencia-type rice brightened with saffron. It is moistened with broth, wine, and always a splash of Cuban beer, and decorated with peas and strips of roasted red pepper. What a great dish to bring to a potluck!

Serves 10

3 pounds (1.4 kg) bone-in, skin-on chicken thighs

⅓ cup (75 ml) sour orange juice, or an equal mix of lime and orange juice

1 tablespoon minced or pressed garlic, plus 2 cloves garlic, chopped

1 teaspoon ground cumin

1 teaspoon dried oregano

Salt and pepper

¼ cup (60 ml) annatto oil (see page 146)

1 cup (110 g) chopped yellow onion

½ cup (75 g) chopped green bell pepper

½ cup (75 g) chopped red bell pepper

1 cup (180 g) chopped seeded tomato

½ cup (120 ml) dry white wine

6 cups (1.4 L) chicken stock or water

3 cups (585 g) medium-grain white rice

¼ teaspoon saffron threads, crumbled

½ cup (120 ml) lager-style beer

2 tablespoons capers in brine

1 (10-ounce / 280-g) box thawed frozen peas

1 cup (90 g) thinly sliced roasted red pepper

1 In a large bowl, combine the chicken thighs, sour orange juice, minced garlic, cumin, and oregano. Season with salt and pepper and mix until well combined. Marinate the chicken for a minimum of 30 minutes or up to overnight in the refrigerator.

2 Remove the chicken from the marinade and pat dry. In a large, wide pot, heat the annatto oil over medium heat. Working in batches, add the chicken, skin side down, and cook, turning once, for 7 to 8 minutes per side, or until golden brown. Remove to a plate and set aside.

Recipe continues on page 216

3 In the same pot, combine the onion, green pepper, and red pepper and cook for 5 to 6 minutes, or until soft. Add the chopped garlic and cook for 1 minute. Add the chopped tomato and white wine and cook for 3 to 4 minutes to cook off the alcohol a bit. Pour in 2 cups (480 ml) of the stock and return the chicken to the pot. Reduce the heat to medium-low and simmer for 10 minutes.

4 Add the rice and saffron and continue to cook for 5 to 7 minutes, or until most of the liquid is absorbed. Pour in another 2 cups (480 ml) of the stock and continue to cook, stirring occasionally, until most of the liquid has been absorbed, 7 to 8 minutes.

5 Add the final 2 cups (480 ml) of the stock and the beer and cook for 5 more minutes. Add the capers, peas, and roasted red pepper. Turn off the heat, cover, and let sit for 10 minutes more. Taste for seasoning and adjust to taste.

CHICKEN FRICASSEE

Fricasé de Pollo

Dainty stews of Gallic origins, fricassees were initially introduced to Cuba by French-Creole migrants from Haiti in the early 1800s. Their popularity was reinforced in the early twentieth century by the general vogue for French cooking all over the world. Luckily, the Spanish-Caribbean fricassee is a lot more feisty and fun than the Gallic original. Case in point: this recipe, lively with a tangy-sweet alcaparrado of olives, capers, and raisins, plus citrus juice and white wine. Potatoes also go into the mix, and the whole thing simmers happily in a tomatoey sauce to produce a one-pot Cuban classic. In some regions of Cuba, cooks add a bit of guarapo (sugarcane juice) to sweeten the dish. Others swear by a finishing touch of orange juice (the non-sour variety) and/or a splash of dark Cuban rum.

Serves 4 to 6

4½ pounds (2 kg) bone-in, skin-on chicken legs or thighs

Juice of 1 orange

Juice of 3 limes

4 cloves garlic, minced

Salt and pepper

2 tablespoons olive oil

1 onion, halved and sliced

1 green bell pepper, sliced into thin strips

1 cup (240 ml) dry white wine

5 teaspoons tomato paste

¾ cup (180 ml) chicken broth

1½ cups (210 g) peeled and diced potato

2 tablespoons capers, rinsed and drained

¼ cup (40 g) pimento-stuffed green olives

¼ cup (35 g) dark raisins

¼ teaspoon saffron threads, crumbled

1 Place the chicken in a bowl. In another bowl, combine the orange juice, lime juice, garlic, and salt and pepper. Pour the marinade over the chicken, cover, and refrigerate for 1 hour.

2 In a large skillet, heat the olive oil over medium-high heat. Remove the chicken pieces, shaking off excess marinade, and brown in the oil, turning once, about 5 minutes per side. Remove the chicken to a plate.

3 In the same skillet, combine the onion and green pepper and cook until soft, about 5 to 7 minutes. Pour in the wine and cook until reduced by half, about 10 minutes. Stir in the tomato paste and chicken broth.

4 Return the chicken to the skillet and add the potato, capers, olives, raisins, and saffron. Cover, reduce the heat, and simmer until the chicken is cooked through and the potatoes are tender, about 20 minutes. Taste and season with more salt and pepper if desired.

Roast Chicken Stuffed with Black Beans and Rice

Pollo Asado con Relleno de Moros y Cristianos

Confronted with leftover Black Beans and Rice (page 152), an inventive Cuban cook might use it as stuffing for roasted chicken. And if said bird is rubbed with oregano and sour orange juice and basted with white wine as it roasts, it earns a place in the chicken hall of fame. Leftover Moros y Cristianos are also often used as a stuffing for turkey prepared for fiestas. The chicken will still be delicious without the stuffing.

Serves 4

¼ cup (60 ml) sour orange juice, or an equal mix of lime and orange juice

1 teaspoon salt

3 cloves garlic, minced

½ teaspoon dried oregano

1 (3-pound/1.4-kg) whole chicken

1½ cups (125 g) leftover Black Beans and Rice (page 152)

1 cup (240 ml) dry white wine

1 Preheat the oven to 325°F (165°C).

2 In a bowl, combine the sour orange juice, salt, garlic, and oregano.

3 Place the chicken in a roasting pan, breast side up, and rub with the sour orange mixture inside and out. Let stand at room temperature for 20 minutes.

4 With a spoon, stuff the chicken with the Black Beans and Rice and tie the legs shut with kitchen twine. Pour the white wine around the chicken and place in the oven.

5 Roast the chicken for 2 to 2½ hours, basting occasionally, until a meat thermometer inserted into the thickest part of the thigh reads 160°F (70°C). Let stand for 10 minutes before scooping the stuffing out of the chicken and serving it alongside the chicken.

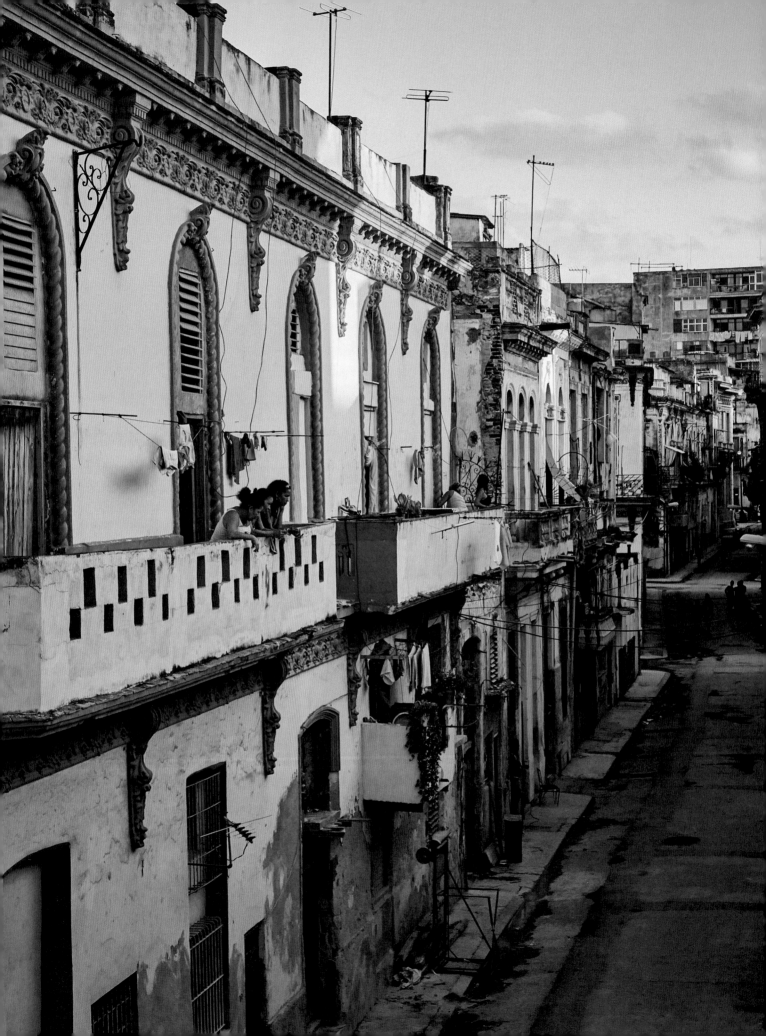

Chicken and Vegetable Stew
La Caldosa

La Caldosa Tunera

La caldosa—from the Spanish word "caldo," meaning "broth"—is the modern Cuban riff on Ajiaco (page 78), the emblematic one-pot meal of the Spanish Caribbean. Though extremely recent, the story of la caldosa's creation is as improbable as a fairy tale. Once upon a time (that is, 1979), a couple named Marina and Kike, living in Las Tunas province on the east side of the island, conjured up a festive pot of tubers and hen to welcome their son back from his studies in the Castro-friendly USSR. Their neighbor, a respected professor who was also an avid guitarist, composed a catchy guaracha [folksy song] to honor the occasion. Somehow a quite famous musician, Inocente Iznaga [aka El Jilguero de Cienfuegos] heard the tune and decided to perform it on Cuban TV. Soon the whole country was singing, "¡Qué bien se camina con esta caldosa de Kike y Marina!" ("How well we all walk with Marina and Kike's caldosa!") Marina and Kike found themselves interviewed and feted by the Cuban press and invited to fiestas and carnivals all over the island to share their recipe. Their caldosa became the "it" dish of communal street parties, cooked up over a live fire in enormous calderos [cauldrons] for barrio fiestas, with neighbors all contributing foodstuffs to the pot. During the drastic food shortages of the Período Especial of the early 1990s, the caldosa acquired an almost existential symbolism as people toted in the last edible scraps they could find—a bit of noodles, a little leftover rice.

Now, in more plentiful times, la caldosa is prepared once again with chicken, as in Marina's original recipe, plus viandas like yuca, calabaza, green plantains, and malanga—all liberally seasoned with tomatoes, chilies, cumin, onions, and plenty of garlic. In an interview with a Cuban newspaper, Marina revealed that she used to add a touch of soy sauce to finish the dish. Kike, meanwhile, proposed his own zesty aliño [dressing] of lemon, tomatoes, and chilies to liven things up. We suggest a puckery Mojo Criollo (see page 30). And so here's la caldosa, a dish not only delicious but meaningful. A one-pot inspiration and improvisation to be shared with others.

Serves 10

Recipe continues on page 222

1 (4-pound / 1.8-kg) chicken, cut into 10 pieces

Salt and pepper

2 tablespoons olive oil

1 cup (110 g) chopped onion

1 cup (145 g) chopped green bell pepper

1½ cups (210 g) chopped carrots

1 jalapeño pepper, chopped

4 cloves garlic, chopped

1 teaspoon dried oregano

1 teaspoon crushed cumin seeds

1 cup (180 g) chopped seeded tomato

2 cups (260 g) peeled and chopped malanga

1 cup (130 g) peeled and chopped yuca

1 cup (135 g) peeled and chopped boniato or white sweet potato

2 green plantains, peeled and cut into 1-inch (2.5-cm) slices

2 cups (230 g) peeled and chopped pumpkin

Mojo Criollo (page 30), for serving

½ cup (20 g) chopped fresh cilantro, for serving

Hot sauce, for serving (optional)

1 Season the chicken pieces with salt and pepper. In a large, wide pot, brown the chicken on both sides over medium-high heat, 3 to 4 minutes per side, and remove to a plate.

2 Add the olive oil to the same pot and cook the onion, green pepper, carrots, and jalapeño over medium heat for 4 to 5 minutes, or until the onions soften and begin to brown. Add the garlic, oregano, and cumin seeds, and cook for 1 minute. Stir in the chopped tomato and cook for 3 to 4 minutes to release some of its juice.

3 Return the chicken to the pot. Add 12 cups (2.8 L) water, the malanga, yuca, boniato, and plantains and bring the stew to a simmer, skimming if necessarry. Cook until all the vegetables are tender, 45 minutes to 1 hour, then add the pumpkin and cook for 30 minutes more.

4 Correct the seasoning, remove from heat, cover, and let rest for 15 minutes to meld the flavors before serving. Serve with the mojo, cilantro, and hot sauce, if desired.

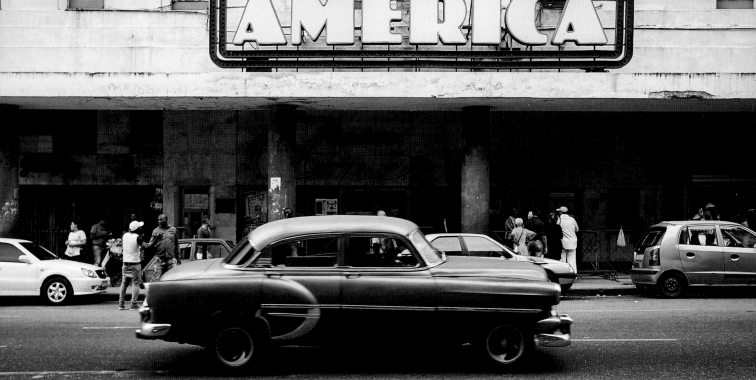

Stuffed Chicken with Apricots and Poached Pears

Pollo Relleno de Frutos Secos

The Cuban flair for combining sweet and savory is on delicious display in this recipe from chef Ariel Mendoza Amey of the classy modern paladar La Foresta. Apples and pears, Ariel said, are pretty rare in Cuba; as a child he tasted a pear just once. Dried fruit are also a sought-after treat, and for his restaurant guests, this dish is doubly special. In his recipe he rolls the butterflied chicken breast around a plump dried fruit filling, sears it, poaches it in stock, then cuts the rolls into attractive diagonal slices. The chicken is served with addictive red wine–poached pears and garnished with fennel.

Serves 4

2½ cups (600 ml) red wine, such as Cabernet or Merlot

2 tablespoons honey

½ cup (65 g) dried apricots

½ cup (75 g) dark raisins

¼ cup (50 g) sugar

2 Bosc or Anjou pears, peeled, cored, and halved lengthwise

1 (2-inch / 5-cm) piece of orange peel

4 boneless, skinless chicken breasts (1½ pounds / 680 g total)

Salt and pepper

2 tablespoons olive oil

¼ cup (60 ml) white wine or sherry

1 cup (240 ml) chicken stock

Fennel sprigs, for garnish (optional)

1 In a small saucepan, mix together ½ cup (120 ml) of the red wine, 1 tablespoon of the honey, the dried apricots, and the raisins. Simmer until the fruit plumps up, 7 to 8 minutes. Set the rehydrated fruit aside to cool.

2 In a small saucepan, over medium heat, add the remaining 2 cups (480 ml) of the red wine with the sugar, stirring until the sugar dissolves. Add the pears and orange peel and simmer over medium-low heat for 8 to 10 minutes, flipping the pears halfway through for even poaching. Remove the poached pears to a bowl and continue to reduce the red wine until it thickens to create a syrup.

3 Butterfly the chicken breasts, taking care not to cut all the way through (you will have four cutlets that open like a book). Spoon the rehydrated fruit mixture along the length of each chicken breast and roll them up tightly like a cigar. Secure each roll with three pieces of butcher's twine, tying tightly. Season with salt and pepper.

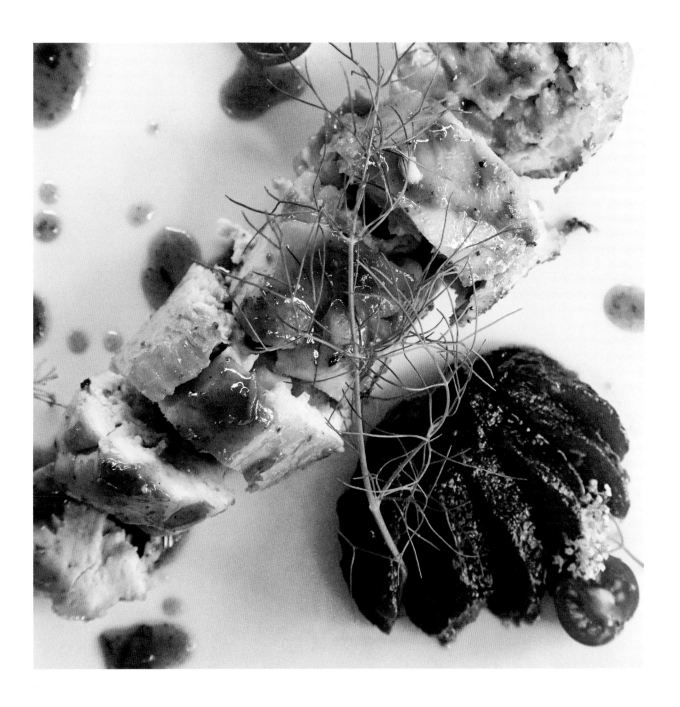

4 In a sauté pan, heat the olive oil over medium-high heat and sear the stuffed chicken cutlets on all sides until golden brown. Deglaze the pan with the white wine, pour in the chicken stock, and poach the chicken in the stock, about 10 to 12 minutes.

5 Remove the stuffed chicken from the pan, cut off the twine with scissors, and slice the chicken. Arrange the sliced chicken on serving plates and spoon the pan sauce over the top. Thinly slice the poached pears, add to the plates, and drizzle them with the red wine reduction. Garnish with the fresh fennel sprigs, if desired.

LA FORESTA

A CLASS ACT

Ariel Mendoza Amey, the forty-something chef at paladar La Foresta, loves chicken. He loves it so much that he eats chicken for lunch every day on the job, then goes to his mother's house after work for more pollo still. "I'd eat chicken every day of my life," confesses the thoughtful, soft-spoken Ariel, adding that his mom's pollo en cazuela [a chicken casserole] might be the world's greatest dish. So would he share the recipe? "Fat chance!" he replies with a laugh. "Mom doesn't even give *me* the recipe!" Located in the ritzy Siboney district, La Foresta, it needs to be said, isn't some neighborhood chicken shack. With comfy rattan couches set out on a posh, spacious patio shaded by palm trees and a sleek, light-filled dining room, it's a vision of Havana by way of Coconut Grove or Beverly Hills. Here Ariel woos cigar-puffing Cuban businessmen and their foreign guests with luscious chicken stuffed with dried fruit and served with poached pears; an irresistible dish of honey-glazed rabbit and baby carrots; and molecular-leaning whimsies, such as "spherified daiquirís" inspired by his idol, the avant-garde Spanish wizard Ferran Adrià. Such is Ariel's special touch in the kitchen that even a simple grilled chicken with a garnish of marinated diced chilies is something out of the ordinary. The man loves to cook.

Ariel's Story

Yes, I adore being a chef. But, you know, I often miss the adrenaline of my previous job. I was a cop. Or more grandly a criminal investigator specializing in murders and assassinations.

After doing my military service, I'd planned to work in intelligence. I even learned Russian. But as I was graduating, Russia dumped Cuba, and so I ended up chasing criminals. Crime rate in Cuba—especially murders—is low compared to most countries. The majority of the offenses I handled were crimes of passion—Cubans are hot-blooded! I'm still proud that our crime-solving rate was 98 percent. Foreigners would be surprised that we had the latest computers, well-financed forensics, and fancy equipment imported from France. For our government, controlling the crime rate is an important priority. I loved every day on the job, decapitated corpses and all. I still can't stop watching films like *Silence of the Lambs*, *Seven*, and *Citizen X*—that last one about a Russian serial killer. But in the end, it got hopeless, doing this important, dangerous work for thirty dollars a month. And so, deciding to learn something new, something I could love for the rest of my life, I enrolled in a professional cooking school.

My mother is Cuban-Chinese and a formidable cook. When I was growing up she made beautiful rice dishes, great beans, and exquisite homemade profiteroles, even when foodstuffs were scarce. Cooking school involved the same rice and beans and flan—but with a whole different attention to detail. Our culinary instructor was scary! He eviscerated us for any tiny mistake, for a little splotch on our chef's uniform. I lived far away, so after getting up before dawn and a long bus ride, I ran like crazy to cooking school, terrified of being late for our 6 A.M. class: Latecomers were expelled on the spot. Imagine! Here I was twenty-eight, a former high-ranking, arms-carrying professional, being subjected to this. Did I fantasize about arresting that instructor? Ha! At times! But in the end, I accepted that cooking school is just like the military—all about discipline.

I've never been out of Cuba. I learned a lot, though, about foreign cuisines and ingredients, working at a big Havana hotel here. But all our hotels are government-run, so the pay was still miserable—plus the frustrations of having zero control over the supply situation. I was much happier going on to a great seafood paladar called Rio Mar. Then La Foresta's owner, Felix, who is a cool race car driver, invited me to be his chef de cuisine. Now every day I learn new dishes and unlock different life secrets. The biggest inspiration besides my mom? Ferran Adrià—not just for me, but for many young Cuban chefs who dream of meeting him one day. Researching his dishes online, I was startled how you can alter a texture without changing the flavor, how you can make miracles like hot gelatin thanks to an Asian seaweed called agar-agar. The idea that you can encapsulate so much flavor in the thinnest of membranes in a technique called "spherification"—it just blew my mind! I felt I was discovering magic.

Sure, Cuba lacks many high-tech molecular gadgets. But you'd be surprised what gets smuggled in via Panama! I'm equally inspired by our traditional dishes; I tweak them only slightly. A touch of honey in the ropa vieja to indulge our national sweet tooth. Some extra care and attention to the texture of beans in congri, a dish where beans cook together with rice and both must be perfect. Ultimately, cooking isn't merely about a recipe you can look up on the Internet. Dishes convey emotions, contexts, sentimientos. Every day I taste and taste and experience a range of different feelings—then I go home and eat Mom's chicken.

ADOBO CHICKEN

Pollo Adobado

There isn't a bird in the world that isn't vastly improved by a soak in a tangy, citrusy adobo—at least that's how the Cuban reasoning goes. The handsome Old Havana paladar Los Mercaderes serves a memorable version of citrus-marinated chicken thighs deliciously seared on the plancha. They present it with plancha-seared vegetables and the classic black beans and white rice combo. Why not do the same?

Serves 4

1½ pounds (680 g) chicken thighs (4 large or 6 small)

6 cloves garlic, peeled

¾ teaspoon salt

3 tablespoons olive oil

½ cup (120 ml) sour orange juice, or an equal mix of lime and orange juice

1 teaspoon dried oregano, crumbled

1 Place the chicken thighs in a large bowl. In a mortar with pestle, pound the garlic and salt together (or chop them together with a knife) and scrape into the bowl with the chicken. Add 2 tablespoons of the olive oil, the sour orange juice, and oregano. Toss to coat the chicken, cover the bowl, and marinate for at least 30 minutes or up to overnight in the refrigerator.

2 When you are ready to cook the chicken, in a griddle or large, flat-bottomed skillet, heat the remaining tablespoon of olive oil over medium-high heat. Working in two batches if necessary, add the chicken thighs to the oil and cook for 3 to 4 minutes per side, or until golden on both sides.

Chicken Salad on Roasted Squash

Ensalada de Pollo sobre Calabazas Asadas

The breezy-cool paladar Rio Mar is so popular because it always surprises guests with something delicious and novel. For instance? This ridiculously good salad of juicy chicken breast, celery, julienned peppers, and chives, all moistened with mayo. The salad comes out spooned onto rounds of densely fleshed roasted pumpkin. We promise: You'll be making it often.

Serves 4

1 (8-ounce / 225-g) boneless, skinless chicken breast

Salt

½ medium onion

¾ cup (75 g) julienned celery

½ cup (45 g) julienned red bell pepper

2 tablespoons chopped scallions

1 tablespoon chopped fresh chives

2½ tablespoons mayonnaise

Black pepper

8 (1-inch / 2.5-cm) thick rings of winter squash, such as acorn squash

Olive oil, for drizzling

Dill, for garnish (optional)

1 In a medium-size skillet or pot, cover the chicken breast with lightly salted water by ½ inch (12 mm). Add the onion and bring to a boil. Cover the pot, reduce the heat, and simmer for 5 minutes to poach the chicken. Remove from the heat and let stand, covered, for 12 minutes, or until the chicken is no longer pink in the center. Cool and shred.

2 Preheat the oven to 400°F (205°C).

3 In a bowl, mix together the shredded chicken, celery, half of the julienned red pepper, the scallions, chives, and mayonnaise. Season with salt and pepper to taste.

4 Toss the squash slices with a drizzle of olive oil and season with salt and pepper. Arrange in a single layer on a baking sheet and roast until tender, about 25 minutes.

5 Place two roasted squash rings side by side, slightly overlapping, on each plate. Top each ring with a scoop of the chicken salad. Decorate with the remaining julienned red pepper, and dill (optional).

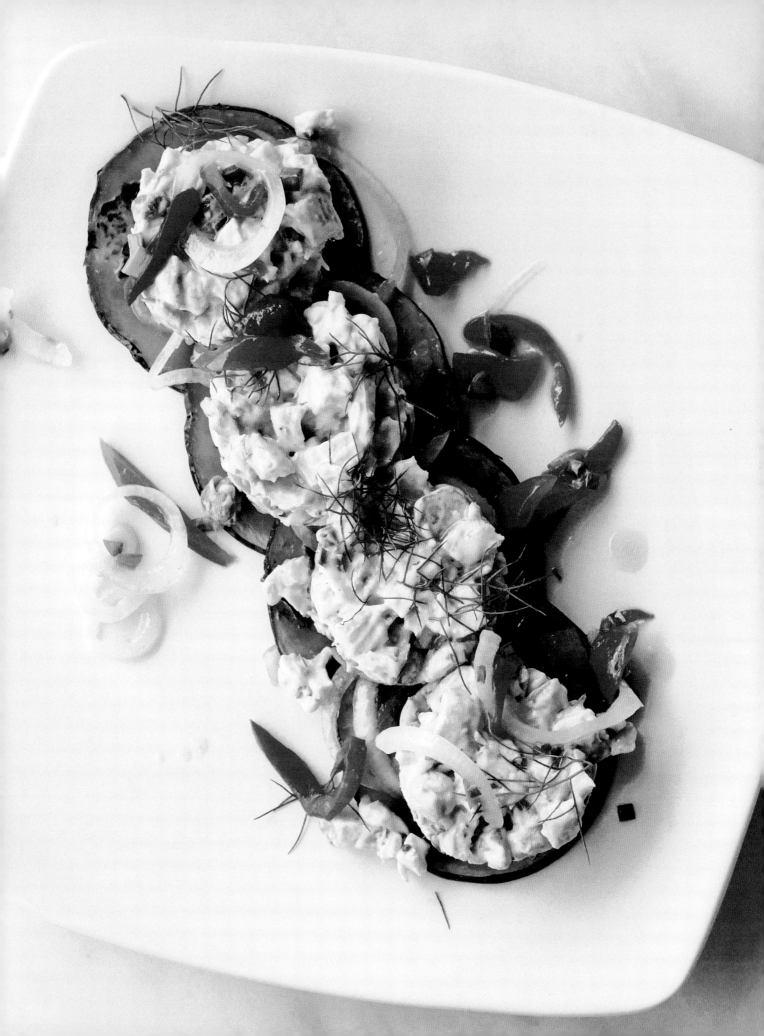

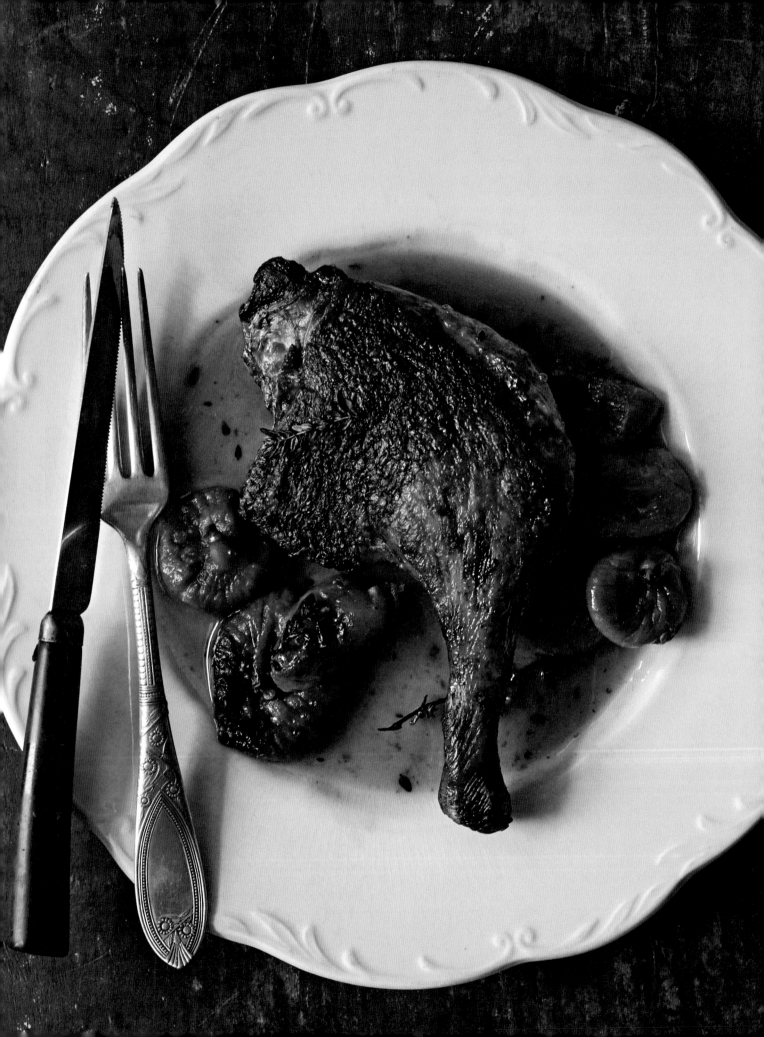

Duck with Figs and Apricots

Pato con Frutos Secos

Run by the brother-and-sister team of Niuris and Herdys Higueras, the softly lit El Atelier is one of Havana's classiest paladares, with striking modern Cuban art on the walls and tables draped with charming lace tablecloths. The mix of the old and the new is also on show in their roasted duck, with its delectable thyme-scented sauce of orange juice and dried fruit. We simplified this recipe using meaty duck legs instead of the whole-roasted bird. Serve it garnished with sprigs of parsley and tarragon and a side of mellow Pumpkin Rice (page 168). This recipe will also work with chicken legs with the thighs attached.

Serves 6

6 duck legs (about 2 pounds / 910 g total)

Salt and pepper

5 sprigs fresh thyme

¼ cup (60 ml) dry white wine

⅔ cup (165 ml) sweet orange juice

2 cups (480 ml) chicken or duck stock

½ cup (75 g) dried brown figs

½ cup (65 g) dried apricots

1 Preheat the oven to 325°F (165°C).

2 Season the duck legs with salt and pepper and set them aside to bring to room temperature.

3 In a large, ovenproof skillet, heat the thyme over medium-high heat. Working in two batches, brown the duck legs atop the thyme, skin side down, for 4 to 5 minutes without moving them. Turn and brown the other side for 4 to 5 minutes without moving them. Remove to a plate and set aside.

4 Increase the heat to high, pour in the white wine and orange juice, and boil until reduced by half, scraping up the brown bits from the bottom of the pan, 5 to 7 minutes. Pour in the stock and return the duck legs, skin side up, to the pan along with the figs and apricots. Cover the pan with a lid or foil, place in the oven, and roast for 45 minutes.

5 Uncover the pan, baste the duck legs with the sauce, and continue to roast for 45 minutes to 1 hour more, uncovered, until the duck is well browned and crispy. Remove the thyme sprigs from the sauce, taste, and season with more salt and pepper if needed. Place the duck legs on a platter, spoon the dried fruit and sauce around the legs, and serve.

Rabbit with Sour Orange and Rosemary Sauce

Conejo al Romero y Naranja Agria

During the dire food situation of the Período Especial in the early 1990s, Castro's government encouraged rabbit farming in Cuba to offset meat shortages. The initiative was a success: Rabbits proved easy to breed even in improvised urban rooftop farms, and Cubans relished this "other white meat" as a delicious source of protein. And Cuban rabbits grew *really* large! These days, rabbit dishes, both creative and rustic, continue to grace menus all over Havana. This one, aromatic with sour orange, rosemary, and oregano, hails from the cozy paladar Decamerón, where it's prepared with boned, rolled rabbit meat. Serve the rabbit with its pan juices with White Rice (page 145), Tamarind Caesar Salad (page 117), and Grandmother's Custard (page 287) for dessert. You can easily substitute chicken if rabbit isn't available in your neighborhood.

Serves 4

1 (3-pound / 1.4-kg) rabbit, cut into pieces, or 4 chicken legs with thighs attached (1½ pounds / 680 g)

3 sprigs rosemary

1 sprig oregano

1 sprig thyme

5 tablespoons (75 ml) olive oil

3 tablespoons sliced shallot

2 tablespoons white wine vinegar

½ cup plus 3 tablespoons (165 ml) sour orange juice, or an equal mix of lime and orange juice

Salt and pepper

2 tablespoons dry white wine

1½ cups (360 ml) chicken stock

1 In a large bowl, combine the rabbit, 2 sprigs of the rosemary, the oregano, thyme, 2 tablespoons of the olive oil, the shallot, white wine vinegar, and 3 tablespoons of the sour orange juice. Season with salt and pepper and mix to coat. Cover the bowl and marinate in the refrigerator overnight, turning the rabbit once to make sure it remains covered in the marinade.

2 Preheat the oven to 350°F (175°C).

3 Remove the rabbit from the marinade and pat dry with paper towels. Discard the marinade. In a large, ovenproof skillet, heat the remaining 3 tablespoons of olive oil over medium-high heat. Working in batches if necessary, brown the rabbit legs for 4 to 5 minutes without moving them. Flip and brown the other side for 3 to 4 minutes without moving them. Remove the rabbit to a plate and set aside.

4 Pour the white wine into the skillet, scraping up the brown bits from the bottom of the pan. Add the remaining ½ cup

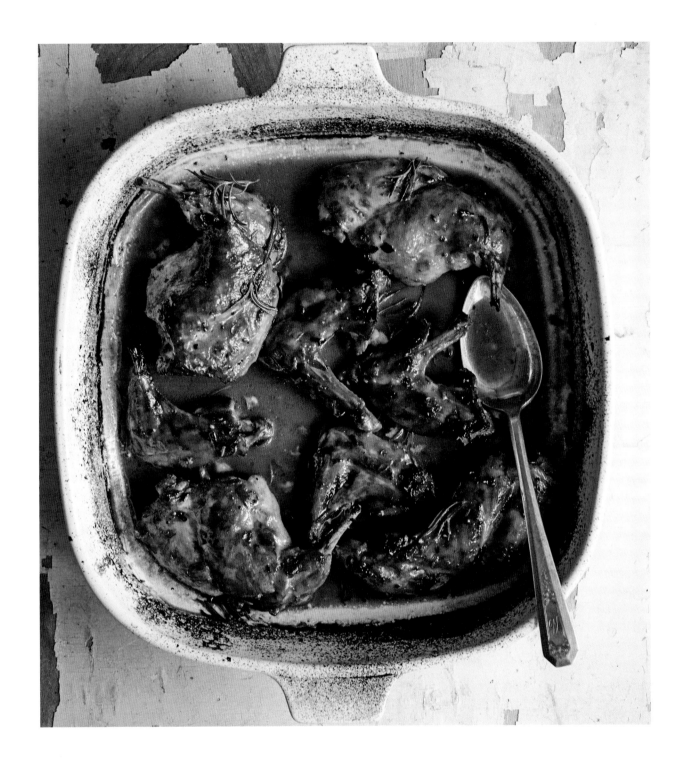

(120 ml) of the sour orange juice, bring to a boil, and cook for 3 to 4 minutes, until the sauce is slightly reduced.

5 Turn off the heat, return the rabbit to the pan, add the remaining rosemary sprig and the chicken stock, and place in the oven. Roast the rabbit for 35 to 40 minutes, basting three or four times with the pan juices, until glossy and golden.

Honey-Glazed Rabbit with Carrots

Sueño de Lobo

Ariel Mendoza Amey, the chef at paladar La Foresta, jokingly calls this rabbit and carrot dish "a wolf's dream." Humans also love his rabbit, cooked in white wine, glazed with honey, and served with cute baby carrots on a bed of sautéed garlicky spinach.

Serves 4

1 (3-pound / 1.4-kg) rabbit, cut into pieces, or 4 chicken legs with thighs attached (1½ pounds / 680 g)

Salt and pepper

2 tablespoons olive oil

¼ cup (35 g) finely chopped yellow onion

1 teaspoon minced garlic plus 1 clove garlic, chopped

½ cup (120 ml) dry white wine

1 cup (240 ml) chicken or vegetable stock

3 tablespoons honey

1 bunch (½ pound / 225 g) baby carrots, tops removed, scrubbed clean

1 pound (455 g) spinach, washed and dried

Dill, for garnish (optional)

1 Preheat the oven to 350°F (175°C).

2 Season the rabbit with salt and pepper. In an ovenproof skillet, heat 1 tablespoon of the olive oil over medium-high heat. Working in two batches, brown the rabbit on both sides, 3 to 4 minutes per side, until well browned. Remove to a plate and keep warm.

3 Reduce the heat to medium, add the onion and the minced garlic, and cook for 2 minutes, or until the onion starts to soften. Pour in the white wine, increase the heat to high, and bring to a boil, scraping to loosen the brown bits from the bottom of the pan, until the wine is reduced by half, 4 to 5 minutes. Pour in the stock and reduce the heat to medium.

4 Return the rabbit to the pan and place the pan in the oven. Roast, basting once or twice, for 20 minutes. Stir in the honey, baste the rabbit with the sauce, and add the baby carrots to the pan. Roast for another 10 minutes (15 minutes if you are cooking chicken).

5 When the rabbit is almost done, in a large skillet combine the chopped garlic and the remaining 1 tablespoon of the olive oil over medium-high heat and cook for 1 minute, or until the

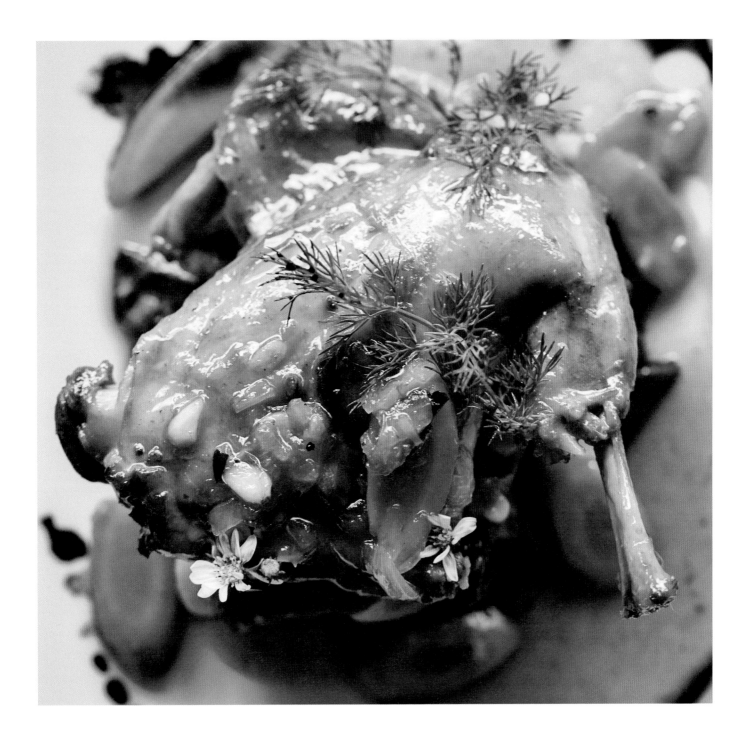

garlic is fragrant. Add the spinach and sauté for 3 to 4 minutes, stirring until the spinach is wilted and well cooked. Season with salt and pepper to taste.

6 The rabbit is done when glossy and golden brown. Mound the spinach on a serving platter and top with the rabbit legs. Strain the sauce over the rabbit and add the baby carrots and dill (optional).

Ropa Vieja 245

Pork Ropa Vieja with Raisins
Ropa Vieja de Cerdo con Pasas 246

Picadillo a la Habanera 249

Cuban Burger with Chorizo and Crispy Potatoes
Frita Cubana 250

Lamb Ribs with Rosemary and Arugula
Chuletas de Cordero al Romero y Arúgula 257

Lamb Chili Miglis
Chili de Cordero Casa Miglis 261

Pork Loin with Onions and Peppers
Masas de Cerdo a la Criolla 262

Pork Ribs and Fried Okra
Costillas de Cerdo con Quimbombó Frito 264

Stuffed Pork Loin with Malta
Lomo de Cerdo Asado con Malta 267

Coffee-Rubbed Pork
Cerdo al Café 268

Pork with Chickpeas and Sausages
Lomo de Cerdo con Garbanzos y Embutidos 271

Crispy Pork Shoulder
Cerdo Asado 272

CARNE

———

Meat

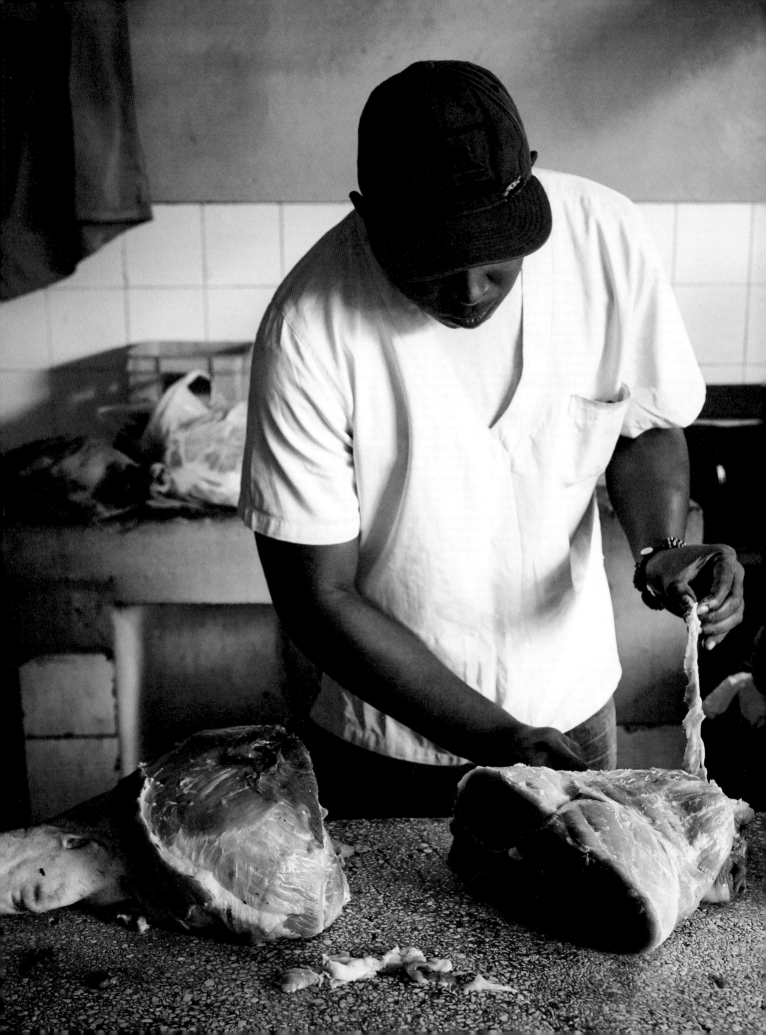

Pity the vegetarian who decides to settle in Cuba! Prior to 1959, the island boasted the largest per capita meat consumption in Latin America, and even today, despite the loss of certain adored animal proteins—e.g., beef—eating meat remains a particular affirmation of cultural vigor. "Without meat, it just isn't a meal," a tiny but clearly carnivorous grandmother insisted to us at a butcher shop while filling her shopping bag with pork belly, liver, tongues, and huge hooves. Our friend Madelaine Vazquez, a TV chef and Cuba's Slow Food adviser, recounted the response during the starving Período Especial of the '90s, when she helped launch a state-run vegetarian restaurant at Havana's botanical garden. "For its time, that restaurant was totally visionary," Madelaine recalls. "Organic, macrobiotic, and using incredible natural stuffs we managed to forage." But while the fare was delicious and Cubans were hungry, customers would come in, find no meat on the menu, and turn up their noses. "They'd rather have eaten picadillo stretched out with soy," says Madelaine, "or strange pastes 'scented' with meat than a great plate of vegetables."

Although vegetables are finally getting their due, meat retains its almost symbolic place at the Cuban table, especially the fervently desired but nearly unavailable beef. "Carne, es nuestra identidad"—"meat, it's our identity"—one restaurateur told us, heart health be damned.

Before the arrival of Columbus irrevocably altered the Americas' ecosystem, Cuba's indigenous Taíno [Arawak] natives had healthier diets. They ate scant animal protein, and their land beasts ran no larger for the most part than turtles and the iguanas that the terrified early chroniclers described as serpents the size of lapdogs. Besides these, the Amerindians' occasional animal protein came from birds, parrots, snakes, and hutias, a rabbit-like rodent. (A hutia was presented to Queen Isabella in 1493 on Columbus's return to Seville, along with chili peppers, monkeys, and gold.) Cuba's aboriginals plucked their iguanas from trees—"tastes like chicken," Columbus reported—and sometimes speared manatees in their rivers. They drove hutias into corrals by chasing them with torches and hairless dogs, which, too, were occasionally eaten.

The first European livestock landed on the neighboring island of Hispaniola in 1493 during Columbus's second voyage, undertaken with the purpose of colonizing the Indies. The armada of seventeen Spanish ships bore a Noah's Ark of Longhorn cattle, sheep, goats, chickens, and a now-proverbial mini-herd of eight pigs, handpicked, goes the story, by Queen Isabella herself—and then saved by Columbus from his ravenous crew—to multiply in the Indies. Around 1512, Cuba's first governor, the wily Diego Velázquez, began bringing livestock over from Hispaniola. The nearly thousand head of cattle reproduced well, but the swine multiplied so prodigiously that by 1514 Velázquez was informing the Spanish crown that more than thirty thousand hogs populated the island. A boon for the colonizers, to the natives livestock brought mostly environmental destruction and epidemics of deadly diseases, such as influenza and smallpox. Gradually, however, the island's ecosystem adapted. From the seventeenth century until the end of the eighteenth, when sugar took over, cattle was Cuba's premier source of income, mostly valued for hides and tallow. The hog, too, proved a highly lucrative beast, cheap to raise and a source of almost unlimited meat, plus soap and fuel—even medicine, in those early colonial days.

Pork was—and remains—Cuba's national meat. In the past, the traditional annual slaughter of the family swine yielded a veritable food bank of hams, bacon, chorizo sausages, blood pudding, and chicharrones [cracklings], plus the manteca

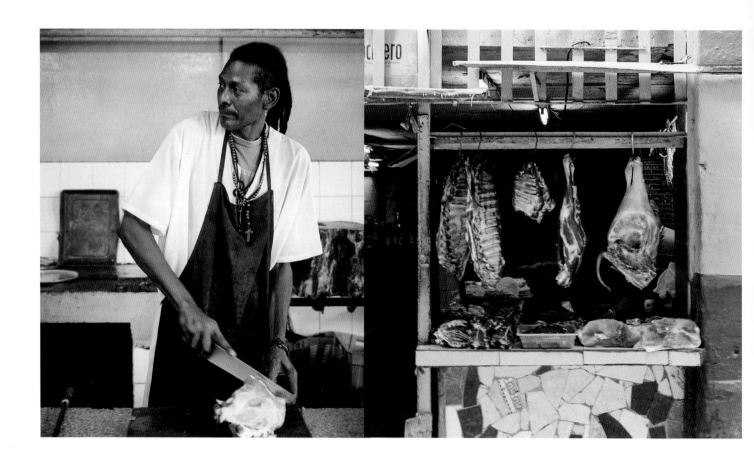

[lard] used for frying and for candies and pastries. Smoked-porkstuffs shops still thrive on the island, hawking their jamón and carne salada [salt pork] for bean dishes and stews, while fresh pork carnicerias [butchers] also tend to be excellent and abundantly stocked. And where would Cuban Christmas Eve, or New Year, or weddings and neighborhood fiestas be without a crispy-skinned lechon asado? The whole little porker gets marinated in buckets of sour orange juice, onions, and garlic, then slow-roasted to crispy perfection over a caja china (literally, "Chinese box"), a plywood container with a rack, or en pua, meaning suspended on a spit over embers in the manner of Taino natives. The pigfest comes replete with mountains of congri, boiled viandas [tubers], yuca with mojo, and gallons of rum.

But a whole roasted puerco—aka marrano, cochino, macho, or lechón—and those big, juicy beefsteaks enjoyed by the swells in Cuba's pre-Revolution days? They were grand, special-occasion food. Thriftiness was always a prized kitchen virtue. Traditionally, on weekdays, meat would be cooked into saucy stews easily stretched to feed extra arrivals at the table. Any leftover meat was further extended into picadillos and other hashes, or repurposed as ropa vieja, or stuffed into tamales, empanadas, and fritters. Or it might be baked between layers of mashed boniato or yuca to create a casserole called tambor [drum].

One still finds plenty of traditional picadillos and ropa viejas on Cuban paladares menus today, the latter often reinvented with pork or lamb because beef is perdído [lost]. On the pages that follow, you'll also find a majestic roast pork in the manner of paladar Ivan Chef Justo, finger-licking adobo-spiked pork ribs, and some newer lamb recipes currently being prepared with the delicious cornero grown by the new-wave generation of Cuban farmers.

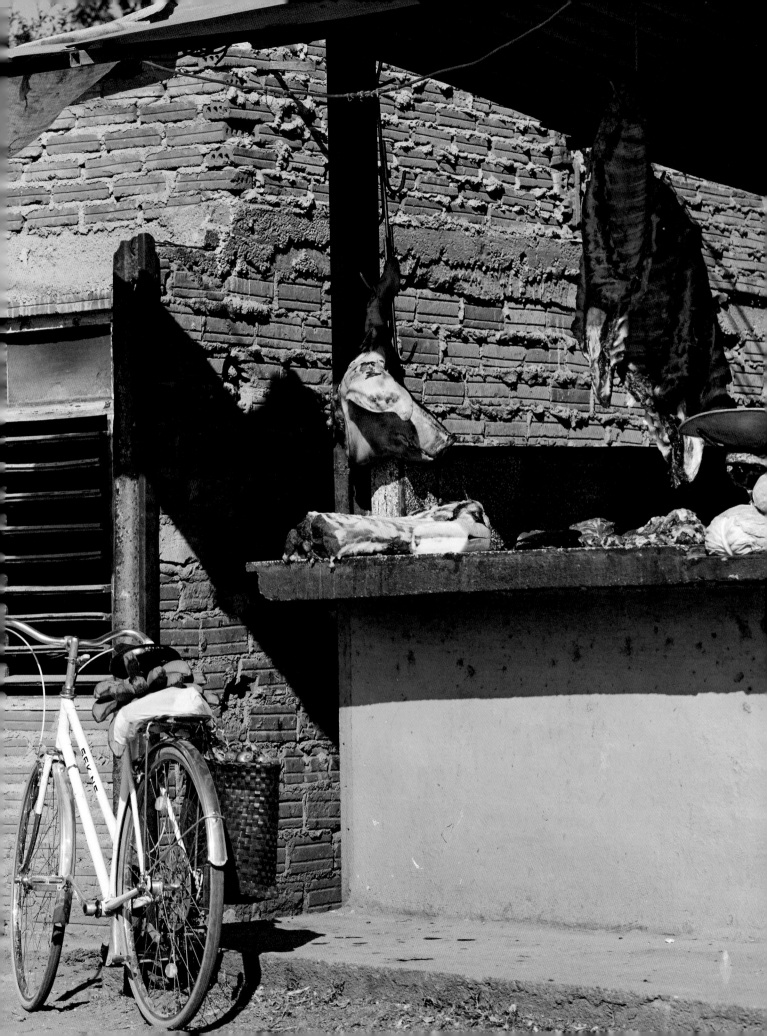

ROPA VIEJA

Ropa vieja—literally "old clothes"—is a true Cuban classic, a dish of slowly simmered beef flank or brisket that's then shredded and cooked again in an aromatic sofrito of peppers, tomatoes, and onions, all generously moistened with simmering broth, seen here with fried yuca slices. One of the various legends behind the name? That a very poor old fellow who couldn't afford to feed his children cooked up some old rags that magically turned into meat because he prepared them with amor. Most likely, though, the dish arrived in Cuba in the nineteenth century via immigrants from the Canary Islands in Spain. In the United States, ropa vieja was popularized by Cuban exiles in Miami. In Cuba itself, there was an unexpectedly poignant echo of the "old rags" legend when the cooking diva Nitza Villapol demonstrated a ropa vieja recipe on TV during the starving days of the early-1990s Período Especial. Instead of unavailable beef, Villapol suggested using plantain skins—even touting their nutritional value Hence Cubans have adapted traditional ropa vieja recipes to accommodate what they have available.

Serves 8 generously

2 pounds (910 g) flank steak, cut into bite-size pieces

1 onion, peeled and quartered

2 cloves garlic

1 bay leaf

1 tablespoon olive oil

1 medium onion, sliced into half-moons (about 1 cup / 110 g)

1 small green bell pepper, seeded and sliced

½ cup (120 ml) canned crushed tomatoes

Salt and pepper

2 tablespoons fresh cilantro, for garnish

1 Place the beef, quartered onion, garlic, and bay leaf in a pot and add water to cover. Bring to a slow boil over medium heat, then reduce the heat to low and simmer for 2 to 3 hours, or until the beef shreds easily when pierced with a fork.

2 Strain the beef and cooking liquid through a fine-mesh strainer set over a bowl, reserving the broth. When the beef is cool enough to handle, shred it with your fingers or two forks and set aside.

3 In a large skillet, combine the olive oil, sliced onion, and green pepper over medium heat and cook for 3 to 4 minutes, or until softened. Add 1½ cups (360 ml) of the reserved beef broth, crushed tomatoes, the shredded beef, and salt and pepper to taste and stir to combine. Cook the ropa vieja for 30 minutes to meld the flavors. Garnish with chopped cilantro and serve.

PORK ROPA VIEJA WITH RAISINS

Ropa Vieja de Cerdo con Pasas

This pork ropa vieja rendition from the homey paladar Hecho en Casa is hash-like and has lovely touches of sweetness from raisins and cinnamon. Try it next time you have leftover roast pork served over white rice with sliced avocado on the side. It will also be terrific in sandwiches or as stuffing for empanadas.

Serves 4

2 tablespoons olive oil

1 cup (110 g) thinly sliced yellow onion

1 cup (90 g) thinly sliced green bell pepper

3 large cloves garlic, chopped

4 cups (780 g) shredded cooked pork (Crispy Pork Shoulder, page 272)

½ cup (90 g) chopped seeded tomato

¼ cup (35 g) dark raisins

½ cup (120 ml) chicken or pork stock

½ teaspoon ground cinnamon

¼ teaspoon ground cumin

Salt and pepper

In a large skillet, combine the olive oil, onion, and bell pepper over medium heat and cook for 3 to 4 minutes until softened. Add the garlic and cook for 1 minute more. Add the shredded cooked pork, tomato, raisins, stock, cinnamon, and cumin and stir until well combined. Cook for 4 to 5 minutes to reheat the already-cooked pork and meld the flavors. Taste and add salt and pepper as needed.

Picadillo a la Habanera

Say "Cuban food" and most people think picadillo, a moist, fragrant hash of sautéed ground meat made subtly sweet-tart-savory with olives and raisins—an Arab influence on Spanish cuisine that was exported to Cuba. Picadillo is to Cuban and Latin-American cooking what ragù is to Italian: an ingenious way to stretch out a cheap cut of meat into a comfort-food classic. Our friend Reynaldo Gonzales, novelist, gastronome, former paladar owner, and winner of Cuba's National Prize for literature, had this to say about Picadillo a la Habanera: "It's a dish that practically sings of Havana. And like the boisterous port life of one of the most cosmopolitan cities of the New World, picadillo is a sum of influences, wisdoms, and cross-excellences. The ingredients of our cherished national hash came to the piers of our harbor from different parts of the world. But the final cooking, the fire that added flavor and savor, was utterly ours."

Variations abound and arguments often flare up when different cooks discuss picadillo, but everyone agrees that picadillo is best served over rice with a side of golden Fried Sweet Plantains (page 118).

Serves 4

- 2 teaspoons olive oil
- 1½ Spanish chorizos, diced (about 1 cup / 138 g)
- ½ cup (55 g) diced yellow onion
- ½ cup (75 g) diced green bell pepper
- 1¼ pounds (570 g) ground beef or pork (or a combination)
- 1 bay leaf
- 1 cup (240 ml) tomato puree or chopped fresh tomato (180 g / 2–3 plum tomatoes)
- 2 tablespoons capers, drained
- ¼ cup (40 g) pimento-stuffed green olives, cut in half
- 3 tablespoons dark raisins
- 1 teaspoon dried oregano, crushed
- Salt and pepper

1 In a large skillet, combine the olive oil and chorizo over medium heat and cook for 5 minutes, stirring until the sausage gives up its oil (it will be red and flavorful). Add the onion and bell pepper and cook for 3 to 4 minutes to soften.

2 Add the ground beef and bay leaf and cook for 7 to 8 minutes, stirring and breaking the meat into crumbles. Stir in the tomato puree and cook for 5 minutes more, or until the sauce is reduced and thickened and the beef is cooked through.

3 Stir in the capers, olives, raisins, and oregano and taste for seasoning, adding salt and pepper as needed. (It shouldn't need a lot of salt; the capers and olives are salty and briny.)

Cuban Burger with Chorizo and Crispy Potatoes

Frita Cubana

You won't see many hard currency–toting tourists hanging around the windows of street shops that sell Cuban burgers for just a few pesos. They don't know what they're missing! These slider-like Cuban hamburguesas of beef and chorizo tucked into squishy buns along with lettuce, fresh tomatoes, and crisp-fried potatoes rank among the world's most addictive substances. Now not as easy to find as the ubiquitous pork burgers with pineapple on top, fritas used to be sold in Havana by Chinese vendors as a popular late-night snack after clubbing and partying. A bit like White Castle burgers, fritas are not easy to replicate at home perfectly. Still, this version does come pretty close to the greasy-spoon fritas we adore in Havana. Look for slider buns in the grocery store—they serve our purposes well.

Serves 3 (3 mini burgers per person)

- 2 cups (480 ml) vegetable oil, for frying
- 1 medium potato, peeled and cut into matchsticks
- 1¼ pounds (570 g) lean ground beef
- 1 (3-ounce / 85-g) Spanish chorizo, casing removed, finely chopped
- 2 tablespoons finely grated onion
- ½ teaspoon salt
- 9 slider buns
- 9 small green lettuce leaves
- 1 ripe tomato, cut into 9 slices

1 In a high-sided skillet, heat the vegetable oil over medium-high heat until it reaches 375°F (190°C) on a deep-fry thermometer. Working in batches to avoid crowding the pan, fry the potato in the hot oil until golden, 2 to 3 minutes per batch. Drain on paper towels. Keep warm on a baking sheet in a low oven until ready to serve.

2 In a mixing bowl, combine the ground beef, chorizo, onion, and salt and mix well. Form the meat mixture into 9 balls and flatten to make 3-inch (7.5-cm) patties.

3 In a skillet, cook the burgers over medium-high heat for 3 to 4 minutes per side, or until nicely browned on each side. (Do this in two batches to avoid crowding the pan and steaming the burgers.)

4 Split the buns and open them up. Top the bottom half of each bun with a lettuce leaf, a burger patty, a tomato slice, and a handful of the crispy potato sticks, then add the tops of the buns.

CASTRO'S COWS: WHERE IS THE BEEF?

Cuban carniceros [butchers] like to tell a sinister joke: On our island you get punished less harshly for killing a man than for killing a cow. Cuba's butchers, of course, sell only pork. Of all the island's perdído [lost] items, it is beef, once so plentiful but now inaccessible to an average eater, that Cubans say they miss most. This intense, almost symbolic longing for el oro rojo [red gold] afflicts Cuba like a lost paradise. Older folk claim they can still taste their grandmother's boliche (pot roast). They invoke an idyllic past where pan con bistec and beef hamburguesas were popular street food, where picadillo and ropa vieja weren't "reinvented" with pork or lamb. And it only rubs salt in the wounds of regular Cubans eking out a living on thirty dollars a month that fancy Havana supermarkets like Palco now occasionally offer imported [inferior] beef for that much a pound. "I buy beef at Palco, and I nearly cry," declares José Colome, the thoughtful owner of the popular paladar Starbien. "I'd rather not even put it on my menu at all. But from a classy paladar such as mine, wealthy Cubans expect things like steak with blue-cheese butter." Ivan Rodríguez of Ivan Chef Justo concurs: "We have the world's greatest pork," he notes, "but diners here are fixated on beef, maybe as a symbol of our vanished abundance." Whenever Sergio Solás of the bohemian paladar Café de los Artistas visits Miami, he tells us, he's besieged by a "never-ending" succession of barbecue invites from Cuban exiles. "Always with these massive North American steaks," he says, "to rub it in—to show me they were right to leave Cuba."

Cuba's beef nostalgia is so poignant because before the 1959 Revolution, the island was a bastion of red-meat consumption. Back then Cuba boasted as many vacas [cows] as people—more than six million, many bred on U.S.-owned cattle ranches. After Castro's government nationalized foreign-owned and some domestic ranchos, thousands of cattle were slaughtered, and many lost further from mismanagement. Former ranches stood abandoned, overgrown with tropical brush, or were converted to sugar production. Cuba's beef industry never recovered. The dairy industry fared a bit better, thanks to Holstein cows imported from Canada and sustained by Soviet animal feed, fuel, and fertilizers. But the Soviet Union imploded in 1991, and Cuba's dairy industry collapsed with it. Today Cubans use powdered milk in their café con leche, vegetable shortening in their puff pastry, soy yogurt in their batidos [shakes]. Fresh cream? Only a hard-currency import for serving at tourist hotels. "I have no idea what flan made with fresh milk even tastes like!" a pastry shop customer sourly informs us. Pointedly, when Florida and Cuba fought over Elian Gonzalez, the Cuban kid who washed up in Miami in 1999, his American relatives boasted that only they could provide the boy with abundant fresh milk.

These days, Cuba's scarce cattle are all government property, with farmers overseen by fierce livestock inspectors. The punishment for illegal cow slaughter: Five to ten years' imprisonment. Breeders who fail to report a new calf risk astronomical fines. The situation has stoked sensationalistic (but perhaps true!) stories of villagers going to jail for "killing" a cow struck by lightning because they didn't notify authorities of the incident, of cows being "accidently" barged off the road to their death and their limbs hacked off. There are rumors, too, that some of Cuba's beef is actually U.S. Grade-D meat that's seeped through a loophole in the embargo laws. And there are tales of the island's beef black market. How thieves steal livestock at night, hide it high in the hills, and sell it to black marketeers who keep the beef in underground fridges at ranches that act as fronts.

Perhaps the strangest Cuban cow stories are actually true—and they feature Fidel.

According to memoirists and historians, El Comandante had such a lactic fixation he could polish off twenty scoops of ice cream at a sitting—he introduced the passion for ice cream to Cubans—and kept statuettes of cows in his office. He waxed lyrical about cows being milked at his father's farm in Biran, held dairy tastings for the press where he boasted of knowing which leche came from which vaca. Early on, the CIA tried to assassinate him by slipping botulinum toxin into his daily milk shake. In the 1980s, Fidel imported milk-giving Canadian Holsteins, which were kept in special air-conditioned corrals, leading better lives than average Cubans. It was a waste of hard currency, it turned out, because Holsteins still suffered hopelessly in tropical climes.

Fidel's profoundest devotion was reserved for one particular bovine: a black-and-white cow superstar called Ubre Blanca [White Udder]. A genetic experiment in crossing those imported milky Holsteins and the local beef-yielding Cebus, which thrive in the tropics, Ubre Blanca lived a fairy-tale life in the 1970s. A milk-producing phenom, feted as Cuba's own national livestock revolutionary, she set a Guinness World Record of giving almost twenty-nine gallons of milk in one day. When in 1985 Ubre was put to sleep, she was buried with military honors. "She gave her all for the people," declared the full-page obituary in *Granma*, the official paper of the Communist Party. Alas, Ubre's lactating secrets went with her to the grave. But Fidel had a new idea. In 2002, international newspapers reported that Cuba's main state scientist claimed research was "very close" to fulfilling Comandante Castro's "dearest wish"—the cloning of Ubre, using her frozen tissue and eggs. Which wasn't as bizarre, really, as Fidel's earlier milk-besotted sci-fi scheme to genetically engineer a different breed of cow altogether: a demi-size vaca that Cubans could keep as a pet—for milking—in their homes. Both schemes, of course, were a bust.

And now Castro is gone. A gleaming life-size marble statue of Ubre Blanca still stands proudly in her hometown of Nuevo Gerona while Cubans continue to pine for beef and devour powdered-milk ice cream.

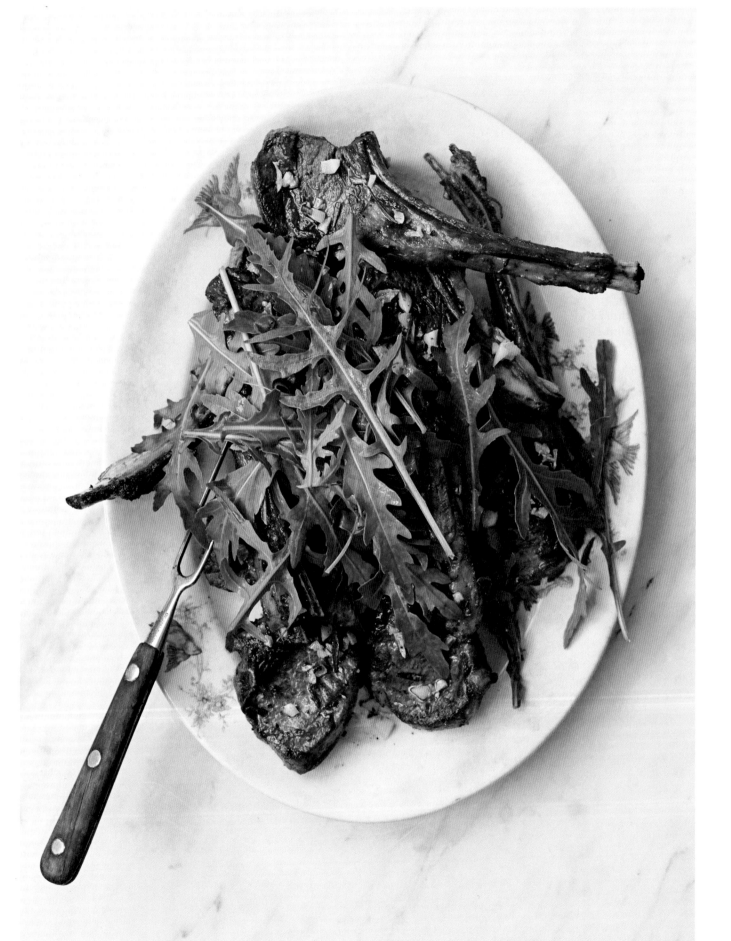

Lamb Ribs with Rosemary and Arugula

Chuletas de Cordero al Romero y Arúgula

This Mediterranean-style recipe from Havana's star chef Ivan Rodríguez is simple, elegant, and can be whipped up in a flash. It also demonstrates how up-to-date the contemporary paladar chefs are on their techniques and ingredients. Using tender lamb raised especially for him by a farmer, Ivan perfumes the sautéed meat with browned garlic and rosemary and sends it out to the table with a tangle of peppery arugula leaves. If you can find them, use baby lamb rib chops; otherwise loin chops are fine.

Serves 4

1½ pounds (680 g) lamb rib chops

Salt and pepper

1 tablespoon olive oil

3 cloves garlic, chopped

1 tablespoon rosemary, coarsely chopped

1 small bunch (about 2 cups / 40 g) arugula

1 Season the lamb chops with salt and pepper. In a large skillet, heat the olive oil over medium-high heat. Working in batches to avoid crowding the pan, brown the lamb chops on all sides, 5 to 7 minutes. Remove the chops to a plate and keep warm.

2 Add the garlic and rosemary to the skillet and cook 1 to 2 minutes, or until they start to brown just a bit. Scrape the garlic and rosemary over the lamb chops and top with arugula.

CASA MIGLIS

NORTH BY SOUTHEAST

Nordic cool meets sultry Havana—improbably!—on a dodgy block of Centro Habana, where paladar Casa Miglis adorns its distressed turquoise façade with a sign that's a mashup of Swedish and Cuban flags. Inside, nursing a Negroni behind the restaurant's snug vintage bar, is Michel Miglis, the owner: clean-shaven, dark-eyed, wearing a hip-hop gold chain around his neck and looking every bit like the music-video impresario that he is. In 1996 Miglis—photographer, producer, director, and low-key raconteur—came to Havana at the age of twenty-seven for some film work, and he never left. Between sparking the Cubaton [Cuban reggaeton] craze with videos, an album, and then a feature documentary and shooting clips for the likes of Jamaican reggae star Jimmy Cliff, he also found time to open a paladar. At night, the tall lofty room has a sexy and slightly madcap air, with its Swedish-designed objets suspended on walls. The kitchen, meanwhile, sends out the kind of eclectic, delicious food that Michel himself likes to eat: from Greek souvlaki to Cuban ceviches to Swedish shrimp skagen. But the party doesn't end with dessert. After hours, the lights go down, the music starts up, and the place pulses to new Cuban beats—which is exactly how Michel likes it.

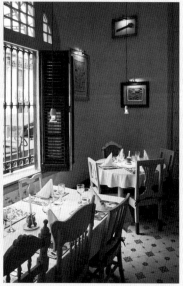

Michel's Story

My parents were hippies. I'm pretty sure I was conceived in a VW bus driving across Europe with a boat tied to the roof—Beatles blasting.

My mother is Swedish, my father Greek. My father had sixteen kids by different women! What he did for work, I still have no idea. At one point he and his brother had a taverna / nightclub on the Greek island of Rhodos. All my life I wanted to re-create that place, a meeting point of the different cultures that summered there. Compared to the delicious Greek grilled fish and the charred souvlaki, the food of my Swedish childhood was totally boring—herring and more herring. When I was eleven, my parents gave me an 8mm film camera. My classmates and I made horror films where everyone died. I kept on shooting, graduating eventually to music videos. After helping bring hip-hop to Sweden, I traveled all over the world producing videos. In 1996, while working in Kingston, Jamaica, I got a call from a Swedish friend. He invited me to Cuba to help

with a documentary about Gregorio Fuentes, the former captain of Hemingway's boat—he was the model for *The Old Man and the Sea*. I arrived in Havana on a dark, stormy night, right near here in this rundown neighborhood in Centro Habana. Some rough-looking guys approached me. If it were Kingston I'd be robbed—or dead—but these guys offered me rum! In a few days I was calling my mother in Sweden telling her, "Mom, I found my home." It was instant attraction. Walking along the Malecón, I knew that for me Havana was it. The relaxed, happy vibe here reminded me of our summers in Rhodos—only Havana was a big city, with lots of culture and a unique, wonderful soul. To this day I marvel at the support here, at that amazing Cuban acceptance.

The one problem I had with Cuba? The food. Flashing back to our Rhodos taverna, I fantasized about starting a restaurant. When the business laws loosened, I jumped right in, converting this enormous eight-room house where I'd lived into a paladar. How'd it go? Imagine the craziness of *Fawlty Towers*—times ten. What a fool I was, thinking if I can direct a film, I can open a restaurant. There were no materials, no skilled labor, no business structures. I approached staffing like a casting director, interviewing folks from the street rather than using "professionals" corrupted by the government restaurant industry. A chef friend in Sweden helped conceive our menu, but once we tested it here we changed the recipes. Cuban ingredients taste so totally different—I don't mean in a bad way. Local vegetables are massively ugly, but they're organic, grown without pesticides. The meats are untreated—no hormones or brines. My 1951 Land Rover works overtime scouting different farms for dill and arugula. Then from the Swedish woods we get lingonberries picked by a friend's mom, to go with our real Swedish meatballs. Rhodos inspired our souvlaki with yogurt tzatziki. Our Mexican-inflected chili dish, with meat cooked for six hours, will never go off the menu. I have fun bringing craft beers from all over Cuba—but I warn my guests that they taste pretty terrible!

Our neighborhood, Centro Habana, is breathtakingly dilapidated, loud, intense, hauntingly beautiful. I'm committed to being part of this barrio. Every day I have coffee with neighbors and hang out with the dudes on the street. You can't have a restaurant charging a monthly Cuban salary for a main dish without giving something back to the neighborhood. That's why I also run a cheap peso restaurant down the street with really good Cuban food—to feed the community. Social responsibility is so important in Cuba!

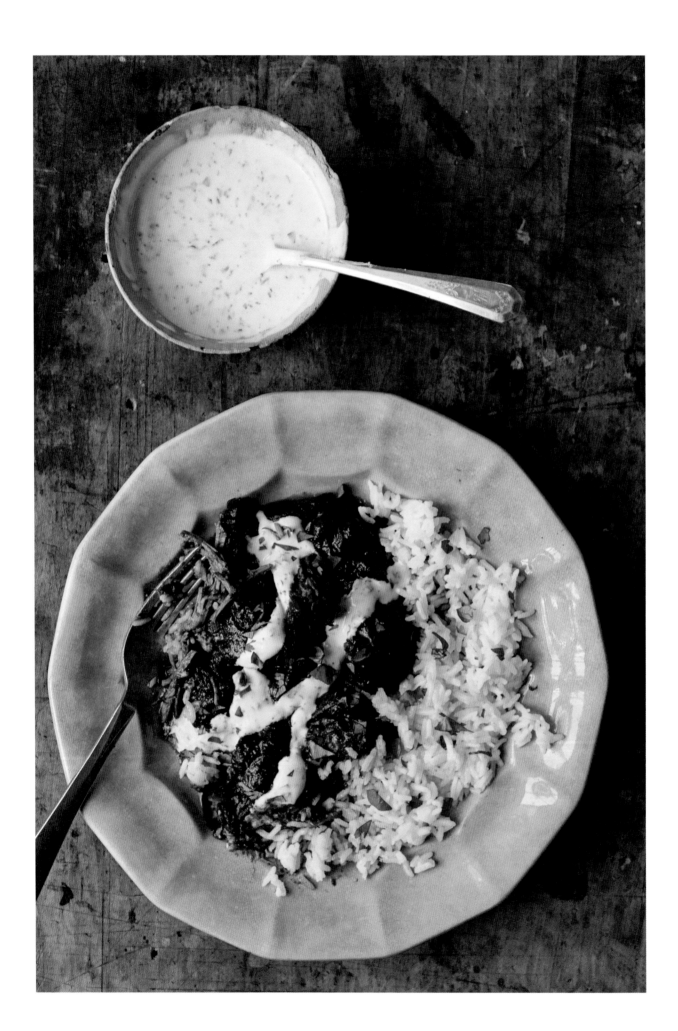

LAMB CHILI MIGLIS

Chili de Cordero Casa Miglis

One of the standouts at Casa Miglis is the lamb, energetically seasoned and left to braise just short of forever in a boldly flavored sauce of red wine, dark beer, Cuban cola, cilantro, lime, and chilies of varying heat. "A friend made it for me on my fortieth birthday," Michel Miglis recalls. "I nagged him to make it again so often, he just taught our chef how to cook it." The dish arrives drizzled with mint-flavored yogurt with a side of white rice showered with chives.

Serves 8

2 tablespoons olive oil

2½ pounds (1.2 kg) boneless lamb, cut into 1½-inch (4-cm) cubes

3 tablespoons ancho chili powder

1 teaspoon red pepper flakes, or to taste

1 cup (145 g) chopped green bell pepper

½ cup (55 g) chopped onion

1 cup (240 ml) dry red wine

1 cup (240 ml) dark beer

½ cup (120 ml) cola

½ cup (120 ml) tomato paste

1½ cups (360 ml) beef broth

Salt and pepper

½ cup (120 ml) plain yogurt

2 tablespoons honey

3 tablespoons chopped fresh mint

2 tablespoons chopped fresh cilantro

1 Preheat the oven to 375°F (190°C).

2 In a Dutch oven or large heavy-bottomed pot, heat the olive oil over medium-high heat. Brown the lamb pieces on all sides, 6 to 7 minutes, working in batches to avoid crowding the pot. Remove the lamb to a plate.

3 Add the chili powder, red pepper flakes, green pepper, and onion to the pot and cook for 5 minutes. Pour in the red wine and deglaze the pan, scraping up any brown bits. Bring to a boil and cook for 3 to 4 minutes to reduce the wine. Return the lamb to the pot, pour in the beer, cola, tomato paste, and broth, and place the pot in the oven. Cook, covered, for 3 hours, basting and checking for seasoning, adding salt and pepper if necessary. If the lamb seems dry, add ½ cup (120 ml) water. Remove the cover and cook for 30 to 45 minutes, or until fork-tender.

4 In a small bowl, combine 3 tablespoons water, the yogurt, honey, mint, cilantro, and ½ teaspoon black pepper and stir until well combined. Spoon 2 tablespoons or more of this sauce over each serving of the lamb.

Pork Loin with Onions and Peppers

Masas de Cerdo a la Criolla

Located on a cobblestoned alley near Cathedral Square in Habana Vieja, paladar Doña Eutimia is truly serious about preserving Cuba's classic criollo cuisine. The traditional Cuban technique in this dish, its owners explained, involves simmering chunks of well-marinated pork in water and fat until the water evaporates, then continuing to cook the meat in the fat until it's tender and crusty brown. The dish comes topped with gently cooked onions and peppers. Lard, insisted the chef, is still the best and most traditional fat, imparting a rich, rounded flavor, but lardophobes can substitute bacon fat.

Serves 4

1½ pounds (680 g) pork loin or boneless pork shoulder, cut into 2-inch (5-cm) pieces

¾ teaspoon salt

3 cloves garlic, smashed

¼ cup (60 ml) sour orange juice, or an equal mix of lime and orange juice

⅛ teaspoon ground cumin

½ teaspoon dried oregano, crumbled

1 bay leaf, crumbled

½ cup (105 g) lard or bacon fat

2 tablespoons olive oil

1 cup (110 g) sliced onion

1 cup (90 g) sliced red bell pepper

1 In a bowl, combine the pork, salt, garlic, sour orange juice, cumin, oregano, and bay leaf. Mix to coat the pork with the marinade and let sit at room temperature for 20 to 30 minutes.

2 In a large, wide pot, combine the pork and the lard with 2 cups (480 ml) water over medium-low heat and simmer for 45 minutes to 1 hour, or until all the water evaporates. Increase the heat to medium-high and pan-fry the pork on all sides until browned and crispy, 9 to 10 minutes.

3 In a skillet, combine the olive oil, onion, and red pepper over medium heat and cook for 4 to 5 minutes until softened but not brown. Add 3 tablespoons water to the pan, cover, and cook for 5 minutes, or until the vegetables are very soft.

4 Serve the pork with the onions and peppers spooned over the top.

PORK RIBS AND FRIED OKRA

Costillas de Cerdo con Quimbombó Frito

Pork ribs—meaty, juicy, and often gigantic—feature on most paladar menus, because pork in Cuba is so delicious and so easy to find. This recipe was one of our favorites, and we enjoyed it at a fun new paladar called Lamparilla Tapas & Cervezas. Located in Old Havana and appointed with funky, retro furniture and a glowing wall of Cristal beer bottles, the place is expertly run by Alexis Orta and Támara Diaz, a simpatico, well-traveled couple who'd both worked in the cigar trade. "If you're going to put pork ribs on the menu in Cuba," declared Támara, "they better be really special." These are! Braised, then browned, then finished in a bracing, vinegary sauce spiked with mild Mexican chilies until fall-apart tender, they come out with the addictive garnish of crispy-fried okra.

Serves 8

6 pounds (2.7 kg) baby back ribs, cut into single ribs

Salt and pepper

2 tablespoons olive oil

10 dried guajillo chili peppers

¼ cup (60 ml) white wine vinegar

2 cups (480 ml) tomato puree

1 cup (110 g) chopped yellow onion

5 cloves garlic, chopped

1 teaspoon ground cumin

2 cups (480 ml) pork broth from cooking the ribs or chicken broth

3 cups (720 ml) vegetable oil, for frying

2 large eggs, beaten

2 cups (200 g) fine dry bread crumbs

2 cups (310 g) small tender okra, cut in half lengthwise

2 tablespoons chopped scallions, for garnish (optional)

1 In a large pot, combine the ribs with ¾ teaspoon of the salt, pepper to taste, and water to cover. Slowly simmer the ribs over medium heat until just cooked, about 30 minutes. Drain the ribs, reserving the broth.

2 In the same pot, heat the olive oil over medium-high heat. Working in batches to avoid crowding the pot, brown the ribs in the oil, 2 to 3 minutes per side, removing to a plate as they finish.

3 In the same pot, combine the guajillo peppers, white wine vinegar, tomato puree, onion, garlic, cumin, and broth and bring to a simmer over medium heat. Cook for 15 minutes to meld the flavors.

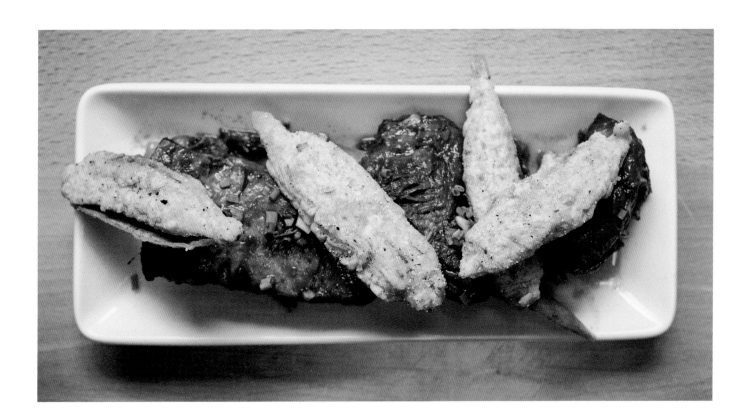

4 Let the sauce cool slightly. Transfer to a blender in batches and blend until smooth. Pour the sauce into a large, high-sided skillet, add the ribs, and simmer over medium heat for 20 to 25 minutes while you fry the okra.

5 In another high-sided skillet, heat the vegetable oil over medium-high heat until it reaches 375°F (190°C) on a deep-fry thermometer. Place the beaten eggs in one bowl and the bread crumbs in another. Working in batches, dip the okra halves in the beaten egg and then in the bread crumbs to coat. Fry in the hot oil, turning once, until golden brown, 2 minutes per side. Set aside on a plate as you finish each batch.

6 Taste the sauce and season with salt and pepper as needed. Place the ribs on a large platter, pour the sauce over the top, and garnish with the fried okra and scallions (optional).

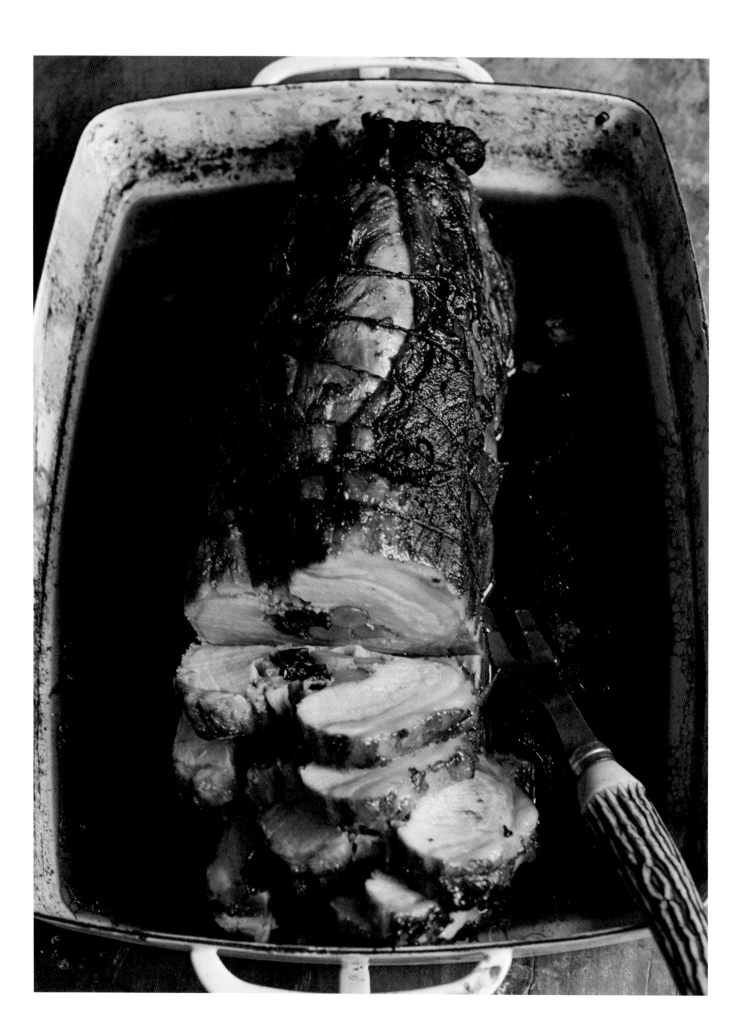

Stuffed Pork Loin with Malta

Lomo de Cerdo Asado con Malta

Malta is the secret Cuban weapon in this Spanish-influenced roast pork loin stuffed with jamón, prunes, and carrots. A sweet malty soft drink brewed from barley and hops and much-appreciated in Latin America, Malta is used in this recipe to baste the meat as it cooks, deliciously caramelizing the juices. You should have no problem finding at least one brand of Malta at a Hispanic market. Otherwise, use a dark malty beer.

Serves 8

1 cup (240 ml) sour orange juice, or an equal mix of lime and orange juice

4 cloves garlic, crushed

1 teaspoon salt

1 teaspoon smoked sweet paprika

1 bay leaf, crumbled

3½ pounds (1.6 kg) pork loin

3½ ounces (100 g) or 6 thin slices jamón serrano

1 cup (130 g) pitted prunes

½ pound (225 g) carrots (about 6 small), tops and bottoms removed

¼ cup (55 g) packed light brown sugar

1 (12-ounce / 360-ml) bottle Malta soda

¼ cup (60 ml) dry white wine

1 In a large bowl, mix together the sour orange juice, garlic, salt, paprika, and bay leaf. Add the pork to the bowl, turn to coat in the marinade, cover with plastic wrap, and let rest in the refrigerator overnight, turning once.

2 Preheat the oven to 350°F (175°C).

3 Remove the pork from the marinade and discard the marinade. Make a slit in the long side of the roast and slice it so it opens like a book. (Do not cut all the way through.) Layer the jamón, prunes, and carrots on one half and fold the roast closed over the stuffing. Tie the roast in six places with butcher's twine.

4 In a Dutch oven or large pot, brown the roast over medium heat, fat side down, for 3 to 4 minutes. Flip the roast and turn the heat off. Add the brown sugar, soda, and white wine to the pot and place the pot in the oven. Roast for 1 hour 15 minutes, basting a few times, or until a meat thermometer inserted into the center of the pork loin reaches 160°F (70°C).

5 Let stand for 20 minutes before carving. Cut the string. Cut the pork into ½-inch (12-mm) slices. Serve the sauce on the side.

COFFEE-RUBBED PORK

Cerdo al Café

The unstoppably creative artist-cook Alexis Alvarez Armas loves surprising his guests with unusual combinations of flavors. He might add chocolate to a mayonnaise, pair papaya with okra, or flavor roast pork with an exotic, sweet-dusky accent of coffee, as he does here. His favorite part? Watching his guests gasp, "Que rico [delicious]!"

Serves 8

1 tablespoon olive oil

1 (3½–4-pound / 1.6–1.8-kg) pork loin roast

1 tablespoon Dijon mustard

1 tablespoon red wine vinegar

3 cloves garlic, minced

1 teaspoon ground cumin

2 teaspoons dried oregano

2–3 tablespoons ground coffee

1 teaspoon salt

Black pepper

1 cup (110 g) sliced red onion

½ cup (120 ml) dry red wine

1 Preheat the oven to 350°F (175°C).

2 In an ovenproof skillet, heat the olive oil over medium-high heat. Brown the pork roast in the oil on all sides, 3 to 4 minutes per side. Remove the pan from the heat and transfer the pork to a plate.

3 In a small bowl, mix together the mustard, red wine vinegar, garlic, cumin, oregano, coffee, salt, and pepper to taste to make a paste. Spread the spice mixture all over the pork.

4 In the same ovenproof skillet that you used to brown the pork, combine the onion and red wine over high heat and bring to a boil, scraping up the brown bits from the bottom of the pan. Turn off the heat, return the pork to the pan, and place the pan in the oven. Roast for 1 to 1½ hours, or until a meat thermometer inserted into the center of the roast reads 140°F (60°C). Let stand for 10 minutes before carving.

5 Slice the pork and serve with the onions and sauce on the side.

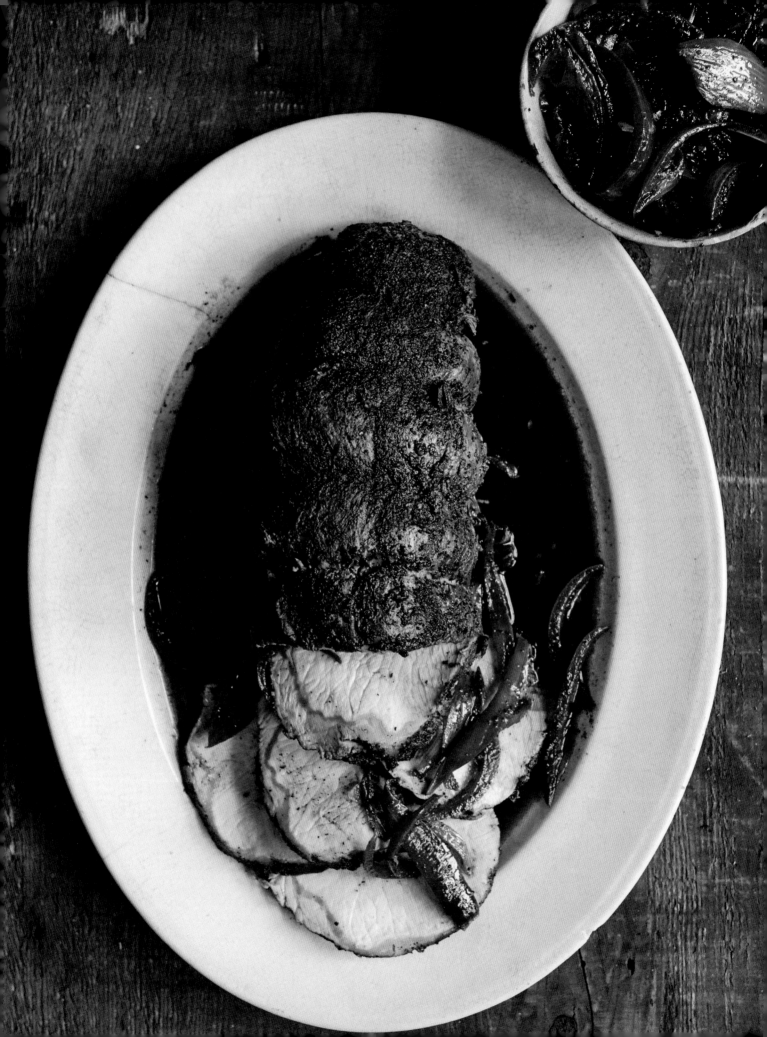

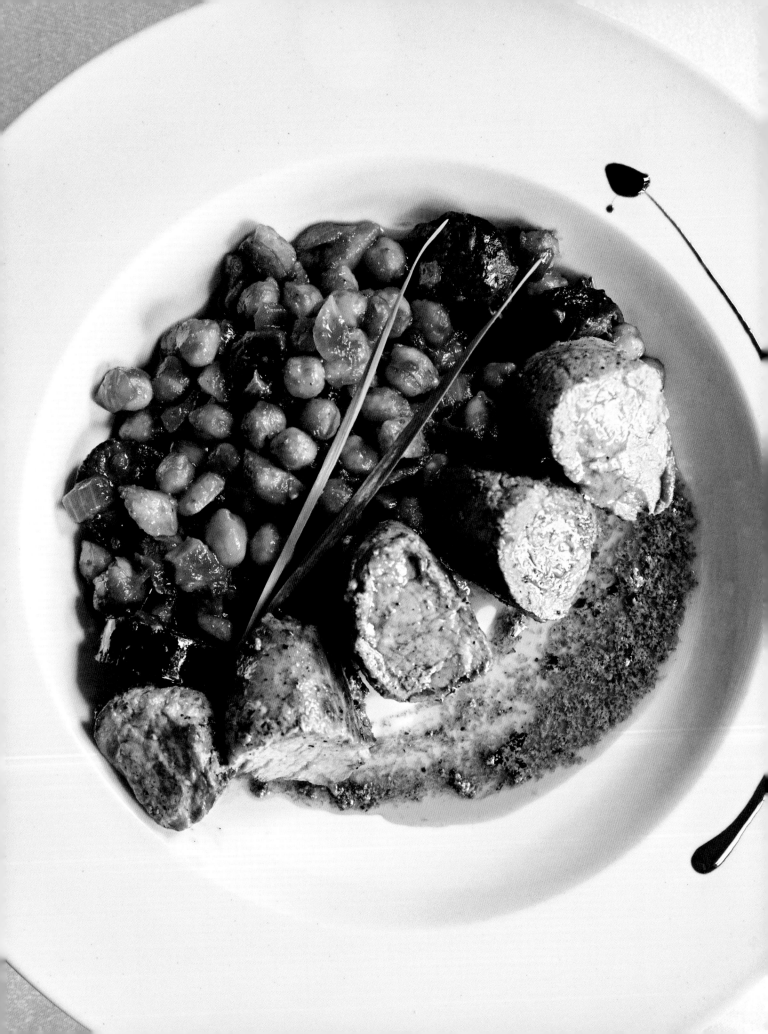

Pork with Chickpeas and Sausages

Lomo de Cerdo con Garbanzos y Embutidos

Javier Gomez, chef-owner of the modern paladar Elite, likes to call his cuisine "stylized Mediterranean." And he wows guests with this quick, modern deconstruction of a pork and garbanzo stew seen here with balsamic drizzle. In his rendition, a juicy pimentón-rubbed pork medallion is served atop garbanzo beans fried with smoky nuggets of chorizo, jamón, and morcilla [blood sausage]. An astringent green salad is welcome here, to help cut through the richness.

Serves 4 to 6

2 cups (320 g) canned chickpeas, drained and rinsed

¼ cup (60 ml) olive oil, plus more for seasoning the pork

2 ounces (55 g) lean bacon, chopped

2 ounces (55 g) Spanish chorizo, cut into ¼-inch (6-mm) slices

2 ounces (55 g) morcilla, cut into ¼-inch (6-mm) slices

1 ounce (28 g) jamón serrano, chopped

¼ cup (60 ml) dry white wine

1½ pounds (680 g) pork loin, cut into medallions

Salt and pepper

1 Pat the chickpeas dry with paper towels, making sure that no moisture clings to them.

2 In a skillet large enough to accommodate the chickpeas in a single layer, heat the olive oil over medium-high heat. Fry the chickpeas in the hot oil for a few minutes, turning them a few times with a spatula. (Work in batches if the pan is not large enough.) Add the bacon, chorizo, morcilla, and jamón serrano and cook until the meats and chickpeas are crisp, about 8 minutes more. Pour in the wine and cook until evaporated. Remove from the heat.

3 Pat the pork medallions dry with paper towels. Season on both sides with salt, pepper, and a little olive oil. Heat a grill or grill pan to medium-high. Grill the pork medallions, turning once, until just cooked through, about 6 minutes per side.

4 Fan out the pork medallions on a platter and spoon the chickpeas next to them.

CRISPY PORK SHOULDER

Cerdo Asado

There are as many recommendations for how to roast a perfect crispy-skinned, golden-brown suckling pig as there are Cubans who can access a whole baby porker. But the majestic roast at paladar Ivan Chef Justo is in a league all its own. That's because chef Ivan Rodríguez López has pigs raised for him at a farm, and because instead of marinating the lechon in the usual sour orange and garlic mojo, he treats it as simply as possible—letting the moist, tender white meat speak for itself. At Ivan Chef Justo, the lechon is presented quartered on a bed of vegetables along with paper-thin slices of onion for a treat we're still daydreaming about. Since roasting a suckling pig at home isn't daily fare for most, we've reinterpreted this recipe by using pork shoulder. The magic holds! Serve with Yuca with Onion Mojo (page 121) or Red Beans and Rice (page 153).

Serves 10

¼ cup (60 g) coarse salt

3 tablespoons olive oil

1 (9-pound / 4-kg) pork shoulder with skin, scored

1½ cups (165 g) thinly sliced yellow onion

3 tablespoons fresh lime juice

½ teaspoon table salt

1 Preheat the oven to 325°F (165°C).

2 Rub the coarse salt and olive oil all over the pork shoulder. Roast on a rimmed baking sheet, skin side up, basting occasionally with the fat and juices in the pan, for 3½ to 4 hours, or until a meat thermometer inserted into the thickest part of the shoulder reads 195°F (90°C). The skin should be crisp and browned.

3 Let stand for 20 to 25 minutes before slicing. (The pork will be so tender it should just fall apart.)

4 Combine the onion, lime juice, and table salt and mix to combine. Serve on the side.

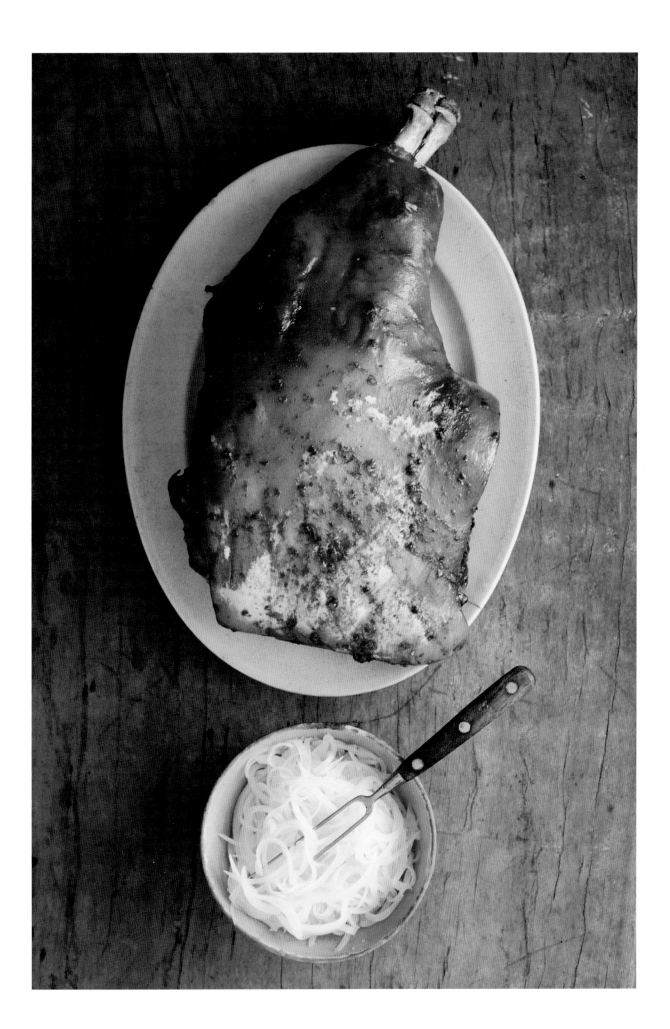

DULCES

———

Sweets

Azúcar! Sugar, sugar, sugar! Sweetness engulfs a visitor to this beautiful island—from the sugarcane juice gratefully downed on a steamy afternoon to the aching, almost unbearable sweetness of the guava tartlets and yellow sponge cakes sold at neighborhood panaderias. From the mind-boggling sight of a college kid devouring fifteen scoops of helado—with cookie crumbs, por favor, plus sticky caramel sauce—for breakfast at the iconic ice cream parlor Coppelia, to the vision of a gray-haired professor who really should know better polishing off fried sugary doughnuts, followed by a thick hunk of cake plastered with clouds of meringue. And it's not just the desserts! Cubans sneak pinches of sugar into their black beans, their ropa vieja, their picadillo. They serve garlicky malanga fritters with honey or cane syrup and smear strawberry jam on pork burgers.

"Azúcar! It's our joy and health hazard," says historian Rafael Lam, a man who can easily inhale two packets of chocolate cookies, summing up the national sweet-tooth dilemma. He adds, "Sugar was the glory of our economy and the tyrannical monoculture that choked us." Indeed. Starting in the nineteenth century, the price of sugar on global markets determined Cuba's economic well-being. Sugared water, euphemistically called sopa de gallo [rooster soup], sustained African slaves on Cuba's sugarcane plantations, and then helped the island suppress its hunger pangs during the starving Período Especial of the 1990s.

"Sin azúcar, no hay país"—"Without sugar, there is no country"—goes the popular Cuban saying. Sugarcane, however, was not native to the island nor to the Caribbean. It was brought by Columbus to Hispaniola in 1493, and from there came to the Cuban colony. By the 1570s, Cuba boasted several primitive sugar mills. Within a few decades, Havana, flush from its new role as a maritime center and layover stop for Spanish galleons, began developing sugarcane fields—but for another two centuries the island's production didn't compare to that of the neighboring sugar big shots, France's Saint-Domingue (Haiti) and Britain's Caribbean possessions.

The change came in 1791 with a massive slave uprising in Haiti. Then the world's leading sugar exporter, Saint-Domingue saw its industry obliterated; Cuba seized the opportunity. Thanks to the sophisticated refining skills of French planters who fled to the island—and, later, trade liberalization and new technologies—Cuba swiftly developed into a massive sugar-plantation economy, and the world's richest colony. Sugar to nineteenth-century Cuba was what oil was to the twentieth-century Gulf States. By the mid-1800s, there were more than 1,300 Cuban mills refining a whopping 450,000 tons of cane sugar crystal—almost a third of the world's total output. The massive growth created an equally massive demand for African slave labor. Cuba's slave population, previously modest, soared almost tenfold in the nineteenth century. The "sugar gold rush" transformed the island from an underpopulated backwater into the world's mightiest tropical outpost of industrial agriculture.

Grandiose urban developments and lavish ingenios [plantation complexes] that resembled small cities were bankrolled, augmented by extensive road networks and more railways per square mile than any other Latin-American country—all for transporting azúcar, of course. The wealth came at a harsh price: the destruction of peasant communities, catastrophic deforestation, the horrors of slavery. Fidel promised to unshackle the island from its one-crop dependency. But Cuba's economy essentially continued in its own way. When Eisenhower summarily closed off Cuban azúcar to its main market, the United States, Castro started selling it—at five times the international price, and neglecting all other agriculture—to a new

sugar daddy and patron, the USSR. Then when that sweet deal collapsed, so did the island's economy. It's never really recovered since.

But come, let's talk about sweeter endings: Desserts!

Just like sugarcane itself, Cuba's confectionary traditions arrived from Spain, which in turn inherited its sweet techniques from the medieval world's most advanced cultivators of sugarcane—the Moors, who planted the sugary reed in Andalusia after their eighth-century Iberian conquest. Perfected by nuns in Andalusian convents, a treasure trove of Muslim-influenced but Catholicized sweets was then transplanted to the New World: smooth, stove-top puddings and syrup-drenched fritters, marzipans and nougats, preserves and sugared fruit, as well as crumbly lard cookies and yemas, those insanely rich, egg-yolk-laden sweets. While convent-style confection was never big business in Cuba as it was in, say, Mexico, local colonial matriarchs kept the tradition alive while adapting to tropical produce. They made buñuelos [fritters] from malanga and yuca, turrones and alegrias [brittles] from coconut, candied fruit from guava shells and papayas, alfajores cookies from casabe flour—and dense sweet puddings from boniato.

Things lightened up by the nineteenth century, when a fashion for Gallic-style sponge cakes, meringues, éclairs, chantilly creams, Napoleons, and the caramel so essential for flan took hold. Such airy dainties were enjoyed by rich planters while campesinos [peasants] and slaves assuaged their sweet yens with vernacular dulces like malarrabia—boniato chunks cooked in cane syrup—an archaic sweet still occasionally found at Cuban street fiestas today. The twentieth century ushered in, along with American imperialism, a taste for cheesecakes, doughnuts, and pies.

But who was it who turned Cuba into a nation of ice cream addicts? Yes, helado had been around since the mid-nineteenth century, but for their state of

genuine obsession Cubans can credit (or curse) one person—El Comandante Fidel, a man with a serious milk fetish, a leader who famously had twenty-eight containers of Howard Johnson's ice cream shipped over by his Canadian ambassador so he could taste-test each flavor. Under the slogan "helado por el pueblo"—"ice cream for the people"—Castro ordered the building of a sleekly modernist-futurist two-story mega-heladeria with seating for a thousand customers. His private secretary, the project's director, named it Coppelia after her favorite ballet. Almost instantly, this catedral de helado became Havana's most popular Revolutionary landmark, a socialist paradise of sugar and tropical fruit (and East German powdered milk). Here couples had their first dates while the country's best bands played under the banyan trees; intellectuals debated the fate of the world over scoops of fresa [strawberry] and chocolate—a combo that provided the title (and Coppelia, the major setting) for Cuba's great international film hit of the early '90s, *Strawberry and Chocolate*. Coppelia's original twenty-six flavors—among them guava, muscatel, and Tutti Frutti—are all but a memory. But a visit here is still a quintessential Havana thrill: joining the huge line before the 10 A.M. opening time, then watching Cubans of all stripes devour five-scoop combos called ensaladas from yellow plastic trays for just a few cents.

As often as we do go to Coppelia—to soak in the ambiance—we're equally drawn to the vivid artisanal ice creams served at the new, privately owned parlor called Helad'oro, which inspired the helado recipes here. And while this chapter pays tribute to Cuba's old-world flans, arroz con leche, and candied papaya, it also celebrates the current shift from the heavy Spanish traditions to brighter, more modern sweets. Whether it's a modern riff on the milk-soaked cult cake tres leches or an heirloom, grandmotherly recipe for a creamy natilla pudding, the island's sweetest side shines through in the following pages.

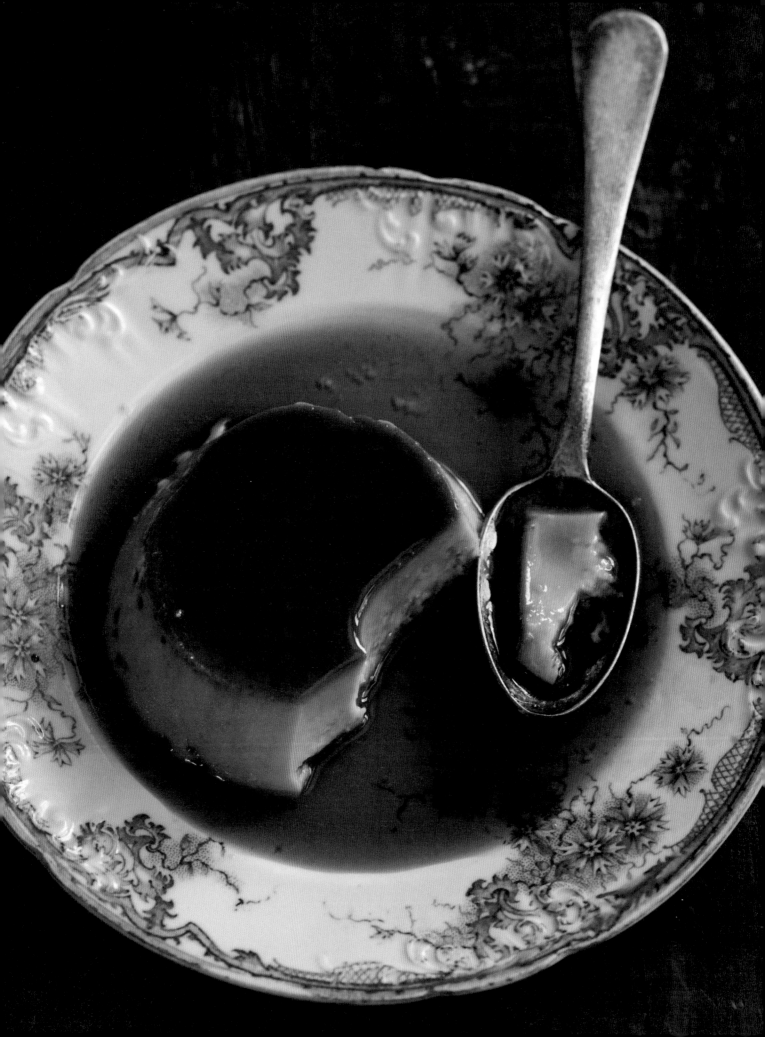

FLAN

Of all the rich, eggy custards perfected by nuns in medieval Spanish Catholic convents then exported to the New World, flan became by far the most popular Latin dessert. In Cuba, flan soaked in dark caramel is as essential and classic as black beans and rice. But because cows—and therefore milk and cream—are so scarce, Cuban cooks resort to canned condensed and evaporated milks, which is actually pretty traditional. It's also quite a boon! Condensed milk offers the added bonus of stabilizing the custard and preventing the dreaded curdling. It also makes for a denser, creamier flan—which is exactly how most Cubans like it. This straightforward version is a rich, silken perfection but it requires a pretty dark caramel to offset the sweetness. Watch closely so it doesn't burn.

Serves 6

1 cup (200 g) sugar

1 (14-ounce / 420-ml) can sweetened condensed milk

1 (12-ounce / 360-ml) can evaporated milk

3 large eggs

2 large egg yolks

2 teaspoons vanilla extract

1 Preheat the oven to 325°F (165°C).

2 Melt the sugar in a saucepan over medium heat, stirring frequently, until it turns into a dark caramel, 9 to 10 minutes. (Watch closely during the last few minutes to make sure it does not burn.) Swirl the pan after you remove the caramel from the heat, as it will keep cooking. Pour about 2 tablespoons of the caramel in each of six ½-cup (120-ml) ramekins and set them in a baking dish with high sides.

3 In a mixing bowl, combine the condensed milk, evaporated milk, whole eggs, egg yolks, and vanilla and whisk to combine. Divide the custard mixture evenly into the prepared ramekins. Fill the baking dish with warm water halfway up the sides of the ramekins and gently place the pan in the oven.

4 Bake the flan for 12 to 15 minutes, or until the centers jiggle slightly when shaken. Let the ramekins cool in the water bath, then refrigerate for at least 2 hours. When ready to serve, run a paring knife around the edge of the ramekin, place a plate over the top, and invert the ramekin, shaking it a bit to release the flan onto the plate. Liquid caramel will drip down the sides of the flan.

EL COCINERO

MEET THE
YOUNG GENERATION

When thirty-somethings Sasha Ramos and Rafael Muñoz cobbled together enough cash to open El Cocinero, a restaurant-bar in an abandoned industrial building with a two-hundred-foot brick smokestack, they didn't expect to be turning away scores of folks who hadn't booked days ahead. Still a bit dazed by it all, they ascribe their success to Rafael's groovy playlist, unfussy crowd-pleasing food, potent drinks, and their hip and wildly crowded neighbor: Fabrica del Arte Cubano, currently the most exciting avant-garde art space in the Americas. Up a few flights of winding steps sits the industrial-chic restaurant, decorated with blown-up black-and-white photos and modern art. But the real party is up on the sunken roof terrace fringed by tropical greenery, where the sexy green-lit bar, adorned with a vintage Coke sign, dispenses good wine and tall, icy mojitos. Every night all the gente linda [beautiful people] pack in here: the leggy models, the DJs, the tattooed, bearded bohemians from LA and Berlin. Fellow young paladar owners also hustle over after their shifts, delighted that Havana finally has a place that can out-cool Miami.

Sasha and Rafael's Story

Sasha is a financial analyst, Rafael a music producer. Laura, the manager here, comes from a well-known design family. We were all childhood friends. The owners of paladares O'Reilly 304 and Otramanera were also part of our group of amigos. We'd all get together on the beach or at somebody's house, cook fancy stuff like pasta with shrimp, and moan how Havana had zero places where we'd want to chill. We're from a generation that wouldn't be caught dead at state-run bars, where they stint you on the ingredients. We wanted a place with great drinks, music we ourselves like to listen to, simple but delicious cosmopolitan food. None of us has traveled abroad other than Sasha; he's been to Russia, where his mother is from. But we were clued in from foreign films, magazines, and the Internet. Funny how we all ended up opening our own paladares—exactly the hip indie spots Havana was missing. There are no bank loans in Cuba, no financing; property was hard to buy until recently. So Rafa's mom traded her house with an old guy who lived here in this dilapidated semi-abandoned industrial building from the 1890s. It used to be a transport generator, then a peanut oil factory for the famous El Cocinero brand, which eventually fell into disuse, though everyone recognizes the chimney. So we found ourselves with this huge, complex space, with many different levels all in pretty terrible shape. Having no money, we took the "minimum-renovation" route, keeping the old brick walls and many original details. Rafael has a great eye for design. From photos in *Wallpaper* and *Architectural Digest*, we commissioned Cuban artisans to replicate stuff like the famous Panton tables and the cool Acapulco

chairs—for just seven dollars a chair!—mostly using discarded materials. Other things we managed to order from Miami and Panama.

For the menu we decided on the concept of a "zero kilometer" food supply—meaning everything totally local. That Cuba barely has any frozen industrial food ended up being a boon. Scarcity was an engine that forced us to innovate every day, every minute. Campesinos [farmers] from the outskirts of Havana bring us tubers and lettuces; we found a farmer who grows real Creole free-range chicken, tiny and scrawny, sure, but so much tastier than those big Brazilian or U.S. birds. We don't really have a "chef de cuisine." We decide as a group what we want on our menu, be it our hugely popular tambores [timbales] of boniato and spicy crab or coconut flan. Or that chicken done on the plancha with a salsa criolla. And we play our favorite music, from Caetano Veloso to House to Depeche Mode from the '80s. Music, food—everything here is eclectic and personal. It was our luck that a few months after we launched in 2013, Fabrica del Arte opened next door— it's brought a cool local and international art crowd to our street. Mick Jagger has been to El Cocinero, so has Natalie Portman, Christian Louboutin, Vin Diesel—and recently Michelle Obama. What a lady! We felt she's one of us, truly we did. So charismatic and simple, nibbling on our frituras and empanaditas and praising our playlist.

The happiest day of our lives, you ask? It's always today, because in Cuba you're just happy to get through the day without some trauma or craziness. The saddest day? Tomorrow . . . since in Cuba you never know what tomorrow's gonna bring.

COCONUT FLAN

Flan de Coco

We enjoyed this flan on the rooftop terrace of the hipster paladar El Cocinero. It was luscious with shredded coconut and coconut milk, baked in a mold, and sported a texture a bit closer to cake than to custard. Instead of the caramel, the chef used delicious honey from the visionary organic farm Finca Marta. If you can find it, orange blossom honey would add a delightful, fragrant touch.

Serves 8

1 (14-ounce / 420-ml) can sweetened condensed milk

1 cup (240 ml) coconut milk

¾ cup (65 g) plus 3 tablespoons unsweetened coconut flakes, toasted

2 cups (480 ml) heavy cream

5 large eggs, beaten

2 teaspoons vanilla extract

Honey, for drizzling

1 Preheat the oven to 350°F (175°C). Grease a 9-inch (23-cm) round casserole dish.

2 In a mixing bowl, combine the condensed milk, coconut milk, ¾ cup of the coconut flakes, and the heavy cream. Whisk in the beaten eggs and vanilla until incorporated. Pour the custard mixture into the prepared casserole dish.

3 Place the filled casserole dish in a larger baking pan. Pour boiling water into the pan until the water comes halfway up the sides of the casserole dish. Carefully place the pan in the oven and bake for 1 hour 15 minutes, or until the center jiggles slightly when shaken.

4 Remove the casserole dish from the water bath and let cool to room temperature, then refrigerate at least 3 hours, or until set.

5 When ready to serve, run a paring knife around edge of the casserole, place a plate over the top of the flan, and flip upside down to release it onto the plate.

6 Cut the flan into wedges. Garnish each serving with a heaping teaspoon of toasted coconut and drizzle with honey (not pictured).

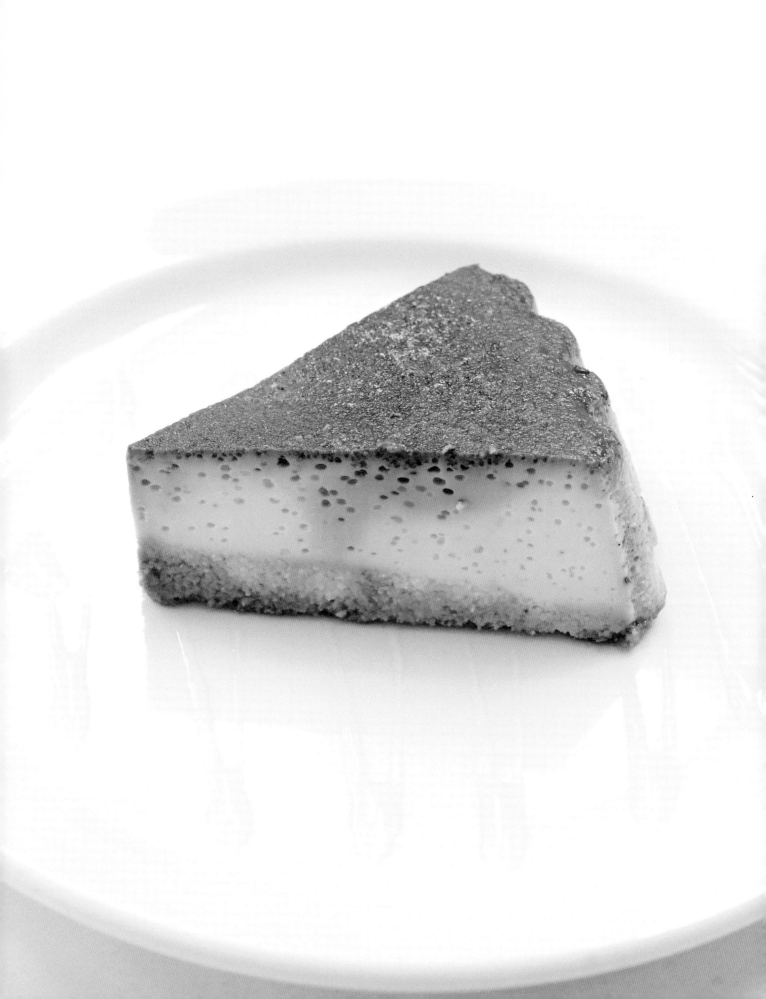

GRANDMOTHER'S CUSTARD

Natilla de la Abuela

In medieval Spain, various stove-top puddings thickened with rice flour—and later cornstarch and egg yolks—were borrowed from the Moors. Prepared from sugar and milk and redolent of vanilla and cinnamon, this loose, lovely custard has the texture of a French pot de crème and the uncanny power to evoke childhood memories. At the charming Havana paladar Hecho en Casa, it's prepared by the owner's mother using her own mother's recipe. Señora Menendez drizzles her creamy sweet with dark caramelized sugar—a kind of simplified flan. As variations, you can melt some chocolate into the milk, adding less sugar. Or infuse the custard with orange peel, or top with fresh strawberries.

Serves 6

3 cups (720 ml) whole milk

½ cup (100 g) sugar

3 tablespoons cornstarch

2 large egg yolks

1 teaspoon vanilla extract

½ teaspoon ground cinnamon or ½ cup sweet cocoa powder

1 In a saucepan, combine the milk and sugar over medium heat and bring to a simmer for 4 to 5 minutes, stirring to dissolve the sugar.

2 Ladle 1 cup (240 ml) of the hot sweetened milk into a small bowl, add the cornstarch, and mix to make a slurry. Slowly whisk the slurry into the milk mixture to thicken it. Increase the heat to medium-high and bring to a boil, whisking continuously to avoid forming lumps, 4 to 5 minutes.

3 Remove the thickened milk mixture from the heat. Ladle 1 cup (240 ml) of the hot sweetened milk into a bowl, then whisk in the egg yolks and return to the pot. Cook over low heat for 2 to 3 minutes more, until thickened and smooth. Stir in the vanilla. Stir in the cinnamon or sift in the cocoa powder.

4 Divide the custard evenly into six ½-cup (120-ml) ramekins. Cover with plastic wrap and chill in the refrigerator for at least 3 hours before serving.

CUATRO LECHES

The current "it" cake of Latin America gets its name from incorporating three kinds of milk: evaporated, condensed, and regular whole milk. But what if tres isn't enough? This was the reasoning behind this clever riff on the classic served at the cozy paladar Al Carbon. There, the sweet is cheekily presented in cute empty condensed milk tins, topped with chopped almonds and dulce de leche (the fourth milk). We could have eaten four servings!

Serves 9

FOR THE CAKE

1½ cups (190 g) all-purpose flour

1 teaspoon baking powder

½ cup (1 stick / 115 g) unsalted butter, room temperature

1 cup (200 g) sugar

5 large eggs

½ teaspoon vanilla extract

FOR THE MILK MIXTURE

2 cups (480 ml) whole milk

1 (14-ounce / 420-ml) can sweetened condensed milk

1 (12-ounce / 360-ml) can evaporated milk

FOR THE GLAZE

1 (13-ounce / 390-ml) jar dulce de leche

¾ cup (105 g) almonds, toasted and chopped

¼ cup (35 g) dark chocolate sprinkles or shaved dark chocolate

1 **Make the cake:** Preheat the oven to 350°F (175°C). Grease and flour a 9-inch (23-cm) baking pan.

2 In a medium bowl, stir together the flour and baking powder and set aside.

3 In a large mixing bowl, using an electric mixer, cream the butter and sugar together until fluffy, about 2 to 3 minutes. Beat in the eggs, one at a time. Add the vanilla extract and beat to incorporate.

4 Gradually add the dry mixture to the wet mixture, mixing until well blended. Scrape down the bowl with a spatula and pour the batter into the prepared pan.

5 Bake for 30 minutes, or until light golden and a knife inserted comes out clean. Let cool slightly and, with a skewer, poke holes evenly all around the cake.

6 **Make the milk mixture:** In a mixing bowl, combine the whole milk, condensed milk, and evaporated milk. Pour over the top of the cake.

7 **Make the glaze:** In a small saucepan, heat the dulce de leche and ¼ cup (60 ml) water over medium heat for 2 to 3 minutes, stirring to combine. Remove from the heat and let cool for 2 minutes. Pour over the cake and top with the toasted almonds and sprinkles.

RICE PUDDING

Arroz con Leche

So ubiquitous is arroz con leche on Cuban menus, it takes a really outstanding version to charm our taste buds. This creamy cinnamon-scented delight from the chic modern paladar Otramanera was a stunner. The secret to its ultralight texture, explained co-owner Amy Torralbas: "Aerating" the pudding with whipped cream and beaten egg whites after it has cooled down.

Serves 6

1 cup (195 g) medium-grain white rice

3 cups (720 ml) whole milk

⅓ cup (65 g) sugar

Pinch of salt

1 egg white

1 cup (240 ml) heavy whipping cream, beaten to soft peaks

1 teaspoon ground cinnamon, or more to taste

1 Place the rice in a saucepan and add water to cover. Bring to a boil over medium-high heat and cook for 7 minutes. Drain the rice in a fine-mesh strainer and rinse in cold water.

2 Return the rice to the saucepan and add the milk, sugar, and salt. Bring to a simmer over medium heat and cook for 15 minutes, or until the rice and milk are creamy. Remove to a large bowl to cool.

3 With a hand mixer, beat the egg white on medium-high to stiff peaks, about 4 to 5 minutes. Fold into the rice mixture with a spatula. Fold the whipped cream into the rice mixture.

4 Scoop the pudding into individual serving dishes and sprinkle with cinnamon. Refrigerate for at least 2 hours or up to overnight before serving.

COCONUT DROPS

Coquitos

Coquitos are Cuba's answer to macaroons: chewy, sweet balls rolled in cooked, shredded coconut and either left to dry for a bit or scooped right away with a melon baller into paper cups as a Christmas sweet or a popular street treat. Variations abound—coquitos blancos, plump with white shredded coconut; coquitos melcochados, toasty with caramelized coco; coquitos con leche, made with sweet milk. Package them in colorful mini baking cups to give as a holiday gift or bring to a party.

Makes 24 balls

1 (14-ounce / 420-ml) can sweetened condensed milk

1 pound (455 g) finely grated unsweetened coconut

1 teaspoon vanilla extract

1 Preheat the oven to 325°F (165°C).

2 In a mixing bowl, stir together the condensed milk, coconut, and vanilla until well combined. The mixture should be dense enough to hold a ball when you roll one in your hands.

3 Using a melon baller and your hands, scoop up the coconut mixture and roll it into twenty-four 2-inch (5-cm) balls. Bake on one large or two smaller baking sheets until light golden brown, 6 to 7 minutes. Transfer to a wire rack to cool.

Guava and Cheese Pasteles

Pasteles de Guayaba y Queso

Brightly colored cases on wheels carrying crumbly filled pastelitos are a common—and welcome!—sight all over Havana. And since a Cuban can never have enough pasteles, many bakeries sell them as well. The shape of the pastel is usually a cue to the filling: the ever-popular triangular guava and white cheese, rectangular plain guava, square coconut, and round meat picadillo. Here we offer the classic guava-cheese combo that becomes irresistibly molten when baked. These are an iteration of an iconic Cuban snack called pan con timba: slabs of guava paste and white cheese tucked between bread. The peculiar name? It's from a time when Brits worked in Cuba in the 1870s installing the Bejucal Railroad, the first railway Spain built in the Americas during colonial times. The tile-like slabs of dark guava paste Cuban laborers tucked in their bread reminded the Brits of the oiled timber logs they used for the railway ties. Hence the name: bread with timber. The expression also signifies something like a "poor man's meal," though these guava pasteles are anything but!

Makes 9 pasteles

½ cup (115 g) cream cheese, at room temperature

1 teaspoon finely grated lime zest

2 tablespoons sugar, plus more for sprinkling

All-purpose flour, for rolling

1 pound (455 g) frozen puff pastry, thawed

9 slices guava paste, about 1 by ¼ inch (2.5 cm by 6 mm) each

1 large egg, beaten

1 Preheat the oven to 375°F (190°C).

2 In a mixing bowl, combine the cream cheese, lime zest, and 2 tablespoons of the sugar.

3 On a floured surface, lightly roll out the puff pastry and cut out nine 2½-inch (6-cm) squares. Place 1 heaping teaspoon of the cream cheese mixture in the center of each square and top with a slice of the guava paste. Fold one corner to the opposite corner to make nine triangles. Seal the triangles closed with the tines of a fork.

4 Transfer the triangles to a baking sheet, brush the tops with the beaten egg, and sprinkle with sugar. Bake for 8 to 10 minutes, or until puffed and golden.

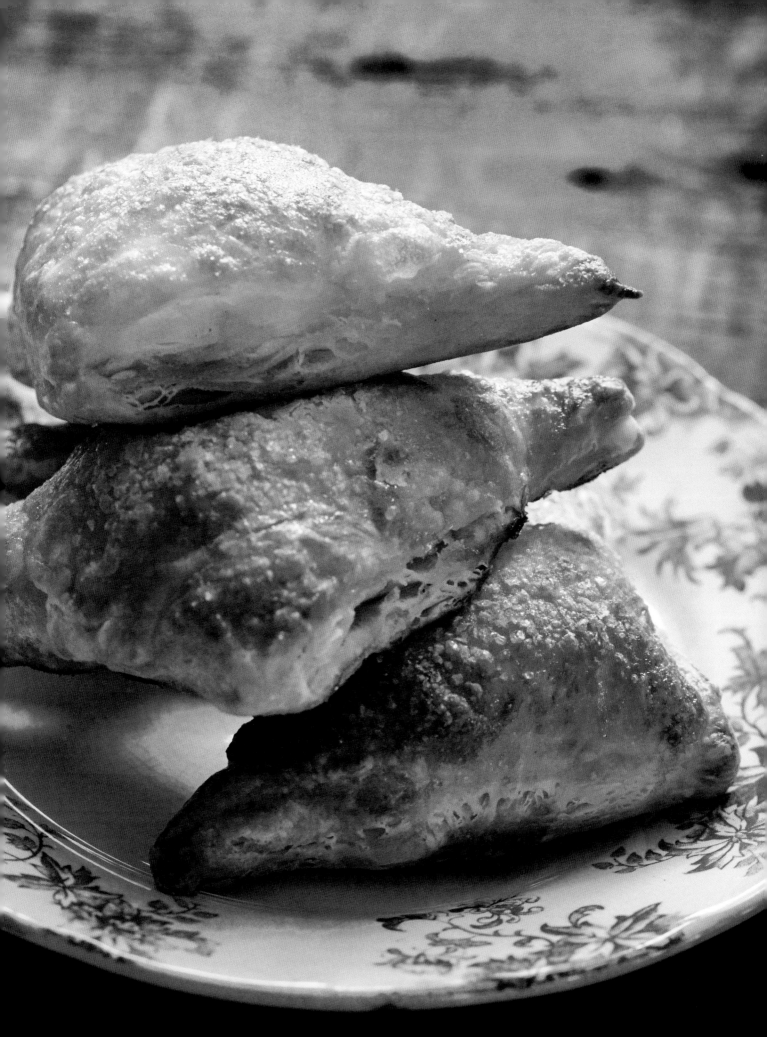

HELAD'ORO

THE DEN OF FROZEN DELIGHTS

On Habana Vieja's Aguilar street, on a block that's part refurbished, part down at the heels, Helad'oro [Golden Ice Cream] announces itself with a sleekly designed yellow sign. Inside the chic little boutique, smiling young servers scoop strictly seasonal, all-natural frozen treats into sweet, crunchy waffle cones. There's a seriously caramel-like dulce de leche, a minty frozen take on mojito, an ice cream from the rich-tasting tropical fruit called mamey. For Cubans accustomed to the classic but (alas) industrial flavors at Coppelia, the iconic state-run ice cream parlor, Helad'oro is a whole new world of helado. French entrepreneur Francoise and her Cuban ice cream–maker husband, Héctor Prendes, who was formerly a well-known boxer, opened their nook in 2015. "It's been such a success," says Francoise, "we're already expanding to the Vedado district." She gives a happy laugh. "A petit empire of ice? Pourquoi pas?"

Francoise's Story

I am from Paris. In my previous life, I owned a commercials casting agency there—then one in New York. In 2001, I'd split with my boyfriend and decided, just like that, on a whim, to go vacation in Cuba. Oh la-la, Havana! It had that sexy je ne sais quoi that got right under my skin. At a French patisserie there I met Héctor, my now husband. He was gorgeous—a famous ex-boxer, a brilliant salsa dancer. To this day I haven't learned salsa—because how do you dance with someone that good? After we met, he invited me out to a music show. That was May. In September he was living in Paris with me—as my husband. Initially all my friends were wild with excitement. They couldn't wait to meet this adorable black dancer-boxer husband of mine. But for Héctor it was a pretty profound culture shock. He didn't know how to use the Parisian Metro. Or even a microwave! When the excitement calmed down, life became difficult. Finding a job was a problem. He ended up working at a souvenir shop, a job without a future. Paris, well, it's not always kind to immigrants.

In 2011, after the Cuban law came out about private businesses, I thought of opening something small in Havana and buying a house there. Initially Héctor protested; he didn't want to return. It took a lot of cajoling. But what food business, I wondered, could we open that would use only available seasonal Cuban produce—so we wouldn't have to spend every waking hour chasing ingredients? Then it dawned on me: Ice cream! Made only with available fruit! Genius, no? I'm not a big ice cream lover, I'll be honest.

But Héctor, like all Cubans, grew up eating at Coppelia—he's gaga for ice cream. Do you know the famous Berthillon ice cream parlor in Paris? We decided to become the Berthillon of Havana! Héctor trained in ice cream in Paris and loved it. Then we found this cute space in Old Havana—and the construction nightmares began. Something we take for granted, basic window panes, becomes an all-consuming preoccupation. I spent three months—three!—chasing down window panes all over Cuba! And simple white paint! It just isn't available here, to say nothing of this bright happy yellow you see on our walls. And don't even ask how long it took to get our beautiful black logo right. I'm a perfectionist! I wanted it to look like Hermès!

Fruit, thank God, isn't a problem because we follow the seasons: after guava comes mango, then mamey and pineapple, then guanabana [soursop] that tastes so rich and creamy in ice cream. But milk? Forget fresh milk; here cows and milk belong to the government. But Héctor made a lucky discovery! The powdered milk available here is pas mal, not bad at all, and chemically it stabilizes the ice cream. All of our troubles were worth it! Seeing our first customers go *wild* for our flavors like dulce de leche, mojito sorbet, and Baracoa chocolate—we almost cried. Cubans, like I say, are a nation of ice cream fanatics . . . and ours, well, it's the best. Héctor's favorite flavor? American Oreo! For some reason you can find Oreos here in Cuba—although by the time I say this they've probably vanished. What do I smuggle in my suitcase from Paris, you ask? Van—no, I won't say. The less one blathers, always the better. The authorities . . . they never sleep.

MAMEY ICE CREAM

Helado de Mamey

One of Francoise's frozen hits features mamey, a tropical fruit much prized in Cuba. Mamey has a brown skin, an oblong shape, and bright orange flesh with a flavor that suggests a cross between persimmon and roasted sweet potatoes. Mameys take a full two years to grow, and finding a perfectly ripe fresh fruit can be a challenge. Luckily, frozen mamey pulp sold at most Latin groceries comes to the rescue—so there's no excuse for not trying this wonderful ice cream.

Serves 6

2 cups (250 g) chopped frozen or fresh mamey

1 (14-ounce / 420-ml) can sweetened condensed milk

½ cup (120 ml) heavy cream

½ teaspoon ground cinnamon

Pinch of salt

In a blender or food processor, combine the mamey, condensed milk, heavy cream, cinnamon, and salt and blend on high speed for 1 minute, or until smooth. Scrape into the bowl of an electric ice-cream maker and freeze for 20 to 25 minutes. Scrape the ice-cream mixture into an airtight container with a lid, cover, and freeze for at least 4 hours to blend the flavors.

MOJITO SORBET

Sorbete de Mojito

Another sought-after flavor at Helad'oro is this slushy frozen take on the mojito, fashioned from lime, mint, sugar, and rum. On a blistering Havana day, what could be better? It's always the first thing to run out.

Serves 6

1½ cups (300 g) sugar

¼ cup (13 g) chopped fresh mint, plus 2 tablespoons finely chopped fresh mint

¾ cup (180 ml) fresh lime juice

2 tablespoons light rum

1 In a saucepan, combine 1½ cups (360 ml) water, the sugar, and chopped mint over medium heat and bring to a simmer. Let simmer for 5 minutes, stirring to dissolve the sugar and extract the mint flavor. Turn off the heat and let the syrup cool for at least 20 minutes. Strain through a fine-mesh strainer placed over a bowl and discard the chopped mint.

2 In a mixing bowl, combine the mint syrup and lime juice and cover with plastic wrap. Chill in the refrigerator for at least 1 hour or up to overnight.

3 Pour the sorbet mixture into the bowl of an electric ice-cream maker and freeze according to the manufacturer's instructions. After 10 minutes, stir in the finely chopped mint and the rum and continue to freeze for 10 to 15 minutes, or until frozen. Scrape into an airtight container with a lid, cover, and freeze for at least 4 hours to let the flavors develop and meld.

Alexis's Mango Mousse
Mouse de Mango a la Alexis

Containing no usual mousse ingredients such as cream, egg whites, or gelatin, this dessert is just the pure essence of mango: a perfect summer refresher that practically floats off the table. The repeated blending renders the fruit light and creamy without adding anything but a bit of lime juice for tartness. This is the kind of ethereal dessert you might have after a nine-course tasting menu, like we did at the house of Alexis Alvarez Armas. Alexis serves this refreshing sweet when the fleshy Cuban mangoes are at their peak, topping it with bits of caramelized pineapple to add texture and a dash of extra acidity. A strong, roaring blender is key to the success of the dish: If yours isn't strong enough, pass the mango puree through a fine sieve to remove any fibers before placing it in the freezer.

Serves 4

3 cups (495 g) cubed very ripe mango (2 large or 3 medium mangos)

2 tablespoons fresh lime juice

1 teaspoon unsalted butter

1 cup (165 g) diced pineapple

½ teaspoon brown sugar

1 tablespoon confectioners' sugar

1 In a blender, combine the mango and lime juice and blend on high speed until smooth, 1 to 2 minutes. Scrape into a bowl and chill in the freezer just until very cold, 7 to 10 minutes.

2 Meanwhile, in a small skillet, combine the butter, pineapple, and brown sugar over medium heat and sauté until the pineapple is caramelized and golden brown on the edges, 4 to 5 minutes. Set aside.

3 Remove the mango puree from the freezer and return it to the blender. Blend on high speed until fluffy and return to the freezer for 10 minutes.

4 Blend the mango puree on high speed a third time until it is as light and creamy as mousse. Divide the mango mousse among four cups, top each serving with 2 to 3 tablespoons of the caramelized pineapple, and dust with confectioners' sugar.

Candied Papaya with Grated Cheese and Lime

Dulce de Papaya con Queso

Everyone in Cuba knows that guava paste and soft, slightly briny white cheese is one of the world's happiest pairings. With this homey recipe from the wonderful Hecho en Casa, Alina Menendez serves up syrup-soaked papayas sprinkled with cheese. A squeeze of lime rounds out the flavors.

Serves 4 to 8

1 (4–5 pound / 1.8–2.3 kg) firm half-ripe papaya

3 cups (600 g) sugar, or more depending on the sweetness of the papaya

3 cups (720 ml) cold water

Rind of 1 lime, white pith removed

Queso blanco, or other grated white cheese, for garnish

Lime slices, for garnish

1 Peel the papaya, remove the seeds, and cut into 1- to 2-inch (2.5- to 5-cm) chunks. Set aside.

2 In a large, heavy-bottomed pot, combine the sugar, water, and lime peel. Cover and bring to a boil over medium-high heat. Add the papaya, reduce the heat to low, and cook, stirring frequently, until the fruit is soft and nearly translucent. Refrigerate with syrup before serving.

3 To serve, sprinkle with grated white cheese and garnish with lime slices.

DULCERIA BIANCHINI

THE SWEETEST
SPOT IN HAVANA

The 1920s Habana Vieja apartment of Swiss-Italian businesswoman and baker Katia Bianchini smells sweetly of the chocolate-coconut cookies her assistants have just popped in the oven. Cozily cluttered with vintage finds and a grand piano left by her former husband, a concert musician, Katia's home doubles as a baking atelier, where she recently started treating guests to bountiful brunches featuring flaky Swiss quiches and tarts, cheeses from small local producers, her signature ginger cookies, and a caramelized-pineapple jam you can't stop eating. Katia, of course, is the woman who's hooked Havana on good croissants—as well as Nutella choux pastries and a rich Baracoa chocolate cake from a recipe she's been developing for more than a decade—at her pair of chic little cafés in Habana Vieja. "I'm happy for the tourists who drop by my cafés for a slice of tart and a good cappuccino," says Katia. "But my main goal is to recapture the spirit of Havana's old pastry shops for Cubans—and then to modernize it with new, global flavors."

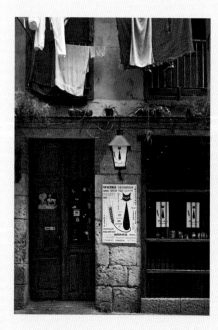

Katia's Story

My family went from the Swiss Lakes to the socialist tropics!

My mother is Swiss and my father is from Rome—an Italian. He is a prominent physicist; in the 1960s he was working at CERN, the European Organization for Nuclear Research in Geneva. And he was a lefty, an idealist, a supporter of Fidel's Revolution. In the late '60s CERN launched a witch hunt against communist sympathizers, so my father accepted a position in Cuba, helping the state with nuclear energy research along with the Russian scientists. I was ten when we moved. For a child, Cuba was magical. The beaches, the tropical flowers—the Coppelia ice cream parlor! Following in my father's footsteps, I studied physics. But it just wasn't for me. Instead for twenty years I worked as the project manager for an international solar energy research and water treatment company. I was a successful businesswoman, you'd say.

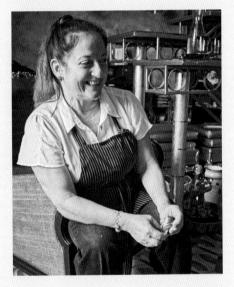

More recently, I decided on a pastry shop, because since childhood I understood, instinctively almost, that sweets are key to social relations. They bring people together, especially in Cuba, a nation of sugar addicts. At home, my mom baked beautiful tarts with Cuba's tropical fruit, but we also made rustic Swiss whole-wheat breads. Our family table was a European-tropical fusion. We were famous in Havana for our Sunday brunches with quiches, croissants, chocolate cakes, and loose soufflés called moelleux. I always collected dessert cookbooks. I felt chocolate called to me somehow. Cuba once had a great tradition of confiterias [pastry shops] that alas disappeared. Finding a decent croissant here became all but impossible; the hotel buffets served frozen industrial pastries. So there was that need to fill. But still, it was daunting to compete with the commercial baroque cakes with huge swirls of meringues that Cubans adore. The biggest problem, though, was the irregular availability of butter. I remember desperately calling dozens of shops to see if anyone had any butter—finally finding one thirty miles outside Havana and jumping into the car and racing there like crazy, heart pounding, terrified that they, too, would run out. And did I mention the tropical humidity? Your pastry changes texture literally in the delivery truck! But you adapt, you accept that your quiches and croissants won't be Parisian—they will be Cuban. You experiment and succeed in making delicious puff pastry with vegetable shortening instead of butter.

Ultimately the difficulty is that the government has legalized small private food businesses but neglected to create wholesale markets or ingredient-distribution mechanisms or customs laws that would enable us to import. Suddenly there are, what, five hundred new paladares in Cuba all clamoring and competing for the same scarce supplies. And getting pushed—whether they like it or not—into the shady world of the illegal black market. We operate licensed businesses. We pay taxes that contribute to the Cuban economy. And yet we have no normal channels that supply us with basics. In such conditions informal networks are lifesavers. Flour and sugar I can buy from the government. For the rest, I depend on my friends who produce and grow things like cheese, eggs, and fruit; on friends and family who travel and tote suitcases of stuff from abroad. We all cultivate and nourish such friendships; it brings us closer together. And yet! Cuba's service and restaurant culture has come an immensely long way in just under a decade. I hope that my adopted country will develop wisely and sensitively, preserving its roots and its values, not falling for crazy Western consumerism, not becoming Downtown Miami. For me opening a business here was not a fast highway but a small country road full of curious things and experiences. I like traveling in the slow lane—with pastries.

Katia's Ginger Cookies

Galletas de Jengibre

These cookies are a highlight of Katia's menu, perfectly spiced and crisp. Double the recipe and store the extra dough in the freezer—it'll last up to three months.

Makes 3 to 4 dozen

2 cups (250 g) all-purpose flour

1 teaspoon baking soda

½ teaspoon salt

1½ teaspoons ground ginger

1½ teaspoons cinnamon

1 teaspoon nutmeg

1 teaspoon white pepper

¾ cup (165 g) packed dark brown sugar

¼ cup (50 g) granulated sugar

1 large egg

7 tablespoons (100 g) unsalted butter, at room temperature

1 In a small bowl, whisk together the flour, baking soda, salt, and spices.

2 In a separate bowl or in a stand mixer fitted with the paddle attachment, add the butter and sugars and mix at medium-high speed until light and fluffy, about 3 minutes. Add the egg, mixing well for another minute.

3 Turn the mixer to low and beat the flour mixture until just combined. Remove from the bowl and form the dough into a ball, coating with any extra flour. Wrap in plastic wrap and refrigerate overnight (up to 12 hours).

4 Preheat oven to 375°F (190°C).

5 Line two baking sheets with parchment paper. Roll out the dough (if using a cat-shaped cookie cutter) or, using a tablespoon, portion the dough into individual balls. Arrange the cookies on the baking sheets and bake for 12 to 15 minutes, or until the edges are golden brown.

6 Transfer the baking sheets to wire racks and allow to cool for 10 minutes, then, using a flat spatula, transfer the cookies to the racks and allow to cool. Repeat in batches until all the dough is finished.

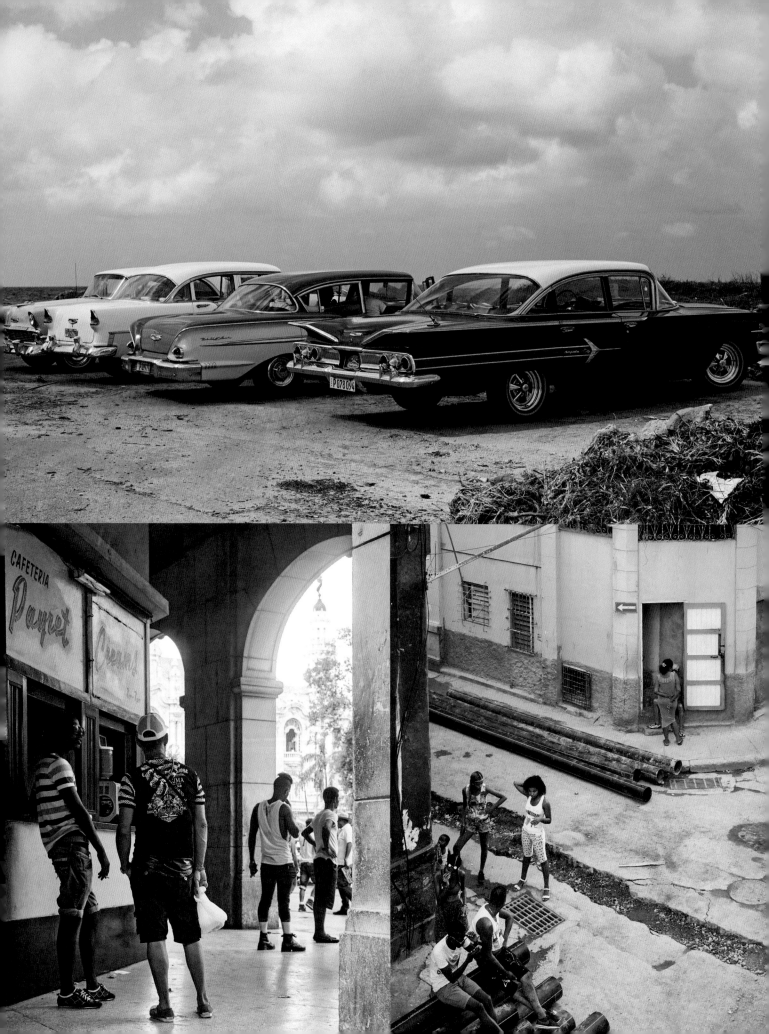

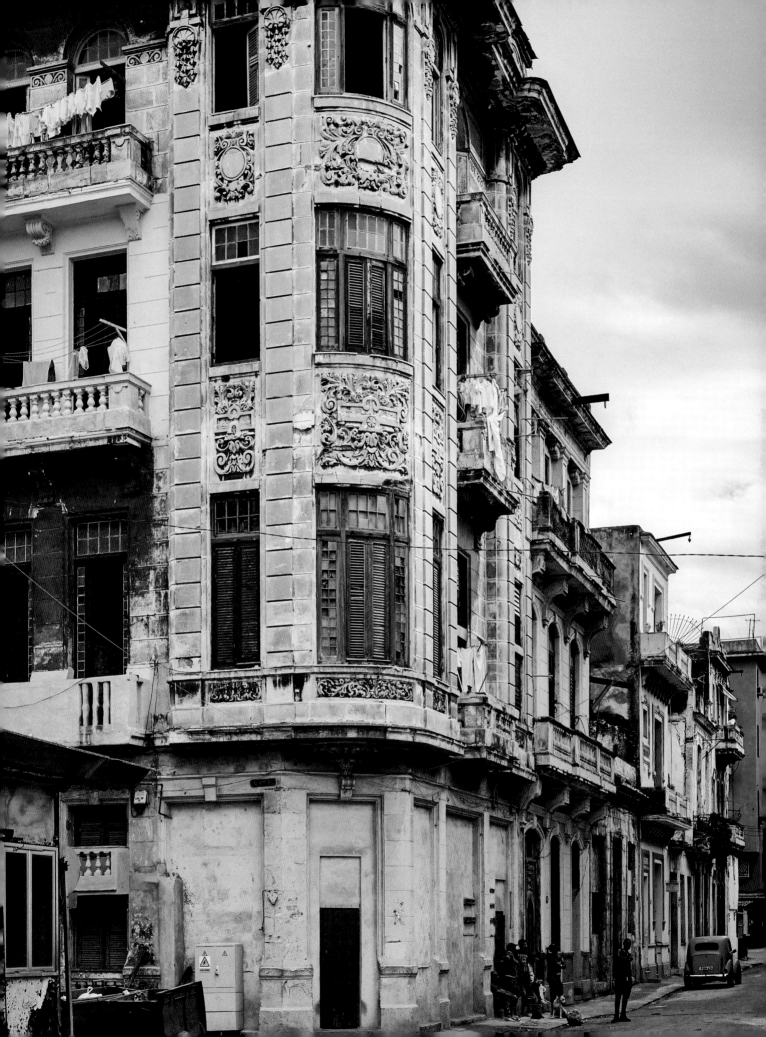

Watermelon-Mint Juice
Jugo de Sandia con Menta 319

Pineapple-Carrot-Ginger Juice
Jugo de Piña-Zanahoria-Jengibre 319

Citrus with Mint and Honey Soda
Ensalada 320

Fresh Limeade
Limonada 321

Café Cubano 323

Mojito 324

Daiquirí 328

Papa Doble Daiquirí 328

Mango and Cachucha Daiquirí
Daiquirí de Mango y Cachuchas 332

G&T O'Reilly 304
Hierba y Flor Ginebra y Tónico 335

Rum and Coconut
Saoco 336

Cuban Bloody Mary
Cubanito 337

Cuba Libre 339

BEBIDAS

Drinks

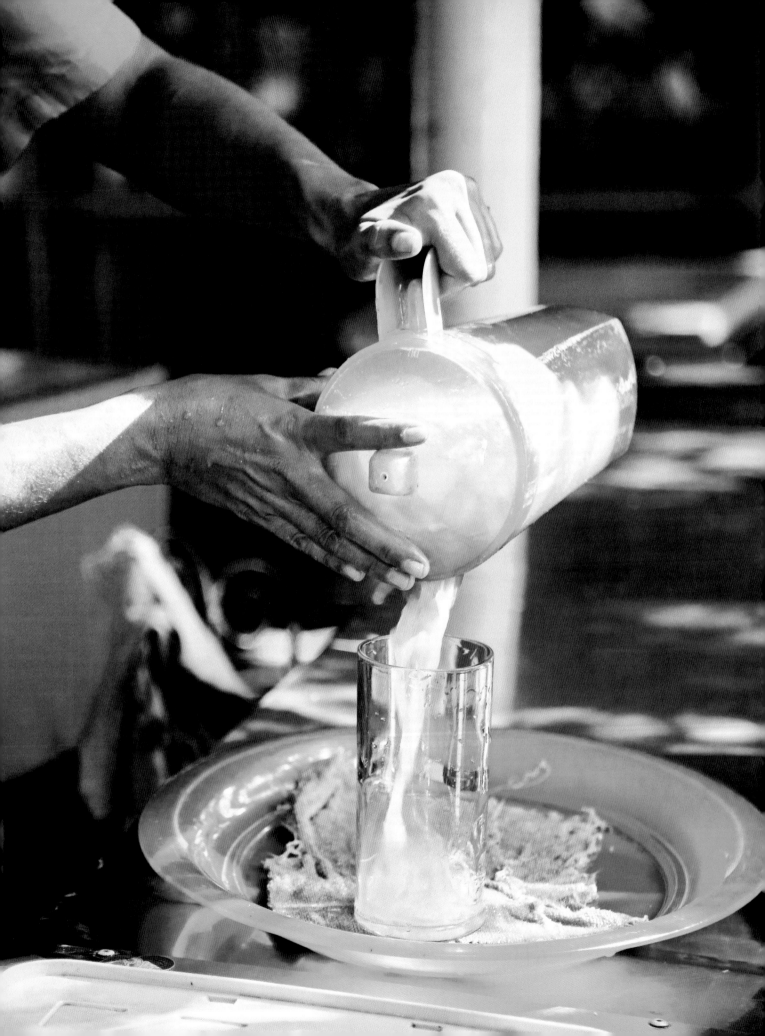

In Cuba, you'll miss good yogurt, you'll wince at the outrageous price of imported beef, you'll wonder why the beautiful fish served to tourists is inaccessible to locals. But one fine thing we can promise: In Cuba you'll never go thirsty—and we're not just talking all the mojitos and daiquirís, and the really good, really cheap, really aged rum sold here even at gas stations.

We're talking juice.

In Havana, we often begin a "drinking binge" not at a bar but at Jugueria de Calle 6, a small, cheerful juice place in Vedado with a tropical patio draped in swaths of aquamarine plastic. The smiley, proficient girls at the counter point to an enormous roster of potions hung on the wall, then patiently wait while we try to make up our minds. Banana-mint-honey? Coconut-sesame? Pineapple-basil? A pink froth of watermelon blended with some yerba buena mint—followed by a slurpy limonada [limeade] frappé, either straight or with ginger and/or spinach and cucumber? Decisions finally made after much taste-testing, the seasonal fruits are plucked from a bowl and the batidoras [blenders] roar into action. Along with flimsy plastic cups of their potions, the girls dispense nutrition advice: papaya eliminates water retention; guava is a powerhouse of vitamin C; mango is a great natural laxative; pineapple is a sure cure for a sore throat.

"What appliance from my kitchen would I take to a desert island?" muses a customer on her second coconut-lime-basil cure. "My batidora, of course! Ask any Cuban—it keeps us happy and cool." Orlando Blanco, manager at the legendary El Floridita bar, would concur. "Two things changed not just our drinks but our lives," he explained. "First was ice, which Cuba started importing in 1805. Then the blenders from the United States in the late 1920s, which Cuban cantineros [mixologists] embraced even before Americans did. And whatever else we lack," he continued, "we can always come home, throw a banana or mamey into the batidora, add ice— whiz—for one of life's little reviving pleasures."

Another drink gadget not specific to bars that Cubans hold essential? The Italian moka pot, for brewing endless tacitas [little cups] of syrupy-thick, super-caffeinated cafecito—sweetened, of course, with lots of azúcar, usually the faintly spicy raw cane sugar that somehow lends the coffee its Cubanness. Much more than a cup of joe is being brewed.

"Coffee for us is amistad [friendship]; it's confianza [trust]," expounds Reynaldo Gonzales, cookbook author and award-winning novelist. "It's hospitalidad [hospitality] and simpatia [affection], and many other good things." As with sugarcane, serious cultivation of coffee began here in the early 1800s, by French planters fleeing Haiti's slave rebellion. The cafetales—the elegant, tree-shaded coffee plantations—rose up mostly in Cuba's southeast, and for a few early-nineteenth-century decades, Cuban coffee was almost sugar's equal as a cash crop. Commercial production has since slackened, but the thirst never diminished. "We can lack bread, butter, and the ever-unobtainable milk," writes Yoani Sanchez, the famous Cuban dissident blogger. But it would be unbearable to not have coffee, dark and bitter "like our roots," to offer a guest, a gesture "as important as giving them a hug"

And now—time for cocktails! But where to drink?

In Havana, the hip cocktail set will gather on the roof terrace of El Cocinero, adjoining the colossally cool Fabrica del Arte Cubano arts center in Vedado, then head to O'Reilly 304 or its sibling El Del Frente in Habana Vieja for new-wave gin and tonics and repurposed jars of fanciful rum-fueled potions. We, too, will head

there—eventually. But first we soak up Havana's booze history at a few of the surviving old classics.

The Hotel Nacional de Cuba is a good place to start. Havana was already well established as "the unofficial United States Saloon" (in one journalist's phrase), a booze-awash kingdom of American and local mixologists, when the Nacional opened in 1930 as a pleasure palace located a quick flight from Prohibition. "Fly with us to Havana," enticed Pan-Am World Airways, "and you can bathe in Bacardi two hours from now." Through the Nacional's landmark Moorish-Spanish Art Deco spaces, a potpourri of the world's illustrious, gaudy, and notorious would come flocking—Hemingway and Sartre, Brando and Sinatra, Churchill and the Duchess of Windsor, alongside a menagerie of Mafia dons before and after mob boss Lucky Luciano took formal ownership of the Nacional in the '50s. Sadly, these days the cocktails here are a sugary mess, but it's still a thrill to nurse an aged Havana Club at a table on the Nacional's plush rear grounds as an orange sunset stains the Florida Straits. Graham Greene, a Nacional regular in the '50s, described his añejo rum as tasting of "ship's wood, like a sea voyage."

Our historic-bar route continues to Sloppy Joe's, a legend recently reborn under its handsome white arcade on a Habana Vieja thoroughfare busy with vintage car traffic. "First port of call, out where the Wet begins," ran Sloppy Joe's original Prohibition-era appeal to its predominantly Yankee clientele. Here, smashed eldery visitors shouted "maudlin ditties" while guzzling giant shakers of daiquirís and piña coladas. Here, more suavely, Noël Coward in 1959 would recruit Alec Guinness as "our man in Havana" in the movie of Graham Greene's novel by the same name. Destroyed by fire soon after Castro's Revolution, the bar was revived recently, a bit glossily antiseptic but still evocative with its shelves of backlit booze bottles and a treasure trove of historic photos on display. There's Coward and Guinness chatting with Hemingway during the movie shoot. There's young Sinatra at a table with an American mobster on either side during the notorious 1946 "Gangster Summit."

What the mafiosi and drunken American dames often didn't appreciate was the skill of Fabio Delgado Fuentes, Sloppy's head barman and member of the "Club de Cantineros," a guild of local bartenders founded in Havana in 1924—in part to compete with the invasion of expat U.S. mixologists. "Fabio invented dozens of cocktails," a Sloppy bartender of today informed us proudly: Cuba Bella, Cuban Manhattan, Havana Beach Special . . . most of them now forgotten. Then, unbidden, he mixed us a beautiful "Fabio Cuba Bella" with lime, grenadine, and a mix of white and aged rum.

The greatest Havana cantinero of all time, of course, blended icy double daiquirís for Hemingway at El Floridita (page 326), which lies a five-minute walk away. We'll save it for another time, though. Right now, we'll pass by Bodeguita del Medio, another iconic watering hole on the narrow calle Empedrado. The walls of the cavernous bar where Hemingway famously guzzled mojitos are a horror vacui, graffitied with the scribbled praises of visitors. And right now it's so jammed with tourists, we pause to take in the scene—and move on, to stroll along calle Obispo, pausing to listen to small bands of oldsters jamming in front of the bars. Their vintage soundtrack carries us up to a hot spot of today's drinking scene, El del Frente. Fade out: a refreshing gin and tonic garnished with rose petals.

GUARAPO

VASO de 8 onz.
$1.00

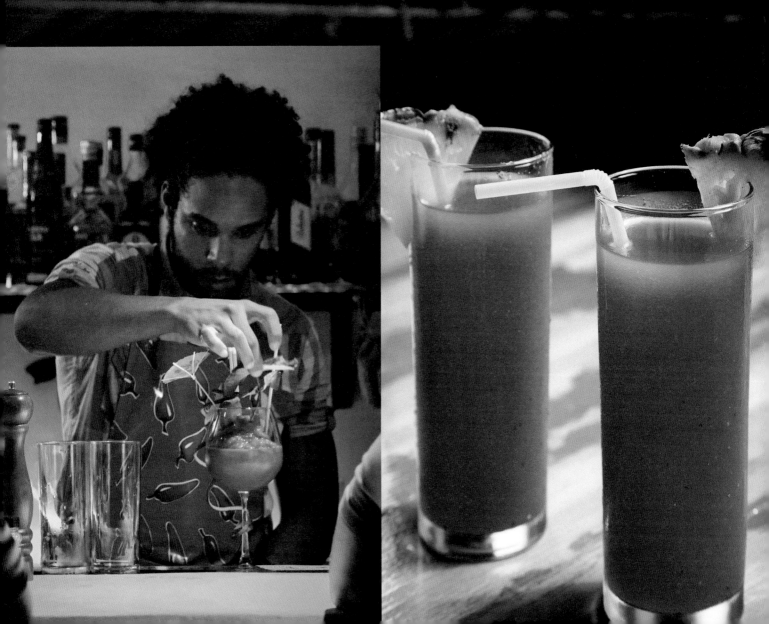

Watermelon-Mint Juice

Jugo de Sandia con Menta

On a hot summer day, when watermelons are at their sweetest and best, this frothy, minty pink potion is something you can guzzle by the gallon and still crave more.

Serves 2

5 cups (750 g) cubed, seeded watermelon

12 fresh mint leaves, plus 2 mint sprigs, for garnish

Ice cubes, for serving

In a blender, combine the watermelon, mint leaves, and ¾ cup (180 ml) water. Blend on high speed for 2 minutes, or until very smooth. Pour the watermelon juice through a fine-mesh strainer into a bowl or pitcher and discard the pulp and foam. Fill two tall glasses with ice, add the mint sprigs, and divide the watermelon juice equally between the glasses.

Pineapple-Carrot-Ginger Juice

Jugo de Piña-Zanahoria-Jengibre

O'Reilly 304 and its offshoot, El del Frente, are Old Havana's temples of cocktails, but their lunchtime regulars know that they are equally creative at blending various juices. Case in point: this delicious spicy-sweet-tangy combo that arrives garnished with theatrical slices of starfruit.

Serves 2

3 cups (495 g) chopped fresh or frozen pineapple

2 cups (280 g) chopped carrot

3 tablespoons chopped fresh ginger

Ice cubes, for serving

In a blender, combine the pineapple, carrot, ginger, and 2 cups (480 ml) water. Blend on high speed for 3 minutes, or until very smooth. Pour the juice through a fine-mesh strainer into a bowl or pitcher and discard the pulp and foam. Serve the juice in tall glasses over ice.

Citrus with Mint and Honey Soda

Ensalada

This lovely virgin cocktail called, yes, a salad, is prepared by muddling together slices of lime, lemon, and orange with a few mint leaves and honey. All you have to do is add soda water—who even needs alcohol?

Serves 2

1 lemon, thinly sliced

1 lime, thinly sliced

1 small orange, thinly sliced

2 tablespoons honey

10 fresh mint leaves

Ice cubes, for serving

1 (12-ounce / 360-ml) can soda water

Divide the lemon, lime, and orange slices between two tall glasses. Add 1 tablespoon honey and 5 mint leaves to each glass. Muddle lightly with a long spoon, add ice, and top with the soda water. Serve each drink with a long spoon so guests can continue muddling the fruit to bring out their juices and flavors.

Fresh Limeade *Limonada*

On a sultry tropical day, a Cuban limonada—a fresh limeade—served over ice or blended with ice into a frappé—always comes to the rescue: not too sweet, not too tart and always super-refreshing. You can play with this recipe by substituting honey for sugar, or blending in some mint or basil, even pineapple. Fresh cucumber is most refreshing—just add 1 cup (135 g) of chopped, seeded cucumber when blending.

Serves 2

⅓ cup (75 ml) fresh lime juice

¼ cup (50 g) sugar

2 lime slices, for garnish

Ice cubes, for serving

In a blender, combine the lime juice, sugar, and 2 cups (480 ml) water and blend on high speed for 30 seconds. Serve the limonada in tall glasses over ice garnished with the lime slices.

CAFÉ CUBANO

The arabica coffee beans that Cuba produces, mostly at high altitudes in the eastern regions between Santiago de Cuba and Baracoa, are usually organic and can be extremely tasty. And like many tasty things on the island, good coffee is hard to find at regular stores and is very expensive for an average citizen. Cubans know times are hard when their meager monthly state ration of coffee brings café mezclado—coffee blended with small roasted chickpeas. This bitter taste of the lean Período Especial is now making an unfortunate comeback due to falling coffee production. Cuban expats, in fact, often tote kilos of the cheap, U.S.-made Café Bustelo back to the island, then leave with bags of the fancy Cuban Serrano brand coffee bought at the airport duty-free shop.

To prepare cafecitos at home, Cubans rely on their cafeteras, the octagonal stove-top espresso makers—aka Bialetti moka pots (you'll need one for the following recipe). Once brewed, the coffee is slowly poured on top of the sugar already placed in a demitasse—a trick that apparently breaks down the sucrose and alters the flavor. Some prefer to whip the first thick drops of café spewed by the moka with brown sugar to create espumita, the thick foamy crema. Another trick from Havana's top barista, Nelson Rodriguez Tamayo, owner of the fabulous El Café coffee bar: When adding ground coffee to the moka, leave it as a loose mound instead of compressing. Add a little hot milk for a cortadito; a shot of dark rum for a carajillo; sweetened condensed milk for a bon bon; and one cup of frothy hot milk for each shot of espresso for a café con leche. If you want to go totally Cuban, look into mail-ordering the slightly caramel-like Cuban Serrano brand or the well-rounded Cubita.

Serves 4

6 tablespoons (85 g) finely ground espresso

6 tablespoons (75 g) sugar, or more or less to taste

Fill the lower chamber of a 4-cup (960-ml) stove-top Italian espresso pot with water and loosely pack the ground espresso into the filter. Seal the top and bottom chambers together. Bring the water to a slow boil over medium heat and continue boiling until the espresso is brewed. Add a heaping teaspoon of sugar to each cup and pour the espresso over it, stirring to dissolve the sugar.

MOJITO

"Mojito is a misunderstood drink, both abroad and in Cuba," sighed Machin Gonzalez, an award-winning Havana sommelier who holds the prestigious Maestro de Maestros title. "The ingredients bartenders most often forget? Corazón y paciencia—the heart and the patience that must go into each glass." To Machin, the other prerequisites to a perfect mojito include just-snipped proper mint—long-leafed yerba buena, with its delicate fragrance—Havana Club three-year-old rum, the aromatic thin-skinned limon criollo squeezed right into the glass, plus a light hand with the muddling stick. "We sugar-addicted Cubans," he added, "like our mojitos sweet, but in the end, the proportions are a personal preference."

The mojito—from the word "mojado" or "wet"—Machin explained further, is descended from a much older potion named El Draque, "Drake," or Draquecito after Francis Drake, the hard-drinking sixteenth-century pirate and slave smuggler. El Draque's original mix included aguardiente de caña (aka tafia), a coarse precursor of rum, plus mint, lime, and cane sugar. "Draquecito was what you got when you complained of a bad stomach," chuckled Machin. "Maybe because the lime and the mint settled it, or perhaps because the aguardiente just knocked you out." In the nineteenth century the potion got more refined, acquiring its signature white rum component, plus spritz, but as Machin says, a good mojito "still cures the soul—and the stomach."

"My mojito in La Bodeguita, my daiquirí in El Floridita," says a handwritten quote from Ernest Hemingway—a man who knew his way around Havana's watering holes—that is on display at the tourist-thronged Bodeguita el Medio bar in Havana Vieja. But while the hard-drinking Papa certainly visited, the note might be a fake, plus these days Bodeguita is actually known for the worst mojitos in town. El Floridita, on the other hand, mixes both drinks to perfection. "Our secret," said Orlando Blanco, the manager, "is careful, intelligent muddling—plus a dash of Angostura bitters to temper the sweetness." Below is one great mojito. Salud!

Serves 2

4 teaspoons superfine sugar, or more to taste

One medium-size lime, preferably thin-skinned, halved

2 sprigs yerba buena or spearmint, with at least 5–6 leaves on each sprig, plus a few more small leaves for garnish

1 (12-ounce / 360-ml) can soda water

3 ounces (90 ml) light rum

Ice cubes, for serving

Angostura bitters (optional)

Divide the sugar between two tall Collins-style glasses. Squeeze a lime half into each glass. Add a mint sprig to each glass and muddle everything together with a long spoon. Add a splash of soda to each glass and gently muddle some more. Divide the rum between the glasses, add 4 to 5 ice cubes to each glass, and stir. Add a drop of bitters to each glass if using. Top with soda water and garnish with the small mint leaves.

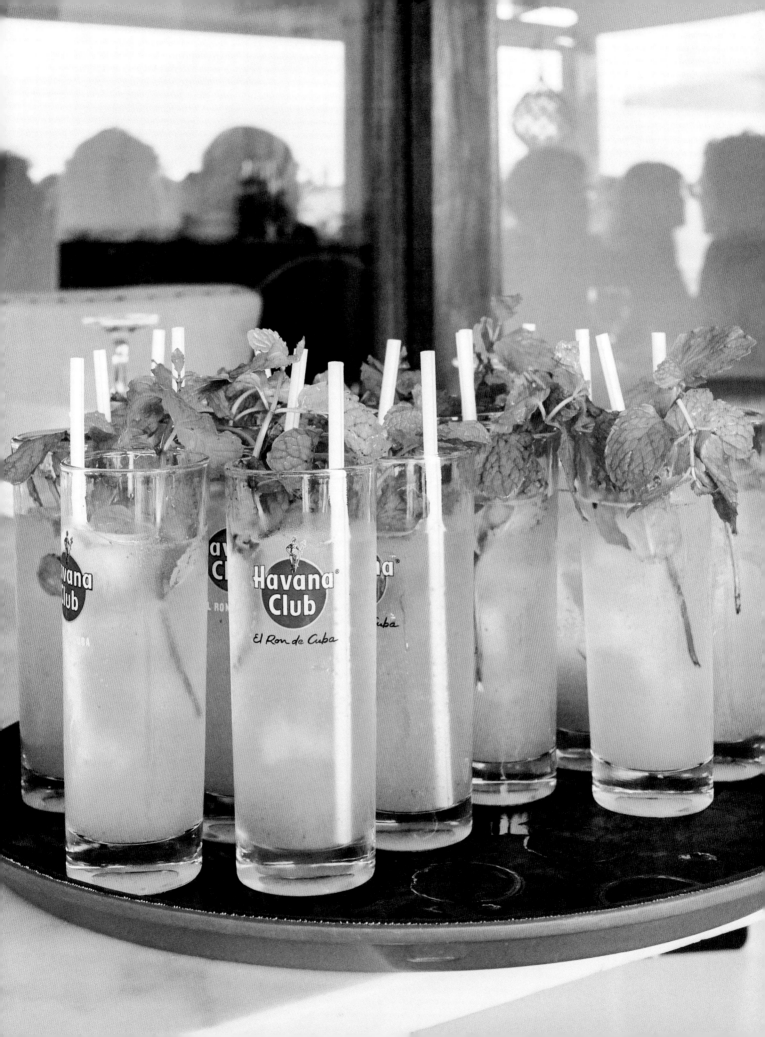

WELCOME TO EL FLORIDITA

One can sneak a midday peek into El Floridita, the hallowed bar under a vintage neon sign in Habana Vieja, and hastily dismiss it as a tourist trap, a blaring quagmire packed with sun-reddened tourists snapping selfies beside the life-size statue of potbellied, bushy-whiskered Ernest Hemingway, Floridita's most famed and faithful patron. Channeling Papa, everyone seems to be smashed, on their fourth—sixth?—frozen daiquirí as the musicians squeezed next to the entrance crank out one more "Guantanamera." But come back, as we often do, at a quieter hour. Now Hem's watering hole practically glows—a faded amber-hued relic frozen in some hedonistic mid-twentieth-century moment. Here are the dark woods and sumptuous velvets, the long bar counter fronted by vintage upholstered stools, a trove of photos of Papa and his starry entourage, from Ava Gardner to Spencer Tracy.

Here, too, is an oil portrait of Constantino "Constante" Ribailagua Vert, the famously perfectionist Catalan-born cantinero [mixologist] who reigned here from 1918 to 1954, serving his impeccable Mary Pickfords and El Presidentes—and especially daiquirís—to celebs like Gary Cooper and Errol Flynn (who apparently stiffed the waiters). In the early 1930s, Hem first dropped into El Floridita (looking for a men's room supposedly), and for the next decade or so he basically never left, driving in from Finca Vigía, his countryside villa, to booze on drinks made by El Grande Constante, as he was known, while sitting on his favorite corner stool (now roped with red velvet). Before that, he strolled up calle Obispo from the Ambos Mundos Hotel, where for a few bucks a literary pilgrim can still behold the Spartan room 511 in which he got started on *For Whom the Bell Tolls*.

These days Floridita's modern-day cantineros, a cheerful platoon of them decked out in red-and-white outfits, are Constante's diligent heirs. It's worth squeezing in here midday just to observe their tightly choreographed mixological moves, even under pressure. Ever-cool despite a hundred simultaneous orders, never resorting to jiggers or measuring cups, they blend, shake, stir, and pour with the practiced finesse of great maracas players—as Floridita's four overworked Osterizer blenders whir in nonstop unison.

"Is it true that Hem could down eight daiquirís in one sitting?" we asked Orlando Blanco, Floridita's suave and hospitable manager and award-winning Master Sommelier. "Are you kidding?" Orlando retorted amiably. "Eight? Make that FIFTEEN!" He bade us inspect the photos above Hem's pot-bellied statue. "Show me one picture," he chuckled, "where Papa doesn't look smashed." That evening, we struggled with the weak Internet signal on a breezy street corner to fact-check with reliable sources. Indeed! To his friend Harvey Breits, Hem recounted a stormy day in 1942 when he set the Floridita record: seventeen double daiquirís. Well, actually eighteen, if you count the one for the road that he guzzled after scarfing down two steak sandwiches.

That, amigos, would be (ahem) seventy-two ounces of rum. More than three fifths of it. In a day!

To talk more Papa—and daiquirís—Orlando invited us back for a lunchtime tasting tutorial. We toted along a copy of *Islands in the Stream*—Hem's mawkish, posthumously published novel—for which we'd overpaid at the Plaza de Armas secondhand book market. The novel's most famous pages are devoted to a woozy appreciation of El Floridita's charms by Thomas Hudson, Hem's painter-adventurer protagonist (modeled in good part on the author). We settled in, away from the

tourist hubbub, in the bar's quiet, ferociously air-conditioned rear dining room, decorated with murals of Havana harbor of yore. Orlando started us off with what he called a "two-hundred-year-old, pre-ice, pre-blender, pre-daiquirí daiquirí." We admired the tight, potent mix of lime juice, sugar, and rum, as Orlando explained that such an ingredient blend was common for centuries throughout the Caribbean. The most classic example is Cuba's canchánchara (two-thirds rum canchánchara to one-third lemon), predecessor of the daiquirí, which helped Cuban combatants fight the Spanish colonial army.

"Our Floridita is known as la cuna del Daiquirí—the cradle of Daiquirí," Orlando continued. "But the cocktail is actually named for a beach near Santiago de Cuba." According to one piece of lore, around 1900 a U.S. mining engineer named Jennings Cox walked into a bar in Santiago, asked for a gin drink, got one with rum instead—and dubbed it a daiquirí, after the beach. Is this, as well as other daiquirí origin stories, apocryphal? Orlando shrugged at the question. What mattered, he said, was that Constante refined the drink with perfect proportions—and a touch of Maraschino liqueur—making it both his own and eternal. Cold, too—with the aid of an automatic ice-crushing machine he imported from the United States.

As if on cue, a cantinero delivered a frosty coupe glass of Constante's best-known creation: His Daiquirí No. 4, aka Daiquirí Frappé, an exacting formula of half a lime, one teaspoon sugar, one ounce rum, and five drops of that Maraschino, all blended with crushed ice for thirty seconds exactly. The secret, insisted Orlando, is keeping the ice bone-dry—lest the drink turn into watery slush. Trying not to finish the ethereal, tart-sweet-boozy-non-watery slurpie all in one blissful gulp, we checked Hem's description of Constante's frozen creations. They felt, waxed Hem, as you drank them, "the way downhill glacier skiing feels running through powder snow and, after the sixth and eighth, felt like downhill glacier skiing feels when you are running unroped." The powdered snow sensation . . . a pretty spot-on metaphor, it must be said.

Constante was a cantinero from God, Orlando declared with an admiring sigh. "Not for nothing they called him el rey de los cocteleros—the king of mixologists." King and self-proclaimed workaholic: Constante invented some two hundred drinks, all flawless; he even turned lime-squeezing into an art form. "We still use his 1930s recipe booklets here," added Orlando, "mostly without changing a thing." For the record, those recipe booklets include four versions of daiquirís: strained, frappéed, with Maraschino, and one other with curaçao.

It was about time for us to move on to aged rum and cigars—but not before ending our daiquirí-thon with Papa Doble, Hem's preferred variation: a frappé of lime, a dash of fresh grapefruit juice, no sugar, and double the rum. "Constante came up with the formula when Hemingway became diabetic and wanted healthier, stronger drinks 'sin azúcar,'" Orlando explained. And all of us had a laugh, shaking our heads. As if rum isn't loaded with sugar! Then we took a sip . . . and felt queasy just imagining seventeen of these down the hatch in a day. Yes, said Orlando: "Daiquirí Salvaje—savage—is Papa Doble's vernacular name."

We looked up Hem's rambling, appropriately slushy description in *Islands in the Stream*. "As [the Doble-swigging protagonist] lifted it, heavy and the glass frost-rimmed, he looked at the clear part below the frappéd top, and it reminded him of the sea. The frappéd part of the drink was like the wake of a ship, and the clear part was the way the water looked when the bow cut it when you were in shallow water over a marl bottom."

Was Papa breaking his own cardinal rule of never writing under the influence when he penned this? We sighed, and braved another sip.

DAIQUIRÍ

The original (pre-blender) daiquirí, strained from a shaker, can be a thing of great beauty when mixed just right, as it is at El Floridita: a tight, elegant potion that can be inhaled by the dozen.

To make the equally classic frappé [frozen] version, add 1½ cups (210 g) of crushed ice to the following recipe and blend at high speed until smooth, about thirty seconds. Taste after blending: The frappé version might need a touch more sugar.

Serves 2

Ice cubes

2 ounces (60 ml) light rum

Juice of 1 large lime (about 2 tablespoons)

2 teaspoons sugar

10 drops Maraschino liqueur, preferably Luxardo

2 wheels of lime or 2 grapefruit wedges, for garnish

In a cocktail shaker filled with ice, combine the rum, lime juice, and sugar. Place the top on the shaker and shake for 20 to 30 seconds. Add the Maraschino and shake once more. Strain into two chilled coupe glasses and garnish with lime wheels.

PAPA DOBLE DAIQUIRÍ

Ernest Hemingway's regular, with double the rum, grapefruit juice, and no sugar.

Serves 2

1½ cups (210 g) crushed ice

4 ounces (120 ml) light rum

Juice of 2 large limes (about 4 tablespoons / 60 ml)

Juice of ½ medium grapefruit (about ½ cup / 120 ml)

4 drops Maraschino liqueur, preferably Luxardo

2 wheels of lime or 2 grapefruit wedges, for garnish

1 In a cocktail shaker filled with ice, combine the rum, lime juice, and grapefruit juice. Place the top on the shaker and shake for 20 to 30 seconds. Add the Maraschino and shake once more. Pour into a blender with the crushed ice and blend at high speed until smooth, about 30 seconds.

2 Pour into two chilled coupe glasses and garnish with lime wheels.

O'REILLY 304 & EL DEL FRENTE

A MOVEABLE FEAST

With fantastical fruity cocktails served in repurposed glass jars (necessity is the mother of invention), unfussy but inventive small plates, and all the cool kids in town squeezed around black wooden tables in the dim glow of Edison bulbs, O'Reilly 304—and its new offshoot, El Del Frente—would capture the millennial zeitgeist even in Berlin or Brooklyn. Presiding over the fiesta is the forty-something owner, José Carlos Imperatori: hipster, artist, self-taught chef, badass nightlife impresario. Burly, curly-mopped, and fashionably disheveled in one of his signature vintage floral shirts, here he is high-fiving Dionisio Arce, front man of Cuba's pioneering heavy-metal band Zeus, who's dropped in for a drink. Here he is dragging at a Lucky Strike with a posse of visiting models out on the balcony overlooking the fast-gentrifying but still picturesquely distressed calle O'Reilly in Habana Vieja. Here he is right before dinner service scribbling new dishes and cocktails on the blackboard menu decorated with a Darth Vader mask. Kentucky Mojito (Jack Daniels instead of rum to celebrate the new Cuban-American friendship)—check. Tostones with caviar—check. Devoted clients often wonder, Where would Havana dining and nightlife be without José's cool brand of manic energy?

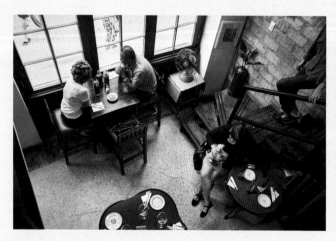

José's Story

I come from an incredible family. My grandfather was a Cuban ambassador to Britain, a man of the world. My grandma, now ninety, is this planet's best cook—she inspires my menu's traditional dishes, like the fish enchilado, and the crispy croquetas. My dad? You gotta talk music with him! He's a specialist in MRI scanning technology, but he lives and breathes rock 'n' roll. He's the one who hooked Cubans on Jimi Hendrix. Recently, Mick Jagger was at O'Reilly 304—he liked it so much he came twice, and he ate everything. When he walked in, I texted my dad to come over. Mick's security guys told me to empty the restaurant, but I said to them: I'm the owner here and this is my dad—my own dad! Either he stays, or Mick eats somewhere else. And my dad got an autograph! I think it was his life's happiest moment.

In Havana I trained as an artist. For a chef, art is the best education because it teaches you creativity. After art school, I worked as a maître d' at the Jazz Café, a famous state restaurant, where I got to know half of Havana. But who wants to work for the government for thirty dollars a month? That kind of work makes you cynical. So I decided to open a place of my own on a dilapidated street here in Habana Vieja, in a space that used to be a gas range warehouse.

My brother and I opened O'Reilly 304 in 2011, and it will always be my first love, my first baby. I designed it myself, with my own artwork and some avant-garde art from my friends. How challenging was it, you ask? Ha! Imagine running a restaurant when the electricity can go off any minute, or water, or gas—or all three! [As if on cue, the electricity goes off, and we continue our conversation by candlelight.] What can I tell my clients, "Sorry, amigos, I can't feed you tonight"? Here in Cuba you improvise—the party somehow goes on. Our culture—it's all about solving things. The inspiration for my dishes? I don't use the Internet or social media, because I don't want to trash up my brain, but ideas are in the air. A friend who works at the airport brings me food magazines from Spain, where I learn about cool Spanish chefs and their tapas. Another friend who knows Japanese food told me about a seared fish dish called tataki—and now half the paladares in town are copying our tuna tataki. Even our explosive, signature hot sauce—it has guavas, chilies, garlic, cilantro, and American hot sauce—is a riff on many different tastes, itself a remix. In the kitchen, I'm always inventing. Plantain tostones with caviar? Why the hell not? For our cocktails, a fruit-carving artisan does fantastical lime-peel creations and pineapple sculptures. Another old man handmakes the tortillas for our tacos, because where in Havana can you find tortillas? Our mismatched vintage plates? We got those from a secret señora who has a house full of amazing antiques. Glassware? It's so expensive and ugly in Cuba, we serve our cocktails in jars from imported Spanish potatoes. A jar gets you a DIY cocktail glass, plus four portions of patatas bravas—cool, no? This is how we do things in Havana! Though I'm having my happiest moment here in Cuba right now, I'm dying to travel abroad if I can score a visa. The only foreign place I've ever been is Cancún, and it blew my mind. My next stop? New York, if I'm lucky. Straight off the plane I'll go to the MoMA—because I love Edward Hopper and even more I love Andy Warhol.

Mango and Cachucha Daiquirí

Daiquirí de Mango y Cachuchas

Every drink that emerges from the cutting-edge bars of paladares O'Reilly 304 and El Del Frente resembles whimsical artwork featuring artistically carved lime peel and fruit, unusual combinations of flavors, and clever receptacles, from massive goblets to repurposed jars. Though we're usually no fans of slushy, tiki-style fruit-flavored daiquirís, we were totally convinced by this version with its smooth taste of mango, good rum, and an aromatic background kick of cachucha peppers.

Serves 2

1 cup (240 ml) frozen mango puree

2 ounces (60 ml) white rum

2 cachucha peppers or ½ jalapeño pepper, seeded and diced, plus 2 more for garnish

1 teaspoon sugar

1 cup (140 ml) crushed ice

In a blender, combine the mango puree, rum, cachucha peppers, sugar, and the ice. Blend on high until very smooth. Pour into large frozen daiquirí glasses and garnish each glass with a cachucha pepper.

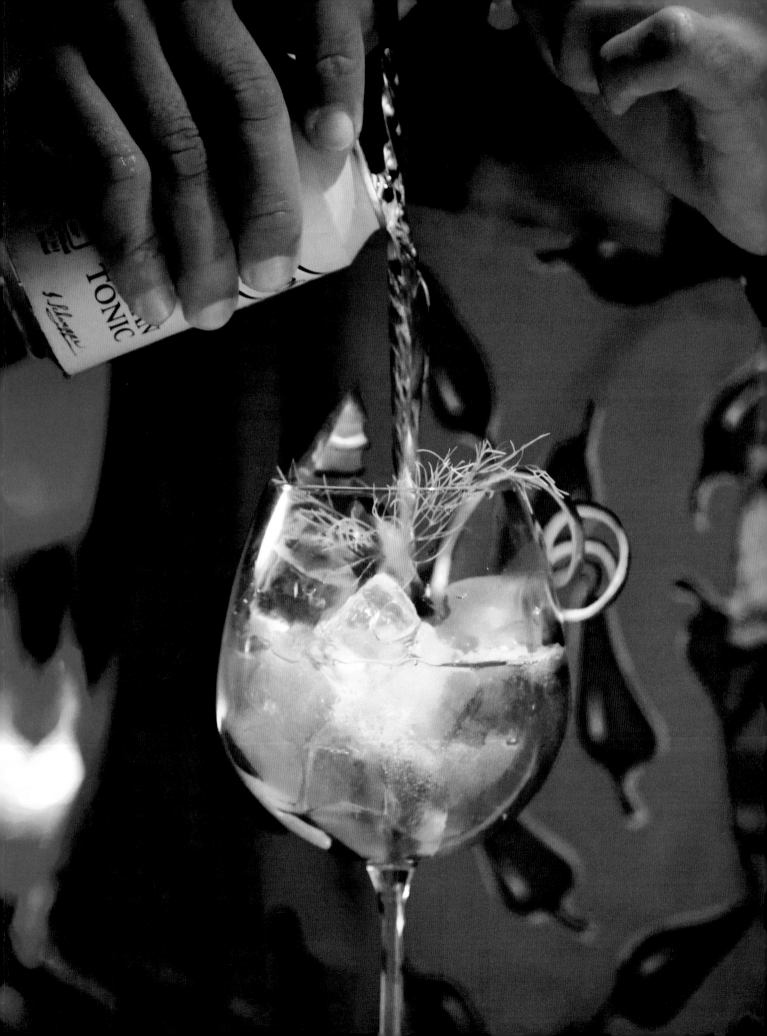

G&T O'Reilly 304

Hierba y Flor Ginebra y Tónico

Although José Carlos Imperatori, the owner of O'Reilly 304 and El Del Frente in Old Havana, has never yet been to America, his creative, fusiony riffs both in the kitchen and behind the bar are greatly inspired by the culture of the forbidden land he's eager to visit. His gin and tonics, served in oversize wine goblets and resembling some fantastical little aquariums, are his own tribute, he says, to both the American and British bar cultures—with a dash of that Cuban inventiveness. This one, garnished with fennel and rose petals, is a huge hit with his artsy regulars. He named it Jimi Hendrix both for the rocker who is his father's idol and for the Hendrick's gin that he favors.

Serves 2

4 ounces (120 ml) gin

2 sprigs fennel greens

2 organic rose petals

2 (2-inch / 5-cm) strips lime zest, white pith removed

2 lime wedges

Ice cubes, for serving

1 (10-ounce / 300-ml) can tonic water

Divide the gin between two large goblets or tall glasses. Add a sprig of fennel, a rose petal, a strip of lime zest, and a wedge of lime to each glass. Add as much ice as desired and top off with the tonic water.

Rum and Coconut *Saoco*

An infinitely quaffable beachside potion of white rum blended with coconut milk and its water, the saoco was supposedly first mixed by Cuba's African slaves by cracking open a coconut and mixing its green water with a shot of crude aguardiente. This story usually has Cuban cocktail historians rolling their eyes and shaking their heads, but the drink itself, they admit, is a keeper.

Serves 2

2 ounces (60 ml) white rum

Ice cubes, for serving

1 cup (240 ml) coconut water

¼ cup (60 ml) coconut milk

Divide the rum between two tall glasses and add ice cubes to fill. Divide the coconut water between the glasses, then gently pour 2 tablespoons coconut milk on top of each.

Cuban Bloody Mary *Cubanito*

There was a history of Cuba's Prohibition-era mixologists "Cubanizing" American drinks with local ingredients. The Cubanito was one such invention. A bloody Mary gone tropical with lime and white rum, it's usually thinner, more refreshing, and easier drinking than the original, especially if made with fresh tomato juice.

Serves 2

1½ cups (360 ml) tomato juice, preferably fresh

4 ounces (120 ml) light rum

2 tablespoons fresh lime juice

½–1 teaspoon hot sauce, such as Tabasco, to taste

1 teaspoon Worcestershire sauce

Salt and pepper

Ice cubes, for serving

Lime wedges, for garnish

In a cocktail mixer, combine the tomato juice, rum, lime juice, hot sauce, Worcestershire sauce, and salt and pepper to taste and stir to blend. Serve in tall glasses over ice garnished with lime wedges.

CUBA LIBRE

The way the Bacardi rum company tells it, the Cuba Libre might have been born on a sweltering August day in 1900 at the American Bar on Neptuno Street in Havana. The Spanish-American war had just ended. A certain Captain Russel of the U.S. Signal Corps stationed in Cuba walked into the bar and ordered a drink of rum and coke with a squeeze of lime. Por Cuba libre!—for a free Cuba!—toasted the captain, saluting Cuba's independence from Spain. Both the name and the cocktail stuck, goes the Bacardi story (which might be apocryphal), and since then more than eighty billion Cuba Libres [aka rum and cokes] have been poured all over the world.

The irony? Because of the embargo, Americans can't make a Cuba Libre with Cuban rum, while the same law prohibits Coca-Cola from entering Cuba. And so the island bartenders make do with the tropical socialist imitation, Tu Kola, which actually doesn't taste bad as long as the rum is of excellent quality. Made with aged añejo dark rum—a version favored by Cuban cocktail connoisseurs—a Cuba Libre becomes a drink called a Cubata, and we urge you to try it as well.

Serves 2

6 lime wedges

Ice cubes, for serving

2½ ounces (75 ml) golden rum

1 (10-ounce / 300-ml) can Coca-Cola

4 lime wedges

Muddle 2 lime wedges at the bottom of each of two Collins or rocks glasses. Add ice and top with rum and soda. Garnish with 1 lime wedge per drink and serve.

INDEX

ACKNOWLEDGMENTS

Above all, *Paladares* is a tribute to the spirit, generosity, and unquenchable vitality of the Cuban people we've met along the course of our journeys. Our profoundest gracias to all in Cuba below—the colleagues, friends, and sometimes perfect strangers who turned into amigos—who shared their food, their life stories, their knowledge, their friendship, their recipes.

Gracias, Acela Matamoros, Alicia García, Enoch Tamayo Acosta, Niove Diaz, Rafael Lam, Alina Menendez, José Carlos Imperatori, Gregory Biniowsky, Irina Butorina, Niuska Miniet, Luigi Fiori, Amy Torralbas and Álvaro Diez, Noemia Lorenzo, Alexis Alvarez Armas, Gabo Pére, Pilar Fernandez, Ariel Mendoza Amey, Ivan Rodríguez Lopez, Katia Bianchini, Michel Miglis, Francoise Guernier Prendes, Alexis Orta and Támara Diaz, Javier Gomez, José Raul Colome, Fernando Cabrera Valle, Sasha Ramos and Rafael Muñoz, Madelaine Vazquez, Jen Lin-Liu, Andres Levin, Asori Soto, Nelson Rodriguez Tamayo, Orlando Blanco, Machin Gonzalez, Lilliam Dominguez Palenzuela, Reynaldo Gonzales, Katharina Voss, Raulito Salgado, Miguel Salcines, and Fernando Funes.

Thanks, too, to amigos far and wide who shared their contacts and their knowledge of Cuba: Esther Allen and Nathaniel Wice, Berta Jottar, Becky Saletan, Steve Fagin, Gabriela and Beatriz Llamas, Wendy Luers, and Ana Sofia Pelaez.

At Abrams, salutes to our editor-extraordinaire Camaren Subhiyah for embracing this project with such enthusiasm, and for guiding it through every stage of the process with such taste and keenly tuned judgment. We thank Deb Wood for the vibrant design, Alex Calamela and Kimberly Sheu for their publicity and marketing efforts, and Gabriel Levinson for keeping it all on track.

As always, Anya's agent, Andrew Wylie, as well as Jin Auh and Jessica Friedman of the Wylie Agency, were everything an author could dream of. And she feels lucky to have had the support and friendship of Nilou Motamed and Dana Bowen at *Food & Wine* magazine.

Anya also thanks her mother, Larisa Frumkin, for teaching her all about hospitality, and her partner, Barry Yourgrau, for his endless support and companionship on each step of the Cuban adventure—in the field and during the writing.

Megan also wishes to acknowledge the people of Cuba for all their warmth, kindness, inspiration, and help with this project; Christina Grahn, for her tireless support; our editor, Camaren Subhiyah, for believing in an idea; Anya von Bremzen, for bringing it to life; Emilio Heredia, for his appetite; and, finally, Roberto Garcia, her man and friend in Havana, for his invaluable assistance in putting it all together.

Editor: Camaren Subhiyah
Designer: Deb Wood
Production Manager: Denise LaCongo

Library of Congress Control Number: 2016961368

ISBN: 978-1-4197-2703-0
eISBN: 978-1-68335-145-0

Printed and bound in the United States
10 9 8 7 6 5 4 3 2 1

Abrams books are available at special discounts
when purchased in quantity for premiums and
promotions as well as fundraising or educational
use. Special editions can also be created to
specification. For details, contact specialsales@
abramsbooks.com or the address below.

ABRAMS The Art of Books
195 Broadway, New York, NY 10007
abramsbooks.com